The Collection

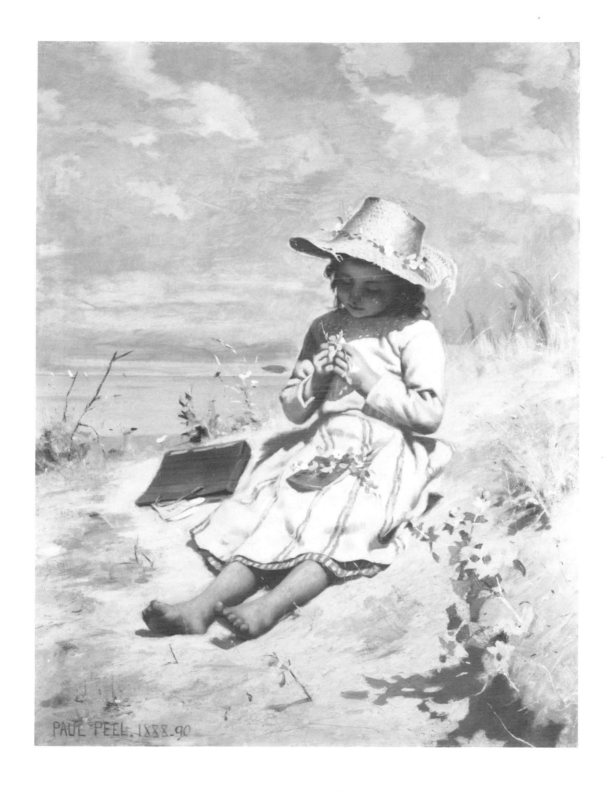

London, Canada

Canadian Cataloguing in Publication Data

Smart, Tom
 The Collection, London Canada

Includes bibliographical references.
ISBN 0-920872-81-6

1. London Regional Art and Historical Museums (Ont.) — History. 2. London
Regional Art and Historical Museums (Ont.) — Catalogs. I. London Regional Art
and Historical Museums (Ont.). II. Title.

N910.L65S53 1990 708.11'326'09 C90-095451-5

Printed in Canada
by The Aylmer Express Ltd.
October, 1990

This book is dedicated to 150 years of art
in London and to the artists who made it possible.

CONTENTS

May 9, 1990

The London Regional Art and Historical Museums has played a key role in the development of London's rich heritage.

The publication of this excellent record of the City's art acquisitions provides the community with a permanent record of the hard work of generations of Londoners who see the merit of building this fine art collection.

On behalf of London City Council let me extend our sincere congratulations on the 50th anniversary of a public art gallery in London, the 10th anniversary of the London Regional Art Gallery and the 1st anniversary of the London Regional Art and Historical Museums. The anniversary dates graphically tell us that we have a heritage in the arts and a vision for the future.

Sincerely,

Tom Gosnell,
Mayor

FOREWORD

The London Regional Art and Historical Museums takes pleasure in publishing *The Collection* to commemorate the 50th anniversary of the opening on October 4, 1940 of the first public art gallery in the City of London.

It all started in 1896 when Frederic Marlett Bell-Smith invited the people of this community to select, by ballot, their favorite painting from an exhibition of his work hanging in our first public library. They chose *"The Wave"* and Bell-Smith donated it to the city. With this gracious and generous act, London's fine art collection began. Since that day we have been indebted to many generous groups and individuals whose gifts and bequests have enriched our gallery.

This book, of course, is not our definitive catalogue. Today, through the magic of our computer, we are able to produce complete, accurate and up-to-date data about our collection by merely pressing a few buttons. However, we thought it appropriate to celebrate our birthday with the publication of a special book filled with photographs of works of art from our collection. We invited Tom Smart, a well-known art historian, to write the story of how the collection has been built over the past ninety-four years.

We are greatly indebted to the hundreds of individuals and many corporations, as well as the Canada Council, whose generous support made this publication possible.

Nancy Poole
Executive Director

ACKNOWLEDGEMENTS

The London Regional Art and Historical Museums is especially indebted to Ellen McKim, an esteemed member of our Art Advisory Board, for her outstanding contribution and to Ruth Anne Murray for her skillful management of and dedication to this project.

Nancy Poole

The writing of this history has depended upon the assistance of many people. I wish to extend my appreciation to them for their contributions to this project.

Edward Phelps at the Regional Collection of the University of Western Ontario has been very generous with his intimate knowledge of the history of London and region. I have benefitted greatly from his advice and that of his staff. I wish also to thank Glen Curnoe and Mary Velaitis at the London Public Library's London Room for providing essential primary source material on the early years of art in London; Pat Pane and Jan White assisted me in sorting out the complexities and formats of the various minute books and governing documents of the art galleries in London; Christopher Severance, Catherine Morrisey, Joanne Reynolds and David Greenglass have been accommodating while I have used their resources; Judith Rodger, Rebecca Boughner and Heidi Sura at the art gallery have given generously of their time and office space; and Barry Fair for access to the registration files and his work on the catalogue listing at the conclusion of the book; Paddy O'Brien's comments and intimate knowledge of the development of the permanent collection have been instructive. The support of Maurice Stubbs and Catherine Elliot Shaw at the McIntosh Gallery, University of Western Ontario, and Ron Bowen is gratefully acknowledged.

I wish also to extend my appreciation and thanks to Nancy Poole for her invitation to me to work on this project. Her insightful comments and imagination have provided direction to the narrative and understanding of the collection's history.

My wife Monica has been most supportive and it is to her that I dedicate this work.

Tom Smart

The publisher would like to thank the following artists and copyright holders for permission to reproduce their works: Louis Archambault, H.J. Ariss, Margot Ariss, Ed Bartram, Aba Bayefsky, Tom Benner, Estate of Clare Bice, Estate of Andre Bieler, Rudolf Bikkers, David Blackwood, Bruno Bobak, Molly Bobak, Don Bonham, John Boyle, Bob Bozak, Claude Breeze, Estate of Bertram Brooker, Leonard Brooks, A.J. Casson, Estate of Jack Chambers, Alan Collier, Alex Colville, Charles Comfort, Ulysse Comtois, Greg Curnoe, Ken Danby, Paterson Ewen, Ivan Eyre, Murray Favro, Roly Fenwick, kerry ferris, Robert Fones, Yves Gaucher, Wyn Geleynse, Ted Goodden, John Gould, Richard Hamilton, Estate of Bess Harris, Estate of Lawren Harris, Jamelie Hassan, Robert Hedrick, David Hockney, Yvonne McKague Housser, E.J. Hughes, Estate of A.Y. Jackson, Jasper Johns, Nick Johnson, Brian Jones, Estate of James Kemp, Duncan de Kergommeaux, Estate of Bert Kloezeman, Dorothy Knowles, Ted Kramolc, Estate of William Kurelek, Suzy Lake, Gino Lorcini, Attila Richard Lukacs, Hugh MacKenzie, John Massey, Estate of Clark McDougall, William McElcheran, John McEwen, Isabel McLaughlin, Doug Mitchell, Leo Mol, Gilbert Moll, Kim Moodie, Louis Muhlstock, Kazuo Nakamura, Louis de Niverville, Paddy O'Brien, Leonhard Oesterle, Estate of Will Ogilvie, Estate of Alfred Pellan, William Perehudoff, Christopher Pratt, Mary Pratt, Walter Redinger, Jean-Paul Riopelle, Ray Robinson, Thelma Rosner, Jack Shadbolt, Gordon Smith, Jeremy Smith, John-Ivor Smith, Albert Templar, David Thauberger, Estate of F.H. Varley, Renee Van Halm, Bernice Vincent, Jeff Willmore, Estate of R. York Wilson, William Winter, Ed Zelenak.

There are a few copyright owners who have not been located after diligent inquiry. The publisher would be grateful for information enabling them to make suitable acknowledgement in future printings.

INTRODUCTION

A consequence of amalgamating London's art gallery and historical museums in 1989 is the assimilation of the collections of both institutions into one comprehensive collection of art, decorative arts and historical artifacts. The marriage occurred at a propitious time for the art collection because in 1990 it celebrates its fiftieth anniversary. The occasion merits review of its development and definition of its identity.

Although it has been housed in the city's art gallery for half a century, the art collection is nearly a century old. The first work of art entered the collection in 1896, and over the years, through acquisitions, gifts and bequests, it has grown to its present size of some two thousand seven hundred pieces.

London did not have a civic art gallery until 1940 when the Elsie Perrin Williams Building was officially opened as a public library and art museum. The small art collection, which was then exhibited chiefly in the City Hall and reading rooms of the old library building on the corner of Wellington Street and Queens Avenue, was moved along with the books to this new building.

Under the creative direction of Richard Crouch, London's Chief Librarian in 1940, the collection was placed on a firm foundation. Programmes, exhibitions and guidelines for acquisitions were established and the role of the art collection in the life of the city was defined. Crouch determined its scope and the periods in the history of art of this country that would be represented in it. Areas of specialized interest were built and strengthened largely due to his guidance.

Crouch's significant contribution to the growth of the permanent art collection derived from his conception of what constituted a work of art. He believed that a painting, a piece of sculpture, a drawing is foremost the expression of an idea, not an object so precious that it had to be protected and removed from the public. Throughout his life he worked to disseminate ideas to as many people as possible. As Director of the Library and Art Museum until 1961 he was custodian of the permanent collection, and through exhibitions and other activities associated with the art gallery, he made works of art accessible and understandable to the citizens of London for their pleasure and education.

Crouch was assisted by London's first Art Curator, Clare Bice, hired by the Library Board of Trustees in August, 1940 specifically to care for and exhibit the art collection.

Bice shared Crouch's belief that art should be enjoyed by all and during his thirty-three years as Curator, the permanent collection grew, galleries were enlarged, the number of exhibitions increased, and the involvement of all Londoners was encouraged. The foundation of the collection was laid by these men and their staffs; they established a representative survey of nineteenth and twentieth century Canadian art, including the history of art in London.

The most important patrons of the collection in its first half century have been Mr. and Mrs. J.H. Moore. Beginning in 1974, and over the successive sixteen years, the Moores gave some six hundred fifty works of art to the collection, strengthening almost every area established by Crouch and Bice. Their generosity also opened new avenues for collecting activity, particularly in the field of international prints and drawings. London's public art collection has a soundly based reputation as a repository of the definitive body of work by local artists who rose to national and international prominence in the 1960s and 1970s. The Moores added depth to the collection of twentieth century Canadian art.

The history of the permanent art collection reflects the ideas, energy and enthusiasm of these people. This book describes the art collection that Crouch and Bice inherited and the manner in which they and their successors—artists, curators and patrons—shaped it into its present form.

Tom Smart

CHAPTER ONE

THE EARLY YEARS: 1840-1896

This section generously sponsored by

LONDON LIFE

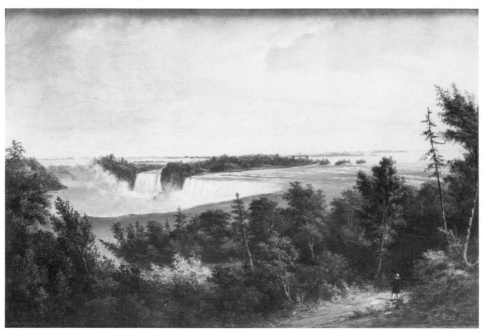

Cornelius Krieghoff, *Niagara Falls from the British Side,* 1856
Special Kreighoff Purchase Fund

Frederick T. Blackwood (Earl of Dufferin), *Lake Winnipeg Near the Mouth of the Saskatchewan River,* c.1877
Mrs. John Harley

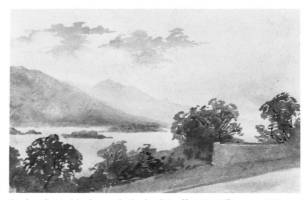

Frederick T. Blackwood (Earl of Dufferin), *Killarney,* c.1874
Mrs. John Harley

"London's earliest artists were associated with its garrison"

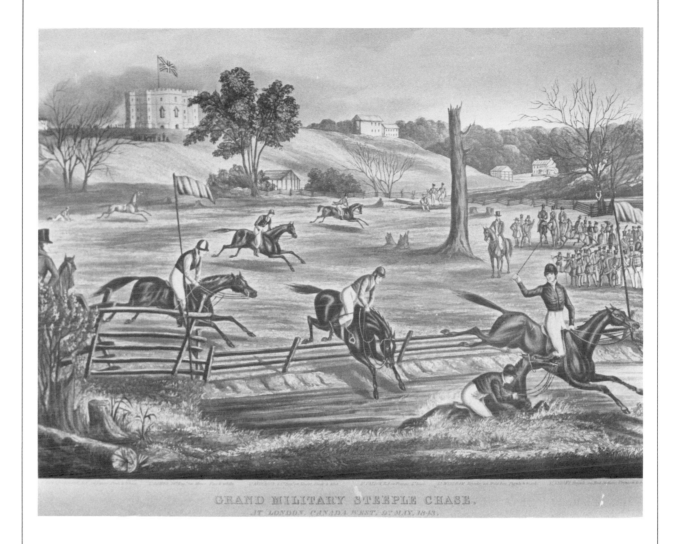

Lady Alexander, *Grand Military Steeple Chase at London, Canada West, 9th May, 1843*, 1846.
Hamilton King Meek Memorial Collection

The Early Years: 1840–1896

Although no permanent art gallery was built for the City of London until 1940, there had been, nevertheless, a century of artistic activity prior to its opening.[1] Local artists had exhibited in several temporary galleries in the city; art societies and art leagues had been established and dissolved; touring exhibitions from around the province and nation had arrived and left; and a beginning had been made in establishing a civic art collection.

London's earliest artists were associated with its garrison and were officers trained in topographical rendering and watercolour painting.[2] Young cadets in the British Army were required to develop an ability in drawing and painting landscape sketches

Peter Valentine Wood, *London, Canada West,* 1842.
Women's Canadian Club of London

because this training heightened an officer's capacity to assess objectively the terrain before him. Some officers, such as Colonel Sir Richard Airey, Captain John Herbert Caddy, Deputy Inspector-General George Russell Dartnell and Captain Edmund Gilling Hallewell, were quite proficient artists and spent leisure hours outdoors sketching London and its environs. One of the favourite views was the landscape around the forks of the Thames River and it was interpreted by many of London's first artists. The paintings of these men, if exhibited at all, were shown in private homes or commercial buildings; many were taken home with the officers when their postings to Canada West were completed. No public collections in the city were started at this time.

By the mid-nineteenth century a small number of galleries and museums were es-

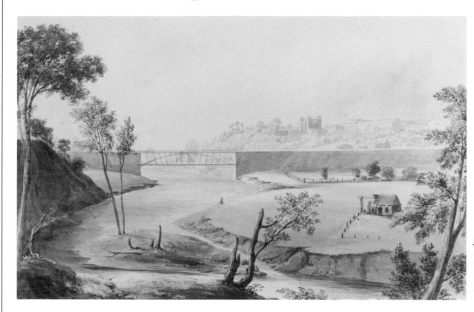

John Herbert Caddy,
*Sketch of Railway Bridge,
London, Canada West,* c.1853.
Mrs. E.G. Pullen &
Mrs. W.P. Fraser

William Armstrong,
Lakeshore Encampment, n.d.

tablished in London. Itinerant exhibitions and portrait artists passed through London giving the impression that art activity in the small town was of a temporary nature. The first recorded public art show was the Upper Canada Provincial Exhibition of 1854 held in the floral hall located at the fair grounds between Oxford and Grosvenor streets.[3] London's Crystal Palace, built in 1861, became the location of a larger version of this annual fair.[4] More participants and a greater level of artistic accomplishment characterized the art show from this point onward. An art gallery that could be used in the summer and autumn was built on the grounds of Queen's Park in East London in 1912.[5]

The exception to the trend of exhibitions of short duration was provided by the

James Hamilton, *The Courthouse and Mechanics' Institute From the Thames River Forks,* n.d.
Dr. Fred Landon

James Hamilton,
Forks of the Thames, c.1850.

James Hamilton, *Becher's Island,* 1883.

Mechanics' Institute, which first opened (temporarily) in London in 1835, before being permanently established in 1842, nearly one hundred and fifty years ago. The founding aims of the Institute and the place of art exhibitions in its programmes stimulated eventual acquisitions, gifts and bequests of works of art for the city's collection.

The activities of Mechanics' Institutes, first established in Glasgow in 1796 to educate the working class in the scientific principles of mechanical work, revolved around a public library.[6] The Institute also initiated classes, lectures, museum and art exhibitions, all intended to encourage the citizens to educate themselves and to use the library. In a rural town, the Institute quickly assumed a central position in the arts, education and entertainment of the local population.

George T. Berthon, *Portrait of Lionel Ridout,*
c.1857.
Misses Pennington

George T. Berthon, *Portrait of Louisa Jane Ridout,*
c.1858.
Misses Pennington

George T. Berthon, *Portrait of Louisa Lawrason
Ridout,* c.1857.
Misses Pennington

In 1871 the London Mechanics' Institute housed the newly-formed Western School of Art and Design, which conducted classes in drawing for adults and children, provided instruction in technical drawing and design, trained public school art teachers, and gave inexpensive art instruction to anyone in the community.[7] The increased awareness of art in London led several artists in this city, notably John R. Peel (father of Paul Peel), Charles Chapman, James and John H. Griffiths, to found the Western Art Union in 1876.[8] Two years later these men were instrumental in gathering together approximately four hundred paintings from local artists and private art collections, and successfully organizing at the Mechanics' Institute the first picture loan art exhibition held in London. The local collectors who submitted works of art from their walls included Colonel John

Ezekiel Sexton, *Self-Portrait with Wife and Daughter,* c.1852.
Mr. Ed McKone

Walker, William McMahon, Mrs. Talbot Macbeth, and John Elliot. Among the important Canadian artists whose work was shown were Allan Edson, Cornelius Krieghoff, Lucius O'Brien, William Nicoll Cresswell and Daniel Fowler. The hopes of the members of the Western Art Union to encourage art appreciation in London were satisfied with this exhibition. In addition to promoting art in London, the loan exhibition illustrated the extent of collecting activity in the community; if London did not yet have its own public collection, it had a number of notable private collections of contemporary Canadian art.

The vitality of the Mechanics' Institute in the city declined near the turn of the century, and with the death of John R. Peel in 1904, the Western Art Union dissolved.

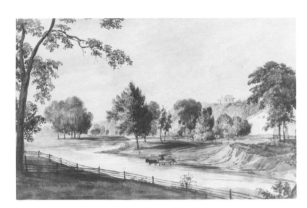

James Duncan, *View of London, Ontario,* 1849.
Mr. F.G. Ketcheson

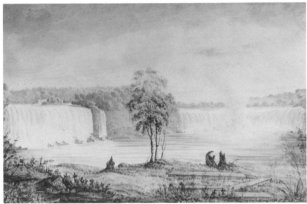

John Herbert Caddy, *The Horseshoe and American Falls from the Canadian Side,* n.d.
Somerville Bequest

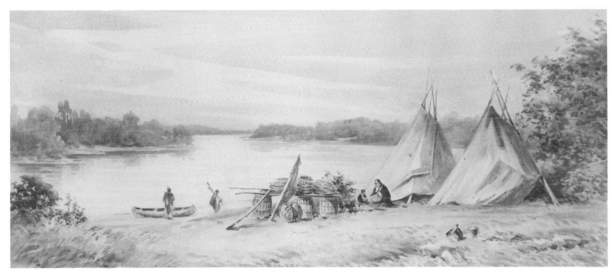

Frederick T. Blackwood (Earl of Dufferin), *The Saskatchewan River,* c.1877.
Mrs. John Harley

The Institute's book collection and its role as an art museum were assumed by the city's new public library, opened in 1895, while the activities of the Art Union were carried on by a younger generation of artists and citizens who organized the Western Art League. An upper storey room in the library was used as an art gallery. The second exhibition there, held in the spring of 1896, was of the work of Frederic Marlett Bell-Smith, a respected artist in the province and one of the first members of the Royal Canadian Academy.[9] In order to stimulate activity for what he hoped would be the establishment of a permanent art gallery and civic collection, Bell-Smith, a former Londoner, offered as a donation one of his paintings, the choice being left to the exhibition's visitors who were asked to cast votes for the canvas they most appreciated. The popular

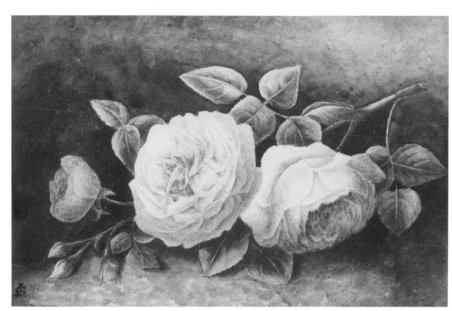

James Griffiths,
Pink Roses, n.d.
Estate of Misses Mary &
Margaret E. Scott

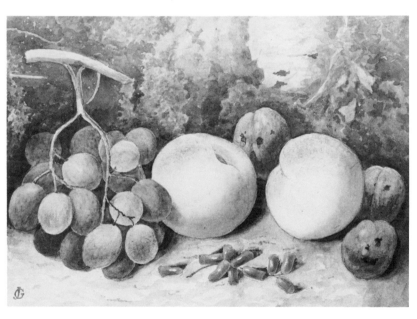

James Griffiths,
Peaches, Plums and Grapes, n.d.
Estate of Misses Mary &
Margaret E. Scott

choice was his seascape, *The Wave,* and as a consequence, this painting was the first work of art to enter London's permanent public art collection.

Robert Reginald Whale, *Portrait of Theresa McClary,* c.1870.
Estate of Miss Dorothy Gunn

Henry Nesbit McEvoy, *Springbank Park*, 1880.
Mrs. Jessie Minhinnick

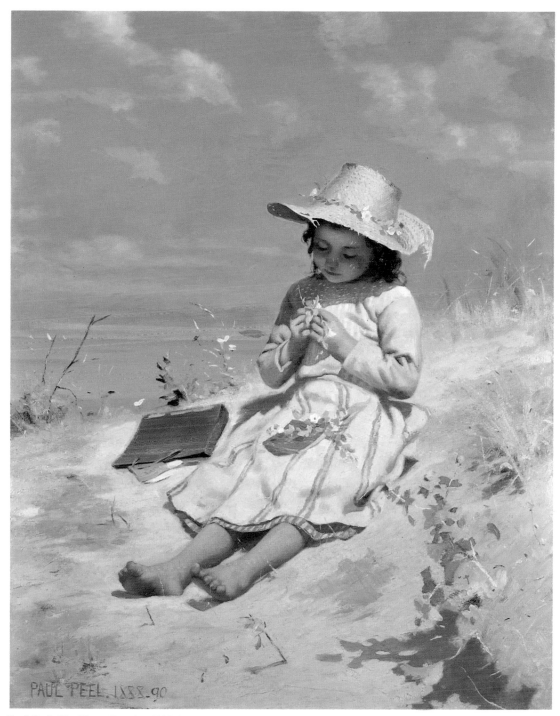

Paul Peel, *The Young Botanist*, 1888–90.
The Richard and Jean Ivey Fund

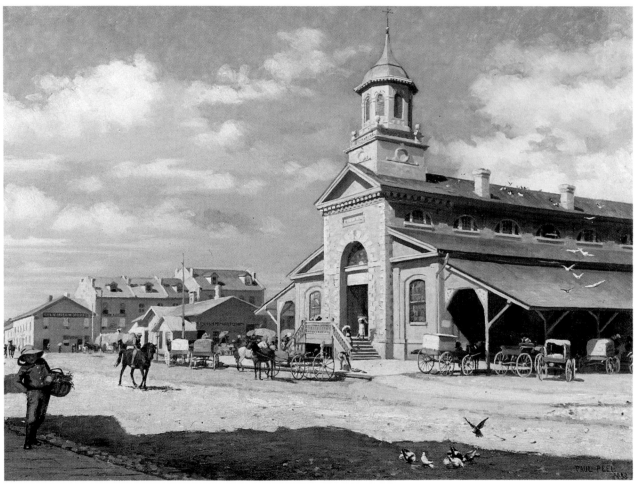

Paul Peel, *The Covent Garden Market, London, Ontario*, 1883.
Mrs. Marjorie Barlow

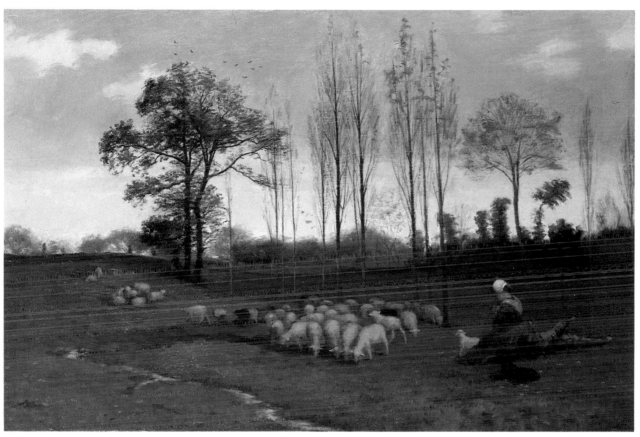

Paul Peel, *Return of the Flock*, 1883.
Mr. & Mrs. Richard M. Ivey

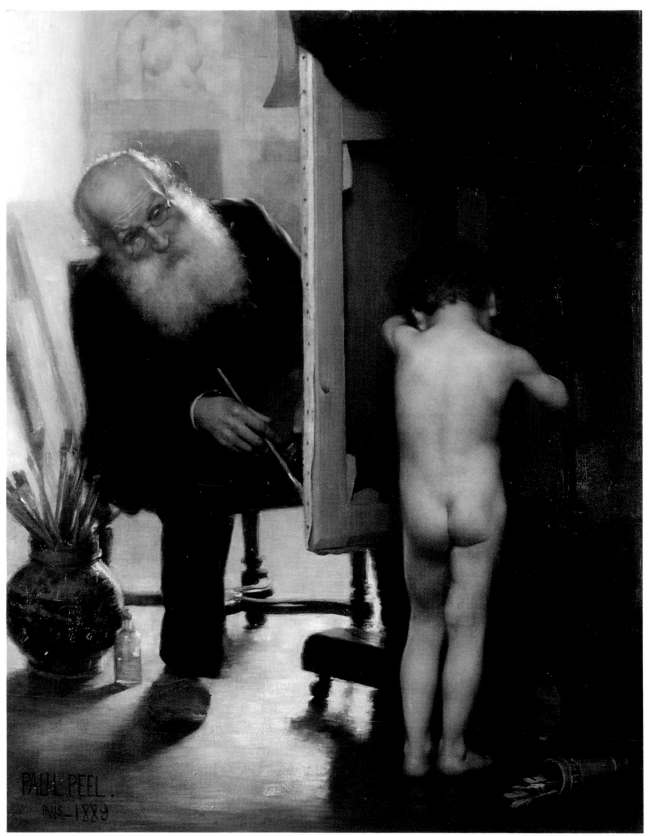

Paul Peel, *The Modest Model,* 1889.
A gift from the estate of Allan J. Wells with assistance from the Canadian Cultural Property Export Review Board

CHAPTER TWO

THE COLLECTION BEGINS: 1896–1940

This section generously sponsored by

JOHN LABATT LIMITED

THE BLACKBURN GROUP INC.

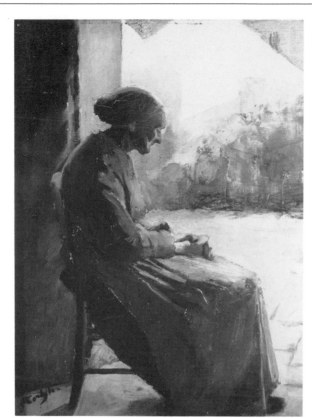

Florence Carlyle,
Old Woman in Doorway, n.d.

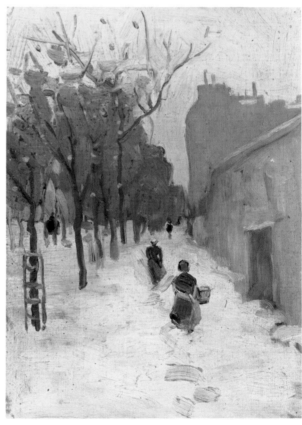

J.W. Morrice, *Winter Street Scene,* n.d.
Estate of Mr. David R. Morrice, Montreal

*"Impetus to build the permanent collection was provided by
artists of the community"*

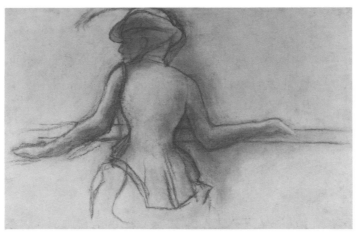

Edgar Degas, *Femme penchée sur une balustrade*, n.d.
Moore Gift (O.H.F.)

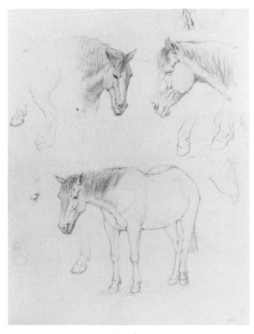

John Robert Peel, *Studies of a Horse*, 1857.
Miss Patricia Brooks-Hammond

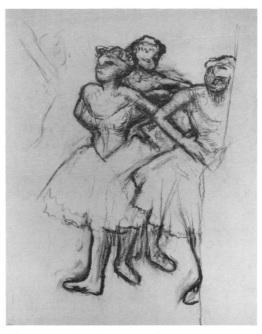

Edgar Degas, *Trois Danseuses*, n.d.
Moore Gift (O.H.F.)

The Collection Begins: 1896–1940

Impetus to build the permanent collection after Bell-Smith's gift was provided by artists of the community who, over the next forty years, responded in kind by donating examples of their work to the city. Other members of the community who were not artists contributed either by donating paintings from their private collections, or making provisions in their wills to have artwork pass from their collections to the permanent collection of a future civic art gallery. The number of paintings in London private collections led one prominent local journalist to conclude in 1923 that, "there are enough fine paintings in London now to make this city a mecca for art lovers and students, were they generally accessible to the public."[10]

William Lees Judson, *Near Hyde Park,* n.d.
Mrs. Audre E. Walker

William Lees Judson, *Snow Journey,* 1877.
Estate of Miss Dorothy Gunn

J.P. Hunt, *Portrait of an Old Man Reading,* n.d.
I.O.D.E. (Nicholas Wilson Chapter)

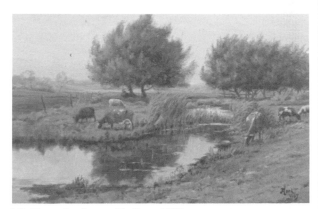

J.P. Hunt, *Landscape with Cows,* 1907.
Mrs. Pennington

A boost was given to the establishment of a permanent collection in 1926, with gifts of works of art by local artists. These included Edward Glen's *Étaples Market,* Albert Templar's *Old Buildings, London,* John Powell Hunt's *Portrait of an Old Man Reading,* Dr. Robert Le Touzel's *Chester Cathedral* and others by Fotherly Hargitt, Caroline Farncomb and Eva Bradshaw, one of the most popular of the city's artists at this time. That same year, the city celebrated its centennial with an exhibition of the work of London artists. Selections from this exhibition also entered the permanent collection.[11] The following year, Richard Bland, President of the Western Art League, donated money to the city for the purchase of Paul Peel paintings, which he hoped would strengthen the developing collection. Nine years later his widow gave Peel's painting *The Wreck*

Robert R. Whale, *Portrait of Catherine Gartshore*, 1870.
Estate of Mrs. A.M. Cleghorn

W.N. Cresswell, *Lake Huron Scene (a.k.a. On the Shore)*, n.d.
Hamilton King Meek Memorial Collection

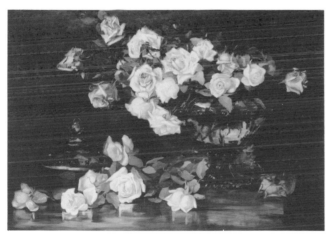

Mary Dignam, *Still Life with Roses*, c.1904.
Mr. & Mrs. B.R. Polgrain

Mary Dignam, *Primroses*, n.d.
Estate of Miss Dorothy Gunn

to the permanent collection in memory of her husband and his favourite artist.

A generous bequest of paintings from the estate of Mrs. Mary E. Meek was left to the city in 1928 on the condition that an art gallery be built to house them and all other works that had accumulated for the collection up to that time. Upon their acceptance by the city's art experts Louis Graves and W.H. Abbott, the paintings were put on display in a room on the third floor of the City Hall, where *The Wreck* had been placed, and they remained on view until 1950 when they were moved to the art gallery. The Hamilton Meek Memorial Collection today includes Paul Peel's painting of Meek's son who died tragically, Joseph Kirkpatrick's *The Clover Harvest*, two paintings by Robert Heard Whale, William Nicoll Cresswell's *On the Shore*, and Nathaniel John Baird's *Mother*

Paul Peel,
Courtyard, Brittany, 1885.

Paul Peel, *Portrait of Robert André Peel,* c.1892.
Miss Marguerite Peel

Paul Peel, *The Wreck,* 1884.
Mrs. Richard Bland

Paul Peel, *Autumn Leaves,* 1881.
Mr. J. Candler and the Volunteer Committee

and Child in Courtyard.[12]

The most significant development in the early history of London's permanent collection was the bequest in 1934 by Elsie Perrin Williams of proceeds from her estate for the construction of an art museum in the city. Although the terms of this bequest were modified by a special Act in the Legislature to include the construction of a library, a substantial capital fund was made available for the purpose of housing the permanent collection, which up to this time was on exhibition in two different locations: the City Hall and the public library building.[13]

The changes that were made to the Williams will were prompted by the fact that the public library was, by 1934, inadequate and structurally unsound for the expansion

Paul Peel, *Self Portrait in Studio*, 1890.
Miss Marguerite Peel

Paul Peel, *Hamilton King Meek*, 1890.
Hamilton King Meek Memorial Collection

Paul Peel,
*A Canadian Winter
Scene*, 1877.
Mrs. Hugh Thompson

of the book stacks; the floor would simply not bear the additional weight.[14] Richard Crouch feared that a tragic calamity was imminent unless a new building could be constructed for a library. But since he was faced with the depressed economic environment in the early 1930s, his expectations were tempered by financial constraints. With the sudden availability of funds destined for the construction of an art museum, the moment seemed right to establish a unique institution in which both art and books would play central roles. Crouch seized the opportunity to put into practice his vision of a public library and art museum as a centre of intellectual activity.

Crouch believed that it was his and the library's responsibility "to place the cultural resources of the nation as close to the doorstep of each individual as possible."[15]

William Cruikshank,
Portrait of an Unknown Man, n.d.
Mr. Max Swartz

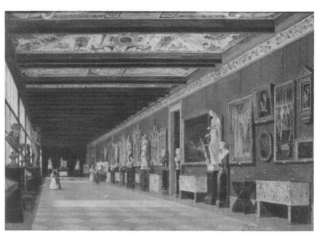

Antoinetta Brandeis, *Main Gallery of the Uffizi Palace,* n.d.
Dr. Sherwood Fox

S. Kelso Davidson, *The Coves,* 1898.
Mr. and Mrs. David Abbott

Henri de Toulouse-Lautrec,
Désiré Dihau, n.d.
Moore Gift (O.H.F.)

For him the library was an educational tool, a repository of the expressions of ideas. He wanted all media—books, films, records, and works of art—to be freely accessible to the public through circulation in the community and display in the public library and art museum. His aim was to demystify books and works of art, and to make art as readily available to households as were books.

His conception of a library, advanced for its time, broadened the definition of the institution. Rather than have a static, isolated municipal service, Crouch worked to integrate fully the library and art museum into the community. Under his direction the London Public Library and Art Museum, which opened in the Elsie Perrin Williams Building in October, 1940, gained international recognition by the mid-1940s for its

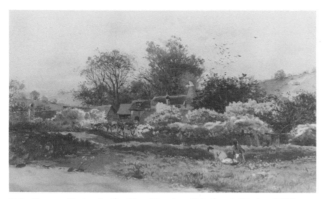

J.A. Fraser, *Spring in the Hop Country, Trigghurst, Kent*, c.1888.
Mitchell Bequest

Robert Heard Whale,
Old Mill, Paris, Ontario, 1893.
Hamilton King Meek Memorial Collection

N.J. Baird, *A Midsummer Dream (The Poppy Girl)*, 1895.
Mitchell Bequest

F.M. Bell-Smith, *Whitehead, Portland, Maine*, c.1886

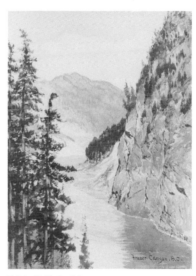

F.M. Bell-Smith,
Fraser Canyon, B.C. 1888.

dynamic mandate and programmes. Crouch kept a deliberately broad design to the functions of different departments within the building, including the art gallery, to allow the opportunity for their creative interaction. He wanted to foster intellectual development, emotional and aesthetic growth, and to contribute to an understanding of the city's cultural heritage. Crouch firmly believed that what he was doing was the key to "the good life."[16]

Crouch's vision of the future direction of London's library and its collections was not entirely new; he was essentially retrieving models from the past and developing them to meet the needs of contemporary society. In particular, he was emulating the programmes of the Mechanics' Institute. Crouch admired the variety of the Institute's

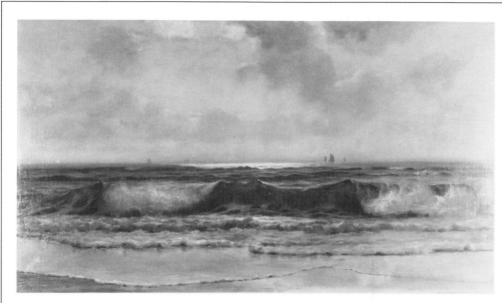

F.M. Bell-Smith,
The Wave, c.1896.
The Artist

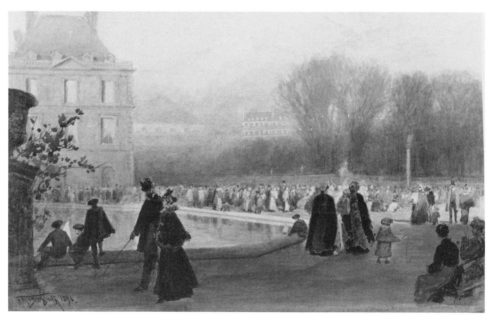

F.M. Bell-Smith,
*In The Luxembourg
Gardens, Paris,* 1896.
Estate of Mrs. A.M. Cleghorn

programming, its role as primarily an educational centre, its integration into all levels of London society. He understood that the foundation for the Institute's work had been an organized library. The transformation of the Institute into being solely a public library at the turn of the century was, for Crouch, restricting. As libraries were mainly engaged in evolving and perfecting the means and methods for the use and distribution of the book, so Crouch believed these activities should be adapted to an art collection.[17]

Crouch was not simply an idealist. His view of the function of the London Public Library and Art Museum was directed to the practical end of reconstructing Canadian society during and following World War II, and he viewed liberal education as the cornerstone. For him it was a moral responsibility to put all the collections under his direc-

Homer Watson, *The Lone Cattle Shed,* 1894.
Mr. & Mrs. Henry Jackman

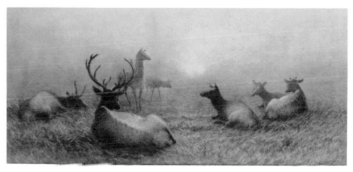

Frederick Arthur Verner,
Elk Resting, 1891.
Mr. Brian Ayer

W. St. Thomas Smith,
Misty Weather, n.d.
Mrs. E.S. Heighway

tion to the service of the community. The permanent collection of art was intended to be frequently exhibited in the gallery, and circulated to borrowers by having selected paintings from the collection placed in a lending library of art. Crouch initially defined the scope of the art collection as a selection of works by contemporary London and Canadian artists, examples of work of artists in London's past, and paintings by important artists in Canadian art history. The development of the collection through acquisition depended upon the availability of funding and the generosity of collectors.[18] This was the basis of the development of the permanent collection from 1940 to the early 1960s.

In the same manner that Crouch looked to the past and built his library and art

J.W. Morrice,
Portrait of Robert Henri, 1896.

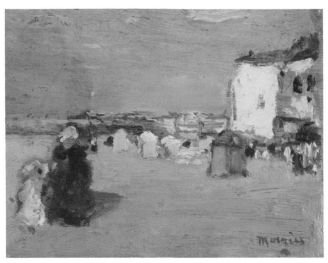

J.W. Morrice, *Sketch: St. Malo,* n.d.
Estate of Miss F.E. Morrice

Georges Chavignaud, *Landscape with Figures,* n.d.
Mitchell Bequest

James McNeil Whistler,
La rue Furstenburg, Paris, 1894.
Contemporary Art Society of Great Britain

gallery on the example of the Mechanics' Institute, he emulated an existing model when he conceived of the place of the art collection in his scheme. He looked primarily to the Canadian equivalent of the English Picture Hire Society, the Picture Loan Society in Toronto. Formed in 1936, the Toronto Society promoted the idea of a picture lending library that benefitted both the artist and the public.[19] The latter would be able to rent original works of contemporary Canadian art, and the former would have the security of an income through rentals and occasional sales. Shortly after its founding by artists and collectors, the Picture Loan Society was run by Douglas Duncan, an influential Toronto art collector and bookbinder.[20] His taste in art was catholic, his influence in the Canadian art world extensive, and his assistance of artists at the beginning of their

Horatio Walker, *Fishing Nets,* 1927.
Moore Gift (O.H.F.)

Horatio Walker, *Study of a Donkey,* n.d.
Mitchell Bequest

George A. Reid,
Rippled Water - Temagami, 1931.
Mrs. Mary Wrinch Reid

George A. Reid,
Portrait of Mary Heister Reid, c.1885.
Mrs. Mary Wrinch Reid

careers was most helpful. Duncan's involvement in the Society was more than that of an agent. He guided and shaped the tastes of collectors by educating them in contemporary artistic expression, and he provided valuable critiques to artists, pushing them to develop. Throughout his life, Duncan amassed a substantial and important art collection of his own, which, following his death in 1968, was dispersed to permanent collections of public art institutions in Canada, including the London Public Library and Art Museum.

Crouch was likely aware of the Picture Loan Society when he established a Lending Library of Canadian Art in June 1942. The similarity between the Picture Loan Society and his Lending Library lay in making available works of art for circulation

Walter Bothams,
Cows In Pasture, n.d.
Mitchell Bequest

J. Kirkpatrick,
The Clover Harvest, 1901.
Hamilton King Meek
Memorial Collection

at a nominal fee. But whereas Duncan's Society was a private operation ostensibly for the benefit of the artists, the promotion of their work, and the pleasure of the public, Crouch's differed in that his provided a foundation for a more rounded permanent collection of contemporary Canadian art for the City of London. The permanent collection was not just the centrepiece of the art museum, but shared the stage equally with all the departments of the library; it served a primarily didactic function. It was a fully integrated and active component of Crouch's design.

F.M. Bell-Smith, *Return from School,* 1884.
Mrs. Annie W. Cooper in loving memory of her husband, Albert Edward Cooper

Eva Bradshaw, *Plums,* c.1924.

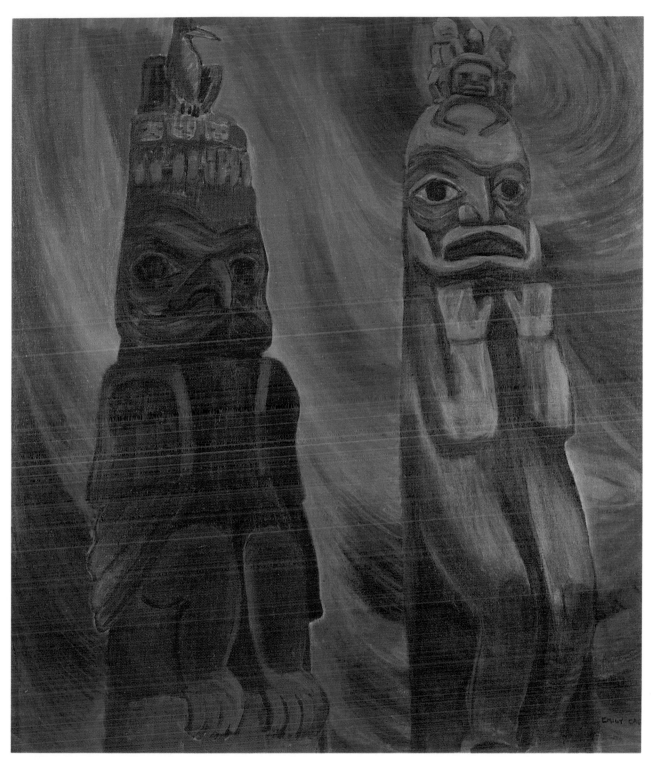

Emily Carr, *Kitwancool Poles,* n.d.
Anonymous Gift

Lawren Harris, *From the North Shore, Lake Superior,* 1923.
Gift of H.S. Southam

CHAPTER THREE

YEARS
OF
GROWTH:
The 1940s

This section generously sponsored by

KINGSMILL'S
ROYAL TRUST

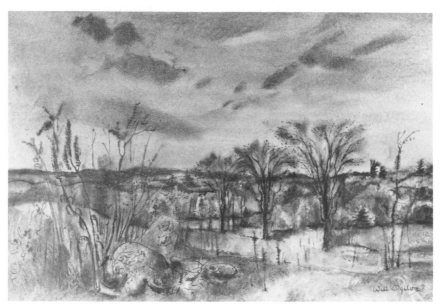

Will Ogilvie, *Autumn Landscape*, n.d.

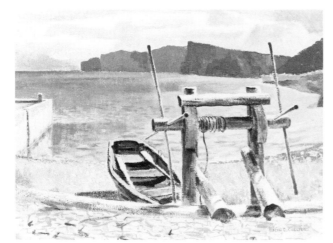

Alan C. Collier, *Capstan and the Forillon*, 1957
Mr. D.H. Gibson

Bess Harris, *Ottawa River*, n.d.
F.B. Housser Memorial Collection

*"Support for the new gallery by the community was also
expressed by gifts and bequests of works of art"*

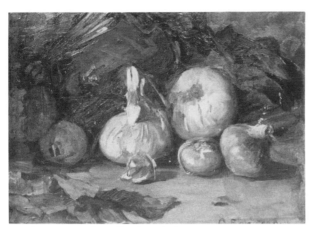

Caroline Farncomb, *Still Life With Onions*, n.d.
Mrs. Pennington

Sir Oswald Birley,
Portrait of Hon. Sir Adam Beck, 1909.
Anonymous Gift

Marc Aurèle de foy Suzor-Côté,
Landscape on a Summer's Day, n.d.
Mr. & Mrs. Hugh Pryce-Jones in
memory of Miss Lenore Crawford

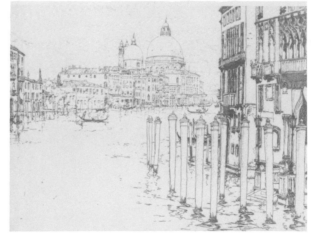

Clarence Gagnon, *Grand Canal, Venice*, 1906.

Years of Growth: The 1940s

Crouch was assisted in the day-to-day operation of the art museum by Clare Bice, a local artist who was appointed to the post of Curator in 1940. His responsibility, like that of the other department heads in the library, was to carry out programmes and policies under the direction of Crouch as established by the Public Library Board of Trustees. This involved the care, exhibition and safe storage of the art collection, and the supervision of ancillary programmes designed to educate Londoners about art. Lectures, demonstrations, art classes and printed hand-outs were all part of an ambitious mandate of the new art museum. These activities were augmented by those instituted by the Western Art League whose members assisted the gallery staff with exhibitions

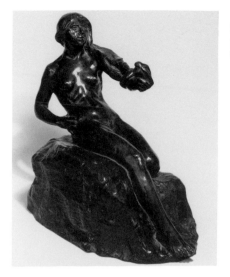

Frances Loring, *Lamia
(Woman with Snake)*
c.1910–1913.

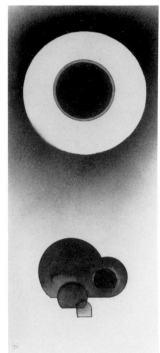

Wassily Kandinsky,
Bildung, 1931.
Moore Gift (O.H.F.)

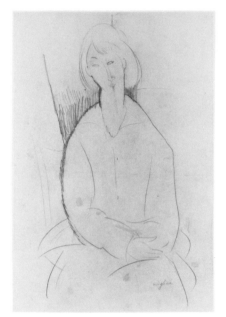

Amedeo Modigliani, *Femme assise,* c.1919.
Moore Gift (O.H.F.)

Wassily Kandinsky, *Birches*, 1909.
Dr. Robert A.D. Ford Collection

and art classes.[21]

Crouch and Bice wasted little time putting into practice their vision of the role of an art gallery as a centre of education. Crouch made arrangements with the London Board of Education to have senior elementary students visit the gallery during the mornings, while Bice prepared them for such visits by meeting classes and teachers in advance to discuss the exhibits. These classes were undertaken chiefly to increase the students' knowledge of art, but also to discover who among the teachers and students showed the greatest interest and ability in art, and who would benefit most from further special training and education.[22] Thus, special Children's Art Classes on Saturday mornings were instituted in February, 1941 under Bice's supervision. Students who

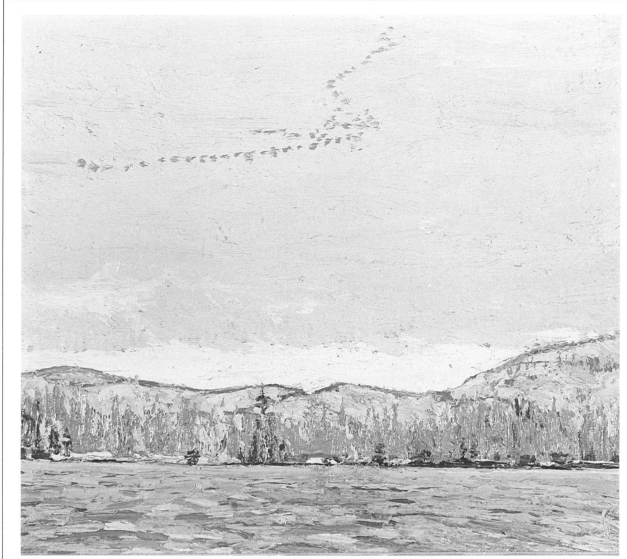

Tom Thomson, *Wild Geese,* 1917.
F.B. Housser Memorial Collection

showed an artistic aptitude and interest during their visits to the museum were recommended by their teachers and principals to participate in the classes.

Adult art education was given in the afternoon in the form of lectures or demonstrations on artistic techniques and processes. An example of the quality and variety of demonstrations may be gleaned from a typical sample from the schedule of April and May, 1942. A.J. Casson, a member of the Group of Seven, gave a demonstration of "the artist's thought and technique" involved in conceiving and executing an oil painting from outdoor sketches; the printmaker's art was discussed by Nicholas Hornyansky, a skilled etcher and engraver; and Frances Loring, a renowned Canadian sculptor, spoke about the methods and techniques of her art.

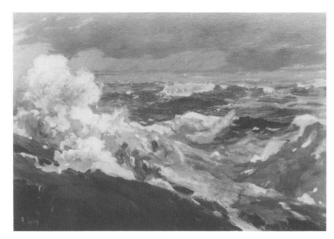

Robert F. Gagen, *Dirty Weather*, 1922.
Mitchell Bequest

J.W. Beatty, *Sketch*, n.d.
F.B. Housser Memorial Collection

Albert Templar, *Old Buildings, London*, 1926.
I.O.D.E. (Nicholas Wilson Chapter)

Frederick H. Brigden, *Still Waters*, c.1903.
Mrs. Irene Pashley

Support for the new gallery by the community was also expressed by gifts and bequests of works of art to the permanent collection. Shortly after it opened, the gallery received from H.S. Southam, an Ottawa publisher and Chairman of the Board of the National Gallery of Canada, Lawren Harris's canvas *From the North Shore, Lake Superior*. At this time, the Accessions Committee reported of the acceptance of a gift of a large collection of early American glass bequeathed by the late Millicent Giddens.[23] The Harriet Priddis Bequest, initially intended for the establishment of a separate museum, was received in 1942. These funds were transferred for use by the museum in purchasing "art museum articles", while the balance was held for future use.[24] The most important gift of art to the museum in its early years was presented by Toronto

Mary E. Wrinch, *Northern Bloodroot*, 1954.

Mary E. Wrinch, *Abitibi Canyon,* c.1930.
The Artist

Mary E. Wrinch, *Sawmill in Action*, 1926.
The Artist

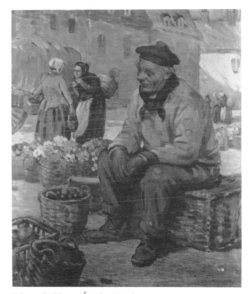

Edward Glen, *Étaples Market
(Corner of Ste. Jardin)*, 1925.
I.O.D.E. (Nicholas Wilson Chapter)

artist Yvonne McKague Housser in April, 1944. She notified the Trustees of the library and museum that she intended to place on extended loan to the museum a collection of work by important Canadian artists.[25] The collection was assembled by her late husband, F.B. Housser, a well-known art critic in Canada, and first chronicler of the activities of the Group of Seven.[26]

The F.B. Housser Memorial Collection consisted of some thirty sketches and finished canvases including examples by Tom Thomson, and Group of Seven members J.E.H. MacDonald, A.Y. Jackson, Lawren Harris, and Arthur Lismer. In making the gift to the museum, Housser felt "it would help to carry out her own and her husband's desire to make Canadian art better known and appreciated" by donating it to

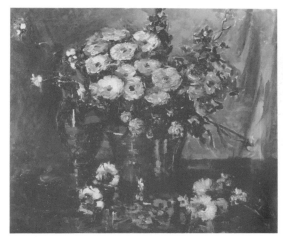

Eva Bradshaw, *Marigolds and Delphiniums,* n.d.
Estate of Jean Campbell Brady

Eva Bradshaw, *Still Life with Red Roses,* c.1930.
Mrs. Frederick Lewis, In Memory of Col. Frederick D. Lewis

Eva Bradshaw, *Still Life with Grapes and Bowl,* n.d.
Estate of Jean Campbell Brady

Eva Bradshaw, *Gladiolas,* n.d.
Western Art League

a new gallery without a permanent collection. Thus, the London gallery had at its disposal what Housser felt would be "a basic collection of the work of selected artists from our own country." The Collection was formally accepted in October, 1944 and was exhibited the following February.[27]

Another important bequest to the gallery was received in 1947 from the Estate of Alfred J. Mitchell. Mitchell, a local art collector, left thirty paintings from his collection to the gallery, among them Nathaniel John Baird's *The Poppy Girl*, John Arthur Fraser's *At the Silent Hour* and *Spring in the Hop Country, Trigghurst, Kent*. In addition, Mitchell bequeathed $25,000, of which $10,000 was to be used for the construction of a gallery to exhibit these paintings, while the balance of the money was to provide

Hortense Gordon, *Early Morning from the Island, Friendship, Maine*, n.d.
Estate of the Artist

Maurice Cullen, *Cache River*, 1928.
John Labatt Limited

Mary Healey, *The Budding Oak, Spring Time, Near London, Ontario*, c.1919.
Mr. W. Baldwin

André Bieler, *St. François, Ile D'Orléans*, 1928.
Estate of Mrs. Margaret Porteous

a fund to generate income for the acquisition of paintings. Mitchell intended that the exhibition of the paintings from his estate and those purchased from the Mitchell Bequest would be remembered as "a permanent memorial of the late W. Thomson Smith, London, who was instrumental in starting my private art collections in Western Ontario, as well as one by my late brother Dr. John P. Mitchell, many of whose pictures are included in my collection.[28] A further significant donation of paintings occurred in the mid-1940s when H.S. Southam gave Henri Masson's *Spring Flood* and Louis Muhlstock's *Haunted House* to the gallery.[29]

In addition to the acquisition of works of art for the permanent collection by way of gift and bequest, purchases of artworks were made through the Lending Library of

Albert Robinson, *Hillside Farm, Bolton Pass,* 1930.

A.Y. Jackson, *Winter, Barn With Red Doors,* 1930.
F.B. Housser Memorial Collection

A.Y. Jackson, *Winter Landscape with Sleigh,* c.1930.
F.B. Housser Memorial Collection

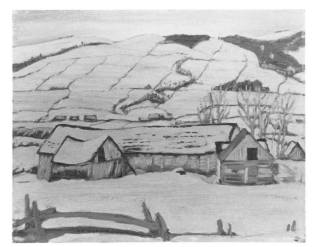

A.Y. Jackson, *St. Urbain, P.Q., April,* 1929.
F.B. Housser Memorial Collection

Canadian Art. Earliest records of the Lending Library show that its holdings were entirely work by contemporary Canadian artists, many of whom were members of the exhibiting societies of the day.[30] This service was most successful and a proud Richard Crouch boasted about his lending library of paintings in a report to his Board of Directors in 1946. He tells of one newcomer to London who was made aware of the Lending Library of Canadian Art when she entered her apartment for the first time. Crouch writes:

> The tenant who was leaving pointed to the picture over the fireplace, said that it belonged to the Public Library and explained our loan collection to her. She liked the picture so well that she came down to the library to have

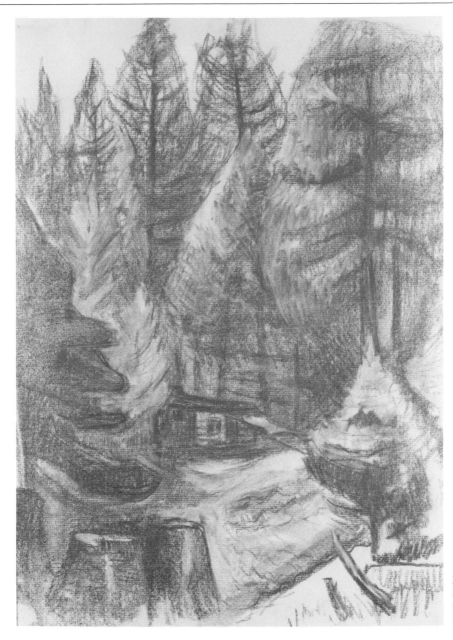

Emily Carr,
Forest Glade with Cabin, B.C.,
n.d.
Moore Gift (O.H.F.)

it transferred from the former tenant's name to hers, and now she is quite an enthusiastic borrower.[31]

Crouch also writes of the Lending Library being used by a suburban school principal who used his parent-teacher meetings as opportunities to utilize material from the Lending Library, and by other teachers who selected pictures "for their value in introducing children to Canadian painters, or adding a colourful visual interest to the lessons."

The exhibition schedule was first established at the London Public Library and Art Museum to display the permanent collection and to increase understanding of it through temporary exhibitions. These were either organized by Bice and the gallery staff, the

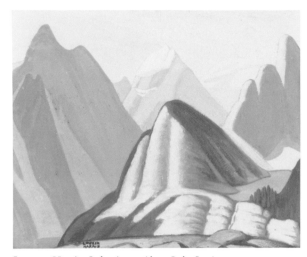

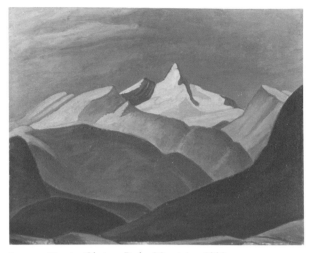

Lawren Harris, *Lake Agnes Above Lake Louise, Rocky Mountains,* 1955.
Moore Gift (O.H.F.)

Lawren Harris, *Glaciers, Rocky Mountains,* 1930.
F.B. Housser Memorial Collection

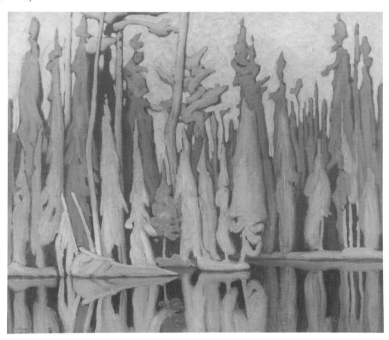

Lawren Harris,
Northern Autumn,
1922.

Western Art League, or originated in other cities and travelled to London on a touring circuit. In the 1940s and 1950s, the annual travelling exhibitions from the Society of Canadian Painter-Etchers and Engravers, Ontario Society of Artists, Royal Canadian Academy, Canadian Society of Painters in Watercolours, and the Sculptors Society of Canada, formed the nucleus of exhibitions received from other centres. They provided viewers in London with a varied perspective of media, approaches, styles and interpretations of subject matter. The exhibitions primarily reflected a wish to educate, using the collection as a point of departure. The Western Art League brought to the gallery, at its own expense, national, provincial and local exhibitions, namely the Royal Canadian Academy and the Ontario Society of Artists shows. They also prepared a local

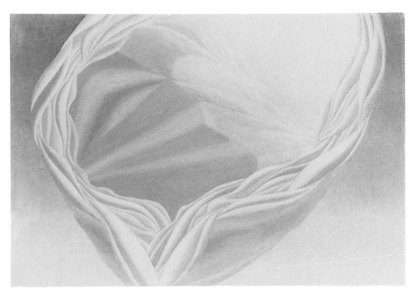

Bertram Brooker,
Abstraction - Music,
1927.
F.B. Housser
Memorial Collection

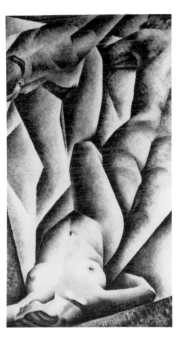

Bertram Brooker,
Three Figures,
1944.

Lawren Harris,
Abstract #576,
c.1938-1940.
Mrs. Margaret Knox

exhibition of London artists, known as *The Western Ontario Exhibition.* If annual funds permitted, the League organized one other exhibition, and prepared interpretive material concerning all shows by giving lectures, demonstrations and art classes of their own.

In the midst of all the excitement attendant upon the opening of the new building and putting exhibitions and educational programmes in place, very little money was spent on acquisitions for the permanent collection; any purchases of art were made through the Lending Library of Canadian Art. Developing the collection depended upon either the generosity of private collectors, such as H.S. Southam and Yvonne McKague Housser, or the transfer of works from other locations where civically owned paintings were displayed. Two instances of the latter occurred in 1941 when Paul Peel's *The*

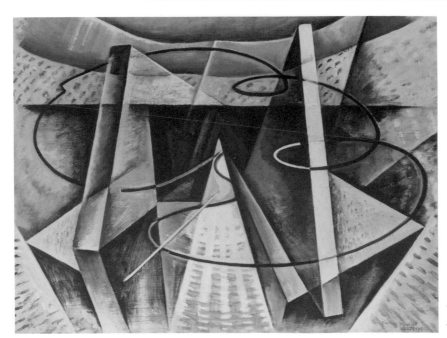

Yvonne McKague Housser,
Abstraction #1, 1949.

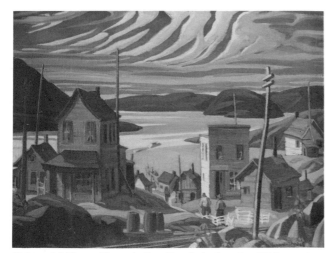

Yvonne McKague Housser, *Ross Port, Lake Superior*, 1938.
F.B. Housser Memorial Collection

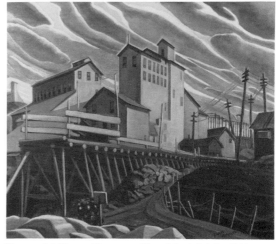

Yvonne McKague Housser, *Silver Mine, Cobalt*, 1930.
F.B. Housser Memorial Collection

Wreck, given to the city by the Bland Estate, and F.M. Bell-Smith's *The Return from School* entered the permanent collection from City Hall.[32]

A further illustration of the manner in which paintings found their way into the permanent collection is provided in the method of acquisition of Lawren Harris's *Northern Autumn.* Crouch initially asked Harris if he would agree to sell the painting, which had been on loan to the gallery. Believing that the painting was representative of the artist's "middle period" and because it had been very useful for instructional purposes in the art classes, Crouch considered it to be an important cornerstone of the collection. He felt its purchase was both logical and desirable.

Harris, however, had other ideas. In response to Crouch's request, the artist said

Manly MacDonald,
Winter Road, 1942.

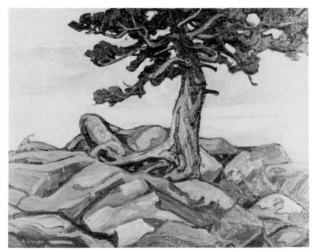

Arthur Lismer, *Pine Tree and Rocks,* 1921.
F.B. Housser Memorial Collection

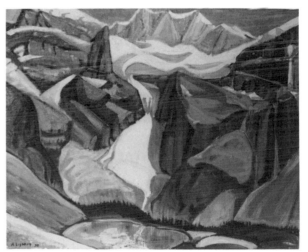

Arthur Lismer, *The Glacier,* 1930.

that he would present the painting to the gallery, that he would set a valuation of $300 on it, that the gallery would not be obligated to pay him, but instead would send him a receipt for the valuation, and use that sum "for the purchase of one or more paintings by Canadian painters."[33]

The programmes, exhibitions, place of the permanent collection in the operation of the gallery, and methods of acquisition in the years immediately following the opening of the Elsie Perrin Williams Building remained the same through the decade and into the 1950s. A strong exhibition policy, an innovative conception of a permanent collection as part of a lending library, and generous bequests and gifts of paintings, defined the London Public Library and Art Museum as a dynamic institution under

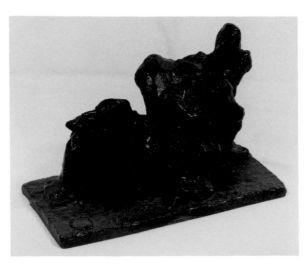

Jacques Lipchitz,
The Embrace, 1933.
Moore Gift (O.H.F.)

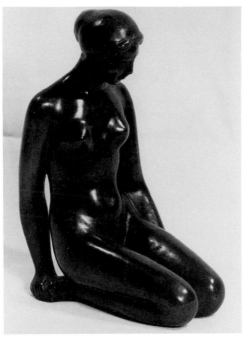

Aristide Maillol, *Femme agenouillée*, n.d.
Moore Gift (O.H.F.)

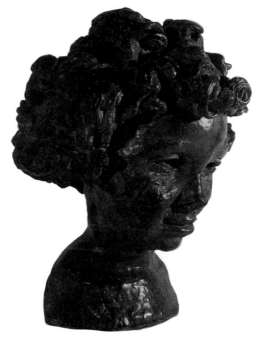

Sir Jacob Epstein, *Joan Greenwood*, c.1930.

creative direction. Accumulating a permanent collection was only one activity of the gallery whose aims were to exhibit, educate and disseminate ideas. Reflecting on the role of the art gallery during the 1940s, Bice offered this assessment of the place the gallery had assumed in the lives of Londoners by 1949:

> During the past ten years there has been a great increase in the number of people actively engaged in painting and handicrafts. It would be reasonable to suggest that there are ten times as many as there were before the war. It is difficult to define the reason for this increase, but it may largely be due to the returning desire of individuals to do and to participate, rather than to continue the passive acceptance by radio, movies and other social factors

Scottie Wilson, *Untitled,* 1942-3.
Douglas M. Duncan Collection

J. Robert Le Touzel,
Chester Cathedral from the South Transept, n.d.
I.O.D.E. (Nicholas Wilson Chapter)

developed in the 1920s and 1930s. Today, great numbers of people...are finding a positive and absorbing means of expression in painting and various forms of art and handicrafts.[34]

Wassily Kandinsky, *Horsemen,* 1909
Dr. Robert A.D. Ford Collection

Wassily Kandinsky, *Women in the Woods,* 1909
Dr. Robert A.D. Ford Collection

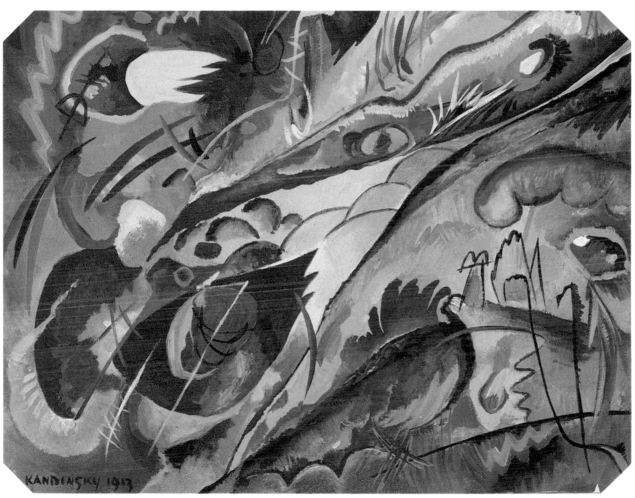

Wassily Kandinsky, *Untitled*, 1913.
Dr. Robert A.D. Ford Collection

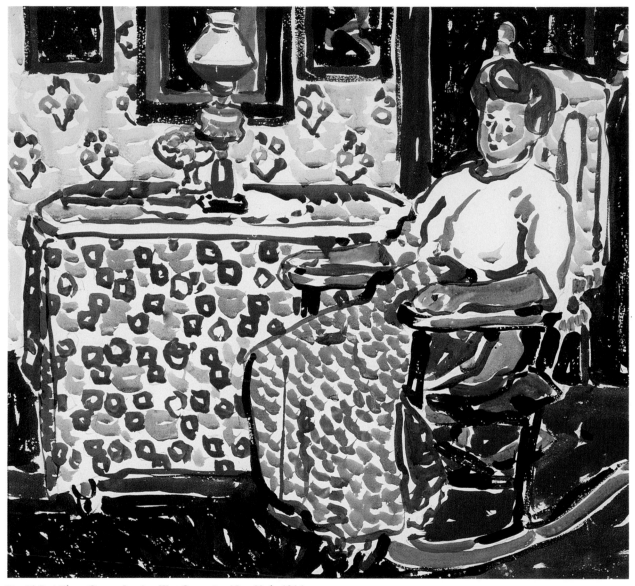

David B. Milne, *Cottage Interior, West Sangerties, New York*, 1914.
Moore Gift (O.H.F.)

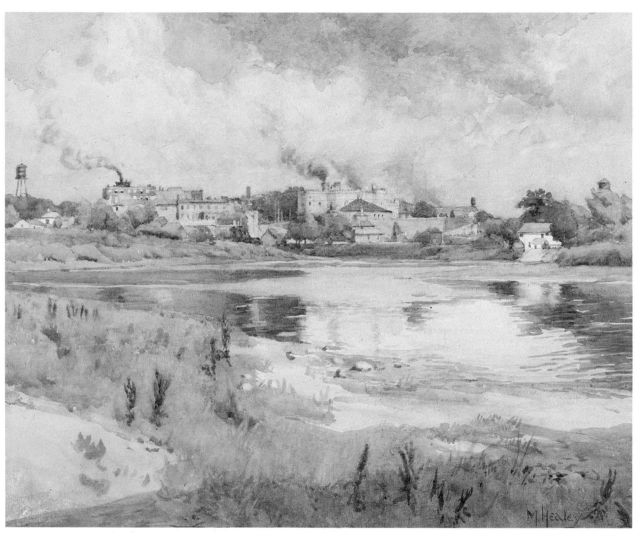

Mary Healey, *Forks of the Thames,* c.1920.
Mrs. E. Albright

J.E.H. MacDonald, *The Little Fall,* 1919.
F.B. Housser Memorial Collection

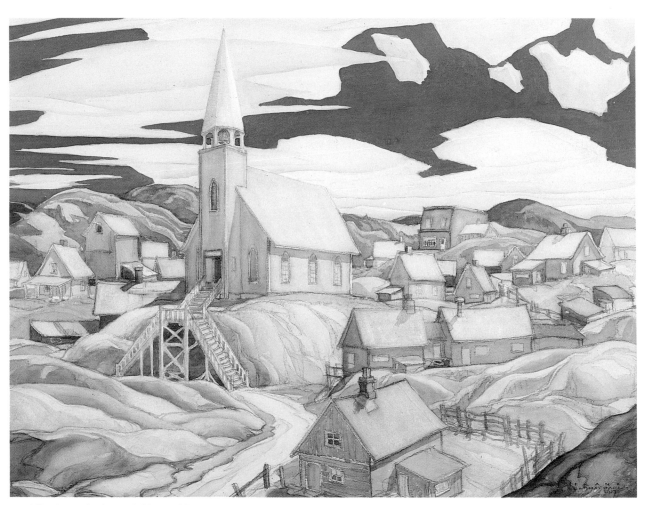

Franklin Carmichael, *North Town,* 1927.
F.B. Housser Memorial Collection

CHAPTER FOUR

BUILDING
THE
COLLECTION:
The 1950s

This section generously sponsored by

BIRKS JEWELLERS 🦌

Herb Ariss, *Ruins of Musical Art Building,* (1952–55)
Estate of Miss Alberta Tory

Bruno Bobak, *Vancouver Looking South,* 1959

"The first Purchase Fund was begun in 1950"

S. Mary Bouchard, *Portrait of the Son of Louise Gadbois*, c.1943.
Mr. Richard Alway

David Milne, *Icebox and Kitchen Shelves*, 1919.
Bequest of Mrs. Frances Barwick

David Milne, *Maple Blooms on Hiram's Farm, Palgrave*, 1933.
Douglas M. Duncan Collection

Building the Collection in the 1950s

The directions that were established for the gallery and collection in its first decade were continued in the 1950s. These were augmented by the addition of one important programme aimed specifically at developing the permanent collection. This was the Purchase Fund where donations from private individuals and companies were directed solely toward acquiring works of art. The first Purchase Fund was begun in 1950 with contributions intended for "the acquisition of an outstanding Canadian work of art or the purchase of additional sketches for a collection of Canadian sketches."[35] Bice indicated in May, 1951 that the Purchase Fund allowed him "to keep an eye out for good examples of such paintings as [those by] A.Y. Jackson, Emily Carr, F.H. Varley and

David Milne,
Hillside with Melting Snow,
Mt. Riga, N.Y., 1923.

David Milne,
Signs and Symbols, Uxbridge, 1943.
Moore Gift (O.H.F.)

others."[36] However, the first purchase was the painting *Grandeur Nigh Unto Dusk* by the contemporary Canadian artist L.A.C. Panton.[37]

The Fund continued in 1952 with donations nearly doubling. This prompted the establishment of an "art purchase committee", comprised of Dr. Fred Landon, the University Librarian, Mr. L.G. Bridgman, and Mackie Cryderman, an art teacher at H.B. Beal Technical School. They were responsible for administering the disbursements from the fund. The first purchases recommended by this committee were J.E.H. Mac-Donald's *Tamaracks, Algoma* (sketch), J.S. Hallam's *Autumn Woodland* and Marthe Rakine's *Midsummer.* It was even suggested that, in order to make purchases reflect popular opinion, a vote of guests at an opening night might be conducted as a basis for making

L.L. FitzGerald,
Nude - Interior, n.d.
Moore Gift (O.H.F.)

L.L. FitzGerald,
Glass Jar,
1943.

L.L. FitzGerald,
Watering Can,
1939.
Douglas M. Duncan
Collection

a selection for purchase. This idea was dismissed by Bice because he did not feel that the gallery should rely "on the results of a popularity poll for the purchase of paintings from a particular exhibition."[38]

A committee was also struck to select three paintings by Bice, an accomplished artist in his own right, for the permanent collection. The paintings chosen were *Fishermen's Houses, Schooner,* and *Two Fishing Boats,* all three completed at Peggy's Cove, Nova Scotia, a popular sketching locale for Bice.[39]

In 1953, Crouch was authorized by the Directors of the Library Board to subscribe to an annual membership in the Contemporary Art Society of Great Britain. This Society acted, without charge, as the gallery's agent for the purchase of British paint-

L.L. FitzGerald, *Abstract,* n.d.
Douglas M. Duncan Collection

L.L. FitzGerald, *Ponemah,* c.1920.
Douglas M. Duncan Collection

L.L. FitzGerald, *Old Maple in Front Yard,* 1948.
Moore Gift (O.H.F.)

ings, and would occasionally present paintings purchased from its own funds.[40] As a result of membership in the Society, the scope of the gallery's permanent collection was broadened to include European works by modern English painters. The first paintings from the Contemporary Art Society entered the collection in 1955—the Society had chosen four drawings by Henri Gaudier-Brzeska from the private collection of Sir Edward Marsh. Later that year Walter Sickert's *The New Bedford* was added to the gallery's holdings.

In order to provide continuity to the development of the permanent collection steps were first taken in 1954 to define a broad statement of purpose. That March, the Art Purchase Committee was asked to consider drafting a general policy for the purchase

Franz Johnston, *Gibraltar, Eldorado, Great Bear Lake, N.W.T.,* 1939.
Mitchell Bequest

Leonard Brooks, *Northern River,* 1942.

Leonard Brooks, *Bic, Quebec,* 1940.

"of outstanding representative paintings of leading Canadian artists."[41] The result of a year of discussion was the consensus among committee members that the gallery's first priority was "to secure one or more significant works or the outstanding sketches, when available, of past artists and artists of the contemporary group."[42] Committee members "agreed to watch for works" by J.S. Hallan, Arthur Lismer, J.W. Morrice, Clarence Gagnon, Horatio Walker, A.Y. Jackson, Fred Varley, Tom Thomson, Cornelius Krieghoff, David Milne and Homer Watson." It is not unusual for the committee to want to establish a policy such as this one. The permanent collection was strong in the areas of contemporary Canadian art, and works by London and area artists; a new avenue for growth was suggested by the recent membership in the Contemporary Art Society;

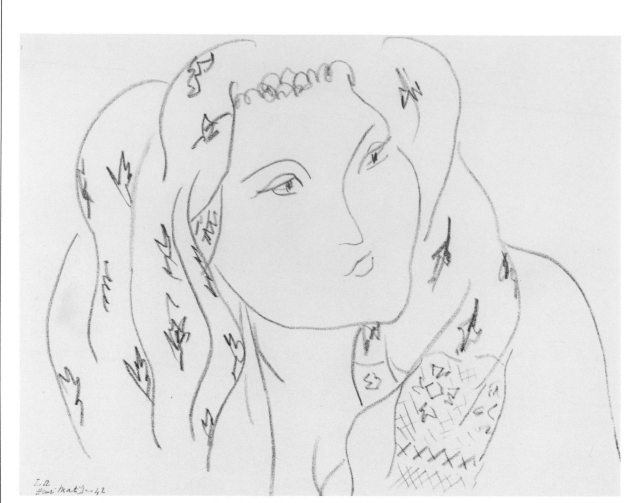

Henri Matisse, *Head of Odalisque,* 1942.
Moore Gift (O.H.F.)

and acquisition funds were increasing. The foundation of the collection had been laid, and it was recognized that personnel on succeeding committees would need guidelines to direct future collecting.

The Lending Library of Canadian Art collection was also re-evaluated at this time. In January, 1956, as a result of the inauguration of Picture Loan Societies in Hamilton and Vancouver, thus depleting the pool of paintings available for inclusion in all collections, Bice felt it advisable to reassess the gallery's rental schedule and his staff's involvement in managing this service. The Women's Committee assumed responsibility for the loan of pictures in January, 1956, freeing permanent staff at the gallery from taking care of all the administrative details it entailed. Moreover, all rental fees earned

Stanley Spencer, *Leah and Rachel*, n.d.
Moore Gift (O.H.F.)

Augustus John,
Cartoon for a Family Group, c.1935.
Contemporary Art Society of Great Britain

on thc paintings were turned over to the artists in order to improve relations with them by offering a further incentive to them to deposit their work with the Lending Library of Canadian Art.[43]

Through 1956, purchases for the collection included Tom Thomson's *Untitled Sketch* (1917),[44] Arthur Lismer's *The Glacier* and A.Y. Jackson's *Road to Charlevoix* along with examples by Eva Bradshaw and Fred Brigden, while gifts received were paintings by Marjorie Spenceley, Harry Britton and Duncan Grant. With funds from the Mitchell Bequest there was a major acquisition of a collection of graphite drawings by Horatio Walker. The availability of funds also made it possible for Bice to purchase important examples of the work of David Milne and Lionel LeMoine FitzGerald from Douglas

Jack Humphrey, *Portrait*, 1931.
Volunteer Committee

A.J. Casson, *Northern Autumn*, c.1940.
The Artist

Marjorie Spenceley, *Breaking Surf, Atlantic Ocean*, n.d.
Mrs. Chester Rowntree

Marion Long, *Canadian Soldier*, 1940.
The Artist

Duncan[45].

By the end of 1958, Crouch and Bice believed it was time for a thorough evaluation and exhibition of the permanent collection. Thus, a show of selections from the collection was mounted in all the gallery's exhibition areas in September and October, 1958. The exhibition of the permanent collection enabled Bice to study the collection in its entirety and to evaluate its strengths and weaknesses. In his Curator's report of the show, Bice outlined the scope of the collection and its thematic—what he referred to as its "coverage"—as disclosing a well-balanced selection of the following:

1) Early London Historical Paintings
2) London Artists, 1900-1935 (Eva Bradshaw, Mary Healey, Albert Templar)

Jack Humphrey, *Market at Taxco,* 1958.
Douglas M. Duncan Collection

Henri Masson, *Spring Flood,* 1937.
Mr. H.S. Southam

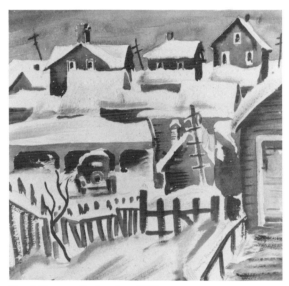

Henri Masson, *Backyards,* c.1945.

3) Canadian Artists, 1885–1910 (G.A. Reid, Horatio Walker, Robert Gagen, F.M. Bell-Smith)
4) Group of Seven (period 1913–1944) (J.E.H. MacDonald, A.Y. Jackson, Tom Thomson, Lawren Harris, Arthur Lismer, A.H. Robinson)
5) Canadian Painters, 1930–1945 (Lionel LeMoine FitzGerald, David Milne, Emily Carr)
6) Important Contemporaries (Jack Shadbolt, Gordon Smith, A.J. Casson)
7) Sketches (Tom Thomson, J.E.H. MacDonald, A.Y. Jackson)
8) Canadian Prints (woodcuts, etchings, lithographs)
9) Eskimo Sculpture, and a few pieces of Canadian sculpture

Louis Muhlstock, *Haunted House,* 1938.
Mr. H.S. Southam

L.A.C. Panton,
*Grandeur Nigh
Unto Dusk,* 1948.

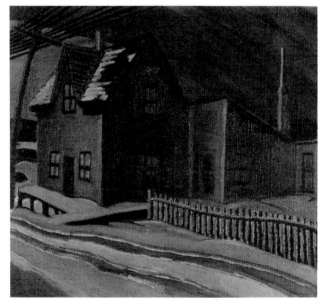

Isabel McLaughlin, *House in the Moonlight,* n.d.
F.B. Housser Memorial Collection

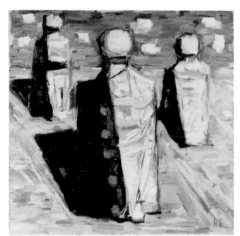

Kenneth Lochhead, *Prairie Reception,* 1953.
Moore Gift (O.H.F.)

Bice concluded his assessment by pointing out that gaps in the collection still needed to be filled, but that this first comprehensive exhibition of the collection was, "surprising and reassuring."[46] The effect of this exhibition stimulated the further growth of the collection, both through gift and benefaction; in December, 1958, two months after the close of the exhibition, an anonymous donor generously provided a substantial sum of money toward the purchase of Emily Carr's painting *Kitwancool Poles*—a gift without which the gallery would have been unable to purchase this painting.

The Women's Committee and Junior Women's Committee, (now called the Volunteer Committee) also took on active roles in raising funds for the acquisition of art. For example, in May, 1958 the Women's Committee presented $1,000 for the pur-

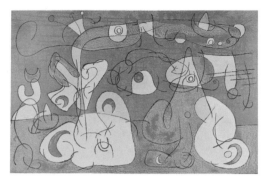

Joan Miró,
Bougrelas et sa mère, 1953.
Volunteer Committee

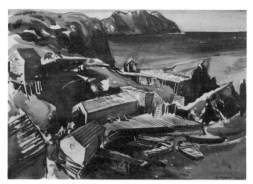

George Pepper,
*Newfoundland
Outport,* 1952.

Ted Kramolc,
Interior, 1954.
Douglas M. Duncan
Collection

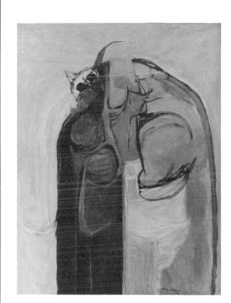

Oscar Cahen,
Animal Structure, 1953.

Herbert Palmer,
Haliburton Hills, n.d.

chase of a painting to be labelled as a gift from the Women's Committee. In the succeeding years, the contributions by these committees to the gallery's acquisitions fund were most beneficial, particularly in developing an important collection of Canadian and international prints and drawings.

The idea of a Graphics Collection was conceived in 1970 by a few members of the Women's Committee. Their aim was to collect works of pivotal contemporary artists who were doing important creative work in original prints — i.e. etchings, lithographs, woodcuts, engravings and mezzotints. They wanted, in particular, to increase the Gallery's holdings in international art. However, paintings and sculpture were beyond their financial reach. They opted, instead, for prints, an area Committee members

Jean-Paul Riopelle, *Bacchus et Neptune*, 1956.
Moore Gift (O.H.F.)

Christiane Pflug, *Church at Blaccourt*, 1955.
Dr. Michael Pflug

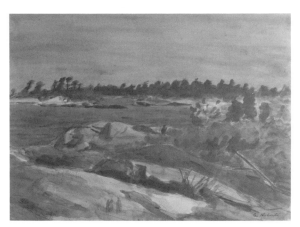

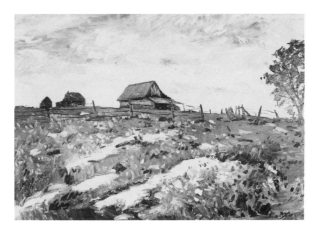

Goodridge Roberts, *Islands, Georgian Bay*, c.1948.
Anonymous Gift

Goodridge Roberts, *Laurentian Farm #35*, 1958.

felt had been neglected in the permanent collection. In a letter written to Elaine Hagarty, Chairman of the Art Gallery Advisory Committee (May, 1970) Marion Richmond, President of the Women's Committee, described the volunteers' intention of developing a collection of prints and graphics, "a section of the Permanent Collection that has been neglected in the past, as funds available have been largely used to purchase paintings and sculpture." Prof. Archie Young, an advisor to the Women's Committee's Graphics Acquisition and Exhibition Committee, told Mrs. Richmond in a letter dated April 27, 1970, "Graphics represent one of the few media where it is possible for a gallery like ours to collect a substantial body of work by international artists."

Tied in with this Collection was a biennial exhibition and sale of prints which served

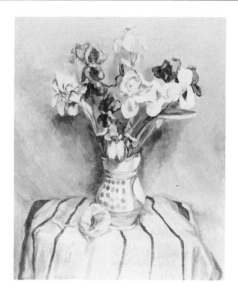

Duncan Grant,
Still Life with Irises and Red Poppy, 1954.
Contemporary Art Society of Great Britain

Paul-Émile Borduas,
Au Gré des crêtes, 1957.
Moore Gift (O.H.F.)

Paul-Émile Borduas, *Untitled*, 1959.
Moore Gift (O.H.F.)

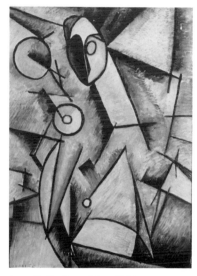

Anatoli Vasiliev, *Mon*, 1956.
Dr. Robert A.D. Ford Collection

a dual purpose of educating the community about prints and graphics as well as raising money for acquisitions. Apart from purchasing graphics, the Women's Committee also continued to make its annual contribution to the Purchase Fund.

The first work purchased by the Women's Committee was *White Line Square XVI*, a serigraph on paper by American artist Josef Albers. Committee members themselves visited galleries throughout Canada and the United States making selections. Thus such works as Marc Chagall's lithograph, *Le Bouquet de peinture*, David Hockney's lithograph, *Flowers Made of Paper and Black Ink*, Jasper John's etching *Land's End*, Joan Miró's lithograph *Bougrelas et sa mère*, Henry Moore's etching *Sheep Plate VIII*, and Andy Warhol's serigraphs, *Flowers No. 8* and *Flowers*, entered the permanent collection.

Jacques de Tonnancour, *Treetops,* 1959.
Mitchell Bequest

Gordon Smith, *Water Lilies,* 1957.
Mitchell Bequest

Robert Hedrick, *Morning Green,* 1959.

The International Graphics Collection was presented to the London Regional Art Gallery Board of Directors in 1978. The Collection now totals some 30 pieces and in 1989 was exhibited at Rodman Hall in St. Catharines. Paddy O'Brien, Chief Curator Emeritus, describes this important contribution as a "truly fine little collection."

After the Gallery moved to its new location at the Forks of the Thames, the Volunteer Committee changed its focus in acquiring works. With money raised through its Art Rental Service and Gallery Shop, the Volunteer Committee returned to the method of making cash donations to the Gallery for additions to the permanent collection. In a system described as unique to this Gallery, no money donated for acquisitions by the Volunteer Committee can be spent unless both the Volunteer Committee and the

Jack Shadbolt, *Farms on the Steps, Alpes Maritimes*, 1957.

Alfred Pellan, *Les Sémaphores*, 1959.
Mr. Wayne Porter and a Wintario Matching Grant

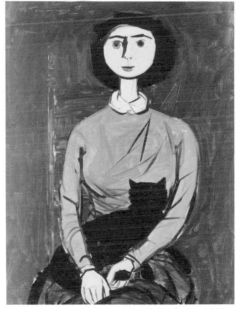

Jack Shadbolt, *Dark Garden No. 2*, 1960.
Volunteer Committee

Jacques de Tonnancour, *Girl with Black Cat*, 1958.
Volunteer Committee

Acquisitions Committee of the Board give their approval. If either group votes no, the purchase is not made. The President of the Volunteer Committee from 1988-90, Jackie Porter said, "no other gallery offers its volunteers such wonderful input."

In each of 1988 and 1989, the Volunteer Committee donated $50,000 for acquisitions, half of the Gallery's acquisition budget. The continuing support of the Volunteer Committee has enabled the Gallery to acquire important works such as F.H. Varley's *Mimulus, Mist and Snow,* and Paterson Ewen's *Shipwreck*, and to support young contemporary artists like Atilla Richard Lukacs with the purchase of *Junge Spartaner Forden Knaben zum Kampf heraus (The Young Spartans Challenge the Boys to Fight).*

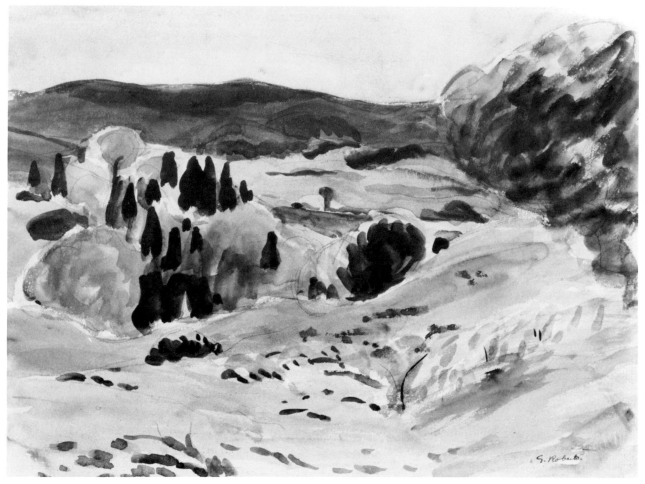

Goodridge Roberts, *Eastern Townships*, c.1945

Frederick H. Varley, *Mimulus, Mist and Snow*, c.1927-28.
Volunteer Committee

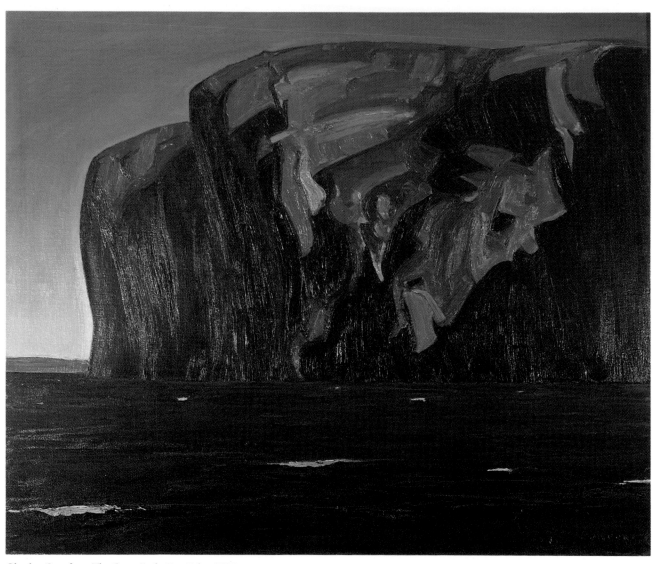

Charles Comfort, *The Great Rock, Bon Echo,* 1928.
Volunteer Committee

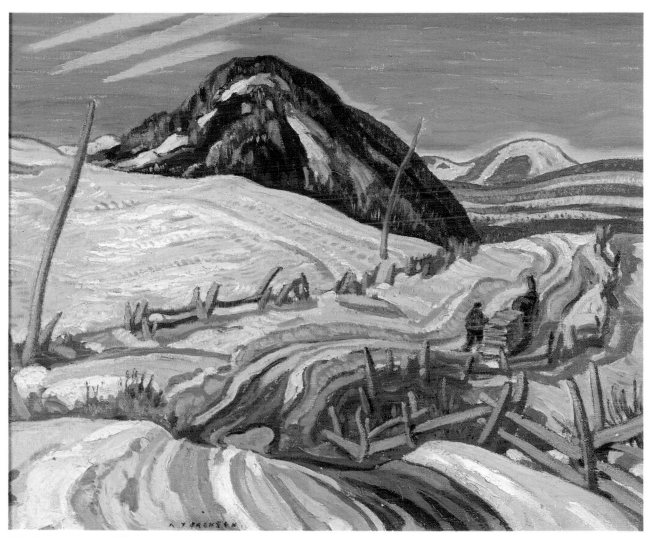

A.Y. Jackson, *Road to Charlevoix*, c.1936.

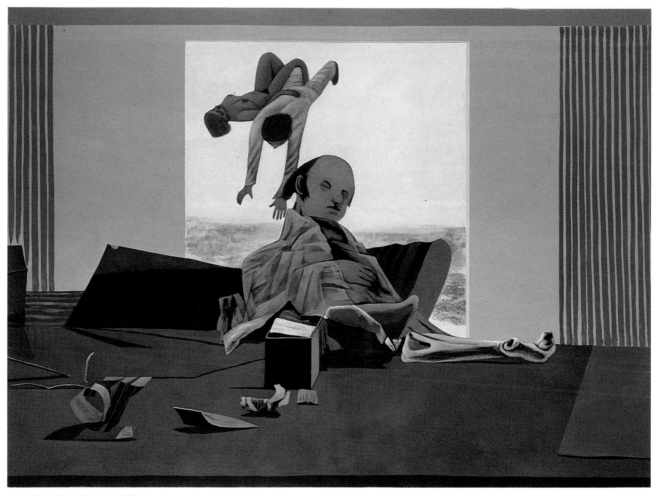

Ivan Eyre, *Day Dream*, 1971.

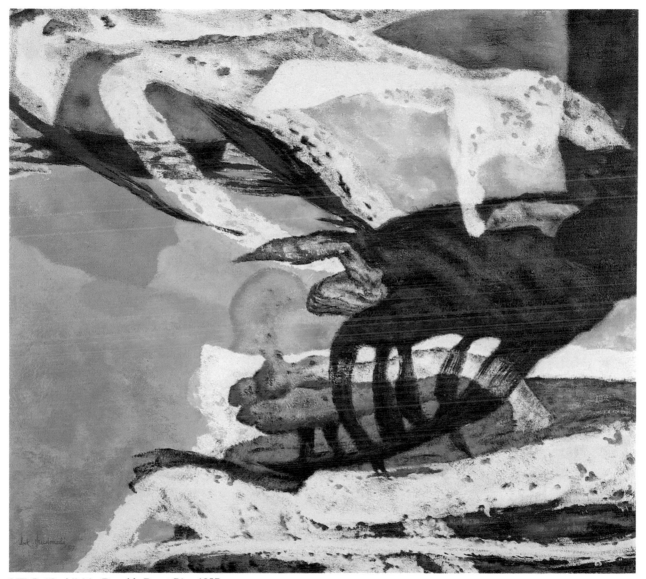

J.W.G. "Jock" MacDonald, *Desert Rim,* 1957.
Canada Council Matching Grant

CHAPTER FIVE

COMMITTEES, POLICIES and CHANGES

This section generously sponsored by

FORREST FURS

ALFRED'S BROADLOOM

Margot Ariss, *Zen Song,* 1969

"The gallery entered a turbulent period in the 1960s"

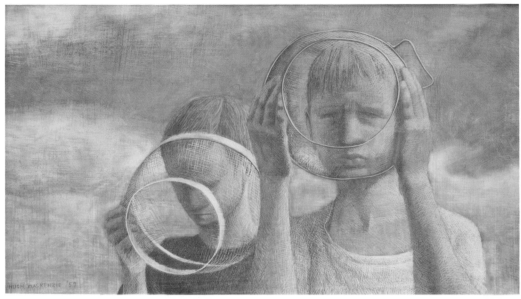

Hugh MacKenzie, *The Young Warriors*, 1959.

Clare Bice, *October Woods*, c.1963.
Dr. & Mrs. O.E. Ault

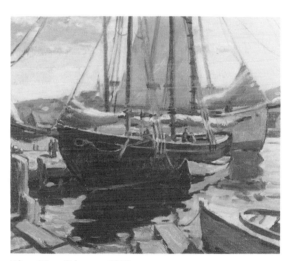

Clare Bice, *Schooner*, 1949.

Committees, Policies and Changes

Throughout the 1960s, policies, committees, agendas, mandates, and all the necessary by-laws regarding the future administration and direction of the gallery and permanent collection were discussed and constituted in order to ensure the continuity of programmes begun in the 1940s. If the substantial foundation on which the collection was based was to be strengthened, abrupt deviation from the trends of the previous twenty years had to be avoided. With Crouch's retirement in 1961 and his replacement by C. Deane Kent, steps were taken to formalize governing practices to provide guidelines for future generations.

The gallery entered a turbulent period in the 1960s. The increasing artistic activity

Alberto Giacometti,
Double Head, 1960.
Moore Gift (O.H.F.)

Molly Bobak,
On the Beach, 1959.
Mitchell Bequest

in London, beginning early that decade, encouraged younger artists in the community to be more involved in the exhibition of their work at the gallery, to help set policy, and to have the gallery purchase their work for the collection. However, what had formerly been a fruitful relationship between the gallery and artist, through the Western Art League, became strained in the course of the decade. The artists perceived that the gallery did not respond as enthusiastically to their needs as they had hoped, while Bice believed that the gallery involved the artistic community fairly. The permanent collection was regarded by local artists as being deficient in the area of contemporary London art (formerly one of its areas of strength) and it was felt that the collecting policy should be modified to encourage vigorous activity in acquiring London artists' work.

John Gould, *Matador*, 1960.
Volunteer Committee

Florence Wyle, *Torso*, c.1959.
Canada Council Matching Grant

Florence Wyle, *Susannah*, c.1940.
Friends of Frances Loring & Florence Wyle

It fell on the shoulders of various acquisition committees to set a clear statement regarding this problematic collecting area, and to establish a process whereby proposed acquisitions were presented to an Acquisitions Committee, evaluated and subsequently accepted or rejected.

Early in the decade the scope of the collection was expanded with the acquisition of pieces of sculpture. In March, 1960 Canadian sculptor Frances Loring presented the honorarium, that she had received from the gallery for giving a lecture to the Western Art League, in the hope that a matching sum from the gallery would "be used to establish a sculpture purchase fund." [47] Pieces of sculpture purchased in 1962 were Anne Kahane's *Figure and Distant Figures,* John Ivor Smith's *Smiling Head #2,* Leonhard Oesterle's

Aba Bayefsky, *Figure at Market,* 1960.
Canada Council Matching Grant

Joseph Plaskett, *Diana Standing,* 1960.
Canada Council Matching Grant

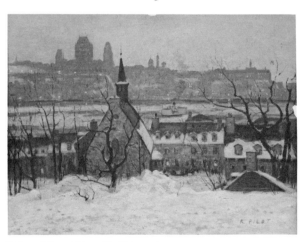

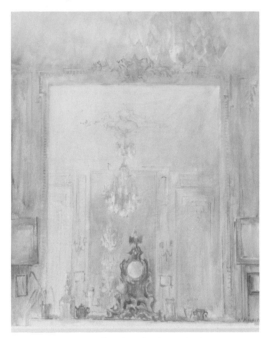

Robert Pilot, *Winter Twilight,* n.d.
Volunteer Committee

Joseph Plaskett, *Reflets dans la glace,* 1955.
Mitchell Bequest

bronze *Mother and Child,* and Sir Jacob Epstein's bust of Joan Greenwood. Jean Paul Lemieux's *L'Été,* Jean-Paul Riopelle's *Trou des fées,* Jack Humphrey's *Embers by the Sea,* and two paintings by Hortense Gordon — *Early Morning from the Island, Friendship, Maine* and *Surrealistic Forms* — entered the collection in the early 1960s. Augustus John's charcoal drawing *Cartoon for a Family Group,* acquired through the Contemporary Art Society, and a suite of etchings by the Canadian artist Clarence Gagnon, enhanced the growing collection of prints and drawings.

At the end of 1963, Bice suggested to the newly-appointed chairman of the Acquisitions Committee, Dr. R.A. Kinch, that "it might be advisable...to prepare some written policy concerning acquisitions for the gallery."[48] Committee member Alex

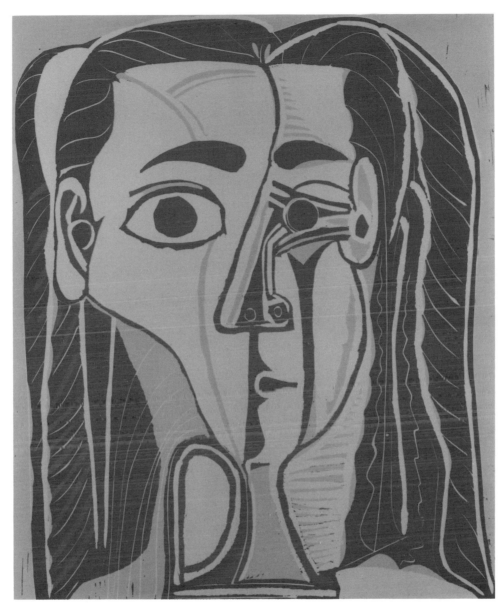

Pablo Picasso, *Grande tête de femme,* 1962.
Moore Gift (O.H.F.)

Graydon responded to Bice by saying that, "in effect there was a policy, but that it was more of an understanding, and that it was not written down." Bice believed that because of the increasing size of the collection, it was necessary to have such a written policy for the reference of future committees. He stated that it would not be "hard and fast," but would be kept, at least in the beginning, as a "general and flexible" guide.

The move to formalizing policies occurred at a time when it became necessary to build an annex to the Elsie Perrin Williams Building. Consideration was also being given to moving the gallery entirely from the library—a move that was to include giving the gallery administrative autonomy. Deane Kent was understandably opposed to such a divorce since the proposal would be completely contrary to Crouch's original con-

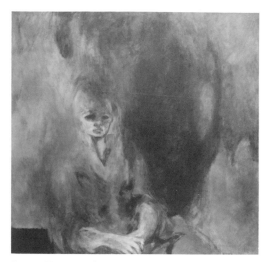

James Kemp, *Reclining Figure,* 1962.
Mitchell Bequest

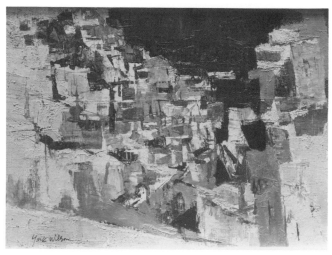

R. York Wilson, *Corner of Greece,* 1962.
Mr. Jack Wildridge

R. York Wilson, *Tlacolula,* c.1962.
Mr. & Mrs. Richard M. Ivey

D.P. Brown, *Wind,* 1962.
Moore Gift (O.H.F.)

ception of the art gallery and its collection. Kent felt that the London Public Library and Art Museum was fulfilling its various functions satisfactorily, as the international reputation of the institution as an innovative educational and cultural centre could attest. Kent presented his case against separating the art gallery from the library by stating that,

> many people found it convenient and of great personal value [having the services of an art gallery and library combined] because they had been able to reach into areas of art appreciation and general ideas better than they would if a library and art museum were in separate institutions.[49]

But Bice wondered if the art gallery and the city's historical museum might be com-

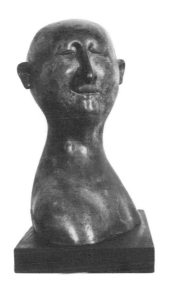

John Ivor Smith, *Smiling Head #2,* 1960.
Mitchell Bequest

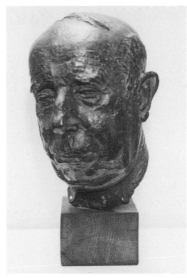

Leo Mol, *Portrait of A.Y. Jackson,* 1962.
Mitchell Bequest

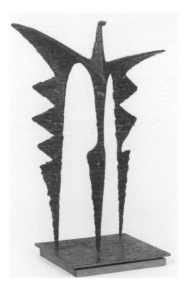

Louis Archambault,
Un Homme ailé, 1962.

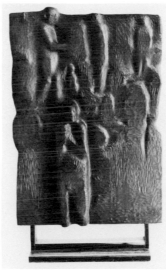

Anne Kahane,
Figure and Distant Figures, 1961.

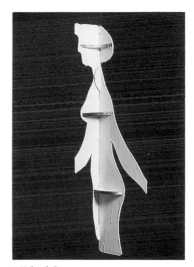

Michael Snow,
Walking Woman Corner Bracket, 1963.
Union Gas Limited honouring
Mr. John B. Cronyn

bined, that is, made "contiguous"—joined together but separate. Kent's hesitation to endorse these proposals was consistent with his wish to preserve the institution that Crouch had built.

If the gallery and library were to separate, there was also uncertainty about the ownership of the permanent collection. The art gallery's assumption was that the collection would be moved into the new quarters of any future gallery building, and be the responsibility of the director, curators and staff. The library resisted because such a scenario meant reducing the activity of the current institution to that of being a book lending and reference library only. The succeeding years of struggle were as much over the independence of the art gallery, as deciding to what end the permanent collection

Arthur Villeneuve, *Ste. Rose du Nord,* 1964.
Moore Gift (O.H.F.)

Dmitry Krasnopevtsev,
Still Life with Pipe, Candle and Papers, 1962.
Dr. Robert A.D. Ford Collection

William Winter, *Music and the Dance,* n.d.

William Kurelek,
Unloading Hay Into Cowbarn Loft, 1964.
Moore Gift (O.H.F.)

would serve, either as an adjunct service in a building wherein ideas are disseminated (a library), or in a building where the art collection is exhibited primarily as an expression of civic pride, history and cultural heritage.

In 1964 the Art Museum Advisory Committee was established. Its terms of reference were defined and responsibilities agreed upon by both the library directors and the museum trustees. Their activities were to advise the Library Board on public relations, budgets, and policy with respect to the permanent collection and its development.[50]

While the governing structure was being established, acquisitions for the permanent collection continued. One of the more important was Cornelius Krieghoff's *Niagara*

Tony Urquhart, *Opening Box - Black,* 1968.

J. Fenwick Lansdowne,
Palm Warbler, 1965.

Jean Paul Lemieux, *Voyage au bout de la nuit,* 1965.

Esther Warkov, *A Procession,* c.1964.
Canada Council Matching Grant

Falls from the British Side, purchased with the assistance of a grant from the Ontario Arts Council, money from the General Purchase Fund and from a group of London doctors.[51] Other paintings that entered the collection in 1965 are Jack Shadbolt's *Dark Garden #2,* which helped to strengthen the collection of works by Western Canadian artists, Jean Paul Lemieux's *Voyage au bout de la nuit* and Paul Peel's portrait of his son, Robert André. The Acquisitions Committee expressed an interest in collecting examples of the art of young London artists such as Greg Curnoe, Jack Chambers, Ron Martin, Murray Favro and others. Believing that a civic collection should consistently collect their work, these artists lobbied to have it gain a place in the permanent collection.

To correct this omission, the Acquisitions Committee members purchased Jack

Ben Nicholson, *Bird's Eye View,* 1966.
Volunteer Committee

Ulysse Comtois, *Wood,* 1965.
Mr. & Mrs. J.H. Moore

Dame Barbara Hepworth, *Four Forms (Porthmeer),* 1965.
Moore Gift (O.H.F.)

Chambers' *Olga and Mary Visiting* early in 1965. It was an important addition to the collection, and a signal to the artists that the original objectives of the art collection had not been abandoned. Further acquisitions of work by local artists in the mid–1960s included Robert Hedrick's canvas *Morning Green,* Connie Jefferess's monoprint *Figure at the Edge of the Sea* and Greg Curnoe's *Feeding Percy,* balanced by the work of important Canadians outside of London, notably Duncan de Kergommeaux's *Untitled,* Harold Town's *Centrebiz,* and Prairie artist Tony Tascona's *Pendulum.* Florence Wyle's bas-relief *Susannah* extended the growing sculpture collection. Jack Bush's *Blue Spot on Green* added to the group of paintings by members of Painters Eleven, while an etching by David Blackwood augmented the print collection.

Unidentified Inuit Artist, *Bear with Seal in its Mouth*, n.d.
Moore Gift (O.H.F.)

Yves Gaucher, *Gris, Bleu, Bleu/Vert*, 1971.
Moore Gift (O.H.F.)

Josef Albers, *Homage to the Square: Slate*, 1965.
Moore Gift (O.H.F.)

By the end of the 1960s, a revised policy of purchasing for the permanent collection still was not formalized. As the decade closed it was proposed that a list be drawn up of artists whose work should be added to the permanent collection.[52] Adopting a clear statement of purpose for the permanent collection was again on top of the agenda for the 1970s, particularly urgent in view of the increasing momentum in the community for the construction of a separate civic art gallery. In an attempt to serve all areas of the collection, the terms of reference for the Acquisitions Committee, drawn up in 1970, advising members to "ensure that local artists are well represented in the gallery while not ignoring Canadian art in general" was fulfilled, judging from the artists whose work was purchased.[53] A balanced range of styles, modes of representation and artists from

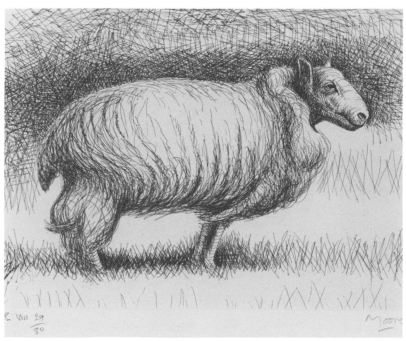

Henry Moore, *Sheep Plate VIII*, 1974.
Volunteer Committee

Walter Redinger, *Caucasian Study*, 1968.
Mr. A. Isaacs

William Perehudoff, *Upward Harmony*, 1969.
Canada Council Matching Grant

various regions of Canada characterized the collection in the late 1960s.

In 1970 the permanent collection received the important gift of forty-six paintings from the Douglas Duncan Estate. Following the death of Duncan, who directed the Toronto Picture Loan Society, his executors dispersed his collections among forty-one Canadian art galleries and universities.[54]

Among the works of art acquired were canvases by the reclusive Canadian artist David Milne—Duncan had built the single, most important collection of Milne's paintings, drawings and prints. London was given five works by this artist, among them the paintings *The Maple Blooms on Hiram's Farm, Palgrave; Sweet Peas and Poppies, Uxbridge;* and the colour drypoint *Yard of the Queen's Hotel.* Duncan also collected exten-

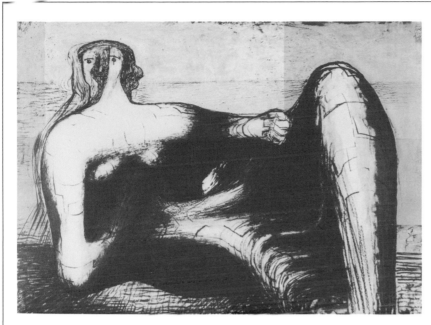

Henry Moore,
Draped Reclining Figure, 1974.
Volunteer Committee

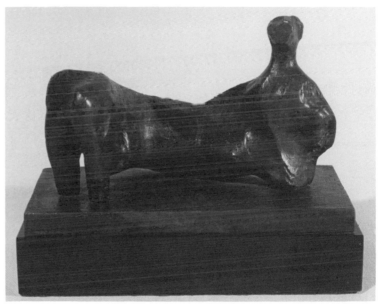

Henry Moore,
Reclining Figure Maquette, 1960.
Moore Gift (O.H.F.)

sively the work of Winnipeg artist Lionel LeMoine FitzGerald and the gallery was given nine works including his drawings *Watering Can, Abstract,* and the oil sketch *Ponemah.* Artwork by Carl Schaefer, Fritz Brandtner, Louis Muhlstock, "Scottie" Wilson, Jack Nichols and Jack Humphrey rounded out the gift from the Duncan Estate.

Other gifts to the gallery at this time included the very fine painting by Paul Peel entitled *The Covent Garden Market, London, Ontario,* which increased the representation of paintings by this artist in the collection and further strengthened the growing study collection on him.

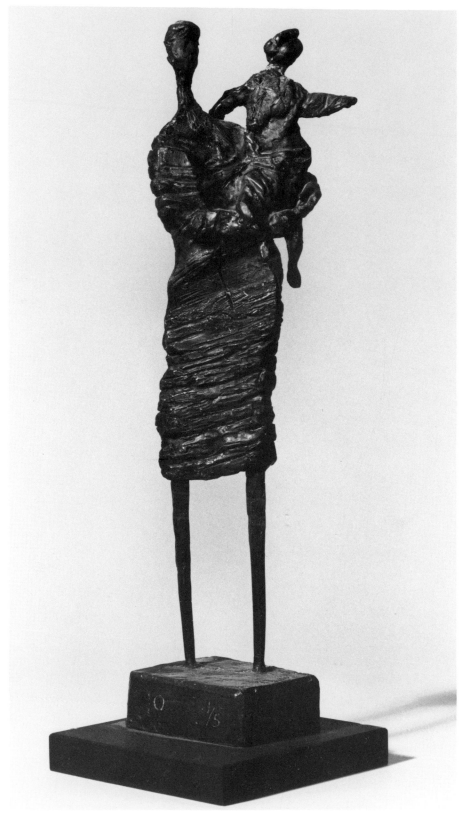

Leonard Oesterle, *Mother and Child,* c.1962

Jean-Paul Riopelle, *Le Trou des fées*, 1957.

Goodridge Roberts, *Flowers and Easel,* 1958.
Moore Gift (O.H.F.)

A.J. Casson, *Mist, Rain and Sun,* 1958.
Volunteer Committee

Alex Colville, *Boy, Dog and St. John River,* 1958.

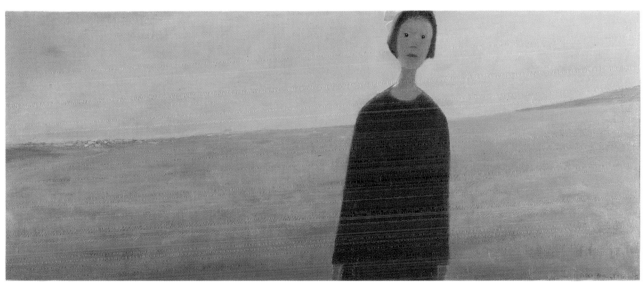

Jean-Paul Lemieux, *L'Été*, 1959.
Maclean-Hunter Publishing Company Limited

CHAPTER SIX

THE
MOORE
COLLECTION

This section generously sponsored by

3M CANADA INC.

COUNTY HERITAGE
FOREST PRODUCTS LIMITED

Fernand Leger,
Femme nue assie, 1912

*"The Moores donated well over six hundred fifty paintings,
drawings, sculpture, print portfolios and limited edition prints
and books"*

Greg Curnoe, *Doc Morton*, 1975.

Greg Curnoe, *View from the Most
Northerly Window in the East Wall*, 1969.
Moore Gift (O.H.F.)

Greg Curnoe, *Car*, 1967.
Moore Gift (O.H.F.)

The Moore Collection

If the broadest areas of collecting activity were defined for the gallery in its earliest days by Richard Crouch, the size and importance of the collection in Canada were greatly enhanced through the generosity of Mr. and Mrs. J.H. Moore. The past sixteen years in the development of the permanent collection are dominated by this couple. From 1974 through 1990, the Moores donated to the gallery well over six hundred fifty paintings, drawings, sculpture, print portfolios and limited edition prints and books, along with a library of journals and art reference texts all from their personal collections.[55]

The Moore Gift, in its totality, is characterized by its inclusion of all artistic styles, modes of representation, subjects, themes and media—eloquent testimony to the wide-

Jack Chambers, *Music Box,* 1968.
Moore Gift (O.H.F.)

Jack Chambers, *Tap,* 1967.
Moore Gift (O.H.F.)

Jack Chambers, *Figs,* 1977.
Wintario Matching Grant

Jack Chambers, *Regatta No. 1,* 1968.
Volunteer Committee

ranging tastes of the Moores. They began to collect art in 1945, when living in Toronto, with the purchase of a sketch by Cleeve Horne. Acquisitions of pieces by Henri Masson, Leonard Brooks, William Winter and York Wilson shortly after that, set the trend for future purchases of contemporary Canadian art chosen for its visual appeal and level of technical mastery. Following their return to London in 1952, the Moores concentrated on building into their collection a significant representation of works by artists of the city and region.

At the beginning of their years as collectors, the Moores received advice from Douglas Duncan and they made frequent purchases through the Picture Loan Society. They recalled one occasion when Duncan spread out before them a large selection of David

William McElcheran, *Peripatetics*, 1968.

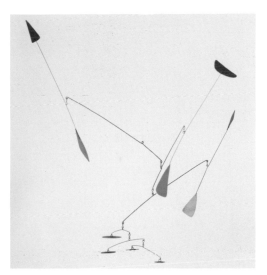

Alexander Calder, *Three Blacks Up*, 1960.
Moore Gift (O.H.F.)

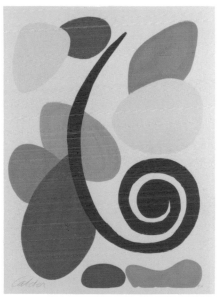

Alexander Calder, *Black Spiral*, 1971-72.
Volunteer Committee

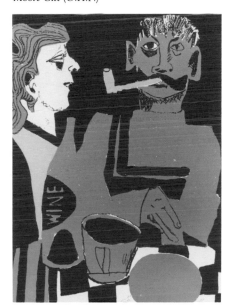

Maxwell Bates, *Figures at a Table*, 1968.
Simon Fraser University

Milne's drypoints and paintings from which they were invited to make their selections. Whenever possible, the Moores dealt directly with the artists because they found them to be stimulating and interesting company—in most cases a welcome antithesis to the business people with whom they associated daily.

Jake Moore often found himself giving financial advice to artists in addition to purchasing their work. This proved to be a mutually satisfying relationship for both parties: for the Moores, an acquisition is remembered fondly as much for the circumstances surrounding its purchase as for the aesthetic pleasure it continues to provide; while the artists benefitted from the collector's business acumen. The Moores' sincere respect for the life an artist had chosen to live caused them to use their skills to ensure that the

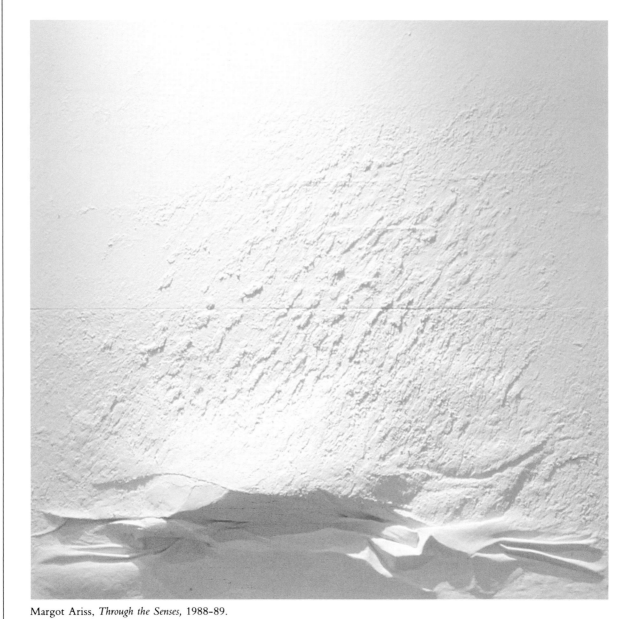

Margot Ariss, *Through the Senses,* 1988-89.
Volunteer Committee

artists and their families were able to survive by their art and to create without the burden of continual anxiety over finances. They also provided opportunities for artists to integrate creatively into the community. For example, Jake Moore was instrumental in helping to institute an Artist-in-Residence programme at the University of Western Ontario and an art centre where artists taught and worked in downtown London. In 1959, he was invited to sit on the gallery's Art Acquisitions Committee, and shortly after that was appointed to a committee to study the possibility of expanding the art gallery and separating it from the library—objectives he was committed to achieving.

As business required Jake Moore to travel across Canada, often in the company of Alex Graydon (himself a member of the Art Museum Board of Trustees), his in-

Herbert Joshua Ariss, *Imaginary Journey: The Somme, 1916,* 1976.
Mrs. Barbara Jackson in Memory of Kathleen Frances Bieman

Roly Fenwick, *Limits of Vision,* 1969.
Mitchell Bequest

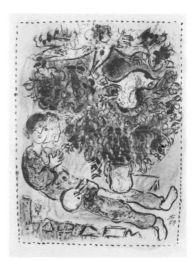

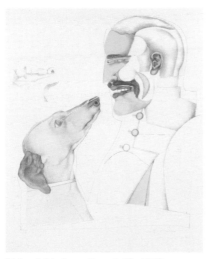

Marc Chagall,
Le Bouquet de peinture, n.d.
Volunteer Committee

Herbert Joshua Ariss,
*In Memoriam, The Wiltshires and
The Worcesters (The Somme),* 1968.
Mitchell Bequest

Richard Lindner, *Portrait #2,* 1969.
Volunteer Committee

terest gradually extended to the art communities in Vancouver, Calgary, Regina, Winnipeg and Montreal. Inevitably, works by artists from each of these centres found their way into the growing Moore collection.

In the later 1960s and 1970s, the Moores became disillusioned with the poor quality of contemporary Canadian art, which they felt was diminished as a consequence of vigorous collecting activity by the Canada Council Art Bank. Believing that Canadian art had become mediocre, the Moores began to look to the international art market. The scope of their collection, therefore, was expanded in the area of drawings and prints by Russian artists, English and Canadian modernists. A brief interval when they lived in Brazil led to the inclusion of many works by that country's artists.

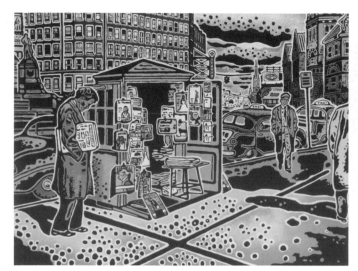

Clark McDougall, *Buffalo News Stand*, 1978.
Mr. & Mrs. Richard M. Ivey

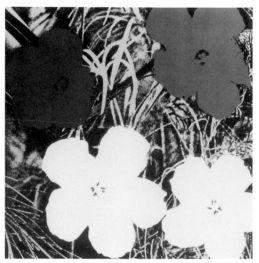

Andy Warhol, *Flowers #8*, 1970.
Volunteer Committee

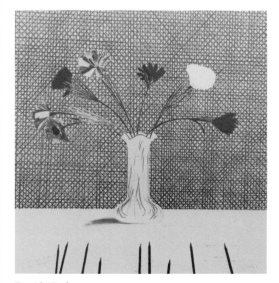

David Hockney,
Flowers Made of Paper and Black Ink, 1971.
Volunteer Committee

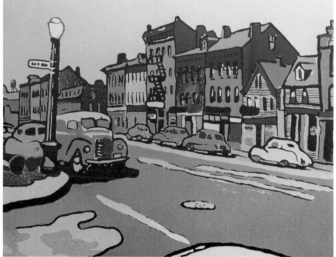

Clark McDougall, *East Broadway, Buffalo*, 1977.
Mr. & Mrs. Richard M. Ivey

The Moores chose to donate their collections to the London art gallery for several reasons: they hoped to provide an "anchor" which would strengthen the foundation of the art collection;[56] they wanted their gift to illustrate that there was tangible support among members of the community for an independent art gallery at a time when preparations were underway to make it an autonomous institution in a new building at the forks of the Thames; and moreover, they wished to express their appreciation to the city of London for the quality of life that they and their ancestors had enjoyed there for five generations.

Their first gift to the gallery, presented in 1974, through the Ontario Heritage Foundation was comprised of two hundred seventy-seven Canadian paintings and draw-

Willem de Kooning,
Figure at Gerard Beach,
1970.
Dr. & Mrs. R. Bull

Bert Kloezeman,
*Structural and Organic
Interplay,* 1971.
Mrs. Phyllis Cohen

Richard Hamilton, *Fashion Plate,* 1969-70.
Volunteer Committee

David Hockney, *Billy Wilder,* 1976.
Mr. & Mrs. J.H. Moore

ings.[57] The selection reflects the guidance the Moores received from Douglas Duncan; there is an analogy between Duncan's collection and the Moores' in that both focussed on works by contemporary Canadian artists. Where Duncan's centred on the art of David Milne and Lionel LeMoine FitzGerald, the Moores' contained a representative selection of works surveying the career of Greg Curnoe. The Canadian artists in their collection also included French Canadians who introduced modernism into Canadian painting, for example, Paul-Émile Borduas, Alfred Pellan and Jean-Paul Riopelle, and work by their English Canadian equivalents in the Painters Eleven, Harold Town, Oscar Cahen and Kazuo Nakamura. Work by Prairie artist Kenneth Lochhead, paintings and drawings by Group of Seven members Lawren Harris, Arthur Lismer, J.E.H. Mac-

Ken Danby, *Walter Moos*, 1976.
Mr. & Mrs. J.H. Moore

Ken Danby, *The Goalie*, 1972.
Moore Gift (O.H.F.)

R.P.D. Hicks, *After the Spring Flood*, 1972.
Mrs. R.P.D. Hicks

Philip Pearlstein, *Nude on a Silver Bench*, 1972.
Volunteer Committee

Donald, and examples from David Milne, Ron Bloore, Alex Colville, Christopher Pratt, Jacques de Tonnancour and Goodridge Roberts were all collected by the Moores and given to the gallery.

The first gift was followed one year later by that of sixty-one paintings and drawings by international artists, among them Edgar Degas, Wassily Kandinsky, Henri Matisse, Pablo Picasso and Henri de Toulouse-Lautrec. Sculpture and multiples by Europeans accompanied this gift. A third donation, given in 1976, was comprised of Canadian graphics, including a suite of fourteen lithographs by Ken Danby, among them one of his most popular images: *The Goalie*. Lawren Harris's *Lake Agnes Above Lake Louise* strengthened the collection's representation of Canadian paintings, while pieces

Murray Favro, *Still Life (The Table)*, 1970.
Wintario Matching Grant

Ed Zelenak, *Convolutions*, 1969.

Ray Robinson, *Study for Reclining Figure*, c.1974.

Murray Favro, *Guitar*, 1982.
Volunteer Committee

by Walter Redinger, Margot Ariss, and John Ivor Smith added depth to the area of three dimensional work in the permanent collection. Selections from the entire gift were featured as one of the first exhibitions at the new gallery in 1980.[58]

The generosity of the Moores also extended into the 1980s. Fifteen limited editions of prints and books, among them a copy of Lewis Carroll's *Alice's Adventures in Wonderland* illustrated by Salvador Dali, were given in 1980, as well as print portfolios by American conceptual artist Sol Lewitt and Quebec artist Yves Gaucher. Five paintings were given a year later: Josef Albers' *Homage to the Square: Slate*, Jeremy Smith's *Window: Cat and Birds*, Christopher Pratt's *Cliff Edge* and *Crow and Raven*, and an untitled canvas by Paul-Emile Borduas.

George Legrady, *Floating Objects: B800601-2*, 1980.
Canada Council Matching Grant

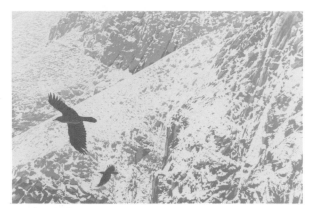

Christopher Pratt, *Crow & Raven*, 1978.
Moore Gift (O.H.F.)

E.J. Hughes, *View of a Freighter at Crofton*, 1972.
Moore Gift (O.H.F.)

Paddy Gunn O'Brien,
Monument to an Ontario Evening, 1970.

From 1982-1987, approximately one hundred ninety more works of art entered the collection along with the significant group of forty paintings by Brazilian artists assembled by Mrs. Moore. Other highlights of these successive gifts are Alexander Calder's mobile *Three Blacks Up*, Edgar Degas' pastel *Femme penchée sur une balustrade*, Jack Chambers' *Moonrise*, a set of twenty-four Greg Curnoe illustrations for Milton Acorn's book *More Poems for People* , two drawings by English artist Stanley Spencer, and a large collection of sculpture and drawings by Ray Robinson.

As a result of the gifts of the Moores, the permanent collection assumed a clear focus—local and regional art—while its depth in the areas of Canadian contemporary and historical art, and international art were broadened. Their benefaction created the

Paterson Ewen, *Rain Over Water*, 1972.
Wintario Matching Grant

Jasper Johns, *Land's End*, 1978.
Volunteer Committee

Paterson Ewen,
Thundercloud as a Generator #1, 1972.

definitive public collection of works by the group of London artists who rose to prominence in Canada and abroad during the 1960s and 1970s. The gifts opened new avenues of growth for the collection, one notable example being in the area of European figurative drawings. In August, 1988 ownership of the entire donation, spread over fourteen years, was transferred to the London Regional Art Gallery from the Ontario Heritage Foundation.[59]

Dorothy Knowles, *Rolling Fields,* 1969

Kazuo Nakamura, *Lakeside, Summer Morning*, 1961.
Moore Gift (O.H.F.)

Jack Bush, *Blue Spot on Green,* 1963-64.

Jack Chambers, *Olga Visiting Mary,* 1964-65.

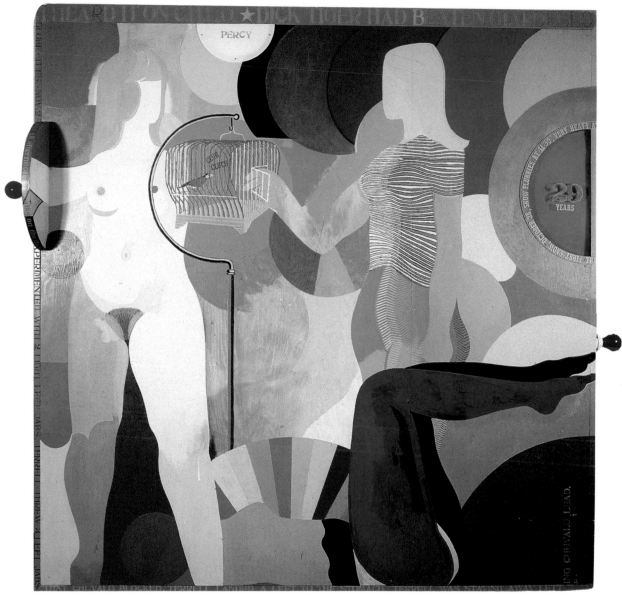

Greg Curnoe, *Feeding Percy*, 1965.

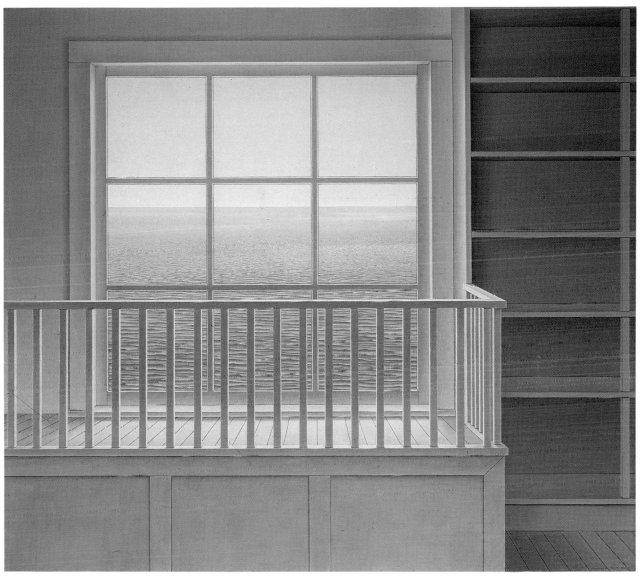

Christopher Pratt, *Shop on an Island,* 1969.
Moore Gift (O.H.F.)

CHAPTER SEVEN

THE
COLLECTION
CONTINUES

This section generously sponsored by

HUSTON'S KAUFMAN HOUSE GALLERY

Clark McDougall, *Untitled: Winter Landscape with
Side of Barn*, 1966
Marion and Alf Murray, Islington

Jack Chambers,
The Artist's First Bride, 1961

*"Acquisitions of artwork were made possible through many
grants from the Women's Committee, London Art Gallery
Association, The Canada Council, and Wintario"*

Ulysse Comtois, *Five Bar Stack*, 1968.
Moore Gift (O.H.F.)

Jamelie Hassan,
The Trial of The Gang of Four, 1981.
Canada Council Matching Grant

Jamelie Hassan,
Bench from Cordoba, 1982 (Detail).
Wintario Matching Grant

The Collection Continues

Purchases for the permanent collection continued to be made throughout the 1970s and 1980s concurrent with the receipt of gifts from the Duncan Estate and the Moores. Acquisitions of artwork were made possible through many grants from the Women's Committee, London Art Gallery Association, The Canada Council, and Wintario, in addition to those from private individuals and corporations. Local artists whose works were purchased for the collection were, among others, Paterson Ewen, Clare Bice, Gilbert Moll and Robert Fones, while other Canadians included Ron Bloore, Bertram Brooker, Frederick Varley, Ivan Eyre and Alfred Pellan. The donation of a Frederick Simpson Coburn sketchbook in 1977 by Mr. and Mrs. Fred Schaeffer enhanced the

Brian Jones, *Wringing Trousers*, 1976.
Mitchell Bequest

Brian Jones, *Father and Son*, 1973.
Mitchell Bequest

importance of the collection of Canadian prints and drawings. The international collection received James McNeill Whistler's *La rue Furstenburg, Paris* and the Junior Women's Committee purchased Richard Hamilton's mixed media print *Fashion Plate*.

After the retirement of Bice in 1972, Paddy O'Brien became the gallery's Curator. Under her guidance, emphasis was deliberately placed on solo, two-person and group shows of local and regional artists in an attempt to garner their support for the institution which they considered had alienated them. However, a great deal of public criticism of this exhibition programme and the controversial subject matter and media exhibited—namely a John Boyle exhibition (during which school children visiting the gallery were told not to look at the paintings!), and a Michael Bidner exhibition —

Robert Fones, *Interior*, 1973.
Junior Volunteer Committee

Evgeny Ruhkin, *Abstract,* 1973.
Dr. Robert A.D. Ford Collection

led to the review of the schedule with the intention of featuring a wider diversity of shows, artwork and artists.[60] One of the means the gallery chose to counteract mounting public criticism was to display selections from the permanent collection on a continuing, rotating basis throughout the gallery. In order to educate the public about the collection, selected paintings were exhibited in a local office mall.[61] This augmented other extension and touring programmes that continued to have works of art from the permanent collection travelling to centres in the Western Ontario region.[62] In fact, the collection had reached a point in its growth where its future direction needed to be defined once again. Should it specialize only in local artists' work; should it be primarily an educational tool; and should its scope be broadened or restricted?

Mario Avati, *Les radis du mars,* 1974.
Volunteer Committee

Fernando Botero, *Bananas,* 1975.
Moore Gift (O.H.F.)

The confusion was finally resolved in January, 1976 when the first Permanent Collection Policy was adopted.[63] It stated that the collection should be chiefly composed of Canadian art ("but need not be entirely of Canadian art") from the earliest topographical artists to contemporary work. Artists from London and area were to be well-represented. The collection was regarded as an educational tool existing for the benefit of everyone. Other areas of the policy statement dealt with methods of acquisition of art through purchase, gift and bequest, deaccession of work from the collection, care of the collection, and rules governing the lending of artwork. The statement was comprehensive and was to be the foundation of all subsequent collecting activity.

An unfortunate consequence of the ambitious programme to tour paintings from

Andrei Voznesensky, *Russian Village in Winter*, c.1974.
Dr. Robert A.D. Ford Collection

Gino Lorcini, *Omega - Mixed Doubles*, 1976.
Anonymous Gift

kerry ferris,
Mother and Michael, Automne, 1973.

the permanent collection to regional centres was the theft of fourteen paintings—two of them being part of the Housser Collection—from an exhibition on loan to the Leamington Art Gallery in November 1975.[64] When it was determined that the paintings would not be returned, the gallery approached Toronto art dealers to use the insurance funds to replace the stolen paintings with either comparable examples by the same artists, or with work by Canadian artists of the late nineteenth and early twentieth centuries.[65] The replacement of the Housser Collection paintings was facilitated by the generosity of Yvonne McKague Housser, who returned to the gallery her portion of the insurance settlement and requested that it be placed in the Acquisitions Fund.[66] As a result, the following five canvases were purchased in 1976 with the

Jim Dine, *Ski Hat Progression, I State,* 1974.
Volunteer Committee

Jim Dine, *Ski Hat Progression, II State,* 1974.
Volunteer Committee

Jim Dine, *Ski Hat Progression, III State,* 1974.
Volunteer Committee

Jim Dine, *Ski Hat Progression, IV State,* 1974.
Volunteer Committee

funds: F.H. Varley's *Lynn Peak;* Goodridge Roberts' *Eastern Townships;* J.W. Beatty's *Summer Landscape*; Homer Watson's *Two Figures Under Beech Trees*; and Otto Jacobi's *Landscape with Lake*. At this same time, A.H. Robinson's painting *Old Fort, St. Malo* was purchased with funds donated by Mrs. Walter Gordon in memory of her mother Marjorie Gibbons Counsell. Other major acquisitions in 1976-1977, a period of austerity as the building programme of the new gallery was well underway, included Alexander Calder's lithograph *Black Spiral* which was donated to the growing Women's Committee International Graphics Collection, Alfred Pellan's *Les sémaphores,* and Homer Watson's *The Lone Cattle Shed.*

At the close of the decade the collection had a permanent, separate home in the

Don Bonham, *Herman Goode at Bonneville*, 1975.

Jeremy Smith, *Window, Cat and Birds*, 1976.
Moore Gift (O.H.F.)

Wyn Geleynse, *Watercolour Paints*, 1975.
Mitchell Bequest

Ed Bartram, *Split Rock, Canadian Shield Series*, 1970.

London Regional Art Gallery (even though most of the collection was only on permanent loan to the gallery from the London Public Library Board and the Ontario Heritage Foundation).[67] Policies were established to provide guidelines for future collecting activity; and the collection's scope was well-defined, while important gifts, bequests and regular purchases added depth to areas of specialization.

John McEwen, *Teko - with Broken Base,* 1980
Volunteer Committee and Canada Council Matching Grant

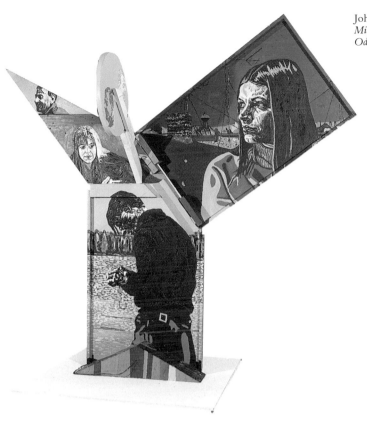

John Boyle,
Midnight Oil -
Ode to Tom Thomson, 1969.

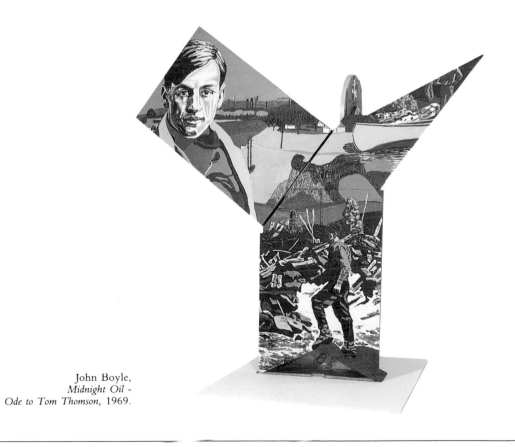

John Boyle,
Midnight Oil -
Ode to Tom Thomson, 1969.

Claude Breeze, *Canadian Atlas: Moonlight,* 1972.
Moore Gift (O.H.F.)

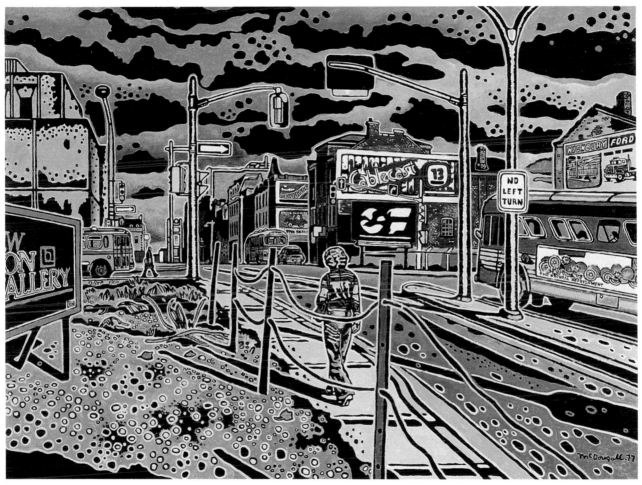

Clark McDougall, *Site,* 1977.
Volunteer Committee

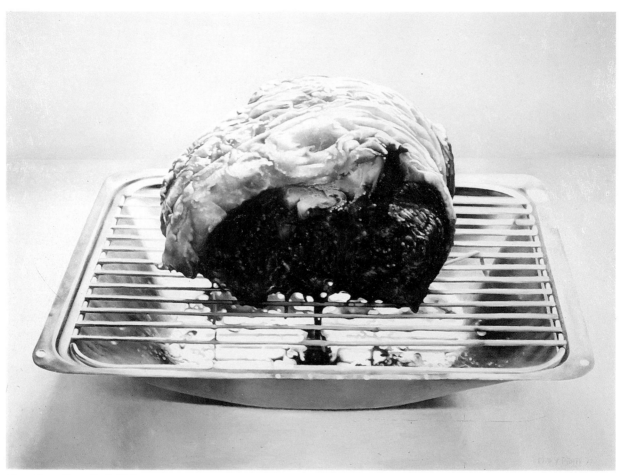

Mary Pratt, *Roast Beef,* 1977.

Robert Bozak, *Jamie Bone,* 1980.
Wintario Matching Grant

CHAPTER EIGHT

THE COLLECTION MATURES:
The 1980s

This section generously sponsored by

ELLIS-DON LIMITED

Nick Johnson, *Dragon Fly*, c.1987

"Collecting activity has been focussed on purchasing major works by important London and area artists"

Eric Fischl, *Winter House*, 1976.
Canada Council Matching Grant

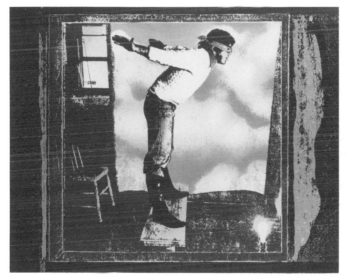

Gilbert Moll, *The Wingwalker's Apprentice*, 1977.
Mr. & Mrs. Richard M. Ivey

Doug Mitchell, *Heartland, Fork at the Thames*, 1978.
Mr. J.H. Moore In Memory of Alex Graydon

The Collection Matures: The 1980s

The early 1980s were challenging years for the gallery, newly arrived at its building on the forks of the Thames River. Owing to budgetary restraint, acquisition, exhibitions and operating funds were restricted thus limiting the purchase of art. Nevertheless, important works entered the collection through judicious acquisitions, bequests and gifts. Programming and exhibitions reflected differing conceptions of the place of the gallery in the community as a result of three changes of directors.

William Forsey, who had been guiding the gallery through the difficult years of constructing its new building, completed his five-year term at the gallery in 1981 and was replaced temporarily by Nancy Poole, as interim director, until a selection com-

John Boyle, *The London Six,* 1984.
Suncor Incorporated

John Boyle, *Eulalie,* 1972.
Mr. Henry Snoek

John Boyle, *Great Grandpa,* 1970-71.
Moore Gift (O.H.F.)

mittee chose Brenda Wallace as the gallery director in late 1981. Under Wallace, the collecting patterns of the previous forty years were continued with emphasis placed on acquiring work by artists at the beginning of their careers, including Spring Hurlbut, George Legrady, Jamelie Hassan and John Scott. Although the gallery received as gifts a small oil sketch of St. Malo, France, by J.W. Morrice and a Goodridge Roberts painting *Islands, Georgian Bay* in July 1981, financial problems caused by the economic recession prevented acquisitions. This led Dr. Geoffrey Rans, a member of the Acquisitions Committee, to express consternation on the part of his committee at the lack of funding in the gallery's budget for the purchase of works of art.[68]

But even as it was proving to be increasingly difficult for the gallery to purchase

Bernice Vincent, *Backyards,* 1979.
City of London 125th Anniversary Committee

Suzy Lake, *Petrouchka's Dance
with Abaddon, Part IV,* 1978-79.
Allstate Foundation

Edward Zelenak, *Untitled #7,* 1976-79.
Wintario Matching Grant

Jeff Willmore,
Black Hounds Hunting, 1979.

artwork, there were important gifts to the collections in addition to those given by the Moores. For example, C-I-L. Ltd. donated Jack Chambers' painting *Three Sisters Waiting* in February, 1982, while shortly before this, an anonymous donor gave Chambers' *Onlookers Over Winnipeg* to the gallery. Later that fall, Rans and the Acquisitions Committee accepted on behalf of the gallery a further four pieces by this artist—*Festival of Life* (poster), *Angel, Grass Box No. 3* and *Umbrella*—thereby establishing the London Regional Art Gallery as an important study centre of Jack Chambers as well as Paul Peel.

After Nancy Poole assumed the Director's position in 1985, many formerly successful programmes and exhibition ideas, first introduced by Richard Crouch nearly fifty years earlier, were reinstituted. Like Crouch, Mrs. Poole envisioned the art gallery

Irene Xanthos, *Number 15,* 1980.
Canada Council Matching Grant

Louise Nevelson, *Six Pointed Star,* 1980.
Volunteer Committee

Kim Moodie, *Houses,* 1983.

as being a fully integrated art centre within the community, comparable to the position that the Mechanics' Institute had held some one hundred years earlier. Her contributions to the permanent collection rest in her continued acquisition of contemporary local and Canadian art. Since 1985, collecting activity has also been focussed on purchasing major works by important London and area artists. Her wish is to collect to strength, and during her tenure Paul Peel's *Autumn Leaves, The Young Botanist, Return of the Flock,* and an example of his juvenalia entitled *A Canadian Winter Scene* all bolstered the holdings of his art.

In 1987 with the Gallery out of debt, Mrs. Poole recommended to the Board that an acquisitions budget be established. The amount was to be determined annually and

Gathie Falk, *Cake Walk Rococo,* 1982.

David Thauberger, *Front Yard,* 1981.
Canada Council Matching Grant

Renée Van Halm, *Curtains,* 1981.
Canada Council Matching Grant

Rudolf Bikkers, *26 Prospect Avenue,* 1980.
Mr. & Mrs. Richard M. Ivey

it was to equal ten per cent of the operating budget, a figure that totalled $100,000 in 1989. On her recommendation the Board also decided that sixty per cent of the acquisitions budget be set aside for the purchase of contemporary Canadian art with an emphasis on London and regional artists; the remainder was to be earmarked for non-living artists with particular emphasis on the works of Paul Peel and Jack Chambers.

The amalgamation of the historical museums with the art gallery in 1989 brought together two collections for the enjoyment of the community; a change that creates a degree of symmetry in the half century of the institution.

Wyn Geleynse,
Portrait of My Father, 1982.

John Massey,
Blind Faith, 1982.
Canada Council Matching Grant

To survey the history of the civic art collection is to see at its centre the ideas of Richard Crouch. He initially established the collection as a component of an innovative adult education centre where many humanistic disciplines and collections were brought together in one building that was both an art gallery and library. In its day this was a unique and imaginative plan. However, Crouch was really recalling the example of the Mechanics' Institute, an important fixture in nineteenth century London that was a library, auditorium, technical school, art gallery, and entertainment hall. Crouch saw in the example of the Institute the theoretical framework for an analogous institution centred around a collection of books and art.

The art collection was begun in 1896. For the next forty years it was gradually

Duncan de Kergommeaux,
Distant Pastures #2, 1985-86.
Volunteer Committee

Duncan de Kergommeaux,
Distant Pastures #1, 1985-86.
Volunteer Committee

Duncan de Kergommeaux,
Distant Pastures #3, 1985-86.
Volunteer Committee

built largely as a result of the generosity of local artists and citizens committed to establishing a public collection and exhibiting it in a public art gallery. Crouch assumed custody of it in 1940 when the London Public Library and Art Museum opened. It immediately became a vital component in his design. Under his direction, Bice's care, and with the assistance of artists, patrons and citizens, the collection grew in its first thirty years to contain a representative survey of twentieth century Canadian art.

Through the 1960s and 1970s the momentum generated by Crouch and Bice, and sustained by successive staffs, committees and policies, assured the continuous development of the collection. The unprecedented and generous gifts by the Moores increased the collection's size, scope and importance in the Canadian cultural landscape.

Tom Benner, *White Rhino,* 1985-86.
International Services of London

The recent merger of the historical museums and art gallery presents an opportunity to reaffirm aspects of the founding aims described by Crouch. The challenge of the future will be to continue to shape the collection with an awareness of its history.

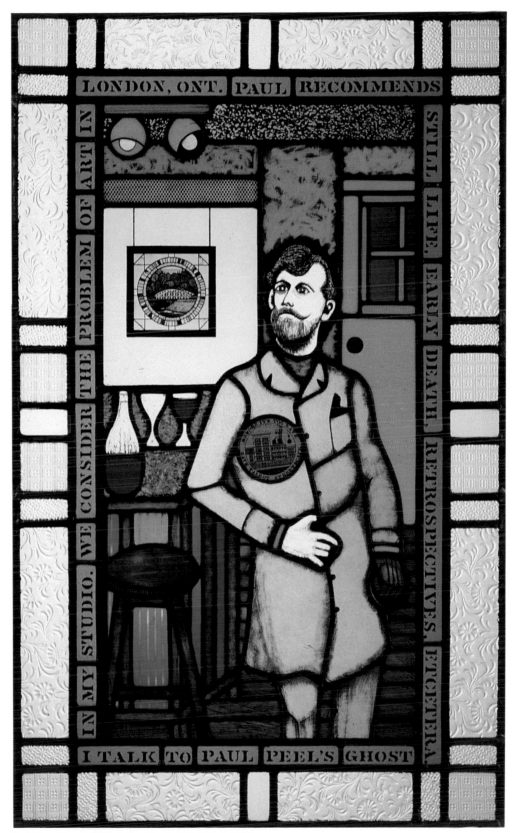

Ted Goodden, *I Talk to the Ghost of Paul Peel*, 1986.
Volunteer Committee

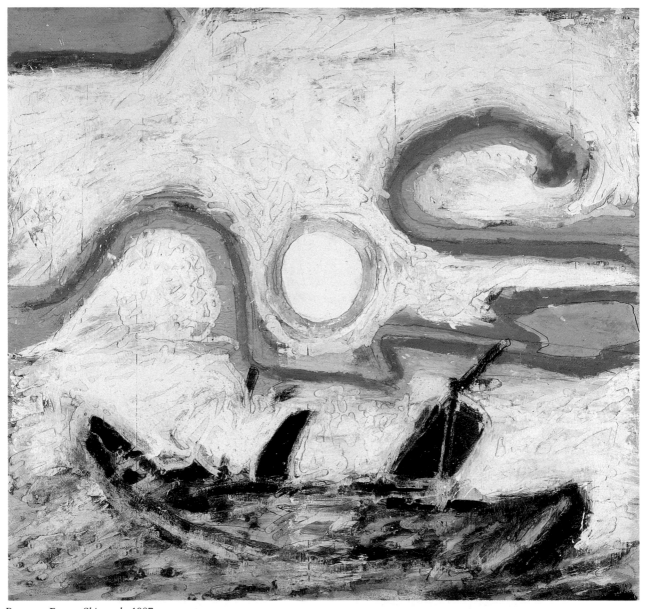

Paterson Ewen, *Shipwreck*, 1987.
Volunteer Committee and the Government of Ontario through the Ministry of Culture and Communications

Louis de Niverville, *Ménage à trois,* 1972.

Thelma Rosner,
Mandelbrote's Garden (Panel #22), 1988.
Volunteer Committee

Thelma Rosner,
Mandelbrote's Garden (Panel #21), 1988.
Volunteer Committee

Thelma Rosner,
Mandelbrote's Garden (Panel #20), 1988.
Volunteer Committee

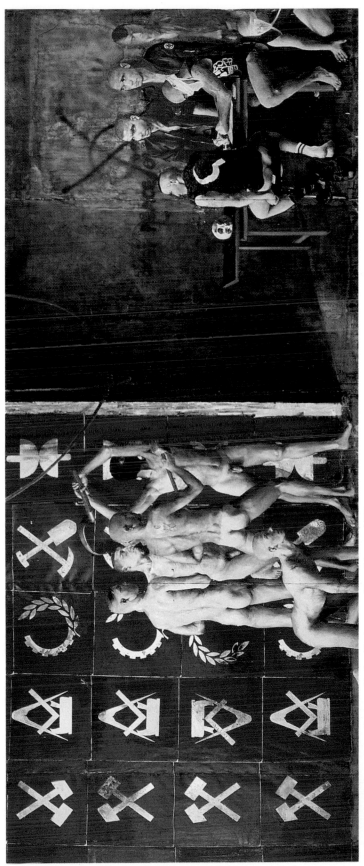

Attila Richard Lukacs, *Junge Spartaner Forden Knaben zum Kampf heraus*, 1988.
Volunteer Committee and Wintario Matching Grant

Footnotes

Chapter 1

1. A thorough history of art in the nineteenth century London is given in Nancy Geddes Poole, *The Art of London, 1830-1980* (London: Blackpool Press, 1984).

2. For a detailed discussion of the role of the garrison in the cultural life of London in the early nineteenth century refer to Jim Burant and Judith Saunders, *The Garrison Years: London, Canada West, 1793-1853* (London: London Regional Art Gallery, 3 July-4 September 1983).

3. The Upper Canada Provincial Exhibition was begun in 1846 and continued through 1878. It was situated annually at different centres throughout the province. Exhibitions included agricultural displays, manufactured goods and artwork. For a brief history of fairs and Provincial Exhibitions in London, consult Frederick H. Armstrong, *The Forest City: An Illustrated History of London, Canada* (London: Windsor Publications, 1986), pp. 111-113.

4. London, Ontario's Crystal Palace was located at the north end of the garrison grounds, near the present-day corner of Wellington Street and Central Avenue.

5. Since this gallery was unheated, it could only be used for exhibitions during the warmer months.

6. Eleanor Shaw, *A History of the London Public Library* (London: London Public Library and Art Museum, 1941), Occasional Paper #4, pp. 1-11.

7. Shaw, p. 20.

8. Poole, pp. 25-27.

9. Roger Boulet, *Frederic Marlett Bell-Smith (1846-1923)* (Victoria: Art Gallery of Greater Victoria, 1977), p. 17.

Chapter 2

10. Refer to these nine articles on London art collectors published in the *London Free Press*: "Private Art Collections in This City Rank With the Best to be Found on the Whole Continent," (11 April 1923), "Paintings of Greatest Artists in Collection of Two Local Brothers," (12 April 1923); " 'Trick' Painting is One of Most Valuable Works in Local Art Treasury," (17 April 1923); "Henschall Masterpiece Occupies First Place in Lawson Collection," (18 April 1923); "Canadian Scenes Form Motif for Number of Londoner's Paintings," (19 April 1923); "Heart Appeal is Strong in Several of Pictures Owned by Mrs. Cummings," (24 April 1923); "London Home Boasts One of the Best Landscape Works Painted by Peel," (25 April 1923); " 'Junk' Pictures Bought by Londoner Appraised as Invaluable Works," (27 April 1923), "Continental Scenes are Depicted by Masters in Local Art Collection," (28 April 1923).

11. Poole, p. 94.

12. Poole, p. 95.

13. Poole, p. 98. See also *An Act Respecting the Elsie Perrin Williams Estate*, Chap. 75, 1938, p. 315.

14. Orlo Miller writes in a speech given at the unveiling of the Dr. Richard E. Crouch Plaque at the Central Library, 13 November 1981, that, "by the early 1930s the [library building] was carrying several times the weight in books that it had been designed to bear. The fabric began to deteriorate alarmingly. A three-foot long crack opened up in the second storey above the entrance overnight. One night while Dick [Crouch] and I were sitting in the furnace room...discussing the situation, the structure gave a louder groan than usual and the floor of the main reading room over our heads dropped nearly two inches. It was obvious something had to be done. We all faced the possibility of a serious, major tragedy."

15. Charles Deane Kent, *Richard Crouch: A Man Ahead of His Time. A Sketch of His Philosophy and Ideas of Library and Art Museum Service as Seen from His Writings* (London: London Public Library and Art Museum, September, 1962), p. 22. Kent quotes from Crouch's speech given in Buffalo at The American Library Association Conference in 1946. This speech was later reprinted as "A Library Meets the Community," *The American Library Association Bulletin* (1946).

16. Richard E. Crouch, "A Community Art Centre in Action," *Canadian Art*, II:1 (October-November, 1944), pp. 22-28.

17. Ibid., p. 22. Crouch writes: "For the past fifty years a number of our libraries have carried on this community centre tradition, established by the [Mechanics] Institutes, through the exhibition of art, historical collections etc. But they have mainly been engaged in evolving and perfecting the means and methods for the democratic use and distribution of the book, and in building up collections to serve the needs of our expanding communities. Our library has followed in this tradition..."

18. Ibid. Crouch writes: "Following our general policy, which is to make our collections available not only in the building but in homes and clubs as well, we are building a collection of paintings, representative of the current work of Canadian artists, which are loaned to people for hanging at home. We have been assisted in this scheme by loans from artists to supplement the purchases we have made..."

19. Alan Jarvis, ed., *Douglas Duncan: A Memorial Portrait* (Toronto: University of Toronto Press, 1974), pp. 52-53 (see the reproduction of the pamphlet).

20. Barbara Moon, "The Man Who Discovered Canadian Painting...", *Maclean's* (4 January 1964), pp. 16, 40-44.

Chapter 3

21. "Agreement between the *Western Art League* and the Trustees of the *Elsie Perrin Williams Memorial Art Gallery*", *Minutes of the London Public Library Board* (15 October 1940). (Hereafter referred to as *Board Minutes* with the date of entry indicated in parentheses).

22. *Minutes of the Art Museum Board of Trustees* (29 November 1940; 21 March 1941). (Hereafter referred to as *Trustees Minutes* with the date of entry indicated in parentheses).

23. *Trustees Minutes* (14 October 1941).

24. *Trustees Minutes* (9 January 1942).

25. *Trustees Minutes* (5 May 1944).

26. F.B. Housser, *A Canadian Art Movement: The Story of the Group of Seven* (Toronto: The MacMillan Company of Canada, 1926).

27. London Public Library and Art Museum, February 1945, *The F.B. Housser Memorial Collection.*

28. *Trustees Minutes* (29 April 1947).

29. *Trustees Minutes* (29 October 1945).

30. The following Canadian artists are presented on a list, appended to the *Trustees Minutes* (28 August 1942), of paintings owned by the library or gallery in the Lending Library of Canadian Art: Herbert S. Palmer, A.Y. Jackson, Frederick S. Coburn, Mary Wrinch, Tom Thomson, J.E.H. MacDonald, A.J. Casson, Nicholas Hornyansky, Leonard Brooks, Manley MacDonald, Clara Hagarty, Walter J. Phillips, Frederick Brigden, Frederick Haines, A.J. Munnings, Frank Brangwyn.

31. *Board Minutes* (9 December 1946). Crouch's report on the Lending Library of Canadian Art was later published in the *Ontario Library Review and Canadian Periodical Index*, XXXI:1 (February 1947), pp. 60-61.

32. *Board Minutes* (18 January 1943).

33. *Trustees Minutes* (15 November 1948).

34. *Board Minutes of the Annual Meeting of 1949* (13 March 1950).

Chapter 4

35. *Board Minutes* (16 October 1950). It was also reported at this meeting that the gallery received a gift of eleven paintings from Mrs. G.A. Reid through Gordon Conn between 1 January and 31 August 1950.

36. *Trustees Minutes* (28 May 1951). Bice notes that the Purchase Fund had "grown to substantial proportions so that we may now consider from time to time the acquisition of an outstanding Canadian work of art or purchase of additional sketches for a collection of Canadian sketches which has been undertaken by the gallery."

37. Contributors to the first Purchase Fund were: London Life Insurance Company; Hay Stationery Ltd.; Simpsons Ltd.; Supertest Petroleum Corp.; Gordon Silverwood, Esq.; T. Eaton Co. Ltd.; Kelvinator of Canada; Scott-McHale Co. Ltd.; London Free Press; Empire Brass; Hugh Mackenzie, Esq.; Emerson Nichols, Esq.; Kellogg Co. Ltd.

38. *Trustees Minutes* (2 June 1952; 3 November 1952).

39. *Board Minutes* (12 January 1953). The paintings were purchased from Bice prior to his leaving for study in France on a Canada Council Fellowship through 1953.

40. *Trustees Minutes* (15 June 1953).

41. Ibid.

42. Acquisition funds were drawn from two sources at this time: The Alfred J. Mitchell Bequest and Art Purchase Fund.

43. *Trustees Minutes* (23 January 1956).

44. In 1976 it was determined that this painting is not by the hand of Thomson. Rather than de-accessioning the painting from the collection, the curator chose to leave it in the collection listed as a "fake" to be used for study purposes.

45. Acquisition Funds for 1959 were increased through a matching grant of $1,000 offered to the gallery by the Canada Council. This grant was applied to the purchase of art from that year's Western Ontario Exhibition.

46. *Trustees Minutes* (11 December 1958).

Chapter 5

47. *Trustees Minutes* (10 March 1960).

48. *Trustees Minutes* (7 October 1963).

49. *Trustees Minutes* (22 November 1963).

50. *Trustees Minutes* (29 January 1965).

51. Donors to "The Special Krieghoff Purchase Fund" were Dr. W.R. Frazer, Dr. Carol Buck, Dr. R.A. Kinch, Dr. and Mrs. Kaveckas, Dr. L.D. Wilcox, Dr. D.A. Nicol, Dr. R.L.J. Annett, Mr. Robert Woxman, Dr. Yorke, Dr. Wilkins, Dr. Ellyatt, Dr. Summerby, Dr. Lindell, Dr. Wermuth, Dr. H. Stewart, Dr. Winder, Dr. MacFarlane, Dr. M. Simpson, Dr. R.G.E. Murray, Dr. Rechnitzer, Dr. Ballantyne, Dr. Lefcoe, Dr. Mowry, Dr. Drake, Dr. Warwick, Dr. A. Denison, and Dr. W.C. Hayman.

52. *Minutes of the Acquisitions Committee* (13 January 1969).

53. *Terms of Reference for the Acquisitions Committee* (March 1970).

54. Frances Duncan Barwick, *Pictures from the Douglas M. Duncan Collection* (Toronto: University of Toronto Press, 1975).

Chapter 6

55. The successive gifts of works of art to the permanent collection by the Moores from 1974 to 1988 were usually administered through the Ontario Heritage Foundation, a provincial agency whose mandate is to preserve Ontario's artistic heritage in the public trust at designated public institutions, which included the London Regional Art Gallery. The number of individual pieces given are as follows: 277 (1974); 55 (1975); 114 (1976); 15 (1980); 5 (1981); 2 (1982); 45 (1985); 30 (1986); 109 (1987). In 1988 ownership of all pieces donated through the OHF was transferred to the art gallery.

56. *London Free Press* (23 July 1975).

57. Exhibited in: London Public Library and Art Museum, 6 March-28 March 1976, *Selections from the Moore Collection Given to the Ontario Heritage Foundation.*

58. London Regional Art Gallery, 20 June-17 August 1980, *The Moore Gift to the Ontario Heritage Foundation.*

59. Something about the OHF and custodial institutions.

Chapter 7

60. The exhibitions were *John Boyle,* March 1974; *Michael Bidner and Ben Linssen,* January 1974.

61. Rent-free space was offered to the gallery to exhibit selections from the permanent collection in the City Centre Mall from 6 January-1 February 1975.

62. *Art Advisory Committee Minutes* (9 September 1974).

63. *Art Advisory Committee Minutes* (5 January 1976).

64. The stolen paintings are: Frederick A. Verner, *Indian in a Canoe* (1872); F. Gayeaume, *Cottage and Tree;* James Hamilton, *London, C.W. Opposite Bank of Upper Canada, 1857;* Hamilton, *The Coves;* Otto Jacobi, *Landscape* (1886); A.Y. Jackson, *A Village in Quebec* (1921); Jackson, *Burnt Trees;* Lucius O'Brien, *Rosseau, Muskoka* (1893); Homer Watson, *On the Grand River;* Franklin Carmichael, *Port Coldwell* (1926); Lawren Harris, *Algonquin Morning;* James Griffiths, *Yellow and Red Roses;* J.E.H. MacDonald, *Moonlight on Sand Dunes, Petite Riviere, N.S.* (1922); MacDonald, *Tamaracks, Algoma* (1921).

65. *Art Advisory Committee Minutes* (10 June 1976).

66. *Art Advisory Committee Minutes* (9 September 1976).

67. The transfer of ownership of the permanent collection from the London Public Library Board to the Art Gallery Board was to have occurred at the end of 1977. However, as a result of a perception among members of the library board that the works of art may be sold in the future to defray operating expenses of the gallery, complete title to the permanent collection has not transferred but remains "on loan" to gallery until December 31, 2030. The Moore Gift was originally donated through the Ontario Heritage Foundation and was transferred in 1988 to the London Regional Art Gallery Board.

Chapter 8

68. *London Regional Art Gallery Board Minutes* (28 October 1981; 31 March 1982). The March entry states that, "Dr. Rans was pleased that the publicity in the *London Free Press* had led to an offer to the Gallery from Mr. Leslie Pickles. These works, a chromolithograph by J.W. Forster of Laurier and an oil landscape by C. Chapman, had been gratefully accepted. The acquisition fund cuts, however, were having a very bad effect on the committee."

COLLECTION LISTING

The Permanent Collection as documented in this volume contains 2532 works of art in various media representing 840 identifiable artists of Canadian and other nationalities. This does not include however an extensive study collection currently holding some 600 additional items or any of the artwork catalogued under the museum division.

The list is arranged in alphabetical order starting with the artist's surname. Several Brazilian and Inuit artists sign their work using only their given name and are thereby listed alphabetically followed by the surname. Unattributed works are documented under "Unidentified Artist". Behind the name and in brackets are the nationality, birth and death dates. If the artist is Canadian, the nationality has been omitted. In some cases, the nationality, birth and death dates are unknown and remain blank.

The second line contains the title of the work and is followed in brackets by its date of execution. If the date is preceeded by a "c." read "circa" or a "p." read "prior to". A "n.d." means that the date is not known at the present time.

The third line details the media, support and edition numbers of the work where applicable.

On the fourth line are the measurements in centimeters in the conventional order of height by width by depth. Where a work is circular, "diameter" will follow the measurement.

The final lines feature the donor or purchase fund credit and conclude with the catalogue number, the first two digits of which indicate the year a work entered the collection.

I would like to thank those who assisted in producing the listing. At the gallery, they are Becky Boughner, Marinella D'Andrea, Ruth Anne Murray, Paddy O'Brien, Nancy Poole and Judith Rodger who helped type, proof and search for information. The staffs of the Art Section and the London Room at the London Public Library, the Reference Department and the Western Ontario Room at the D.B. Weldon Library at the University of Western Ontario, the E.P. Taylor Reference Library at the Art Gallery of Ontario, the Library of the National Gallery of Canada and the computer centre of the Canadian Heritage Inventory Network have all contributed valuable research to its compilation. This help is truly appreciated.

D.B.G. Fair,
Registrar/Curator

A & B ASSOCIES
(René Pierre ALLAIN: (1951-)
(Miguel-Angel BERLANGA:
(1951-)
Tour à Treuil (1983)
mixed media on plywood
76 x 129 x 211 cm.
Art Fund, 85.A.32

Core Island (1984)
mixed media on plywood
243 x 122 x 112 cm.
Art Fund, 85.A.33

Core Island Complex (1984)
graphite, pastel, watercolour and ink
stamp on paper
66 x 101.3 cm.
Art Fund, 85.A.20

Core Island Complex (1984)
graphite, pastel, watercolour and ink
on paper
66 x 101 cm.
Art Fund, 85.A.21

Core Island Complex (1984)
graphite, pastel, charcoal and
watercolour on paper
66 x 101.2 cm.
Art Fund, 85.A.22

Core Island Project (1984)
letra-set, ink, graphite and ink stamp
on paper
40.3 x 58.4 cm.
Art Fund, 85.A.19

Étude pour la tour (c.1983)
graphite, charcoal and ink on paper
51 x 66.1 cm.
Art Fund, 85.A.23

Étude pour la tour (c.1983)
charcoal on paper
50.8 x 66 cm.
Art Fund, 85.A.24

**Étude pour le radeau de Core Island
Complex** (1984)
graphite, watercolour and charcoal on
paper
84.8 x 61 cm.
Art Fund, 85.A.25

Tunnel Entrance (1984)
mixed media on plywood
91 x 66 x 91 cm.
Art Fund, 85.A.34

Untitled (1984)
black marker, graphite pastel and
pencil crayon on paper
33.2 x 50.9 cm.
Art Fund, 85.A.26

Untitled (1984)
black marker, graphite, pastel and
pencil crayon on paper
32.7 x 50.9 cm.
Art Fund, 85.A.27

ADAMS, Sue (1953-)
Aaron's Rod (c.1977)
mixed media on paper
73.7 x 53.3 cm.
Art Fund, 77.A.3

AIROLA, Paavo (1918-1983)
Landscape with Trees (n.d.)
oil on canvas
61 x 101 cm.
Gift of F.A. McGarry, Esq., London,
59.A.1

**AKKANARSHOONAK, Barnabus
(1924-)**
Musk Ox (n.d.)
soapstone
20.9 x 35.6 x 15.2 cm.
Art Fund, 67.A.376

**ALBERS, Anni (American:
1899-)**
Untitled B (1969)
screenprint 48/50 on paper
55.9 x 47 cm.
Gift of Mrs. Mira Godard, Toronto,
90.A.6

Untitled C (1969)
screenprint 56/65 on paper
43.2 x 55.9 cm.
Gift of Mrs. Mira Godard, Toronto,
90.A.7

Untitled D (1969)
screenprint 50/60 on paper
43.2 x 55.9 cm.
Gift of Mrs. Mira Godard, Toronto,
90.A.8

**ALBERS, Josef (American:
1885-1976)**
Homage to the Square: Slate (1965)
oil on masonite
101.6 x 101.6 cm.
Gift of Mr. J.H. Moore, London,
through the Ontario Heritage
Foundation, 81.A.50

White Line Square II (1966)
lithograph trial proof II on paper
39.4 x 39.4 cm.
Gift of Mr. J.H. Moore, London,
through the Ontario Heritage
Foundation, 78.A.215

White Line Square IV (1966)
lithograph trial proof IV on paper
39.4 x 39.4 cm.
Gift of Mr. J.H. Moore, London,
through the Ontario Heritage
Foundation, 78.A.216

White Line Square VII (1966)
lithograph artist's proof on paper
39.4 x 39.4 cm.
Gift of Mr. J.H. Moore, London,
through the Ontario Heritage
Foundation, 78.A.217

White Line Square XII (1966)
lithograph 44/125 on paper
39.4 x 39.4 cm.
Gift of Mr. J.H. Moore, London,
through the Ontario Heritage
Foundation, 78.A.218

White Line Square XVI (1966)
lithograph 62/124 on paper
53.3 x 53.8 cm.
Gift of the Volunteer Committee,
78.A.7

Variants I (1966)
screenprint on paper
21.6 x 33 cm.
Gift of Mrs. Mira Godard, Toronto,
90.A.9

Variants III (1966)
screenprint on paper
25.4 x 36.5 cm.
Gift of Mrs. Mira Godard, Toronto,
90.A.10

Variants IV (1966)
screenprint on paper
27.3 x 27.3 cm.
Gift of Mrs. Mira Godard, Toronto,
90.A.11

**ALEXANDER, Eveline (British:
1818-1906)**
**Grand Military Steeplechase at
London, Canada West, 9th May,
1843** (1846)
engraving on paper
36.9 x 50.8 cm.
Hamilton King Meek Memorial
Collection, 40.A.6

ALLEN, Joyce (1911-)
The Old Brewery (c.1963)
watercolour on paper
26.5 x 34.3 cm.
Gift of Mr. J.H. Moore, London,
through the Ontario Heritage
Foundation, 78.A.27

ALLEN, Ralph (1926-)
Landscape Machine (n.d.)
oil on canvas laid on masonite
76.8 x 96.5 cm.
Art Fund, 62.A.29

Abstract (n.d.)
oil on canvas
45.7 x 55.9 cm.
Gift from the Douglas M. Duncan
Collection, 70.A.58

Flowers in the Air (1960)
oil on board
40.1 x 57.9 cm.
Gift of Mr. J.H. Moore, London,
through the Ontario Heritage
Foundation, 78.A.28

ALMEIDA, Henry (1913-)
Autumn Sunset (1964)
gouache on paper
43.2 x 56.2 cm.
Art Fund, 64.A.74

Landscape (1964)
oil on card
64.1 x 55.9 cm.
Gift from the Douglas M. Duncan
Collection, 70.A.95

ALOUPA (active in 1950s)
**Inuit in Kayak with Hunting
Harpoons and Seals**
stone, ivory and leather
26 x 6.8 x 11 cm.
Gift of Miss Margaret May, London,
90.A.32

ALTWERGER, Libby (1915-)
On the Track (c.1966)
watercolour on paper
50.8 x 61 cm.
Art Fund, 66.A.95

ANDERSON, John (1940-)
Untitled (1973)
acrylic on paper
45.7 x 65.4 cm.
Gift of Mr. J.H. Moore, London,
through the Ontario Heritage
Foundation, 78.A.29

ANDREWS, Sybil (1898-)
Tillers of the Soil (1934)
linocut 51/60 on paper
27 x 36.9 cm.
Gift of the Society of Canadian
Painter-Etchers and Engravers,
50.A.7

Indian Dance (1951)
coloured linocut 21/75 on paper
20.9 x 22.3 cm.
Gift of the Society of Canadian
Painter-Etchers and Engravers,
52.A.7

**ANERGNA (Anirnik Oshuitoq)
(c.1902/09-1983)**
Animal and Bird (1964)
etching 38/50 on paper
25.4 x 22.9 cm.
Print Fund, 72.A.87

ANGELIS, Joseph de (1938-)
Untitled (1972)
collage on paper
56.5 x 88.4 cm.
Purchased with funds from the
Mitchell Bequest, 72.A.9

ANGLISS, George (1921-)
Bottle Cupboard (n.d.)
wood, glass and cork assemblage
104.8 x 41.9 x 5.5 cm.
Art Fund, 71.A.36

ANGOTIGULU (1910-)
Composition (1964)
stonecut 13/50 on paper
45.7 x 41.9 cm.
Print Fund, 72.A.29

Spirit Bird (1964)
stonecut 38/50 on paper
27.9 x 33 cm.
Print Fund, 72.A.32

Flower Bird (1964)
stonecut 38/50 on paper
35.6 x 29.2 cm.
Print Fund, 72.A.33

Dream Flower (1964)
stonecut 38/50 on paper
29.2 x 34.3 cm.
Print Fund, 72.A.74

ANNANIK, George (1904-1968)
Elderly Father and Son (n.d.)
grey soapstone
16 x 13 x 10.7 cm.
Art Fund, 77.A.73

Father Playing with Child (n.d.)
soapstone
14.5 x 12.5 x 7.0 cm.
Art Fund, 77.A.74

APPEL, Karel (Dutch: 1921-)
Untitled (1959)
lithograph 100/125 on paper
54.6 x 64.5 cm.
Gift of Mr. J.H. Moore, London,
through the Ontario Heritage
Foundation, 80.A.187

Untitled (1969)
lithograph 50/75 on paper
76.2 x 66 cm.
Gift of Mr. J.H. Moore, London,
through the Ontario Heritage
Foundation, 80.A.188

Untitled (1979)
serigraph H/C on paper
77.8 x 56.2 cm.
Gift of Mr. & Mrs. Richard M. Ivey,
London, 87.A.16

Untitled (1979)
serigraph H/C on paper
77.7 x 56 cm.
Gift of Mr. & Mrs. Richard M. Ivey,
London, 87.A.17

Untitled (1979)
serigraph H/C on paper
77.7 x 55.9 cm.
Gift of Mr. & Mrs. Richard M. Ivey,
London, 87.A.18

For Rudolph Bikkers . . . (1979)
serigraph H/C on paper
78.1 x 56.3 cm.
Gift of Mr. & Mrs. Richard M. Ivey,
London, 87.A.19

ARCHAMBAULT, Louis (1915-)
Un Homme ailé (1962)
bronze
68.5 x 29.8 x 29.8 cm.
Art Fund, 67.A.15

ARISS, Herb (1918-)
Ruins of Musical Art Building
(1952-55)
gouache on paper
48.3 x 82.6 cm.
Gift of the Estate of Miss Alberta
Tory, 74.A.10

Study (1953)
watercolour on paper
53.3 x 75 cm.
Art Fund, 54.A.80

Mediaeval Horsemen #3 (1957)
watercolour on paper
49.6 x 99.1 cm.
Art Fund, 58.A.103

Idols (1963)
ceramic mounted in wood frame
28.3 x 58.8 x 6.4 cm.
Gift of Mr. & Mrs. J.H. Moore,
London, 87.A.86

**In Memoriam, The Wiltshires and
the Worcesters (The Somme)** (1968)
mixed media
top: 97.8 x 121.9 cm.
bottom: 61 x 121.9 cm.
Purchased with funds from the
Mitchell Bequest, 68.A.47A-B

The Listening Post, Somme Series
(1968)
watercolour on paper
63.5 x 45.7 cm.
Gift of Mr. J.H. Moore, London,
through the Ontario Heritage
Foundation, 78.A.30

**Pop Singer, The Legacy,
Somme Series** (1968)
watercolour on paper
38.1 x 43.2 cm.
Gift of Mr. J.H. Moore, London,
through the Ontario Heritage
Foundation, 78.A.31

Voyeurs, Modern Legend Series
(1973)
pastel and graphite on paper
61 x 93.4 cm.
Gift of Mr. J.H. Moore, London,
through the Ontario Heritage
Foundation, 80.A.59

**Cape Pass #2, The Art of the
Bullfight Series** (1973)
pastel and graphite on paper
61 x 93.9 cm.
Gift of Mr. J.H. Moore, London,
through the Ontario Heritage
Foundation, 80.A.201

Conference, Modern Legend Series
(1973)
pastel and graphite on paper
93.9 x 61 cm.
Gift of Mr. J.H. Moore, London,
through the Ontario Heritage
Foundation, 80.A.202

Judi with Bicycle (1973)
pastel and graphite on paper
93.9 x 61 cm.
Gift of Mr. J.H. Moore, London,
through the Ontario Heritage
Foundation, 80.A.203

The Americans Land in England
(1979)
watercolour on paper
57.2 x 218.5 cm.
Anonymous gift, 82.A.52

**Imaginary Journey: The Somme,
1916** (1976)
graphite on paper
50.5 x 66.5 cm.
Gift of Mrs. Barbara Jackson in
memory of her daughter, Kathleen
Frances Bieman, 89.A.83

ARISS, Joshua (1952-)
Figure: Standing Man (c.1970)
acrylic on steel
198.1 x 60.9 x 6.3 cm
Gift of Mr. J.H. Moore, London,
through the Ontario Heritage
Foundation, 87.A.88

ARISS, Margot (1929-)
Zen Song (1969)
fired clay on wood
88.9 x 58.4 cm.
Gift of Western Art League, 69.A.26

I Love You (1973)
unglazed, fired clay and plastic
on wood
76.2 x 62.9 cm.
Gift of Mr. J.H. Moore, London,
through the Ontario Heritage
Foundation, 87.A.187

Lerida (1973)
glazed, fired clay on wood
71.1 x 91.4 cm.
Gift of Mr. J.H. Moore, London,
through the Ontario Heritage
Foundation, 78.A.200

Through the Senses (1988-89)
cellulose on board, diptych
121.9 x 243.8 cm. each panel
Gift of the Volunteer Committee,
89.A.30A-B

Significant Form (n.d.)
white fired clay on panel
71.1 x 99.1 cm., 133.1 x 99.7 cm.
Gift of the Junior Volunteer
Committee, 75.A.9A-B

**ARMITAGE, Kenneth (British:
1915-)**
Little Torso (1960)
bronze 7/9
12.7 x 25.3 x 9 cm.
Gift of Mr. J.H. Moore, London,
through the Ontario Heritage
Foundation, 78.A.184

ARMSTRONG, William (1822-1914)
View of London, Canada West
(c.1852)
lithograph on paper
11.4 x 17.8 cm.
Anonymous gift, 49.A.50

View of London, Canada West
(c.1852)
lithograph on paper
11.4 x 17.8 cm.
Anonymous gift, 68.A.50

Lakeshore Encampment (n.d.)
watercolour on paper
24.9 x 35.2 cm.
Purchased with matching Acquisitions
funds and a Wintario Grant, 80.A.6

ARP, Jean (French: 1887-1966)
**Variante zu "Configurations Blatt
10"** (c.1949)
woodcut on paper
59.7 x 45.7 cm.
Gift of Mr. J.H. Moore, London,
through the Ontario Heritage
Foundation, 80.A.189

Untitled (n.d.)
serigraph 27/75 on paper
24.8 x 19 cm.
Gift of Mr. J.H. Moore, London,
through the Ontario Heritage
Foundation, 87.A.102

Le Soleil recerclé (n.d.)
woodcut 26/60 on paper
43.5 x 36.7 cm.
Gift of Mr. & Mrs. Richard M. Ivey,
London, 87.A.204

Découpage (n.d.)
bronze #3
26.6 x 19.6 x 0.3 cm.
Gift of Mr. J.H. Moore, London,
through the Ontario Heritage
Foundation, 78.A.105

**ASHENAK (Toomas, Mary)
(1942-)**
Walrus (p.1966)
green serpentine
20.3 x 6.4 x 5.1 cm.
Art Fund, 77.A.83

ATKINS, E. Caven (1907-)
Castles of Decay (1942)
watercolour on paper
41.9 x 57.8 cm.
Gift of Mr. E. Caven Atkins in
memory of his parents, Mr. & Mrs.
Ernest Atkins, London, 74.A.22

Nature's Cathedral Arches (1954)
watercolour on paper
55.3 x 77.2 cm.
Gift of Mr. E. Caven Atkins in
memory of his parents, Mr. & Mrs.
Ernest Atkins, London, 74.A.23

ATKINSON, Eric (1928-)
Witchcraft #3 (1971)
mixed media on wood
66.3 x 62.3 cm.
Gift of Rothmans of Pall Mall Canada
Limited, 74.A.59

Icon Drawing (1970)
ink on paper
43.5 x 38.1 cm.
Gift of Mr. J.H. Moore, London,
through the Ontario Heritage
Foundation, 80.A.10

ATKINSON, William (1862-1926)
The Ravine, Baby Point Road (1919)
oil on canvas
99.1 x 124.5 cm.
On permanent loan from
Mr. Ian B. Flann, Ottawa, 85.A.87

AVATI, Mario (Monacan: 1921-)
Les Radis du mars (1974)
mezzotint 50/85 on paper
30.5 x 24.5 cm.
Gift of the Volunteer Committee,
78.A.8

**AYERD, Paul (British: active circa
1925)**
Landscape (1925)
watercolour on paper
56.5 x 57.2 cm
Gift of Mr. Gordon Conn, Newmarket,
50.A.17

**AYKROYD, Woodruff Kerr
(1904-)**
A. Brittany Farm (n.d.)
drypoint etching 6/50 on paper
25.4 x 20.3 cm.
Print Fund, 45.A.7

Tour de la grosse horloge, Rouen
(n.d.)
drypoint etching 14/50 on paper
19.8 x 27.9 cm.
Print Fund, 45.A.14

**AZEVEDO, Gilda (Brazilian:
1924-)**
Untitled (1970)
wool on canvas
132 x 90.8 cm.
Gift of Mr. & Mrs. J.H. Moore,
London, 85.A.74

AZIZ, Philip (1923-)
Still Life (1955)
watercolour and graphite on paper
37 x 49.5 cm.
Gift of Mr. & Mrs. Richard M. Ivey,
London, 87.A.210

The Four Seasons (1956)
oil on paper
22.8 x 50.8 cm. each panel
Gift of Mr. J.H. Moore, London,
through the Ontario Heritage
Foundation, 78.A.190

Hands and Pectoral Cross (1963)
charcoal on paper
43 x 42 cm.
Gift of Mr. J.H. Moore, London,
through the Ontario Heritage
Foundation, 78.A.32

Ballerina (1964)
watercolour on paper
63 x 47.3 cm.
Gift of Mr. J.H. Moore, London,
through the Ontario Heritage
Foundation, 80.A.96

After Glow (1974)
egg tempera on gesso panel with
handwoven linen and antique silver
165.1 x 114.4 cm.
Anonymous gift, 89.A.63

Polar Spectrum (1974)
egg tempera on gesso panel with gold
leaf
203.2 x 101.6 cm.
Anonymous gift, 89.A.64

Encounter (1976)
egg tempera on masonite
165.1 x 114.3 cm.
Gift of Mr. Taft Aziz, London, 88.A.31

Departure (1976)
egg tempera on masonite
165.1 x 114.3 cm.
Gift of Mr. Taft Aziz, London, 88.A.32

Blue Semi-Circles on Red (1978)
egg tempera on gesso panel
101.6 x 203.2 cm.
Anonymous gift, 89.A.82

Workman Listening to St. Paul
(1956)
ink wash on paper
55.9 x 45.7 cm.
Gift of Mr. J.H. Moore, London,
through the Ontario Heritage
Foundation, 78.A.33

BAILEY, Daisy (1921-1972)
Dragon Flies (1960)
watercolour on paper
41.6 x 67.3 cm.
Purchased with a Canada Council
matching grant and the Art Fund,
61.A.28

The Interloper (1962)
oil on masonite
91.3 x 84.2 cm.
Gift of Mr. & Mrs. Richard M. Ivey,
London, 87.A.207

Study of a Girl (n.d.)
watercolour and collage on paper
65.5 x 35.2 cm.
Gift of Mr. & Mrs. Richard M. Ivey,
London, 87.A.212

BAIRD, Nathaniel John (British:
1865-1936)
A Midsummer Dream (1895)
oil on canvas
30.5 x 50.8 cm.
The W. Thomson Smith Memorial
Collection (Bequest of Alfred J.
Mitchell), 48.A.66

Mother and Child in Courtyard
(1895)
watercolour on paper
34.3 x 24.3 cm.
Hamilton King Meek Memorial
Collection, 40.A.7

Cowboy on Horse (n.d.)
watercolour on paper
33 x 27.9 cm.
The W. Thomson Smith Memorial
Collection (Bequest of Alfred J.
Mitchell), 48.A.70

BAKER, Anna (1928-1985)
The Semi-Anonymous Ones (1954)
lithograph A/P on paper
30.5 x 43.2 cm.
Print Fund, 55.A.48

BARTRAM, Edward John
(1938-)
Split Rock (1970)
etching and aquatint 13/20 on paper
54.9 x 70.6 cm.
Print Fund, 72.A.118

Precambrian Rune #2
etching 36/36 on paper
61 x 91.4 cm.
Gift of Mrs. Mira Godard, Toronto,
90.A.30

Lichen, Starvation Bay (1971)
aquatint and etching 17/30 on paper
55.5 x 70.6 cm.
Gift of Mr. J.H. Moore, London,
through the Ontario Heritage
Foundation, 79.A.33

Rockscape #8 (1976)
serigraph A/P on paper
44.6 x 60.5 cm.
Gift of Mr. & Mrs. Richard M. Ivey,
London, 87.A.15

Red Square (n.d.)
etching 4/20 on paper
59 x 71.1 cm.
Gift of Mr. J.H. Moore, London,
through the Ontario Heritage
Foundation, 80.A.208

BATES, Maxwell (1906-1980)
Children on the Parkway (1951)
oil on canvas
40 x 50.2 cm.
Gift of Mr. J.H. Moore, London,
through the Ontario Heritage
Foundation, 78.A.34

Studio Interior (1961)
oil on board
91.4 x 121.9 cm.
Purchased with a Canada Council
matching grant and the Art Fund,
61.A./2

Centennial Suite: Interior: Figure at
a Table (1968)
serigraph 19/50 on paper
50.8 x 37.6 cm.
Gift of Simon Fraser University,
Burnaby, B.C., 68.A.73

BAXTER, Iain (1936-)
Centennial Suite: Bagged Dayglo
Oranges (1967)
plastic and serigraph 19/50 on paper
47.9 x 36.6 cm.
Gift of Simon Fraser University,
Burnaby, B.C., 68.A.71

BAYEFSKY, Aba (1923-)
The Doves (1951)
watercolour on paper
45.7 x 58.4 cm.
Art Fund, 52.A.16

Boy With Butterflies (1951)
monoprint on paper
35 x 44.5 cm.
Gift from the Douglas M. Duncan
Collection, 70.A.94

Camel Caravan (1958)
watercolour on paper
33.6 x 43.8 cm.
Gift of Mr. J.H. Moore, London,
through the Ontario Heritage
Foundation, 80.A.97

Figure at Market (1960)
watercolour on paper
55.3 x 75.7 cm.
Purchased with Canada Council
matching grant and the Art Fund,
61.A.18

Going to Market (1969)
watercolour on paper
40 x 29.3 cm.
Gift of Mr. J.H. Moore, London,
through the Ontario Heritage
Foundation, 79.A.28

Vegetable Garden, Ogawa (1969)
watercolour on paper
39.7 x 29.3 cm.
Gift of Mr. J.H. Moore, London,
through the Ontario Heritage
Foundation, 79.A.40

Forces of Earth and Sky: Star
Necklace (1971)
serigraph 45/107 on paper
30.7 x 23.1 cm.
Gift of Mr. & Mrs. J.H. Moore,
London, 81.A.45A

Forces of Earth and Sky: Night
Spirit (1971)
serigraph 45/107 on paper
30.7 x 23.1 cm.
Gift of Mr. & Mrs. J.H. Moore,
London, 81.A.45B

Forces of Earth and Sky: Sea
Monster (1971)
serigraph 45/107 on paper
30.7 x 23.1 cm.
Gift of Mr. & Mrs. J.H. Moore,
London, 81.A.45C

Forces of Earth and Sky: Images
(1971)
serigraph 45/107 on paper
30.7 x 23.1 cm.
Gift of Mr. & Mrs. J.H. Moore,
London, 81.A.45D

Forces of Earth and Sky: Giant
Legend (1971)
serigraph 45/107 on paper
30.7 x 23.1 cm.
Gift of Mr. & Mrs. J.H. Moore,
London, 81.A.45E

Forces of Earth and Sky: Lunar
Figure (1971)
serigraph 45/107 on paper
30.7 x 23.1 cm.
Gift of Mr. & Mrs. J.H. Moore,
London, 81.A.45F

Forces of Earth and Sky: Thunder
God (1971)
serigraph 45/107 on paper
30.7 x 23.1 cm.
Gift of Mr. & Mrs. J.H. Moore,
London, 81.A.45G

Forces of Earth and Sky: Creation -
The Galaxies (1971)
serigraph 45/107 on paper
30.7 x 23.1 cm.
Gift of Mr. & Mrs. J.H. Moore,
London, 81.A.45H

Forces of Earth and Sky: Man - Bird
(1971)
serigraph 45/107 on paper
30.7 x 23.1 cm.
Gift of Mr. & Mrs. J.H. Moore,
London, 81.A.45 I

Forces of Earth and Sky: Turtle
Image (1971)
serigraph 45/107 on paper
30.7 x 23.1 cm.
Gift of Mr. & Mrs. J.H. Moore,
London, 81.A.45J

Forces of Earth and Sky: Leaping
Figure (1971)
serigraph 45/107 on paper
30.7 x 23.1 cm.
Gift of Mr. & Mrs. J.H. Moore,
London, 81.A.45K

Forces of Earth and Sky: Sun Spirit
(1971)
serigraph 45/107 on paper
30.7 x 23.1 cm.
Gift of Mr. & Mrs. J.H. Moore,
London, 81.A.45L

BAYER, Herbert (American:
1900-)
Profil en face (1929)
gelatin silver print 11/40 on paper
35.6 x 27.9 cm.
Gift of Mrs. Mira Godard, Toronto,
90.A.28

Der Mennsh Gwint (1932)
gelatin silver print 1/40 on paper
34.9 x 25.4 cm.
Gift of Mrs. Mira Godard, Toronto,
90.A.22

Einsamer Grobstadter (1932)
gelatin silver print 8/40 on paper
33 x 27.2 cm.
Gift of Mrs. Mira Godard, Toronto,
90.A.23

Monument #4 (1932)
gelatin silver print 19/40 on paper
34.3 x 21 cm.
Gift of Mrs. Mira Godard, Toronto,
90.A.26

Knochen Mit Meer (1936)
gelatin silver print 2/40 on paper
26.7 x 33 cm.
Gift of Mrs. Mira Godard, Toronto,
90.A.24

Metamorphose (1936)
gelatin silver print 11/40 on paper
25.4 x 34.6 cm.
Gift of Mrs. Mira Godard, Toronto,
90.A.25

Nature morte (1936)
gelatin silver print 6/40 on paper
26.7 x 31.9 cm.
Gift of Mrs. Mira Godard, Toronto,
90.A.27

Stehende Objekte (1936)
gelatin silver print 2/40 on paper
34.6 x 24.1 cm.
Gift of Mrs. Mira Godard, Toronto,
90.A.29

Chromatic and Weave #23 (1966)
watercolour on paper
40.6 x 40.6 cm.
Gift of Mr. J.H. Moore, London,
through the Ontario Heritage
Foundation, 78.A.168

Distant Glow (1970)
acrylic on canvas
127 x 127 cm.
Gift of Mr. & Mrs. Richard M. Ivey,
London, 90.A.5

**Two Curves from Coloured
Procession in Red** (1975)
screenprint 5/50 on paper
75.6 x 75.6 cm.
Gift of Mrs. Mira Godard, Toronto,
90.A.18

**Two Curves from Coloured
Procession in Blue** (1975)
screenprint 5/50 on paper
75.6 x 75.6 cm.
Gift of Mrs. Mira Godard, Toronto,
90.A.19

Two Triangulated Squares (1975)
screenprint 4/50 on paper
75.6 x 75.6 cm.
Gift of Mrs. Mira Godard, Toronto,
90.A.21

Three Floating Segments (1981)
screenprint 8/50 on paper
75.6 x 75.6 cm.
Gift of Mrs. Mira Godard, Toronto,
90.A.20

BEAMENT, Harold (1898-1984)
Winter Evening, Georgian Bay (n.d.)
oil on canvas
59.7 x 72.4 cm.
Art Fund, 42.A.17

BEAMENT, Tib (1941-)
Lindy Made It (1967)
acrylic and oil pastel on masonite
71.7 x 64.1 cm.
Gift of Reeves (Canada) Ltd., Toronto,
67.A.392

BEATTIE, Brent (1950-)
Double Wedding (1982)
mixed media collage on paper
56.5 x 76.2 cm.
27.9 x 21.7 cm. for other
three panels
Art Fund, 83.A.21A-D

BEATTY, J.W. (1869-1941)
Old Stumps (1910)
oil on canvas board
22.9 x 29.2 cm.
Gift of Dr. & Mrs. Daniel Lowe,
London, 82.A.51

Lake Shore Line (c.1925)
oil on board
20.5 x 30.5 cm.
Gift of Dr. & Mrs. Daniel Lowe,
London, 82.A.50

Meadow Vale (c.1925)
oil on board
20.5 x 30.5 cm.
Gift of Dr. & Mrs. Daniel Lowe,
London, 82.A.49

Summer Landscape (n.d.)
oil on wood
26.7 x 21.6 cm.
Art Fund, 76.A.13

Sketch (n.d.)
oil on wood
21.6 x 26.7 cm.
F.B. Housser Memorial Collection,
45.A.37

Ontario Farm (n.d.)
oil on wood
48.9 x 59 cm.
Gift of the Volunteer Committee,
59.A.6

**BEAUDIN, André (French:
1895-1970)**
Illustration for Sylvie Suite (n.d.)
serigraph on paper
31.1 x 23.2 cm.
Gift of Mr. J.H. Moore, London,
through the Ontario Heritage
Foundation, 87.A.92

BEAULIEU, Paul (1910-)
Les Marguerites (1957)
watercolour on paper
31.8 x 57.4 cm.
Gift of Dr. Max Stern, Montreal,
58.A.102

Provence (1959)
oil on canvas
88.9 x 116.8 cm.
Art Fund, 61.A.69

Trees (1957)
watercolour on paper
48.9 x 63.5 cm.
Gift of Mr. J.H. Moore, London,
through the Ontario Heritage
Foundation, 78.A.35

BEDER, Jack (1909-)
Rocky Vista, Nova Scotia (1948)
watercolour on paper
37.6 x 53.3 cm.
Art Fund, 49.A.34

BELL, Alistair (1913-)
Two Eland (1952)
woodcut 3/10 on paper
25.4 x 30.5 cm.
Print Fund, 53.A.69

Zennor (1960)
ink and watercolour on paper
53.9 x 37.6 cm.
Purchased as a "Director's Choice"
with a Canada Council grant, 69.A.72

Above Lamorna (1960)
ink and watercolour on paper
37.6 x 54.6 cm.
Purchased with Canada Council
matching grant and the General
Purchase Fund, 61.A.73

Llamas (1961)
etching 33/75 on paper
19.8 x 27.4 cm.
Gift of the Society of Canadian
Painter-Etchers and Engravers,
61.A.49

Sand Dune Trees (1968)
ink and watercolour on paper
33.6 x 42.8 cm.
Purchased as a "Director's Choice"
with a Canada Council grant, 69.A.71

BELL, Robin (1949-)
Relic (1977)
bronze on green marble base
23.8 x 29.5 x 15 cm.
Gift of Mr. J.H. Moore, London,
through the Ontario Heritage
Foundation, 85.A.2

BELLEFLEUR, Leon (1910-)
Regates (1958)
oil on canvas
48.9 x 59.1 cm.
Gift of Mr. J.H. Moore, London,
through the Ontario Heritage
Foundation, 78.A.36

Giboulee (1960)
oil on canvas
56.5 x 47 cm.
Art Fund, 61.A.70

**BELL-SMITH, Frederic Marlett
(1846-1923)**
Return from School (1884)
oil on canvas
91.4 x 153.7 cm.
Presented to the City of London by
Mrs. Annie W.G. Cooper in loving
memory of her husband, Albert
Edward Cooper, 40.A.4

Whitehead, Portland, Maine (1886)
watercolour on paper
15.5 x 30.5 cm.
The Director's Discretionary Fund,
87.A.39

Fraser Canyon, B.C. (1888)
watercolour on paper
34.3 x 26 cm.
Anonymous gift, 74.A.11

Albert Canyon, B.C. (1888)
watercolour on paper
34.3 x 26 cm.
Anonymous gift, 74.A.14

The Wave (c.1891)
oil on canvas
71.1 x 127 cm.
Gift of Mr. F.M. Bell-Smith to the City
of London in 1896, 12.A.1

In the Luxembourg Gardens, Paris
(1896)
watercolour on paper
30.5 x 49.5 cm.
Gift of the Estate of Mrs. A.M.
Cleghorn, London, 67.A.399

Mt. Temple in the Rocky Mountains
(1901)
watercolour on paper
63.5 x 45.7 cm.
The W. Thomson Smith Memorial
Collection (Bequest of Alfred J.
Mitchell), 48.A.86

Pacific Breakers, B.C. (c.1915)
oil on canvas
61 x 81 cm.
Gift of Mr. & Mrs. Donald H. Swift,
London, 88.A.28

The Great Silence (1921)
oil on canvas
91.4 x 139.7 cm.
Anonymous gift, 68.A.92

Valley of the Wye (n.d.)
watercolour on paper
22.9 x 33 cm.
Gift of Mary Rowell Jackman in
memory of Mary Coyne Rowell,
77.A.13

The Yoho Valley, B.C. (n.d.)
watercolour on paper
36.9 x 53.3 cm.
The W. Thomson Smith Memorial
Collection (Bequest of Alfred J.
Mitchell), 48.A.40

Rocky Coast (n.d.)
watercolour on paper
44.2 x 62 cm.
The W. Thomson Smith Memorial
Collection (Bequest of Alfred J.
Mitchell), 48.A.85

**Landseer's Lions Beneath Nelson's
Monument, Trafalgar Square** (n.d.)
watercolour on paper
30.5 x 22.9 cm.
The W. Thomson Smith Memorial
Collection (Bequest of Alfred J.
Mitchell), 48.A.72

BENNER, Tom (1950-)
White Rhino (1985-86)
aluminium and wood
160 x 108 x 305 cm.
Purchased with funds from
International Services of London,
87.A.37

The Coves (1990)
mixed media on paper mounted on
wood
140 x 79 cm.
General Purchase Fund, 90.A.4

**BENTON, Thomas Hart (American:
1889-1975)**
The Meeting (1941)
lithograph on paper
22.9 x 29.2 cm.
Print Fund, 46.A.63

Night Firing (1943)
lithograph on paper
21.9 x 33.6
Print Fund, 46.A.65

Island Hay (1945)
lithograph on paper
31.8 x 25.4 cm.
Print Fund, 46.A.62

BENY, Roloff (1924-1984)
Jocasta (1946)
serigraph on paper
40.6 x 29.2 cm.
Gift of Mr. J.H. Moore, London,
through the Ontario Heritage
Foundation, 87.A.188

Cosmic (1946)
etching 6/10 on paper
43.2 x 29.9 cm.
Gift of Mr. J.H. Moore, London,
through the Ontario Heritage
Foundation, 80.A.60

Metamorphosis (1946)
etching 5/15 on paper
43.2 x 29.9 cm.
Gift of Mr. J.H. Moore, London,
through the Ontario Heritage
Foundation, 80.A.61

Maya, A Place in the Sun (n.d.)
oil on canvas
156.8 x 124.5 cm.
Gift of Roloff Beny, Esq., 58.A.7

BERGMAN, Eric (1893-1958)
Peonies (1932)
wood engraving 9/60 on paper
16.5 x 20.9 cm.
Print Fund, 47.A.33

**BERTHON, George Theodore
(1806-1892) (attributed to)**
Portrait of Lionel Ridout (1857)
oil on linen
76.2 x 63.5 cm.
Gift of the Misses Pennington,
London, 76.A.25

Portrait of Louisa (Lawrason) Ridout
(1858)
oil on linen
76.2 x 63.5 cm.
Gift of the Misses Pennington,
London, 76.A.22

Portrait of Louisa Jane Ridout
(c.1858)
oil on linen
50.8 x 43.2 cm.
Gift of the Misses Pennington,
London, 76.A.23

Portrait of Joseph Ridout (n.d.)
oil on linen
76.2 x 63.5 cm.
Gift of the Misses Pennington,
London, 76.A.26

Portrait of George Ridout (n.d.)
oil on linen
76.2 x 63.5 cm.
Gift of the Misses Pennington,
London, 76.A.27

BETTS, Flora Douglas (1914-)
Nude (1960)
oil on canvas
55.9 x 35.6 cm.
Gift of Mr. J.H. Moore, London,
through the Ontario Heritage
Foundation, 78.A.37

BIANCO (Brazilian: -)
Santa (1974)
oil on board
60 x 45 cm.
Gift of Mr. & Mrs. J.H. Moore,
London, 85.A.38

BICE, Clare (1908-1976)
Seated Boy (c.1935-36)
pastel on paper
22.9 x 15.2 cm.
Gift of Mr. Roy Kerr, London,
81.A.60

Portrait of J.W. Westervelt Sr.
(1938)
oil on canvas
106.7 x 91.4 cm.
Gift of Mr. W. Floyd Marshall,
London, 77.A.50

Schooner (1949)
oil on canvas
40.6 x 45.7 cm.
Art Fund, 52.A.23

Two Fishing Boats (1951)
oil on canvas board
40.6 x 50.8 cm.
Art Fund, 52.A.70

Fishermen's Houses (1952)
oil on card
40.6 x 50.8 cm.
Art Fund, 52.A.27

Round Pond, Tuilleries, Paris (1954)
oil on masonite
63.5 x 76.2 cm.
Gift of Mr. J.H. Moore, London,
through the Ontario Heritage
Foundation, 80.A.98

Horseback in the Bois (1957)
oil on canvas
101.6 x 127 cm.
Art Fund, 58.A.9

Grey Music (1959)
oil on masonite
91.4 x 121.9 cm.
Gift of Robert Simpson Company,
Toronto, 75.A.5

October Woods (c.1963)
oil on board
40.3 x 50.3 cm
Gift of Dr. & Mrs. O.E. Ault, Ottawa,
85.A.9

Evening Light, Atlantic Cove
(c.1960-65)
oil on canvas
61.0 x 76.2 cm.
Gift of Mr. John White, London,
85.A.88

St. Fidèle, Québec (1973-74)
oil on canvas
61.0 x 76.2 cm.
Gift of the London Art Gallery
Association, 74.A.9

**BIDDLE, George (American:
1885-1973)**
Three Heads (1906)
etching on paper
34.3 x 44.5 cm.
Print Fund, 46.A.52

BIDNER, Michael (1944-1989)
**1 Suite Xerox Study on Several
Levels** (1972)
Xerox on paper
35.6 x 22.3 cm.
Art Fund, 72.A.95 I-XXVII

BIELER, André (1896-1989)
St. François, Île d'Orléans (1928)
linocut on paper
15.2 x 18.1 cm.
Gift of the Estate of Mrs. Margaret
Porteous, London, 69.A.6

BIERK, David (1944-)
**Music Gallery Portfolio: Wrapped
Sax** (1982)
serigraph 4/40 on paper
53.3 x 35.9 cm.
Purchased with Canada Council
matching grant and the Acquisitions
Fund, 82.A.30

BIKKERS, Rudolf (1943-)
Shostakovitch Suite: Prelude (1971)
serigraph 146/150 on paper
75.9 x 63.5 cm.
Print Fund, 72.A.92A

Shostakovitch Suite: Fugue (1971)
serigraph 146/150 on paper
75.9 x 63.5 cm.
Print Fund, 72.A.92B

Shostakovitch Suite: Scherzo (1971)
serigraph 146/150 on paper
75.9 x 63.5 cm.
Print Fund, 72.A.92C

Shostakovitch Suite: Intermezzo
(1971)
serigraph 146/150 on paper
75.9 x 63.5 cm.
Print Fund, 72.A.92D

Shostakovitch Suite: Finale (1971)
serigraph 146/150 on paper
75.9 x 63.5 cm.
Print Fund, 72.A.92E

Rope (1974)
egg tempera on board
50.8 x 43.8 cm.
Art Fund, 74.A.18

13 Prospect (1975)
serigraph on paper
79.5 x 55.3 cm.
Gift of Mr. & Mrs. Richard M. Ivey,
London, 87.A.6

26 Prospect Avenue (1980)
serigraph 23/115 on paper
76 x 55 cm.
Gift of Mr. & Mrs. Richard M. Ivey,
London, 87.A.7

BILL, Jakob (Swiss: 1942-)
1970 No. 2 (1970)
acrylic on canvas
121.9 x 121.9 cm.
Gift of Mrs. Mira Godard, Toronto,
90.A.12

BILL, Max (Swiss: 1908-)
4:4 Series, Number I (1968)
screenprint 29/100 on paper
41.3 x 41.3 cm.
Gift of Mrs. Mira Godard, Toronto,
90.A.13

4:4 Series, Number VI (1968)
screenprint 29/100 on paper
41.3 x 41.3 cm.
Gift of Mrs. Mira Godard, Toronto,
90.A.14

4:4 Series, Number VII (1968)
screenprint 29/100 on paper
41.3 x 41.3 cm.
Gift of Mrs. Mira Godard, Toronto,
90.A.15

4:4 Series, Number VIII (1968)
screenprint 29/100 on paper
41.3 x 41.3 cm.
Gift of Mrs. Mira Godard, Toronto,
90.A.16

4:4 Series, Number XI (1968)
screenprint 29/100 on paper
41.3 x 41.3 cm.
Gift of Mrs. Mira Godard, Toronto,
90.A.17

Excentrische Farbver Schranking
(1972)
serigraph 24/25 on paper
64.1 x 48.6 cm.
Gift of Mr. J.H. Moore, London,
through the Ontario Heritage
Foundation, 80.A.51

BINNING, Bertram (1909-1976)
Centennial Suite: Merging Sides
(c.1967)
serigraph 19/50 on paper
35.6 x 49.6 cm.
Gift of Simon Fraser University,
Burnaby, B.C., 68.A.70

**BIRLEY, Oswald, (British:
1880-1952)**
Portrait of the Hon. Sir Adam Beck
(1909)
oil on canvas
111.8 x 90.2 cm.
Anonymous gift, 50.A.48

**BISHOPP, Patience E. (British:
active 1887-1906)**
Bruges on the Dyver (1905)
watercolour on paper
37.6 x 22.3 cm.
The W. Thomson Smith Memorial
Collection, (Bequest of Alfred J.
Mitchell), 48.A.75

The Cedar, Monken Hadlow (1919)
watercolour on paper
7.9 x 45.7 cm.
The W. Thomson Smith Memorial
Collection, (Bequest of Alfred J.
Mitchell), 48.A.73

BLACK, Sam (1913-)
Fraser Loggers (1964)
woodcut 4/25 on paper
35.6 x 71.7 cm.
Print Fund, 65.A.91

BLACKWOOD, David (1941-)
The Messenger (1965)
etching A/P on paper
50.3 x 63.5 cm.
Print Fund, 66.A.26

Search Party (1964)
etching 4/10 on paper
75 x 50.3 cm.
Gift from the Douglas M. Duncan
Collection, 70.A.69

**BLACKWOOD, Frederick Temple
(British: 1826-1902)**
Ottawa (c.1872-78)
watercolour on paper
10.8 x 19.8 cm.
Gift of Mrs. John Harley, London,
64.A.146

A Beaver Dam (c.1872-78)
watercolour on paper
16.5 x 24.5 cm.
Gift of Mrs. John Harley, London,
64.A.149

La Roche percée, Gulf of the St. Lawrence (c.1872-78)
watercolour on paper
13 x 52.8 cm.
Gift of Mrs. John Harley, London, 64.A.151

Killarney (c.1874)
watercolour on paper
13.0 x 20.6 cm.
Gift of Mrs. John Harley, London, 64.A.148

Our Fishing Camp on the St. John's River Near Gaspé (1874)
watercolour on paper
18.1 x 25.7 cm.
Gift of Mrs. John Harley, London, 64.A.150

Lake Winnipeg near Mouth of the Saskatchewan (c.1877)
watercolour on paper
15.8 x 25.4 cm.
Gift of Mrs. John Harley, London, 64.A.145

The Red River Where it Flows into Lake Winnipeg (c.1877)
watercolour on paper
15.8 x 27.4 cm.
Gift of Mrs. John Harley, London, 64.A.147

The Saskatchewan River (c.1877)
watercolour on paper
15.5 x 35 cm.
Gift of Mrs. John Harley, London, 64.A.152

Waterspout in Manitoba (1877)
watercolour on paper
15.5 x 35 cm.
Gift of Mrs. John Harley, London, 64.A.153

Moonrise Over Reeds on Lake Winnipeg (1877)
watercolour on paper
14.4 x 42.6 cm.
Gift of Mrs. John Harley, London, 64.A.154

BLOORE, Ronald (1925-)
Painting No. 13 (1965)
oil on masonite
61 x 61 cm.
Gift of Mr. J.H. Moore, London, through the Ontario Heritage Foundation, 78.A.39

B.67 (1968)
enamel on masonite
121.9 x 121.9 cm.
Gift of the London Art Gallery Association, 70.A.106

B.51 (n.d.)
graphite and ink on paper
66 x 52.1 cm.
Art Fund, 68.A.41

Untitled (n.d.)
oil on board
17.8 x 12.7 cm.
Gift of Mr. J.H. Moore, London, through the Ontario Heritage Foundation, 78.A.38

BOA PRODUCTIONS
Chambers (n.d.)
colour film
44 minutes long
Gift of Mr. & Mrs. J.H. Moore, London, 78.A.239

BOBAK, Bruno (1923-)
Rock Hill (c.1951)
wood engraving 11/30 on paper
14 x 20.3 cm.
Print Fund, 52.A.6

Young Pine (1955)
pastel on paper
45.7 x 61.6 cm.
Gift of the W. Purdom Insurance Co. Ltd., London, 64.A.116

Vancouver Looking South (1959)
oil on canvas
106.7 x 172.7 cm.
Art Fund, 60.A.114

BOBAK, Molly (1922-)
Flowers (1958)
serigraph 8/32 on paper
53.9 x 38.1 cm.
Gift of F.A. McGarry, Esq., London, 59.A.2

On The Beach (1959)
oil on canvas
116.8 x 143.5 cm.
Purchased with funds from the Mitchell Bequest, 60.A.113

Florence, Italy (1961)
lithograph 4/10 on paper
25.4 x 35 cm.
Print Fund, 64.A.4

Sweet Rocket (c.1968)
watercolour on paper
59.7 x 42.6 cm.
Gift of Mr. J.H. Moore, London, through the Ontario Heritage Foundation, 80.A.100

Pink Poppies (c.1968)
watercolour on paper
61 x 46.7 cm.
Gift of Mr. J.H. Moore, London, through the Ontario Heritage Foundation, 80.A.99

BOLDUC, David (1945-)
Light Moon (1978)
oil on canvas
162.6 x 274.3 cm.
Purchased with Canada Council matching grant and the Acquisitions Fund, 79.A.14

BOLT, Ron (1938-)
Precambrian Variation #13 (1977)
acrylic on canvas
89.0 x 119.5 cm.
Gift of Dr. & Mrs. L. Shankman, London, 86.A.6

BONDERENKO, Richard (1950-)
Cha Cha Cha (1977)
acrylic on canvas
198.1 x 167.6 cm.
Purchased with matching Acquisitions funds and a Wintario Grant, 80.A.3

BONHAM, Don (1940-)
A Cut Away View of Yamahama Momma With A Big Ass Tire (1973)
woodcut 1/25 on paper
52.1 x 105.4 cm.
Print Fund, 73.A.15

Herman Goode at Bonneville (1975)
mixed media on panel
58.4 x 88.4 cm.
Art Fund, 75.A.12

BORDUAS, Paul-Émile (1905-1960)
Au Gré des crêtes (1957)
oil on canvas
45.1 x 37.4 cm.
Gift of Mr. J.H. Moore, London, through the Ontario Heritage Foundation, 78.A.40

Untitled (1959)
oil on canvas
73 x 59.7 cm.
Gift of Mr. J.H. Moore, London, through the Ontario Heritage Foundation, 81.A.51

BORDUAS, Paul Jr. (1940-)
Oiseau de feu (n.d.)
welded steel
34.9 x 25.4 x 12.7 cm.
Gift of Mr. J.H. Moore, London, through the Ontario Heritage Foundation, 87.A.99

BOROWSKY, Peter (1948-)
Come Alive (1973)
canvas, foam rubber and steel
127 x 40 x 46 cm.;
121.9 x 147.3 x 31 cm.
Gift of the Junior Volunteer Committee, 73.A.106A-B

Morning Light (1976)
photo silkscreen 4/100 on paper
45.7 x 58.1 cm.
Purchased with funds from the Mitchell Bequest, 76.A.1

BOTERO, Fernando (Columbian: 1932-)
Bananas (1975)
oil on canvas
99 x 133.4 cm.
Gift of Mr. J.H. Moore, London, through the Ontario Heritage Foundation, 79.A.8

BOTHAMS, Walter (British: active 1882-1914)
Cows in Pasture (n.d.)
watercolour on paper
19.1 x 27.4 cm.
The W. Thomson Smith Memorial Collection, (Bequest of Alfred J. Mitchell), 48.A.68

BOUCHARD, Simone Mary (1912-1945)
Portrait of Son of Louise Gadbois (c.1943)
oil on panel
45.5 x 53.7 cm.
Gift of Mr. Richard Alway, Toronto, 84.A.242

BOURDELLE, Émile (French: 1861-1929)
Torse d'une Suedoise (c.1907)
bronze VII
38.1 x 19 x 10.5 cm.
Gift of Mr. J.H. Moore, London, through the Ontario Heritage Foundation, 78.A.186

BOYDELL, John (British: 1719-1804) after PATON, Richard (British: 1717-1791)
...Louisbourgh Harbour...July 26, 1758 ... (c.1771)
etching on paper
41.5 x 60.5 cm.
Gift of Mr. & Mrs. J.H. Moore, London, 89.A.40

BOYLE, John (1941-)
Reitman's (1965)
ink on paper
44.8 x 29.5 cm.
Gift of Mr. J.H. Moore, London, through the Ontario Heritage Foundation, 80.A.12

Sitting on the Pot, Looking at my New Studio (1965)
ink on paper
44.5 x 29.9 cm.
Gift of Mr. J.H. Moore, London, through the Ontario Heritage Foundation, 80.A.13

Stolen Chair (1965)
ink on paper
44.8 x 29.9 cm.
Gift of Mr. J.H. Moore, London, through the Ontario Heritage Foundation, 80.A.14

Gladiolas (1966)
ink on paper
45.4 x 29.5 cm.
Gift of Mr. J.H. Moore, London, through the Ontario Heritage Foundation, 80.A.11

Midnight Oil - Ode to Tom Thomson (1969)
oil on wood, light bulb and electrical wiring
243.8 x 248.9 x 83.8 cm.
Art Fund, 69.A.85

Great Grandma/Cityscape (1970-71)
oil on canvas
31.1 x 31.1 cm.
Gift of Mr. J.H. Moore, London, through the Ontario Heritage Foundation, 78.A.41

Great Grandpa/Cityscape (1970-71)
oil on canvas
24.4 x 24.4 cm.
Gift of Mr. J.H. Moore, London, through the Ontario Heritage Foundation, 78.A.42

Eulalie (1971)
oil on canvas mounted on board
101.6 x 132.1 cm.
Gift of Mr. Harry Snoek, Willowdale, 89.A.36

Boy with Blue Moose (1973)
serigraph 73/80 on paper
53.0 x 68.0 cm.
Gift of Dr. Lynne DiStephano, London, 84.A.247

The London Six (1984)
oil on canvas
65.5 x 96.3 cm.
Gift to the City of London from
Suncor Incorporated, 87.A.25

BOZAK, Robert (1944-)
Hockey Stick Piece (1974)
watercolour on paper
90.9 x 106.6 cm.
Gift of the London Art Gallery
Association, 75.A.7

Jamie Bone (1980)
acrylic on canvas
106.7 x 213.4 cm.
Purchased with matching Acquisitions
funds and a Wintario Grant, 80.A.230

BRADSHAW, Alice (1916-)
The Pearl Divers (1947)
ink and crayon on paper
31.8 x 28.2 cm.
Gift of Mr. J.H. Moore, London,
through the Ontario Heritage
Foundation, 80.A.15

BRADSHAW, Eva (1871-1938)
Portrait of Francis Thomas Aldridge
(1916)
oil on canvas
40.6 x 30.5 cm.
Gift of Francis Thomas Aldridge,
Sidney, B.C., 72.A.119

Boy with Book (c.1925)
oil on board
96.5 x 72.4 cm.
Gift of the Western Art League and
I.O.D.E., Nicholas Wilson Chapter,
39.A.1

Portrait of George M. Reid (1927)
oil on canvas
121.9 x 91.4 cm.
Gift of Joseph McManus, London,
72.A.1

Marigolds and Larkspur (1937)
oil on canvas
71.1 x 58.4 cm.
Gift of a group of London citizens,
37.A.1

Bowl of Flowers (n.d.)
oil on canvas
51 x 58.5 cm.
Gift of Dr. & Mrs. Daniel Lowe,
London, 84.A.239

Gladiolas (n.d.)
oil on canvas
58.4 x 68 cm.
Gift of the Western Art League,
37.A.2

Plums (c.1924)
oil on canvas
94 x 73.7 cm.
Art Fund, 56.A.16

Portrait of a Young Boy (n.d.)
oil on canvas
61 x 45.8 cm.
Gift of Miss Rachel Johnston,
London, 78.A.220

Roses (n.d.)
oil on canvas
40.1 x 47 cm.
Bequest of Miss Ethel Brenda Howie,
London, 71.A.19

Roses (n.d.)
oil on canvas
30.5 x 53.9 cm.
Gift of Mrs. A.K. North, London,
80.A. 231

Spring Bouquet (n.d.)
oil on canvas
59 x 46.4 cm.
Gift of Mrs. Ruth Fitzgerald, London,
85.A.8

Untitled (n.d.)
oil on canvas
35.6 x 20.3 cm.
Gift of Mr. J.H. Moore, London,
through the Ontario Heritage
Foundation, 78.A.43

Still Life with Grapes (n.d.)
oil on canvas
35.6 x 61 cm.
Gift of Mrs. Louise McLandress,
Winnipeg, 87.A.221

Study of Flowers in a Glass Vase
(n.d.)
oil on canvas board
20 x 15 cm.
Gift of the Estate of Jean Campbell
Brady, 88.A.5

Still Life with Grapes and Bowl
(n.d.)
oil on canvas
28 x 46 cm.
Gift of the Estate of Jean Campbell
Brady, 88.A.6

Marigolds and Delphiniums (n.d.)
oil on canvas
51 x 61 cm.
Gift of the Estate of Jean Campbell
Brady, 88.A.7

Girl at the Window (n.d.)
oil on canvas
56 x 41.5 cm.
Gift of the Estate of Jean Campbell
Brady, 88.A.8

Still Life with Red Roses (n.d.)
oil on canvas
41.5 x 57.5 cm.
Gift of Mrs. Frederick Lewis, in
memory of her husband, Colonel
Frederick Du Nord Lewis, London,
88.A.15

BRAINERD, Charlotte (1923-)
Aerial (1965)
aquatint 2/10 on paper
30.5 x 22.3 cm.
Gift of the Western Art League,
65.A.15

BRANDEIS, Antonietta
(Czechoslavakian: 1849-1920)
Main Gallery of the Uffizi Palace
(n.d.)
oil on wood
31.8 x 44.5 cm.
Gift of Dr. Sherwood Fox, London,
48.A.90

BRANDTNER, Fritz (1896-1969)
Montreal West (1934)
charcoal and graphite on paper
35.6 x 28.9 cm.
Gift of Mr. J.H. Moore, London,
through the Ontario Heritage
Foundation, 80.A.101

The Other Side of Life, No. 5 (1938)
watercolour and ink on paper
22.9 x 16.5 cm.
Gift from the Douglas M. Duncan
Collection, 70.A.75

BRAQUE, Georges (French:
1882-1963)
Bullfighter (n.d.)
serigraph 58/75 on paper
38.1 x 25.1 cm.
Gift of Mr. J.H. Moore, London,
through the Ontario Heritage
Foundation, 87.A.103

BREEZE, Claude (1938-)
Centennial Suite: Untitled (1967)
serigraph 19/50 on paper
49.6 x 36.9 cm.
Gift of Simon Fraser University,
Burnaby, B.C., 68.A.78

Island Painting No. 3 (1968)
acrylic on canvas
125.7 x 76.2 x 8.8 cm.
Purchased as a ''Director's Choice''
with a Canada Council Grant, 69.A.52

Canadian Atlas: Moonlight (1972)
acrylic on canvas
149.9 x 121.9 c.m
Gift of Mr. J.H. Moore, London,
through the Ontario Heritage
Foundation, 78.A.44

Coast Channel No. 1 (1976)
serigraph 4/50 on paper
59.7 x 42.8 cm.
Purchased with funds from the
Mitchell Bequest, 76.A.7

Coast Channel No. 2 (1976)
serigraph 40/50 on paper
59.7 x 42.8 cm.
Purchased with funds from the
Mitchell Bequest, 76.A.8

BRENDER à BRANDIS, Gerard
(1942-)
March Sundown (1967)
wood engraving A/P on paper
20 x 28.3 cm.
Purchased with funds from the
Mitchell Bequest, 67.A.9

BRIANSKY, Rita (1925-)
Discovery (1961)
graphite on paper
46.3 x 35.6 cm.
Art Fund, 62.A.30

The Mandolin Player (1964)
etching and aquatint 18/75 on paper
25.1 x 20.3 cm.
Print Fund, 65.A.89

BRIANT, Aubrey (British: active
circa 1815)
Portrait of William Cradock Bettridge
(1815)
watercolour on paper
6.3 x 4.7 cm.
Gift of the Misses Pennington,
London, 76.A.28

BRIGDEN, Fred (1871-1956)
Haying In the Laurentians (n.d.)
watercolour on card
41.9 x 53.6 cm.
Gift of Mr. Fred Brigden, 52.A.69

Still Waters (c.1903)
watercolour on paper
36.8 x 40 cm.
Gift of Mrs. Irene Pashley, London,
81.A.56

Orchard (n.d.)
oil on canvas
50.8 x 60.9 cm.
General Purchase Fund, 45.A.38

BRISBY, Peggy (c.1898-1985)
The Deserted Cottage Near Whitby
(n.d.)
watercolour on paper
47 x 66 cm.
Gift of Mr. Gordon Conn, Newmarket,
49.A.5

BRITTON, Harry (1878-1958)
Sheep Returning by Moonlight
(1939)
oil on canvas
47 x 56.5 cm.
Anonymous gift, 68.A.88

BROOKER, Bertram (1888-1955)
Abstraction - Music (c.1927)
oil on card
43.2 x 61 cm.
F.B. Housser Memorial Collection,
45.A.47

Three Figures (1944)
oil on canvas
96.5 x 53.3 cm.
Art Fund, 71.A.35

BROOKS, Leonard (1911-)
Maple Sugar Bush (1938)
etching on paper
20.3 x 24.9 cm.
Print Fund, 45.A.15

Bic, Quebec (1940)
watercolour on paper
26.7 x 36.9 cm.
Art Fund, 42.A.10

Northern River (1942)
oil on canvas
50.8 x 61 cm.
Art Fund, 42.A.18

El Oro Mining Town (1952)
watercolour on paper
28.9 x 36.9 cm.
Gift of Mr. J.H. Moore, London,
through the Ontario Heritage
Foundation, 80.A.102

Pacific Tropics (n.d.)
watercolour on paper
56.5 x 74.9 cm.
Art Fund, 50.A.12

Big Trees, San Miguel (n.d.)
watercolour on paper
38.1 x 49.6 cm.
Art Fund, 52.A.40

The Market Square (n.d.)
watercolour on paper
47.7 x 60.4 cm.
Art Fund, 73.A.42

BROWN, Ann (1927-)
Untitled (n.d.)
metal and marble
15.6 x 16.4 x 16.9 cm.
Gift of Mr. J.H. Moore, London,
through the Ontario Heritage
Foundation, 87.A.96

BROWN, Daniel P. (1939-)
Untitled Landscape (1962)
ink on paper
45.7 x 61.6 cm.
Gift from the Douglas M. Duncan
Collection, 70.A.93

Wind (1962)
tempera on canvas
60.3 x 90.2 cm.
Gift of Mr. J.H. Moore, London,
through the Ontario Heritage
Foundation, 78.A.45

BRUCE, Blair (1859-1906)
Sunset, Giverny, France (c.1887-88)
oil on board
26 x 34.3 cm.
Art Fund, 77.A.9

BRUNEAU, Kittie (1929-)
Coeur d'Orange (1966)
etching 21/75 on paper
41.2 x 34 cm.
Gift of Mr. J.H. Moore, London,
through the Ontario Heritage
Foundation, 80.A.62

**BUFFET, Bernard, (French:
1928-)**
Decanter (1955)
lithograph 24/30 on paper
69.9 x 50.8 cm.
Gift of Mr. J.H. Moore, London,
through the Ontario Heritage
Foundation, 80.A.52

BURDENY, Barry (1943-)
Autumnal Colours (1963)
oil on masonite
40.6 x 50.8 cm.
Gift of Mr. J.H. Moore, London,
through the Ontario Heritage
Foundation, 80.A.103

**BURLE MARX, Roberto (Brazilian:
1909-)**
Santo Antonio da Bicca a Noite
(1974)
gouache and ink on paper
55 x 75 cm.
Gift of Mr. & Mrs. J.H. Moore,
London, 85.A.39

BURTON, Dennis (1933-)
Toronto 20: Untitled (1965)
monotype 50/100 on blue cardboard
50.8 x 40.7 cm.
Gift of Mr. & Mrs. J.H. Moore,
81.A.16

Boxing Day (1968)
oil on canvas
71.1 x 55.9 cm.
Gift of Mr. J.H. Moore, London,
through the Ontario Heritage
Foundation, 78.A.46

Music Gallery Portfolio:
Horny Business (1982)
serigraph 4/40 on paper
62.2 x 43.5 cm.
Purchased with Canada Council
matching grant and the Acquisitions
Fund, 82.A.31

BUSH, Jack (1908-1977)
Blue Spot on Green (1963-64)
oil on canvas
177.8 x 154.9 cm.
Art Fund, 68.A.6

Toronto 20: Untitled (1965)
silkscreen 50/100 on paper
66 x 50.8 cm.
Gift of Mr. & Mrs. J.H. Moore,
London, 81.A.17

**BUTLER, Reginald (British:
1913-)**
Untitled (1973)
graphite on paper
59 x 94 cm.
Gift of Mr. J.H. Moore, London,
through the Ontario Heritage
Foundation, 78.A.169

CADDY, John Herbert (1801-1883)
Sketch of London, C.W. from
Wortley Road Hill (c.1845)
graphite on paper
30 x 45.1 cm.
Gift of Mrs. E.G. Pullen & Mrs. W.P.
Fraser, Oakville, 73.A.25

Road Tunnel Under Railway, London
(c.1851)
sepia wash on paper
24.2 x 38.1 cm.
Gift of Mrs. E.G. Pullen & Mrs. W.P.
Fraser, Oakville, 73.A.24

Railway Bridge, London (c.1852)
sepia wash on paper
26.7 x 39.4 cm.
Gift of Mrs. E.G. Pullen & Mrs. W.P.
Fraser, Oakville. 73.A.26

Horseshoe and American Falls from
the Canadian Side (n.d.)
watercolour on paper
18.4 x 26.8 cm.
Purchased with funds from the
Somerville Bequest, 84.A.232

CADDY, John Herbert (attributed to)
London, Canada West (1850)
lithograph on paper
31.4 x 43.3 cm.
Purchased with funds from the
Mitchell Bequest, 77.A.1

CAHEN, Oscar (1916-1956)
Animal Structure (1953)
oil on masonite
121.9 x 91.4 cm.
Art Fund, 63.A.28

Untitled (1955)
oil on canvas
50.8 x 40.6 cm.
Gift of Mr. J.H. Moore, London,
through the Ontario Heritage
Foundation, 78.A.47

**CAISERMAN ROTH, Ghitta
(1923-)**
Spring (1959)
oil on masonite
90.2 x 121.2 cm.
Art Fund, 60.A.69

**CALDER, Alexander (American:
1898-1976)**
Three Blacks Up (1960)
paint, sheet metal and steel wire
68.6 x 63.5 x 58.4 cm.
Gift of Mr. J.H. Moore, London,
through the Ontario Heritage
Foundation, 83.A.5

Aspect lunaire (1963)
lithograph 71/90 on paper
31.1 x 47.7 cm.
Gift of Mr. J.H. Moore, London,
through the Ontario Heritage
Foundation, 80.A.190

Black Spiral (1971-72)
lithograph on paper
72.4 x 82.6 cm.
Gift of the Volunteer Committee,
78.A.9

**CARGALEIRO, Manuel (Portuguese:
1927-)**
Untitled (1972)
coloured lithographed 41/80 on paper
36.8 x 53.3 cm.
Gift of Mr. & Mrs. J.H. Moore,
London, 85.A.64

CARLYLE, Florence (1864-1923)
Portrait of a Girl (n.d.)
oil on canvas
21.6 x 15.8 cm.
Gift of Donald Routledge, Esq.,
London, 66.A.87

Old Woman in Doorway (n.d.)
oil on canvas
35.6 x 26.7 cm.
The W. Thomson Smith Memorial
Collection (Bequest of Alfred J.
Mitchell), 48.A.71

CARMICHAEL, Franklin (1890-1945)
North Town (1927)
graphite and watercolour on paper
55.9 x 71.1 cm.
F.B. Housser Memorial Collection,
45.A.43

CARR, Emily (1871-1945)
Forest Glade with Cabin, B.C. (n.d.)
graphite on paper
45.7 x 33 cm.
Gift of Mr. J.H. Moore, London,
through the Ontario Heritage
Foundation, 78.A.48

Kitwancool Poles (n.d.)
oil on canvas
81.9 x 71.7 cm.
Anonymous gift, 58.A.125

**CARTER, Harriet Manore
(1928-)**
Hearts and Flowers (1971)
watercolour on paper
55.3 x 73.7 cm.
Purchased with funds from the
Mitchell Bequest, 72.A.12

**CARVALHO, Genarao de (Brazilian:
active in 1960s)**
Untitled (n.d.)
wool on canvas
126 x 138.1 cm.
Gift of Mr. & Mrs. J.H. Moore,
London, 85.A.75

CARZOU, Jean (French: 1907-)
Blue Lady (1965)
lithograph 103/150 on paper
71.1 x 53.3 cm.
Gift of Mr. J.H. Moore, London,
through the Ontario Heritage
Foundation, 80.A.191

CASSON, A.J. (1898-)
Lake Superior near Port Coldwell
(1928)
oil on wood
23.9 x 27.9 cm.
Gift of Mr. A.J. Casson, Toronto,
72.A.94

October, White River (1929)
oil on wood
24.9 x 29.9 cm.
Gift of Mr. J.H. Moore, London,
through the Ontario Heritage
Foundation, 80.A.104

Northern Autumn (c.1940)
watercolour on paper
43.5 x 51.5 cm.
Gift of Mr. A.J. Casson, Toronto,
82.A.23

Mist, Rain and Sun (1958)
oil on masonite
75.7 x 120.6 cm.
Gift of the Volunteer Committee,
58.A.130

Bedard Pond (1960)
oil on masonite
74.9 x 89.5 cm.
Gift of Mr. J.H. Moore, London,
through the Ontario Heritage
Foundation, 78.A.49

Landscape Sketch (1968)
oil on masonite
45.7 x 55.3 cm.
Gift of Mr. A.J. Casson, Toronto,
68.A.89

March Thaw (n.d.)
watercolour on paper
43.5 x 50.8 cm.
Art Fund, 42.A.9

Rock Study (n.d.)
ink on paper
27.9 x 34.3 cm.
Gift of Mr. J.H. Moore, London,
through the Ontario Heritage
Foundation, 80.A.105

CASTRO, Robert C. De (1923-1986)
Fossil Men (1959)
serigraph 25/100 on paper
49.6 x 31.8 cm.
Print Fund, 59.A.15

CATTELL, Ray (1921-)
October Pendulum (c.1971)
watercolour on paper
101.6 x 76.2 cm.
Art Fund, 72.A.6

**CECCHI, Adriano (Italian:
1850-)**
Man With Wine Flask (n.d.)
oil on canvas
35 x 27.4 cm.
The W. Thomson Smith Memorial
Collection (Bequest of Alfred J.
Mitchell), 48.A.77

CH'ANG SHU CHI (Chinese: -1953)
Yellow Birds on Pink and Blue Flowers (1944)
watercolour on paper
96.5 x 41.9 cm.
Gift of Mr. Ch'ang Shu Chi, Washington, D.C., 44.A.24

Bird on Chrysanthemum Bough (1944)
watercolour on paper
71.4 x 44.5 cm.
Gift of Mr. Ch'ang Shu Chi, Washington, D.C., 44.A.25

Bird on Cherry Bough (1944)
watercolour on paper
66 x 45.7 cm.
Gift of Mr. Ch'ang Shu Chi, Washington, D.C., 44.A.26

Birds on a Bough (1944)
watercolour on paper
31.8 x 48.3 cm.
Gift of Mr. Ch'ang Shu Chi, Washington, D.C., 44.A.16

CHAGALL, Marc (French: 1887-1985)
Le Bouquet de peinture (n.d.)
lithograph 62/75 on paper
72.4 x 54.6 cm.
Gift of the Volunteer Committee, 78.A.10

Job désespéré (n.d.)
lithograph A/P on paper
30.5 x 35.5 cm.
Gift of Mr. J.H. Moore, London, through the Ontario Heritage Foundation, 78.A.180

CHAMBERS, Jack (1931-1978)
Umbrella (1959)
oil on canvas
48.3 x 44.5 cm.
Gift of Dr. & Mrs. Ross Woodman, London, 82.A.26

Angel (1959-60)
oil on paper
48.9 x 31.8 cm.
Anonymous gift, 82.A.25

The Artist's First Bride (1961)
oil on board
81.3 x 88.4 cm.
Purchased with matching Acquisitions funds and a Wintario Grant, 79.A.53

Onlookers over Winnipeg (1962)
oil on wood
143.5 x 94.6 cm.
Anonymous gift, 81.A.66

Olga Listening (1964)
oil on wood
71.1 x 71.1. cm.
Gift of Mr. J.H. Moore, London, through the Ontario Heritage Foundation, 78.A.51

Three Sisters Waiting (1964)
oil on wood
112 x 139.4 cm.
Gift of C.I.L. Incorporated, Willowdale, 82.A.2

Olga and Mary Visiting (1964-65)
oil on wood
125.1 x 193.7 cm.
Art Fund, 65.A.39

Moonrise (1965)
wood, paint, steel rods and supports
57.5 x 50.3 x 12.7 cm.
Gift of Mr. J.H. Moore, London, through the Ontario Heritage Foundation, 85.A.4

Olga, Diego and Geraniums (1966)
oil on wood
130 x 160 cm.
Gift of Mr. J.H. Moore, London, through the Ontario Heritage Foundation, 78.A.50

Tap (1967)
aluminum paint on fibreboard
213.4 x 121.9 cm.
Art Fund, 69.A.64

Tap (1967)
graphite and ink on paper
47.7 x 52.4 cm.
Gift of Mr. J.H. Moore, London, through the Ontario Heritage Foundation, 80.A.107

Music Box (1968)
mixed media mounted on paper and plexiglass
58.4 x 54.6 cm.
Gift of Mr. J.H. Moore, London, through the Ontario Heritage Foundation, 80.A.106

Regatta No. 1 (1968)
oil and graphite mounted on paper and plexiglass
129.5 x 122.5 cm.
Gift of the Volunteer Committee, 69.A.1

Grass Box No. 3 (1970)
photolithograph 23/45 on paper
80.7 x 106.7 cm.
Anonymous gift, 82.A.46

Festival of Life Poster (1973)
lithograph 8/50 on paper
55.9 x 37.5 cm.
Anonymous gift, 82.A.24

Figs (1977)
serigraph 60/80 on paper
48.9 x 50.9 cm.
Purchased with matching Acquisitions funds and a Wintario Grant, 79.A.54

Daffodils (1977)
serigraph 16/300 on paper
25.5 x 25.5 cm.
Gift of John Labatt Limited, London, 87.A.195

Untitled No. 4 (n.d.)
mixed media on card
45.7 x 61 cm.
Gift of Mr. J.H. Moore, London, through the Ontario Heritage Foundation, 80.A.225

CHAPLIN, Charles (1907-)
Early Spring (1950)
engraving 24/75 on paper
15.2 x 18.1 cm.
Gift of the Society of Canadian Painter-Etchers and Engravers, 50.A.6A

Early Spring (1950)
engraving 25/75 on paper
15.2 x 18.1 cm.
Gift of the Society of Canadian Painter-Etchers and Engravers, 50.A.6B

Stoat (1950)
engraving on paper
10.8 x 21.6 cm.
Print Fund, 52.A.8

CHAPMAN, Charles (1827-1887)
Landscape (1882)
oil on wood
50.8 x 40 cm.
Gift of Mr. Leslie Pickles, Byron, 82.A.3

The Thames River (1882)
oil on canvas
59.8 x 120.8 cm.
Gift of Mrs. Marjorie Blackburn, London, 87.A.66

CHAPPELL, Edward (British: 1859-1946)
Summer Landscape (n.d.)
oil on canvas
22.9 x 27.9 cm.
The W. Thomson Smith Memorial Collection (Bequest of Alfred J. Mitchell), 48.A.67

CHATEL, Manoel (Brazilian: -)
Baiana (1970)
oil on canvas
33 x 24.1 cm.
Gift of Mr. & Mrs. J.H. Moore, London, 85.A.40

CHAVDA, S.
Indian Dancer (1975)
ink and graphite on paper
38 x 24.7 cm.
Gift of Mr. J.H. Moore, London, through the Ontario Heritage Foundation, 87.A.98

CHAVIGNAUD, Georges (1865-1944)
Landscape With Figures (n.d.)
watercolour on paper
35 x 47 cm.
The W. Thomson Smith Memorial Collection (Bequest of Alfred J. Mitchell), 48.A.64

CHEFFETZ, Asa (American: 1897-1965)
Farm Buildings (n.d.)
wood engraving on paper
14 x 24.2 cm.
Print Fund, 46.A.70

CHRISTIE, Vera (British active: 1893-1904)
St. John (copy: da Vinci's *Madonna of the Rocks*)
oil on canvas
61 x 50.8 cm.
Gift of Mr. Gordon Conn, Newmarket, 50.A.65

CHU, Gene (1936-)
The Ant Series: No. 3 - O'Peace (1967)
lithograph 30/31 on paper
40.1 x 53.6 cm.
Print Fund, 71.A.62

The Flies No. 8 (1978)
watercolour and graphite on paper
75.7 x 56.2 cm.
Art Fund, 78.A.1

CICCIMARA, Richard (1924-1973)
Nude (1959)
serigraph 25/100 on paper
49.6 x 31.8 cm.
Print Fund, 59.A.8

CLARK, Glen (active circa 1962)
Young Screech Owl (1962)
etching 1/5 on paper
45.7 x 29.9 cm.
Print Fund, 64.A.28

CLARKE, Geoffrey (British: 1924-)
Untitled (1964)
metal 3/6
20.6 x 79.3 x 29.9 cm.
Gift of the Contemporary Art Society of Great Britain, 69.A.48

CLIFF, Denis (1942-)
Quixoti (1970)
collage on canvas
121.9 x 171.4 cm.
Gift of Mr. J.H. Moore, London, through the Ontario Heritage Foundation, 80.A.108

CLIFFE, Henry (British: 1919-)
Small Box - Fièvre (1965)
multi-media
12 x 12 x 5.8 cm.
Gift of Mr. J.H. Moore, London, through the Ontario Heritage Foundation, 87.A.94

CLOSE, Robert (active: 1952-1960)
Study of Judith Paré (1952)
pastel and wash on paper
20.3 x 17.8 cm.
Gift of Mr. J.H. Moore, London, through the Ontario Heritage Foundation, 78.A.52

Untitled figure (1960)
oil on paper
22.9 x 17.8 cm.
Gift of Mr. J.H. Moore, London, through the Ontario Heritage Foundation, 80.A.109

Untitled (n.d.)
oil and watercolour on paper
24.2 x 22.9 cm.
Gift of Mr. J.H. Moore, London, through the Ontario Heritage Foundation, 80.A.110

COBURN, F.S. (1871-1960)
Sombre Day in the Hills (1934)
crayon on paper
14.7 x 19.1 cm.
Gift of Mr. Fred Schaeffer, Thornhill, through the Ontario Heritage Foundation, 77.A.41

Belle Isle (n.d.)
crayon on paper
11.5 x 15.2 cm.
Gift of Mr. Fred Schaeffer, Thornhill, through the Ontario Heritage Foundation, 77.A.26

Blue Day (n.d.)
crayon on paper
10.2 x 17.8 cm.
Gift of Mr. Fred Schaeffer, Thornhill,
through the Ontario Heritage
Foundation, 77.A.35

Blue Mountains (n.d.)
crayon on paper
11.5 x 15.2 cm.
Gift of Mr. Fred Schaeffer, Thornhill,
through the Ontario Heritage
Foundation, 77.A.24

Break in the Clouds (n.d.)
crayon on paper
10.8 x 18.4 cm.
Gift of Mr. Fred Schaeffer, Thornhill,
through the Ontario Heritage
Foundation, 77.A.28

The Bright Bush (n.d.)
crayon on paper
16.5 x 21.6 cm.
Gift of Mr. Fred Schaeffer, Thornhill,
through the Ontario Heritage
Foundation, 77.A.43

The Bright Day (n.d.)
crayon on paper
16.5 x 21.6 cm.
Gift of Mr. Fred Schaeffer, Thornhill,
through the Ontario Heritage
Foundation, 77.A.45

Cloud Study (n.d.)
crayon on paper
12.7 x 20.3 cm.
Gift of Mr. Fred Schaeffer, Thornhill,
through the Ontario Heritage
Foundation, 77.A.39

Colour in the Forest (n.d.)
crayon on paper
11.5 x 15.2 cm.
Gift of Mr. Fred Schaeffer, Thornhill,
through the Ontario Heritage
Foundation, 77.A.22

Dark Hills (n.d.)
crayon on paper
11.5 x 15.2 cm.
Gift of Mr. Fred Schaeffer, Thornhill,
through the Ontario Heritage
Foundation, 77.A.23

Dumping Pulp at Brampton (n.d.)
crayon on paper
17.2 x 23.5 cm.
Gift of Mr. Fred Schaeffer, Thornhill,
through the Ontario Heritage
Foundation, 77.A.46

Dutch Windmill (n.d.)
crayon on paper
25.4 x 20.9 cm.
Gift of Mr. Fred Schaeffer, Thornhill,
through the Ontario Heritage
Foundation, 77.A.47

Fence Along the Road (n.d.)
charcoal on paper
12.7 x 10.3 cm.
Gift of Mr. Fred Schaeffer, Thornhill,
through the Ontario Heritage
Foundation, 77.A.37

Habitant's Home (n.d.)
crayon on paper
8.9 x 8.9 cm.
Gift of Mr. Fred Schaeffer, Thornhill,
through the Ontario Heritage
Foundation, 77.A.21

Head Study (n.d.)
charcoal on paper
12.7 x 20.3 cm.
Gift of Mr. Fred Schaeffer, Thornhill,
through the Ontario Heritage
Foundation, 77.A.32

The Last Logs (n.d.)
charcoal on paper
17.2 x 23.5 cm.
Gift of Mr. Fred Schaeffer, Thornhill,
through the Ontario Heritage
Foundation, 77.A.44

Mountain Clouds (n.d.)
crayon on paper
11.5 x 15.2 cm.
Gift of Mr. Fred Schaeffer, Thornhill,
through the Ontario Heritage
Foundation, 77.A.31

Near the Distant Hills (n.d.)
crayon on paper
9 x 16.2 cm.
Gift of Mr. Fred Schaeffer, Thornhill,
through the Ontario Heritage
Foundation, 77.A.19

Nude Study (n.d.)
charcoal on paper
19.8 x 15.2 cm.
Gift of Mr. Fred Schaeffer, Thornhill,
through the Ontario Heritage
Foundation, 77.A.42

Quebec Barn (n.d.)
charcoal on paper
13.3 x 17.8 cm.
Gift of Mr. Fred Schaeffer, Thornhill,
through the Ontario Heritage
Foundation, 77.A.40

Quebec Home (n.d.)
crayon on paper
12.7 x 20.3 cm.
Gift of Mr. Fred Schaeffer, Thornhill,
through the Ontario Heritage
Foundation, 77.A.34

Road through the Bush (n.d.)
crayon on paper
12.7 x 20.3 cm.
Gift of Mr. Fred Schaeffer, Thornhill,
through the Ontario Heritage
Foundation, 77.A.33

Road to the Hills (n.d.)
charcoal on paper
11.5 x 15.2 cm.
Gift of Mr. Fred Schaeffer, Thornhill,
through the Ontario Heritage
Foundation, 77.A.30

Silhouetted Hills (n.d.)
charcoal on paper
10.8 x 18.4 cm.
Gift of Mr. Fred Schaeffer, Thornhill,
through the Ontario Heritage
Foundation, 77.A.29

Sleeping Mother and Child (n.d.)
charcoal on paper
21.6 x 27.4 cm.
Gift of Mr. Fred Schaeffer, Thornhill,
through the Ontario Heritage
Foundation, 77.A.48

Snow in the Hills (n.d.)
crayon on paper
11.5 x 17.8 cm.
Gift of Mr. Fred Schaeffer, Thornhill,
through the Ontario Heritage
Foundation, 77.A.27

Sombre Day (n.d.)
crayon on paper
10.2 x 15.2 cm.
Gift of Mr. Fred Schaeffer, Thornhill,
through the Ontario Heritage
Foundation, 77.A.25

The Team (n.d.)
charcoal on paper
12.7 x 10.2 cm.
Gift of Mr. Fred Schaeffer, Thornhill,
through the Ontario Heritage
Foundation, 77.A.38

Tearn Talk (n.d.)
crayon on paper
17.8 x 12.7 cm.
Gift of Mr. Fred Schaeffer, Thornhill,
through the Ontario Heritage
Foundation, 77.A.20

Tree Study (n.d.)
crayon on paper
21.6 x 27.4 cm.
Gift of Mr. Fred Schaeffer, Thornhill,
through the Ontario Heritage
Foundation, 77.A.49

The Workhorse (n.d.)
charcoal on paper
12.7 x 10.2 cm.
Gift of Mr. Fred Schaeffer, Thornhill,
through the Ontario Heritage
Foundation, 77.A.36

COHEN, Sheldon (1935-)
Ozalid Print No. J2 (1966)
ozalid print 5A/10 on paper
53.3 x 40.6 cm.
Gift of Ontario Centennial Art
Exhibition, 69.A.83A

Ozalid Print No. J3 (1966)
ozalid print 8A/10 on paper
40.6 x 53.3 cm.
Gift of Ontario Centennial Art
Exhibition, 69.A.83B

Ozalid Print No. J4 (1966)
ozalid print 2A/10 on paper
40.6 x 53.3 cm.
Gift of Ontario Centennial Art
Exhibition, 69.A.83C

Ozalid Print No. J5 (1966)
ozalid print 2A/10 on paper
53.3 x 40.6 cm.
Gift of Ontario Centennial Art
Exhibition, 69.A.83D

Ozalid Print No. J6 (1966)
ozalid print 9/10 on paper
53.3 x 40.6 cm.
Gift of Ontario Centennial Art
Exhibition, 69.A.83E

Ozalid Print No. J8 (1966)
ozalid print 4A/10 on paper
53.3 x 40.6 cm.
Gift of Ontario Centennial Art
Exhibition, 69.A.83F

Ozalid Print No. J11 (1966)
ozalid print 2A/10 on paper
40.6 x 53.3 cm.
Gift of Ontario Centennial Art
Exhibition, 69.A.83G

Ozalid Print No. J12 (1966)
ozalid print 1A/10 on paper
53.3 x 40.6 cm.
Gift of Ontario Centennial Art
Exhibition, 69.A.83H

COLLIER, Alan (1911-)
Capstan and the Forillon (1957)
oil on canvas
43.2 x 61 cm.
Gift of D.H. Gibson, Esq., Toronto,
58.A.8

Dawson City (1962)
gouache and graphite on paper
29.2 x 25.4 cm.
Gift of Mr. J.H. Moore, London,
through the Ontario Heritage
Foundation, 80.A.112

Booming Ground (1967)
ink on paper
27.9 x 25.4 cm.
Gift of Mr. J.H. Moore, London,
through the Ontario Heritage
Foundation, 80.A.111

Suspirations of the Sea (1970)
oil on canvas
76.2 x 127 cm.
Art Fund, 71.A.34

**Open Lead-Off West End of Charles
Island** (1972)
oil on board
30.5 x 40.6 cm.
Gift of Mr. J.H. Moore, London,
through the Ontario Heritage
Foundation, 80.A.113

COLVILLE, Alex (1920-)
Boy, Dog and St. John River (1958)
oil and synthetic resin on masonite
61 x 82.6 cm.
Art Fund, 59.A.79

Ballad of the Fox Hunter (1959)
serigraph on paper
29.2 x 22.1 cm.
Gift of Mr. J.H. Moore, London,
through the Ontario Heritage
Foundation, 78.A.197A-D

Snow (1969)
serigraph 43/70 on paper
60.9 x 45.7 cm.
Gift of Mr. J.H. Moore, London,
through the Ontario Heritage
Foundation, 78.A.198

**Study for "June": DeHavilland
"Beaver"** (1974)
graphite on paper
19.3 x 22.8 cm.
Gift of Mr. C. Southward Jr.,
Windsor, 88.A.4

COMFORT, Charles (1900-)
The Great Rock, Bon Echo (1928)
oil on canvas
127 x 152.4 cm.
Gift of Volunteer Committee, 61.A.22

COMTOIS, Ulysse (1931-)
Wood (1965)
wood composition and paint
49.9 x 40.2 x 23.4 cm.
Gift of Mr. & Mrs. J.H. Moore,
London, 87.A.87

Cylindrical Construction (1966)
aluminum
45.7 x 6 x 6 cm.
Gift of Mr. J.H. Moore, London,
through the Ontario Heritage
Foundation, 78.A.201

Five Bar Stack (1969)
anodized aluminium and nylon joints
71 x 37 x 14.1 cm.
Gift of Mr. J.H. Moore, London,
through the Ontario Heritage
Foundation, 79.A.49

Pregnant Woman (prior to 1978)
welded steel
77.5 x 35 x 29 cm.
Gift of Dr. J.T. and Dr. Marta
Hurdalek, Toronto, 90.A.33

COOKE, Edwy (1926-)
Assemblage in Yellow (1952-53)
gouache on paper
40.6 x 55.9 cm.
Art Fund, 53.A.154

COOPER, Stanley (1906-)
Whitefish Lake (1947)
oil on canvas
32.5 x 42.2 cm.
Gift of Mr. J.H. Moore, London,
through the Ontario Heritage
Foundation, 80.A.114

**COSTIGAN, John (American:
1888-1972)**
Springtime (n.d.)
etching on paper
24.9 x 30.5 cm.
Print Fund, 46.A.66

COUGHTRY, Graham (1931-)
**Head Arrangements for the Artist's
Jazz Band #5** (1973)
single autographic print on paper
55.3 x 45.2
Gift of Mr. J.H. Moore, London,
through the Ontario Heritage
Foundation, 80.A.209

Reclining I (1958)
oil on canvas
137.2 x 131.9 cm.
Purchased with Canada Council
matching grant and the Acquisitions
Fund, 79.A.12

Toronto 20: Untitled (1965)
linocut 50/100 on paper
66 x 50.8 cm.
Gift of Mr. & Mrs. J.H. Moore,
London, 81.A.18

French Black Suite: Untitled
(1981-82)
lithograph on paper
92.4 x 76.6 cm.
Gift of the Volunteer Committee,
85.A.13

French Black Suite: Untitled
(1981-82)
lithograph on paper
92.4 x 76.8 cm.
Gift of the Volunteer Committee,
85.A.14

French Black Suite: Untitled
(1981-82)
lithograph on paper
92.5 x 76.4 cm.
Gift of the Volunteer Committee,
85.A.15

French Black Suite: Untitled
(1981-82)
lithograph on paper
92.4 x 76.6 cm.
Gift of the Volunteer Committee,
85.A.16

**Music Gallery Portfolio: Mountain
Music** (1982)
serigraph 4/40 on paper
55.9 x 45.7 cm.
Purchased with Canada Council
matching grant and the Acquisitions
Fund, 82.A.32

COULTER, Ted (1937-)
Untitled Box (n.d.)
fired clay
77 x 63 x 46 cm.
Gift of Mr. J.H. Moore, London,
through the Ontario Heritage
Foundation, 87.A.97

COURTICE, Rody Kenny (1895-1973)
Along the Gowanda Road (n.d.)
oil on board
29.9 x 35 cm.
Gift of the Estate of Miss Florence
Wyle, Toronto, 74.A.38

COURTLEY, Susan (1953-)
The Big Suck-Off (1975)
watercolour and ink on paper
55.9 x 76.8 cm.
Gift of the London Art Gallery
Association, 75.A.8

COUSINS, William
Portrait of Clifford Bastla (1933)
charcoal on paper
56.3 x 44.3 cm.
Gift of Mr. Clifford Bastla, London,
87.A.36

**COX, David (British: 1783-1859)
(attributed to)**
Landscape with Bridge (n.d.)
oil on canvas
20.5 x 30.5 cm.
Gift of Mr. Max Swartz, Toronto,
88.A.26

COX, Elford B. (1914-)
Torso (c.1960)
marble
53.3 x 19 x 12 cm.
Gift of the Western Art League,
60.A.119

Figure (c.1972-74)
dolomite
30.5 x 15 x 10 cm.
Gift of Mr. J.H. Moore, London,
through the Ontario Heritage
Foundation, 80.A.91

Head (n.d.)
stone
21 x 9 x 11 cm.
Gift of Mr. J.H. Moore, London,
through the Ontario Heritage
Foundation, 87.A.104

CRAVEN, David (1946-)
Corner Stone (1976)
acrylic on canvas
228.6 x 198.1 cm.
Art Fund, 76.A.10

CRAWFORD, Betty (1910-)
Fading Weeds (1959)
watercolour on paper
55.9 x 38.1 cm.
Gift of the Western Art League,
60.A.60

CRESSWELL, William N. (1818-1888)
Beached Fishing Boats (1876)
watercolour on paper
30 x 50 cm.
Purchased with funds from the
Somerville Bequest, 78.A.224

Fishing Scene at Dawn (1880)
watercolour on paper
17.8 x 30.3 cm.
Purchased with funds from the
Somerville Bequest, 78.A.223

View from the Hillside (1883)
watercolour on paper
14 x 22.8 cm.
Purchased with funds from the
Somerville Bequest, 78.A.222

On the Shore (n.d.)
watercolour on paper
24.2 x 34.3 cm.
Hamilton King Meek Memorial
Collection, 40.A.11

CRUIKSHANK, William (1848-1922)
Portrait of an Unknown Man (n.d.)
oil on canvas
76.5 x 63.7 cm.
Gift of Mr. Max Swartz, Toronto,
88.A.27

CRYDERMAN, Mackie (1900-1968)
Boats at Gloucester (c.1956)
watercolour on paper
52.8 x 73.1 cm.
Art Fund, 71.A.31

Figure Study (n.d.)
oil on canvas
61 x 50.8 cm.
Gift of Mr. Clifford Cryderman,
London, 71.A.32

Spring Flowers (n.d.)
watercolour on paper
54.5 x 67.2 cm.
Gift of the Estate of Miss Dorothy
Gunn, London, 82.A.12

CULLEN, Maurice (1866-1934)
Cache River (1928)
pastel on paper
59.7 x 80 cm.
Gift of John Labatt Limited, London,
60.A.6

CURNOE, Greg (1936-)
Self Portrait (1961)
ink and collage on card
30 x 25 cm.
Gift of Mr. J.H. Moore, London,
through the Ontario Heritage
Foundation, 78.A.55

**Richmond Street - Second Floor
Papers** (1962)
collage on paper
46 x 35.7 cm.
Gift of Mr. J.H. Moore, London,
through the Ontario Heritage
Foundation, 80.A.124

Sheila at the Studio (1964)
ink on paper
57.2 x 44.5 cm.
Gift of Mr. J.H. Moore, London,
through the Ontario Heritage
Foundation, 80.A.120

I was worried at the time #2 (1964)
mixed media collage on paper
43.5 x 10.2 cm.
Gift of Dr. & Mrs. R. Bull, London,
85.A.93

Girl with Book (1964)
ink on paper
55.3 x 42.2 cm.
Gift of Mr. J.H. Moore, London,
through the Ontario Heritage
Foundation, 80.A.116

Feeding Percy (1965)
oil on wood, light bulbs and
electrical wiring
190.5 x 166.4 x 35.6 cm.
Art Fund, 66.A.86

I have been looking at Rousseau
(1965)
oil on wood
60.3 x 61 cm.
Gift of Mr. J.H. Moore, London,
through the Ontario Heritage
Foundation, 78.A.53

**Toronto 20: Hockey Stick Blades
from West Lions Park, London**
(1965)
relief print 50/100 and rubber stamp
on paper
66 x 50.8 cm.
Gift of Mr. & Mrs. J.H. Moore,
London, 81.A.19

**Toronto 20: Hockey Stick Blades
from West Lions Park, London**
(1965)
relief print 91/100 and rubber stamp
on paper
64.8 x 49.6 cm.
Gift of the London Art Gallery
Association, 70.A.113

Rousseau Bouquet, No. 2 (1965)
ink on paper
55.5 x 42.6 cm.
Gift of Mr. J.H. Moore, London,
through the Ontario Heritage
Foundation, 80.A.119

Sheila (1965)
ink on paper
55.5 x 42.8 cm.
Gift of Mr. J.H. Moore, London,
through the Ontario Heritage
Foundation, 80.A.121

Sheila and Owen (1967)
ink on paper
54.6 x 42.6 cm.
Gift of Mr. J.H. Moore, London,
through the Ontario Heritage
Foundation, 80.A.122

Sheila and Owen No. 2 (1967)
ink on paper
54.9 x 39.7 cm.
Gift of Mr. J.H. Moore, London,
through the Ontario Heritage
Foundation, 80.A.123

Girl from T.N.T. (1967)
ink on paper
54.9 x 42.6 cm.
Gift of Mr. J.H. Moore, London,
through the Ontario Heritage
Foundation, 80.A.115

Car (1967)
oil on board, steel and enamel
167.7 x 172.8 cm.
Gift of Mr. J.H. Moore, London,
through the Ontario Heritage
Foundation, 78.A.191

Quotation No. 2 - Gödel (1968)
acrylic on board
93.9 x 63.5 cm.
Gift of Mr. J.H. Moore, London,
through the Ontario Heritage
Foundation, 80.A.118

**The True North Strong and Free
(5 panels)** (1968)
polyurethane and ink on plywood
each panel: 59.7 x 63.5 cm.
Art Fund, 70.A.44A-E

Yellow and Blue Printing (1968)
oil on canvas
82 x 82 cm.
Gift of Mr. J.H. Moore, London,
through the Ontario Heritage
Foundation, 78.A.54

**View From The Most Northerly
Window** (1969)
acrylic on board with tape, tape
recorder and speaker system
226.1 x 256.5 x 20.3 cm.
Gift of Mr. J.H. Moore, London,
through the Ontario Heritage
Foundation, 80.A.126

Lions Head (1971)
watercolour on paper
12.7 x 20.3 cm.
Gift of Mr. J.H. Moore, London,
through the Ontario Heritage
Foundation, 80. A.117

Tobermory (1971)
watercolour on paper
12.7 x 20.3 cm.
Gift of Mr. J.H. Moore, London,
through the Ontario Heritage
Foundation, 80.A.125

Glenn (1972)
ink on paper
30.5 x 31.7 cm.
Gift of Mr. J.H. Moore, London,
through the Ontario Heritage
Foundation, 86.A.19

Harry Hibbs (1972)
ink on paper
30.5 x 30.5 cm.
Gift of Mr. J.H. Moore, London,
through the Ontario Heritage
Foundation, 86.A.25

Jean Carignan (1972)
ink on paper
30.5 x 31.7 cm.
Gift of Mr. J.H. Moore, London,
through the Ontario Heritage
Foundation, 86.A.24

Jimmy McLarnin (1972)
ink on paper
30.5 x 31.7 cm.
Gift of Mr. J.H. Moore, London,
through the Ontario Heritage
Foundation, 86.A.20

Man's Face (partially dark) (1972)
ink on paper
31.7 x 30.5 cm.
Gift of Mr. J.H. Moore, London,
through the Ontario Heritage
Foundation, 86.A.22

Milt (1972)
ink on paper
31.7 x 30.5 cm.
Gift of Mr. J.H. Moore, London,
through the Ontario Heritage
Foundation, 86.A.28

Milton (1972)
ink on paper
31.7 x 30.5 cm.
Gift of Mr. J.H. Moore, London,
through the Ontario Heritage
Foundation, 86.A.21

More Poems for People (1972)
ink on paper
30.5 x 30.5 cm.
Gift of Mr. J.H. Moore, London,
through the Ontario Heritage
Foundation, 86.A.30

P.E.I. (1972)
ink on paper
30.5 x 31.7 cm.
Gift of Mr. J.H. Moore, London,
through the Ontario Heritage
Foundation, 86.A.29

Robert Charlebois (1972)
ink on paper
30.5 x 31.7 cm.
Gift of Mr. J.H. Moore, London,
through the Ontario Heritage
Foundation, 86.A.26

Stompin' Tom (1972)
ink on paper
30.5 x 31.7 cm.
Gift of Mr. J.H. Moore, London,
through the Ontario Heritage
Foundation, 86.A.18

Wallet - Canada (1972)
ink on paper
30.5 x 31.7 cm.
Gift of Mr. J.H. Moore, London,
through the Ontario Heritage
Foundation, 86.A.27

Wilf Carter (1972)
ink on paper
31.7 x 30.5 cm.
Gift of Mr. J.H. Moore, London,
through the Ontario Heritage
Foundation, 86.A.23

Port Stanley Looking S.E. (1974)
watercolour on paper
20.9 x 27.3 cm.
Gift of Mr. J.H. Moore, London,
through the Ontario Heritage
Foundation, 86.A.17

Wheel (1974)
watercolour on paper
72.4 x 72.4 cm.
Gift of Mr. J.H. Moore, London,
through the Ontario Heritage
Foundation, 80.A.204

Doc Morton (1975)
watercolour on paper
110.5 x 176.8 cm.
Art Fund, 75.A.26

Bowering's Kitchen (1977)
watercolour on paper
11.04 x 15.88 cm.
Gift of Mr. J.H. Moore, London,
through the Ontario Heritage
Foundation, 86.A.9

Adult Education #1 (1978)
watercolour on paper
11.04 x 15.88 cm.
Gift of Mr. J.H. Moore, London,
through the Ontario Heritage
Foundation, 86.A.7

Adult Education #4 (1978)
watercolour on paper
11.04 x 15.88 cm.
Gift of Mr. J.H. Moore, London,
through the Ontario Heritage
Foundation, 86.A.8

For Glen (1979)
watercolour on paper
118.7 x 79.4 cm.
Gift of Mr. J.H. Moore, London,
through the Ontario Heritage
Foundation, 86.A.12

Mariposa T.T. (1979)
serigraph 16/30 on plexi
107.9 x 169.5 cm.
Gift of Mr. & Mrs. Richard M. Ivey,
London, 79.A.17

Moosenee River (1979)
watercolour on paper
22.9 x 30.5 cm.
Gift of Mr. J.H. Moore, London,
through the Ontario Heritage
Foundation, 86.A.15

Northern Lights Motel, Cochrane
(1979)
watercolour on paper
22.9 x 30.5 cm.
Gift of Mr. J.H. Moore, London,
through the Ontario Heritage
Foundation, 86.A.16

First Ellipse Drawn with String
(1980)
watercolour on paper
37.5 x 51.5 cm.
Gift of Mr. J.H. Moore, London,
through the Ontario Heritage
Foundation, 86.A.11

Ellipse in Circle (1981)
watercolour on paper
18.0 x 26.0 cm.
Gift of Mr. J.H. Moore, London,
through the Ontario Heritage
Foundation, 86.A.10

Improved Canadian Flag (1981)
watercolour on paper
12.5 x 17.5 cm.
Gift of Mr. J.H. Moore, London,
through the Ontario Heritage
Foundation, 86.A.14

**Agnes Shaw Cowan: Moral Victor in
the 1982 Mayoralty Race** (1982)
graphite and ink on paper
26.6 x 30 cm.
Art Fund, 86.A.9

Hotel Window (1982)
watercolour on paper
26.0 x 18.0 cm.
Gift of Mr. J.H. Moore, London,
through the Ontario Heritage
Foundation, 86.A.13

**Music Gallery Portfolio: Middle Aged
Man with Horns and Symbols** (1982)
serigraph 4/40 on paper
48.3 x 40.6 cm.
Purchased with Canada Council
matching grant and the Acquisitions
Fund, 82.A.39

**Owen, June 21, 1983-February 15,
1984**
watercolour and graphite on paper
183 x 108.5 cm.
Gift of Mr. & Mrs. J.H. Moore,
London, 90.A.1

**Galen, February 12-November 26,
1984**
watercolour and graphite on paper
201 x 110 cm.
Gift of Mr. & Mrs. J.H. Moore,
London, 90.A.2

**Zoe, December 6, 1984-May 12,
1986**
watercolour and graphite on paper,
194 x 90 cm.
Gift of Mr. & Mrs. J.H. Moore,
London, 90.A.3

CYOPIK, William (1921-)
Soldiers of Steel (1963)
oil on canvas
124.5 x 152.4 cm.
Purchased with funds from the
Mitchell Bequest, 64.A.78

DABINETT, Diana (1943-)
Diatoms II (1974)
graphite on paper
48.3 x 33 cm.
Purchased with funds from Shell
Canada, 74.A.17

**DA COSTA, Milton (Brazilian:
1915-)**
Figura c/Chapeau (n.d.)
oil and graphite on canvas
21.9 x 15.9 cm.
Gift of Mr. & Mrs. J.H. Moore,
London, 85.A.41

Venus I (n.d.)
oil and graphite on canvas
21.9 x 15.9 cm.
Gift of Mr. & Mrs. J.H. Moore,
London, 85.A.42

DAINES, Miesajs (1929-)
Muskeg, Noranda (1965)
watercolour on paper
57.2 x 78.7 cm.
Gift from the Douglas M. Duncan
Collection, 70.A.76

DALI, Salvador (Spanish: 1904-1989)
Untitled Frontispiece (1968-1969)
Illustration from Lewis Carroll's
Alice's Adventures in Wonderland:
etching 399/2500 on paper
34.2 x 58 cm.
Gift of Mr. & Mrs. J.H. Moore,
London, 83.A.2A

Down the Rabbit Hole (1968-69)
Illustration from Lewis Carroll's
Alice's Adventures in Wonderland
coloured woodcut 399/2500 on paper
34.2 x 58 cm.
Gift of Mr. & Mrs. J.H. Moore,
London, 83.A.2B

Pool of Tears (1968-69)
Illustration from Lewis Carroll's
Alice's Adventures in Wonderland
coloured woodcut 399/2500 on paper
34.2 x 58 cm.
Gift of Mr. & Mrs. J.H. Moore,
London, 83.A.2C

Caucus Race and a Long Tale
(1968-69)
Illustration from Lewis Carroll's
Alice's Adventures in Wonderland
coloured woodcut 399/2500 on paper
34.2 x 58 cm.
Gift of Mr. & Mrs. J.H. Moore,
London, 83.A.2D

The Rabbit Sends in a Little Bill
(1968-69)
Illustration from Lewis Carroll's
Alice's Adventures in Wonderland
coloured woodcut 399/2500 on paper
34.2 x 58 cm.
Gift of Mr. & Mrs. J.H. Moore,
London, 83.A.2E

Advice from a Caterpillar (1968-69)
Illustration from Lewis Carroll's
Alice's Adventures in Wonderland
coloured woodcut 399/2500 on paper
34.2 x 58 cm.
Gift of Mr. & Mrs. J.H. Moore,
London, 83.A.2F

Pig and Pepper (1968-69)
Illustration from Lewis Carroll's
Alice's Adventures in Wonderland
coloured woodcut 399/2500 on paper
34.2 x 58 cm.
Gift of Mr. & Mrs. J.H. Moore,
London, 83.A.2G

A Mad Tea Party (1968-69)
Illustration from Lewis Carroll's
Alice's Adventures in Wonderland
coloured woodcut 399/2500 on paper
34.2 x 58 cm.
Gift of Mr. & Mrs. J.H. Moore,
London, 83.A.2H

The Queen's Croquet Ground
(1968-69)
Illustration from Lewis Carroll's
Alice's Adventures in Wonderland
coloured woodcut 399/2500 on paper
34.2 x 58 cm.
Gift of Mr. & Mrs. J.H. Moore,
London, 83.A.2 I

The Mock Turtle's Story (1968-69)
Illustration from Lewis Carroll's
Alice's Adventures in Wonderland
coloured woodcut 399/2500 on paper
34.2 x 58 cm.
Gift of Mr. & Mrs. J.H. Moore,
London, 83.A.2J

The Lobster Quadrille (1968-69)
Illustration from Lewis Carroll's
Alice's Adventures in Wonderland
coloured woodcut 399/2500 on paper
34.2 x 58 cm.
Gift of Mr. & Mrs. J.H. Moore,
London, 83.A.2K

Who Stole the Tarts (1968-69)
Illustration from Lewis Carroll's
Alice's Adventures in Wonderland
coloured woodcut 399/2500 on paper
34.2 x 58 cm.
Gift of Mr. & Mrs. J.H. Moore,
London, 83.A.2L

Alice's Evidence (1968-69)
Illustration from Lewis Carroll's
Alice's Adventures in Wonderland
coloured woodcut 399/2500 on paper
34.2 x 58 cm.
Gift of Mr. & Mrs. J.H. Moore,
London, 83.A.2M

Inferno No. 3 (n.d.)
lithograph 3/750 on paper
Gift of Mr. J.H. Moore, London,
through the Ontario Heritage
Foundation, 80.A.92

Paradise (n.d.)
lithograph 3/750 on paper
26.7 x 20.6 cm.
Gift of Mr. J.H. Moore, London,
through the Ontario Heritage
Foundation, 80.A.93

DALLAIRE, Jean (1916-1965)
Carnival Figure (1963-64)
oil on canvas
64.8 x 53.6 cm.
Gift of Mr. J.H. Moore, London,
through the Ontario Heritage
Foundation, 78.A.56

DALTON, Brian (1947-)
How Brief (1972)
aquatint and etching 1/1 on paper
90.9 x 50.5 cm.
Purchased with funds from the
Mitchell Bequest, 72.A.10

DALY, Kathleen (1898-)
Joshua Kajui - Eskimo Boy (n.d.)
oil on card
45.7 x 38.1 cm.
Art Fund, 53.A.142

DANBY, Ken (1940-)
Mill Window (1970)
serigraph XVII/XXX on paper
28.8 x 39.6 cm.
Gift of Mr. J.H. Moore, London,
through the Ontario Heritage
Foundation, 79.A.27

Butter Bowl (1970)
serigraph IX/XX on paper
40.2 x 55.9 cm.
Gift of Mr. J.H. Moore, London,
through the Ontario Heritage
Foundation, 79.A.36

The Prowler (1970)
serigraph X/X on paper
40 x 55.9 cm.
Gift of Mr. J.H. Moore, London,
through the Ontario Heritage
Foundation, 79.A.35

Study for "The Miller" (1970)
graphite and watercolour on paper
35.5 x 58.4 cm.
Gift of Mr. J.H. Moore, London,
through the Ontario Heritage
Foundation, 78.A.192

Bobsled (1971)
serigraph 14/100 on paper
42.8 x 58 cm.
Gift of Mr. J.H. Moore, London,
through the Ontario Heritage
Foundation, 79.A.24

Early Autumn (1971)
serigraph 57/100 on paper
39.3 x 55.7 cm.
Gift of Mr. J.H. Moore, London,
through the Ontario Heritage
Foundation, 79.A.45

Mill Wheel (1971)
serigraph 19/100 on paper
31.8 x 45.6 cm.
Gift of Mr. J.H. Moore, London,
through the Ontario Heritage
Foundation, 79.A.42

On the Gate (1971)
serigraph 21/100 on paper
39.5 x 55.9 cm.
Gift of Mr. J.H. Moore, London,
through the Ontario Heritage
Foundation, 79.A.44

The Goalie (1972)
lithograph 54/100 on paper
45.6 x 58.1 cm.
Gift of Mr. J.H. Moore, London,
through the Ontario Heritage
Foundation, 79.A.43

In the Shade (1972)
serigraph 17/100 on paper
39.5 x 55.8 cm.
Gift of Mr. J.H. Moore, London,
through the Ontario Heritage
Foundation, 79.A.37

The Skates (1972)
silkscreen 7/100 on paper
42.8 x 58 cm.
Gift of Mr. J.H. Moore, London,
through the Ontario Heritage
Foundation, 79.A.19

Under the Arch (1972)
serigraph 65/100 on paper
39.5 x 56 cm.
Gift of Mr. J.H. Moore, London,
through the Ontario Heritage
Foundation, 79.A.32

Sunning (1974)
serigraph 2/100 on paper
53.9 x 78.8 cm.
Gift of Mr. J.H. Moore, London,
through the Ontario Heritage
Foundation, 79.A.38

Summer Girl (1974)
lithograph 2/100 on paper
56.8 x 45.7 cm.
Gift of Mr. J.H. Moore, London,
through the Ontario Heritage
Foundation, 79.A.25

Boy in Chair (1975)
lithograph 2/100 on paper
58.2 x 45.7 cm.
Gift of Mr. J.H. Moore, London,
through the Ontario Heritage
Foundation, 79.A.26

Olympic Serigraphs: The Sculler
(1976)
serigraph 4/150 on paper
33.7 x 40 cm.
Gift of Mr. & Mrs. J.H. Moore,
London, 87.A.15A

Olympic Serigraphs: The Vaulter
(1976)
serigraph 4/150 on paper
33.7 x 40 cm.
Gift of Mr. & Mrs. J.H. Moore,
London, 87.A.15B

Olympic Serigraphs: The Diver
(1976)
serigraph 4/150 on paper
33.7 x 40 cm.
Gift of Mr. & Mrs. J.H. Moore,
London, 87.A.15C

Olympic Serigraphs: The Hurdler
(1976)
serigraph 4/150 on paper
33.7 x 40 cm.
Gift of Mr. & Mrs. J.H. Moore,
London, 87.A.15D

Walter Moos (1976)
watercolour on paper
25.5 x 34.4 cm.
Gift of Mr. & Mrs. J.H. Moore,
London, 87.A.75

DANKS, Hilda (1893-1969)
Off the Beaten Track (n.d.)
watercolour on paper
63.5 x 76.2 cm.
Gift of the Western Art League,
61.A.15

DARTNELL, George R. (British:
1798-1878)
Bridge Near Port Stanley (c.1841)
watercolour on paper
15.7 x 24.2 cm.
Art Fund, 48.A.61B

The Gaol and Courthouse, London
(c.1841)
watercolour on paper
15.7 x 24.2 cm.
Art Fund, 48.A.61A

Entrance to the West End of London
(c.1841)
watercolour on paper
15.7 x 24.2 cm.
Art Fund, 48.A.60

Indians in a Canoe Near Port
Stanley (c.1841)
watercolour on paper
15.7 x 24.1 cm.
Art Fund, 48.A.62

Port Stanley (c.1841)
watercolour on paper
17.2 x 24.2 cm.
Art Fund, 48.A.59

DA SILVA, Fernando V.
(Brazilian: -)
Bumba - Meu - Boi (1974)
oil on canvas
101.6 x 146.5 cm.
Gift of Mr. & Mrs. J.H. Moore,
London, 85.A.43

Untitled (1974)
acrylic on masonite
34.5 x 44.7 cm.
Gift of Mr. & Mrs. J.H. Moore,
London, 85.A.44

DA SILVA, Francisco (Brazilian:
1910-)
Passaro e Ave (1972)
acrylic on canvas
60 x 70 cm.
Gift of Mr. & Mrs. J.H. Moore,
London, 85.A.45

DAVIDEE (1919-)
Arctic Owl (n.d.)
green stone
10 x 11 x 5 cm.
Art Fund, 77.A.80

DAVIDSON, S. Kelso (1856-1926)
The Coves (1898)
oil on paper mounted on canvas
45 x 70 cm.
Gift of Mr. & Mrs. David Abbott,
London, 84.A.234

DAWSON, Russell (1933-)
Composition (1960)
monoprint on paper
50.8 x 62.3 cm.
Gift of Mr. J.H. Moore, London,
through the Ontario Heritage
Foundation, 80.A.210

DAYTON, Alan (1948-)
Portrait of Paterson Ewen (1986)
mixed media on canvas
183.4 x 140 cm.
Anonymous gift, 87.A.67

DEELEY, Kenneth (1938-)
The Polluters (1971)
watercolour on paper
30.5 x 48 cm.
Art Fund, 72.A.7

DEGAS, Edgar (French: 1834-1917)
Femme penchée sur une balustrade
(n.d.)
pastel on paper
50.8 x 78.8 cm.
Gift of Mr. J.H. Moore, London,
through the Ontario Heritage
Foundation, 83.A.6

Trois Danseuses (n.d.)
charcoal on paper
69.1 x 56.4 cm.
Gift of Mr. J.H. Moore, London,
through the Ontario Heritage
Foundation, 79.A.1

**DELAUNAY, Nicholas (French:
1739-1792) after WEST, Benjamin
(American: 1738-1820)**
La Mort du General Wolfe à Québec
(n.d.)
etching on paper
30.2 x 37.5 cm.
Gift of Mr. and Mrs. J.H. Moore,
London 89.A.29

DELRUE, Georges (1920-)
L'Aiglon (1966)
bronze
19.5 x 17.5 x 13.3 cm.
Gift of Mr. J.H. Moore, London,
through the Ontario Heritage
Foundation, 87.A.91

DEPEW, Viola (1894-)
Nicotiana (1956)
linocut 51/75 on paper
24.2 x 20.9 cm.
Gift of the Society of Canadian
Painter-Etchers and Engravers,
56.A.19

Edge of the North (c.1947)
linocut on paper
27.9 x 24.9 cm.
Print Fund, 47.A.55

Sumac and Pines (c.1945)
linocut on paper
24.2 x 27.4 cm.
Print Fund, 45.A.5

**DEYROLLE, Jean Jacques (French:
(1911-1967)**
Untitled (n.d.)
serigraph on paper
20 x 13.8 cm.
Gift of Mr. J.H. Moore, London,
through the Ontario Heritage
Foundation, 87.A.95

DIGNAM, Mary Ellen (1860-1938)
Katherine's Meuriel Roses (1886)
oil on canvas
34.8 x 44.9 cm.
Gift of Mrs. Audre E. Walker, London,
87.A.64

Still Life with Roses (c.1904)
oil on canvas mounted on masonite
73.0 x 104.5 cm.
Gift of Mr. & Mrs. B.R. Polgrain,
London, 86.A.41

Grey Wall and Red Earth (n.d.)
oil on panel
33.7 x 49.5 cm.
Gift of Mr. Clare Wood, Toronto,
through the Ontario Heritage
Foundation, 83.A.12

Kay's Cottage, Caledon (n.d.)
oil on canvas
38.1 x 61 cm.
Gift of Mr. Clare Wood, Toronto,
through the Ontario Heritage
Foundation, 83.A.13

Primroses (n.d.)
oil on canvas
63 x 52.4 cm.
Gift of the Estate of Miss Dorothy
Gunn, London, 82.A.13

DINE, Jim (American: 1935-)
Girl and Her Dog (1971)
etching 16/75 on paper
68.6 x 53.3 cm.
Gift of Mr. J.H. Moore, London,
through the Ontario Heritage
Foundation, 80.A.192

Ski Hat Progression, First State
(1974)
etching 8/50 on paper
69.9 x 49.6 cm.
Gift of the Volunteer Committee,
78.A.11A

Ski Hat Progression, Second State
(1974)
etching 8/30 on paper
66 x 50.8 cm.
Gift of the Volunteer Committee,
78.A.11B

Ski Hat Progression, Third State
(1974)
etching 8/25 on paper
75 x 54.6 cm.
Gift of the Volunteer Committee,
78.A.11C

Ski Hat Progression, Fourth State
(1974)
etching 8/20 on paper
71.1 x 50.8 cm.
Gift of the Volunteer Committee,
78.A.11D

DINKEL, Marcus (Swiss: 1762-1832)
Reclining Nude (1826)
watercolour on paper
25.4 x 35.6 cm.
Gift of Mr. Gordon Conn, Newmarket,
50.A.61

DOBSON, Frank (British: 1888-1963)
Nude Drawing (1914)
graphite on paper
47 x 30.5 cm.
Gift of the Contemporary Art Society
of Great Britain, 64.A.71

DONGES, Langley (1901-)
Bridge at Bruce's Mill (1949)
oil on card
40.6 x 49.6 cm.
Gift of Langley Donges, Esq.,
Toronto, 50.A.11

DONOGHUE, Lynn (1953-)
Still Life (1975)
watercolour on paper
36.8 x 53.1 cm.
Purchased with funds from the
Mitchell Bequest, 75.A.20

Portrait of Erik Gamble (1979)
charcoal on paper
47.3 x 56.5 cm.
Purchased with matching Acquisitions
funds and a Wintario Grant, 79.A.55

DORAY, Audrey Capel (1931-)
Centennial Suite: Diamond (c.1967)
serigraph 19/50 on paper
38.1 x 50.8 cm.
Gift of Simon Fraser University,
Burnaby, B.C., 68.A.81

DORSETT, Thomas
Skeleton of a Sawmill (1962)
etching 4/15 on paper
35.2 x 63.5 cm.
Print Fund, 64.A.113

DOWNE, Lise (1955-)
Wasp (1977)
serigraph A/P on paper
46 x 31.3 cm.
Gift of Mr. & Mrs. Richard M. Ivey,
London, 87.A.10

DOWNING, Robert (1935-)
Cube #1 (n.d.)
aluminum
22.2 x 17.7 x 20.9 cm.
Gift of Mr. J.H. Moore, London,
through the Ontario Heritage
Foundation, 78.A.202

DRAPELL, Joseph (1940-)
Message (1978)
acrylic on canvas
170 x 213 cm.
Gift of Dr. J.T. and Dr. Marta
Hurdalek, Toronto, 90.A.34

DUCK, Adele (1948-)
Cold Blood and White Heat (1974)
mixed media collage on paper
76.2 x 58.4 cm.
Art Fund, 75.A.13

DUFF, Ann McIntosh (1925-)
Afterglow (1975)
watercolour on paper
56.5 x 76.2 cm.
Art Fund, 75.A.24

DUMOUCHEL, Albert (1916-1971)
Les Barques, Portugal (1959)
watercolour on paper
29.8 x 40 cm.
Gift of Mr. J.H. Moore, London,
through the Ontario Heritage
Foundation, 78.A.59

L'Étang (1960)
oil on canvas
76.2 x 91.4 cm.
Art Fund, 61.A.68

DUNCAN, Alma (1917-)
Spring (1964)
ink on paper
18.8 x 19.4 cm.
Art Fund, 65.A.94

Woman Series, Bouquet (1965)
conté on paper
71.1 x 68.6 cm.
Gift of the Western Art League,
66.A.25

DUNCAN, James (1806-1881)
View of London (1849)
watercolour on paper
20.9 x 31.8 cm.
Gift of F.G. Ketcheson, Esq.,
Montreal, Quebec, 42.A.19

View of Indian Lorette (c.1850)
watercolour on paper
20.3 x 22.9 cm.
Gift of Dr. & Mrs. Daniel Lowe,
London, 80.A.235

View of the Rideau River (c.1850)
watercolour on paper
19.1 x 29.2 cm.
Gift of Dr. & Mrs. Daniel Lowe,
London, 80.A.234

DUPUIS, Daniel (French: 1849-1899)
Medal: Société des Artistes
Français: Peinture Salon de 1890
(1890)
cast gold, leather case
metal: 5.4 cm. diameter
case: 9 x 9 x 1.5 cm.
Gift of Miss Marguerite Peel, Laguna
Beach, California, 82.A.1A-B

DURHAM, Michael (1944-)
Yellow Monarch (1972)
acrylic on canvas, painted wood
181.9 x 244.5 cm.
Art Fund, 72.A.123

Drawing (1973)
paint over stencil on paper
72.4 x 55.9 cm.
Purchased with funds from the
Mitchell Bequest, 73.A.108

DYONNETT, Edmond (1859-1954)
Portrait of ''St. Thomas'' Smith
(n.d.)
pastel on paper
17.8 x 12.7 cm.
Gift of Mr. Edmond Dyonnett,
Montreal, Quebec, 53.A.149

EGYVUDLO, Roger (1920-)
Walrus At Play (1964)
stonecut 18/50 on paper
40.6 x 55.9 cm.
Print Fund, 72.A.48

EITEL, George (1906-1961)
Port Dover (1948)
watercolour on paper
41.9 x 54.6 cm.
Gift of Mr. J.H. Moore, London,
through the Ontario Heritage
Foundation, 80.A.127

Country Road (n.d.)
watercolour on paper
36.2 x 53.3 cm.
Art Fund, 53.A.114

ELENIA (Brazilian: -)
Untitled (1973)
acrylic on canvas
34.9 x 48.9 cm.
Gift of Mr. & Mrs. J.H. Moore,
London, 85.A.46

ENSOR, John (1905-)
Liberty Ships Anchored Off "Utah"
Beachhead (1944)
watercolour on paper
26.7 x 47 cm.
Gift of Mr. Gordon Conn, Newmarket,
49.A.14

EPSTEIN, Jacob (British: 1880-1959)
Head of Joan Greenwood (c.1930)
bronze
35 x 29 x 27.5 cm.
Art Fund, 62.A.1

The High Pond (n.d.)
watercolour on paper
43.2 x 55.9 cm.
Gift of the Contemporary Art Society
of Great Britain, 55.A.118

ESLER, John (1933-)
The Great Northwest (1963)
etching 6/15 on paper
45.7 x 61 cm.
Purchased with a Canada Council
matching grant and Acquisitions
funds, 64.A.172

Prairie Winter (1963)
etching 6/15 on paper
45.7 x 61 cm.
Purchased with a Canada Council
matching grant and Acquisitions
funds, 64.A.163

Monument No. 2 (1964)
etching 10/15 on paper
61 x 45.7 cm.
Purchased with a Canada Council
matching grant and Acquisitions
funds, 64.A.162

The Apartment (1965)
collograph 7/15 on paper
52.1 x 57.9 cm.
Gift of Mr. J.H. Moore, London,
through the Ontario Heritage
Foundation, 80.A.211

Bishop (1965)
etching A/P on paper
86.4 x 50.3 cm.
Gift of Mr. William Norfolk, London,
74.A.55

August Night (1969)
etching 2/25 on paper
45.7 x 36.2 cm.
Purchased with a Canada Council
matching grant and Acquisitions
funds, 69.A.51

Rhombus No. 1 (1970)
collograph 5/15 on paper
53.3 x 47.9 cm.
Gift of Mr. J.H. Moore, London,
through the Ontario Heritage
Foundation, 80.A.63

ETROG, Sorel (1933-)
Toronto 20: Untitled (c.1965)
embossed print 50/100 on paper
40.6 x 30.7 cm.
Gift of Mr. & Mrs. J.H. Moore,
London, 81.A.20

Untitled (c.1968)
embossed print on paper
28 x 20.5 cm.
Gift of Mr. & Mrs. J.H. Moore,
London, 87.A.76

Voyovod (1969)
painted bronze 1/10
13 x 12.1 x 8.9 cm.
Gift of Mr. J.H. Moore, London,
through the Ontario Heritage
Foundation, 78.A.203

Voyager (1973-76)
bronze 1/10
19.3 x 5 x 9.1 cm.
Gift of Mr. J.H. Moore, London,
through the Ontario Heritage
Foundation, 87.A.105

Voyager Study (1974)
pastel and charcoal on paper
61.9 x 46.4 cm.
Gift of Mr. J.H. Moore, London,
through the Ontario Heritage
Foundation, 87.A.106

EWEN, Paterson (1925-)
Montreal West (1950)
watercolour on paper
50.2 x 64.8 cm.
Art Fund, 75.A.23

Untitled (c.1963)
oil on canvas
81.5 x 91 cm.
Gift of the Volunteer Committee,
88.A.14

Thundercloud as a Generator #1
(1972)
acrylic on canvas
213.4 x 152.4 cm.
Art Fund, 72.A.124

Rain Over Water (1974)
acrylic on gouged plywood
243.8 x 335.3 cm.
Purchased with matching Acquisitions
funds and a Wintario Grant, 80.A.223

Rain on a Coastline Stopping (1975)
watercolour on paper
48.3 x 61 cm.
Art Fund, 75.A.22

Thundercloud As A Generator (1976)
lithograph 43/50 on paper
78.7 x 56.5 cm.
Print Fund, 77.A.2

Shipwreck (1987)
acrylic on gouged plywood
228.6 x 243.6 cm.
Purchased with the support of the
Volunteer Committee and the
Government of Ontario through the
Ministry of Culture and
Communications, 88.A.1

EYRE, Ivan (1935-)
Day Dream (1971)
acrylic on canvas
157.5 x 213.4 cm.
Art Fund, 73.A.101

EYSACKERS, Andre (1928-)
Winter Landscape (1962)
oil on canvas
66 x 50.8 cm.
Gift of Mr. J.H. Moore, London,
through the Ontario Heritage
Foundation, 78.A.60

FALK, Gathie (1928-)
Cake Walk Rococo (1982)
graphite on paper
63.5 x 43.6 cm.
Art Fund, 83.A.22

FALKENBERG, Ene (1914-)
Portrait (1951)
pastel on paper
26.7 x 36.9 cm.
Art Fund, 53.A.153

FARNCOMB, Caroline (1859-1951)
The French Girl (n.d.)
oil on canvas
45.7 x 33 cm.
Gift of Mrs. Pennington, London,
53.A.151

Still Life with Onions (n.d.)
oil on canvas
36 x 51.4 cm.
Gift of Mrs. Pennington, London,
53.A.144

Woman with Basket (n.d.)
oil on canvas
78.7 x 53.8 cm.
Gift of Mrs. Pennington, London,
53.A.146

FARNESE, Andrade de (Brazilian:
1926-)
Portrait of a Boy & Girl (n.d.)
ink and varnish on board
68.9 x 49 cm.
Gift of Mr. & Mrs. J.H. Moore,
London, 85.A.48

Portrait of a Girl (n.d.)
ink and varnish on board
68.9 x 49 cm.
Gift of Mr. & Mrs. J.H. Moore,
London, 85.A.47

FAVRO, Murray (1940-)
Light Bulbs (1970)
16 mm colour film loop, projector,
timer control, wood and plaster
86 x 91 x 28 cm.
Purchased with a Wintario Grant and
matching funds from the Mitchell
Bequest and the Somerville Bequest,
85.A.35A-D

Still Life: The Table (1970)
35 mm colour slide, projector,
projector stand, canvas, wood, table
91.4 x 74.9 x 81.3 cm.
Purchased with matching Acquisitions
funds and a Wintario Grant,
80.A.4A-L

Guitar (1982)
wood, aluminum, steel and
guitar hardware
33 x 119.4 x 5.1 cm.
Purchased with a Canada Council
matching grant and funds from the
Volunteer Committee, 85.A.81

Music Gallery Portfolio: Guitar
Design (1982)
serigraph 4/40 on paper
44.5 x 62.6 cm.
Purchased with a Canada Council
matching grant and Acquisitions
funds, 82.A.40

Untitled: Preparatory Study for
Guitar (1982)
graphite on paper
21.6 x 25.4 cm.
Purchased with a Canada Council
matching grant and funds from the
Volunteer Committee, 85.A.82

Untitled: Preparatory Study for
Guitar (1982)
graphite on paper
21.6 x 25.4 cm.
Purchased with a Canada Council
matching grant and funds from the
Volunteer Committee, 85.A.83

Untitled: Preparatory Study for
Guitar (1982)
graphite on paper
21.6 x 25.4 cm.
Purchased with a Canada Council
matching grant and funds from the
Volunteer Committee, 85.A.84

Untitled: Preparatory Study for
Guitar (1982)
graphite on paper
21.6 x 25.4 cm.
Purchased with a Canada Council
matching grant and funds from the
Volunteer Committee, 85.A.85

Untitled: Preparatory Study for
Guitar (1982)
graphite on paper
21.6 x 25.4 cm.
Purchased with a Canada Council
matching grant and funds from the
Volunteer Committee, 85.A.86

FELDMAR, Kay (1941-)
Pleasures of the Bath, No. 4 (1971)
acrylic on canvas
59.2 x 87.7 cm.
Gift of Mr. J.H. Moore, London,
through the Ontario Heritage
Foundation, 80.A.17

Pleasures of the Bath, No. 6 (1971)
acrylic on canvas
58.4 x 86.4 cm.
Gift of Mr. J.H. Moore, London,
through the Ontario Heritage
Foundation, 80.A.16

FENWICK, Roly (1932-)
Limits of Vision (1969)
watercolour on paper
40.1 x 53.6 cm.
Purchased with funds from the
Mitchell Bequest, 70.A.114

Concentration as an Art Form (1970)
watercolour on paper
58.4 x 56 cm.
Gift of Mr. H.O. Bunt, Toronto,
78.A.4

Skipper (1971)
watercolour on paper
66 x 63.5 cm.
Gift of Dr. & Mrs. J. Hiscock,
St. Mary's, 80.A.1

FERRARO, Robert C. (1936-)
Untitled (n.d.)
acrylic on canvas
203.2 x 160 cm.
Art Fund, 77.A.4

ferris, kerry (1949-)
Mother and Michael, Automne (1973)
acrylic on canvas
91.4 x 69.2 cm.
Art Fund, 75.A.14

Armacarde (c.1974)
magic marker and watercolour on
paper
26 x 34.3 cm.
Purchased with funds from the
Mitchell Bequest, 74.A.58

Oldest Woman in Lake Harbour
(1982)
watercolour on paper
56.3 x 66.7 cm.
Purchased with matching Acquisitions
funds and a Wintario Grant, 82.A.7

Woman from Pangnirtung (1982)
watercolour on paper
56.3 x 66.7 cm.
Purchased with matching Acquisitions
funds and a Wintario Grant, 82.A.6

FIGHTER, Anne (1952-)
Uptigrove Barn near Rosehill (1974)
charcoal on paper
27 x 37.8 cm.
Gift of Mr. J.H. Moore, London,
through the Ontario Heritage
Foundation, 87.A.153

FILIPOVIC, Augustine (1931-)
Project for Don Mills (1967)
bronze 3/5
10.7 x 11.7 x 9 cm.
Gift of Mr. J.H. Moore, London,
through the Ontario Heritage
Foundation, 78.A.204

FINCH, Robert (1900-)
The Lighthouse, Vendée (1935)
watercolour and pastel on paper
27.4 x 27.4 cm.
Gift from the Douglas M. Duncan
Collection, 70.A.63

FINLEY, Gerald (1931-)
Lamprey Barrier (1957)
oil on masonite
30.8 x 46 cm.
Gift of Mr. J.H. Moore, London,
through the Ontario Heritage
Foundation, 80.A.128

FINN, Christopher (1950-)
Marilyn Cut-out (n.d.)
graphite on paper
63 x 85.8 cm.
Art Fund, 74.A.19

Window View (n.d.)
collage lithograph on paper
48.3 x 37.6 cm.
Gift of Shell Canada Limited, 75.A.10

FISCHL, Eric (American: 1948-)
Sleeve (1975)
lithograph 9/75 on paper
17.2 x 68.4 cm.
Purchased with a Canada Council
matching grant and funds from the
Somerville Bequest, 83.A.9

Untitled (1975)
lithograph 6/10 on paper
17.1 x 68.1 cm.
Purchased with a Canada Council
matching grant and funds from the
Somerville Bequest, 83.A.8

Winter House (1976)
oil on wood
52.7 x 153 cm.
Purchased with a Canada Council
matching grant and Acquisitions
funds, 82.A.28

FISHER, Brian (1939-)
Flowers (1964)
ink on paper
48.3 x 36.8 cm.
Gift of Mr. J.H. Moore, London,
through the Ontario Heritage
Foundation, 78.A.62

Lyra (1966)
polymer acrylic on canvas
218.4 x 137.2 cm.
Art Fund, 68.A.87

Moving In Alone (1966)
polymer acrylic on canvas
172.7 x 208.3 cm.
Purchased with a Canada Council
matching grant and Acquisitions
funds, 68.A.60

Centennial Suite: Untitled (1967)
serigraph 19/50 on paper
47 x 34.3 cm.
Gift of Simon Fraser University,
Burnaby, B.C., 68.A.80

Angst (1967)
collage on paper
38.5 x 49 cm.
Gift of Mr. J.H. Moore, London,
through the Ontario Heritage
Foundation, 78.A.61

Mandala No. 1 (1968)
acrylic on canvas
111.8 x 111.8 cm.
Gift of Mr. J.H. Moore, London,
through the Ontario Heritage
Foundation, 78.A.63

Odyssey 1 (1969)
serigraph 1/40 on paper
57.8 x 69.6 cm.
Gift of Mr. & Mrs. J.H. Moore,
London, 81.A.36A

Odyssey 2 (1969)
serigraph 1/40 on paper
57.8 x 69.6 cm.
Gift of Mr. & Mrs. J.H. Moore,
London, 81.A.36B

Odyssey 3 (1969)
serigraph 1/40 on paper
57.8 x 69.6 cm.
Gift of Mr. & Mrs. J.H. Moore,
London, 81.A.36C

Odyssey 4 (1969)
serigraph 1/40 on paper
57.8 x 69.6 cm.
Gift of Mr. & Mrs. J.H. Moore,
London, 81.A.36D

Odyssey 5 (1969)
serigraph 1/40 on paper
57.8 x 69.6 cm.
Gift of Mr. & Mrs. J.H. Moore,
London, 81.A.36E

Odyssey 6 (1969)
serigraph 1/40 on paper
57.8 x 69.6 cm.
Gift of Mr. & Mrs. J.H. Moore,
London, 81.A.36F

Odyssey 7 (1969)
serigraph 1/40 on paper
57.8 x 69.6 cm.
Gift of Mr. & Mrs. J.H. Moore,
London, 81.A.36G

Odyssey 8 (1969)
serigraph 1/40 on paper
57.8 x 69.6 cm.
Gift of Mr. & Mrs. J.H. Moore,
London, 81.A.36H

Odyssey 9 (1969)
serigraph 1/40 on paper
57.8 x 69.6 cm.
Gift of Mr. & Mrs. J.H. Moore,
London, 81.A.36 I

Odyssey 10 (1969)
serigraph 1/40 on paper
57.8 x 69.6 cm.
Gift of Mr. & Mrs. J.H. Moore,
London, 81.A.36J

**FITZGERALD, Lionel LeMoine
(1890-1956)**
Prairie Sunset (c.1920)
oil on masonite
16.5 x 22.2 cm.
Gift of Mr. J.H. Moore, London,
through the Ontario Heritage
Foundation, 78.A.69

Ponemah (c.1920)
oil on canvas
40.1 x 32.5 cm.
Gift from the Douglas M. Duncan
Collection, 70.A.78

Airplane Hangar (1933)
graphite on paper
22.9 x 30.5 cm.
Gift from the Douglas M. Duncan
Collection, 70.A.85

Watering Can (1939)
graphite on paper
38.1 x 29.2 cm.
Gift from the Douglas M. Duncan
Collection, 70.A.70

Glass Jar (c.1943)
pastel on paper
59.7 x 45.2 cm.
Art Fund, 58.A.96

Old Maple in Front Yard (1948)
watercolour on paper
36.8 x 27.9 cm.
Gift of Mr. J.H. Moore, London,
through the Ontario Heritage
Foundation, 78.A.67

Picket Fence (1949)
watercolour on paper
27.9 x 45.1 cm.
Gift of Mr. J.H. Moore, London,
through the Ontario Heritage
Foundation, 78.A.68

Apples On A Plate (1953)
pastel on paper
31.1 x 47 cm.
Gift of the Volunteer Committee,
58.A.95

Apple in Bowl (n.d.)
graphite on paper
32.4 x 40.6 cm.
Gift of Mr. J.H. Moore, London,
through the Ontario Heritage
Foundation, 78.A.65

Apples and Grapefruit (n.d.)
watercolour on paper
45.7 x 61 cm.
Gift from the Douglas M. Duncan
Collection, 70.A.90

Abstract (n.d.)
ink and pastel on paper
20.6 x 47.7 cm.
Gift from the Douglas M. Duncan
Collection, 70.A.91

Book (n.d.)
ink on paper
29.8 x 45.1 cm.
Gift of Mr. J.H. Moore, London,
through the Ontario Heritage
Foundation, 78.A.64

Leaves (n.d.)
pastel on paper
60.5 x 48.3 cm.
Gift from the Douglas M. Duncan
Collection, 70.A.88

Nude - Interior (n.d.)
graphite on paper
31.1 x 24.4 cm.
Gift of Mr. J.H. Moore, London,
through the Ontario Heritage
Foundation, 78.A.66

Squash and Apple (n.d.)
conté on paper
61 x 45.7 cm.
Gift from the Douglas M. Duncan
Collection, 70.A.89

Watering Can (n.d.)
oil on canvas
20.6 x 21.6 cm.
Gift from the Douglas M. Duncan
Collection, 70.A.86

Watering Can and Spade (n.d.)
oil on canvas
20.6 x 21.6 cm.
Gift from the Douglas M. Duncan
Collection, 70.A.87

FONES, Robert (1949-)
Interior (1973)
graphite on paper
43.2 x 35.9 cm.
Gift of the Junior Volunteer
Committee, 74.A.66

FONSECA, Jose Paulo (Brazilian: 1922-)
Doorway (1969)
oil on canvas
34.6 x 23.8 cm.
Gift of Mr. & Mrs. J.H. Moore, London, 85.A.57

FONSECA, Reynaldo (Brazilian: 1925-)
Oavo (1970)
oil on canvas
35 x 27 cm.
Gift of Mr. & Mrs. J.H. Moore, London, 85.A.58

FONTANA, Lucio (Italian: 1899-1968)
Concetto Spaziale (n.d.)
oil on canvas
21.6 x 15.8 cm.
Gift of Mr. J.H. Moore, London, through the Ontario Heritage Foundation, 78.A.170

FORREST, Nita (1926-)
Cow (1959)
serigraph 25/100 on paper
49.6 x 31.8 cm.
Print Fund, 59.A.13

FORREST, Trudi
Bombes Away (1982)
graphite and crayon on paper
66.6 x 86.2 cm.
Art Fund, 83.A.23

FOURNIER, Paul (1939-)
Nature Page (1964)
ink on paper
45 x 60 cm.
Gift of Mr. J.H. Moore, London, through the Ontario Heritage Foundation, 78.A.71

S.A. Mushroom Series, No. 41 (1972)
ink on paper
90.2 x 61.6 cm.
Gift of Mr. J.H. Moore, London, through the Ontario Heritage Foundation, 78.A.70

FOWLER, Daniel (1810-1894)
After the Storm, Amherst Bay (1873)
watercolour on paper mounted on card
24 x 35.5 cm.
Gift of Miss Alice Oswald, London, 87.A.35

FOX, John (1927-)
Quayside, Honfleur (c.1959)
oil on canvas
64.8 x 47 cm.
Art Fund, 59.A.5

Sunday Harbour (c.1959)
oil on canvas
61 x 48.3 cm.
Gift of Mr. J.H. Moore, London, through the Ontario Heritage Foundation, 80.A.18

Nude (1965)
brown wash on paper laid on masonite
61.9 x 46.4 cm.
Gift of Mr. J.H. Moore, London, through the Ontario Heritage Foundation, 78.A.72

FRASER, John A. (1838-1898)
At The Solemn Hour (1889)
watercolour on paper
35.6 x 53.3 cm.
The W. Thomson Smith Memorial Collection (Bequest of Mr. Alfred J. Mitchell), 48.A.63

Spring in the Hop Country, Trigghurst, Kent (c.1888)
watercolour on paper
27.9 x 45.7 cm.
The W. Thomson Smith Memorial Collection (Bequest of Mr. Alfred J. Mitchell), 48.A.65

FRIEND, William Frederick "Washington" (British: 1820-1891)
Lake Scene at Sunset (n.d.)
watercolour on paper
34.9 x 51.4 cm.
Gift of Dr. & Mrs. Daniel Lowe, London, 81.A.48

View of a Lake from a Mountainside (n.d.)
watercolour on paper
34.3 x 52.7 cm.
Gift of Dr. & Mrs. Daniel Lowe, London, 81.A.49

FRY, Roger (British: 1866-1944)
Bruges (n.d.)
watercolour on paper
21.6 x 33 cm.
Gift of the Contemporary Art Society of Great Britain, 64.A.72

FUJI (20th century)
Lumière sous le baisseau (1967)
serigraph 18/32 on paper
63.5 x 45.7 cm.
Gift of Mr. J.H. Moore, London, through the Ontario Heritage Foundation, 80.A.212

GAGEN, Robert F. (1847-1926)
Dirty Weather (1922)
oil on canvas
73.7 x 99.1 cm.
Purchased with funds from the Mitchell Bequest, 56.A.27

GAGNON, Clarence (1881-1942)
Oxen Ploughing, Québec (fourth state) (1904)
etching on paper
7.6 x 14 cm.
Print Fund, 60.A.16

Rouen (1905)
etching on paper
16.8 x 10 cm.
Print Fund, 60.A.25

En novembre (1905)
etching on paper
13.6 x 21 cm.
Print Fund, 60.A.12

Grand Canal, Venise (1906)
etching on paper
18.7 x 25.1 cm.
Print Fund, 60.A.20

Le Jardin public, Venise (1906)
etching on paper
16.8 x 9.7 cm.
Print Fund, 60.A.28

Souvenir de Granada (1906)
etching on paper
10 x 11.5 cm.
Print Fund, 60.A.15

Canal du Loing, Moret (1907)
etching on paper
14.8 x 21.5 cm.
Print Fund, 60.A.18

Mont St. Michel (1907)
etching on paper
19.7 x 24.9 cm.
Print Fund, 60.A.13

L'Orage (1907)
etching on paper
14.6 x 16.8 cm.
Print Fund, 60.A.31

Rue des Cordeliers, Dinan (1907)
etching on paper
19.6 x 24.6 cm.
Print Fund, 60.A.11

Rue des Petits Dégres, St. Malo (1907)
etching on paper
21.7 x 11.7 cm.
Print Fund, 60.A.29

Vue, Rue à Nemours (1907)
etching on paper
20.8 x 13.9 cm.
Print Fund, 60.A.24

Jardins du Luxembourg (1908)
etching on paper
13.9 x 10.2 cm.
Print Fund, 60.A.26

Porte de Bourgogne, Moret-sur-Loing (1908)
etching on paper
20.9 x 13.7 cm.
Print Fund, 60.A.14

Venise, Canal San Pietro (1908)
etching on paper
14.8 x 22 cm.
Print Fund, 60.A.30

Ripon Cathedral (1909)
etching on paper
14 x 20.9 cm.
Print Fund, 60.A.21

Rue à Pont de L'Arche (1909)
etching on paper
16.4 x 12.4 cm.
Print Fund, 60.A.17

Séminaire St. Sulpice - Les Jardins (1917)
etching on paper
19.1 x 24.2 cm.
Print Fund, 60.A.27

GAUCHER, Yves (1934-)
En Hommage à Webern - I (1963)
impression/relief print 26/30 on paper
55.4 x 75.2 cm.
Gift of Mr. J.H. Moore, London, through the Ontario Heritage Foundation, 79.A.29

En Hommage à Webern - II (1963)
impression/relief print 28/30 on paper
55.4 x 75.2 cm.
Gift of Mr. J.H. Moore, London, through the Ontario Heritage Foundation, 79.A.30

En Hommage à Webern - III (1963)
impression/relief print 22/30 on paper
55.4 x 75.2 cm.
Gift of Mr. J.H. Moore, London, through the Ontario Heritage Foundation, 79.A.31

Houda (1963)
collage and silkscreen 5/5 on paper
60 x 91.4 cm.
Gift of Mr. J.H. Moore, London, through the Ontario Heritage Foundation, 80.A.64

Transitions I (1967)
lithograph 19/59 on paper
44.5 x 58.4 cm.
Gift of Mr. & Mrs. J.H. Moore, London, 81.A.42A

Transitions II (1967)
lithograph 19/59 on paper
44.5 x 58.4 cm.
Gift of Mr. & Mrs. J.H. Moore, London, 81.A.42B

Transitions III (1967)
lithograph 19/59 on paper
44.5 x 58.4 cm.
Gift of Mr. & Mrs. J.H. Moore, London, 81.A.42C

Transitions IV (1967)
lithograph 19/59 on paper
44.5 x 58.4 cm.
Gift of Mr. & Mrs. J.H. Moore, London, 81.A.42D

Transitions V (1967)
lithograph 19/59 on paper
44.5 x 58.4 cm.
Gift of Mr. & Mrs. J.H. Moore, London, 81.A.42E

Transitions VI (1967)
lithograph 19/59 on paper
44.5 x 58.4 cm.
Gift of Mr. & Mrs. J.H. Moore, London, 81.A.42F

Transitions VII (1967)
lithograph 19/59 on paper
44.5 x 58.4 cm.
Gift of Mr. & Mrs. J.H. Moore, London, 81.A.42G

Transitions VIII (1967)
lithograph 19/59 on paper
44.5 x 58.4 cm.
Gift of Mr. & Mrs. J.H. Moore, London, 81.A.42H

B-JL/68 (1968)
acrylic on canvas
203.2 x 203.2 cm.
Purchased with matching Acquisitions funds and a Wintario Grant, 76.A.31

Vert, Bleu, Vert (1971)
acrylic on canvas
107 x 148 cm.
Gift of Mr. J.H. Moore, London, through the Ontario Heritage Foundation, 79.A.51

Gris, Bleu, Bleu/Vert (1972)
acrylic on canvas
91.4 x 91.4 cm.
Gift of Mr. J.H. Moore, London, through the Ontario Heritage Foundation, 78.A.73

GAUDIER-BRZESKA, Henri (French: 1891-1915)
Male Torso (1912)
ink on paper
25.4 x 18.4 cm.
Gift of the Contemporary Art Society
of Great Britain, 55.A.122

3/4 Length Male Torso (1912)
ink on paper
25.4 x 18.4 cm.
Gift of the Contemporary Art Society
of Great Britain, 55.A.123

Monkeys (n.d.)
ink on paper
27.9 x 22.9 cm.
Gift of the Contemporary Art Society
of Great Britain, 55.A.121

Standing Male (n.d.)
ink on paper
25.4 x 18.4 cm.
Gift of the Contemporary Art Society
of Great Britain, 55.A.124

GELEYNSE, Wyn (1947-)
Watercolour Paints (1975)
watercolour on paper
35.6 x 43.2 cm.
Purchased with funds from the
Mitchell Bequest, 76.A.17

Portrait of my Father (1982)
16 mm film loop, projector, timer,
loop cassette, metal stool, hand
coloured photograph laid on masonite
137.2 x 264.2 x 137.2 cm
Art Fund, 84.A.2A-D

GENOVES, Juan (Spanish: 1930-)
Solo (1973)
acrylic on canvas
130 x 115 cm.
Gift of Mr. J.H. Moore, London,
through the Ontario Heritage
Foundation, 79.A.48

GERSOVITZ, Sarah (1920-)
Departure of the Spirit (1964)
etching 8/25 on paper
58.4 x 36.2 cm.
Print Fund, 65.A.1

GERSTNER, Karl (Swiss: 1930-)
Colour Sound I (1971)
mixed media collage on card
60 x 60 cm.
Gift of Mr. J.H. Moore, London,
through the Ontario Heritage
Foundation, 78.A.171

GIACOMETTI, Alberto (Swiss: 1901-1966)
Double Head (c.1960)
ink on paper
8.9 x 11 cm.
Gift of Mr. J.H. Moore, London,
through the Ontario Heritage
Foundation, 78.A.172

GIGUERRE, Roland (1929-)
Papillon des Volcans (1964)
monoprint on paper
53.3 x 43.2 cm.
Gift of Mr. J.H. Moore, London,
through the Ontario Heritage
Foundation, 80.A.65

GILLIES, Jim (1951-)
Sweet Dreamies (1973)
crayon and graphite on paper
88.9 x 114.3 cm.
Art Fund, 73.A.16

GILLIES, William (British: 1898-1973)
Temple Village (n.d.)
watercolour on paper
50.8 x 68.6 cm.
Art Fund, 56.A.31

GILSON, Jacqueline (1912-)
Salamanca (c.1952)
oil on masonite
54.6 x 120.6 cm.
Art Fund, 52.A.74

GLADSTONE, Gerald (1929-)
Toronto 20: Random Magnetic Print Series (c.1965)
lithograph 50/100 on paper
66 x 50.8 cm.
Gift of Mr. & Mrs. J.H. Moore,
London, 81.A.21

Astral Figure No. 2 (n.d.)
oil on canvas
55.9 x 76.2 cm.
Gift of Mr. J.H. Moore, London,
through the Ontario Heritage
Foundation, 80.A.129

Watercolour No. 10 (n.d.)
watercolour and graphite on paper
27.4 x 22.8 cm.
Gift of Mr. J.H. Moore, London,
through the Ontario Heritage
Foundation, 80.A.19

GLEN, Edward (1887-1963)
Head Study (1909)
oil on canvas
43.2 x 35.6 cm.
Gift of the Estate of Mr. Edward Glen,
London, 63.A.24

Portrait Study (Young Girl) (1911)
oil on wood
26.7 x 18.4 cm.
Gift of Mrs. Pennington, London,
53.A.143

Étaples Market (1920)
oil on canvas
81.3 x 66 cm.
Gift of Mr. Edward Glen, London,
through the I.O.D.E., Nicholas Wilson
Chapter, 26.A.2

Self Portrait (n.d.)
oil on canvas
81.3 x 65.5 cm.
Gift of the Estate of Mr. Edward Glen,
London, 63.A.25

GOETZ, Peter (1917-)
Elora Rocks, (1960)
watercolour on paper
69.9 x 85.1 cm.
Gift of the Western Art League,
61.A.16

Stockholm (1968)
watercolour on paper
53.3 x 73.1 cm.
Gift of the Western Art League,
69.A.27

GOLDBERG, Eric (1890-1969)
Yemenite Mother and Child (n.d.)
oil on masonite
50.8 x 40.9 cm.
Gift of Mr. J.H. Moore, London,
through the Ontario Heritage
Foundation, 80.A.130

GOODDEN, Ted (1947-)
I Talk to the Ghost of Paul Peel
(1986)
stained glass and lead
71.4 x 58.4 cm.
Gift of the Volunteer Committee,
89.A.32

GORDON, Dave (1944-)
Chess Table (1973)
watercolour on paper
45.4 x 60.4 cm.
Art Fund, 73.A.9

GORDON, Hortense (1897-1961)
Surrealistic Forms (1946)
oil on canvas
76.6 x 38.1 cm.
Gift of the Estate of Mrs. Hortense M.
Gordon, Hamilton, 64.A.127

**Early Morning from the Island,
Friendship, Maine** (n.d.)
oil on canvas
50.2 x 60.6 cm.
Gift of the Estate of Mrs. Hortense M.
Gordon, Hamilton, 64.A.126

GORMAN, Richard (1935-)
Toronto 20: Untitled (1965)
random magnetic print 50/100 on
paper
66 x 50.8 cm.
Gift of Mr. & Mrs. J.H. Moore,
London, 81.A.22

GOTTLIEB, Adolph (American: 1903-1974)
Pink Ground (1972)
serigraph 98/150 on paper
60.5 x 44.8 cm.
Gift of Mrs. Mira Godard, Toronto,
87.A.28

Roman III (1973)
acrylic on canvas
152.4 x 121.9 cm.
Gift of Mr. J.H. Moore, London,
through the Ontario Heritage
Foundation, 79.A.9

GOULD, John (1929-)
Matador (1960)
oil on canvas
153.7 x 76.2 cm.
Gift of the Volunteer Committee,
62.A.36

Torero (1961)
oil on board
99.4 x 67.6 cm.
Gift of Mr. J.H. Moore, London,
through the Ontario Heritage
Foundation, 80.A.131

Seated Nude (c.1963)
black wash on paper mounted on
masonite
52.1 x 75.5 cm.
Gift of Mr. J.H. Moore, London,
through the Ontario Heritage
Foundation, 78.A.74

Alphabet (1967)
conté on paper
26.7 x 33.6 cm.
Art Fund, 68.A.4

Woman in Market, Cuzco (1967)
conté on paper
33 x 26.7 cm.
Art Fund, 68.A.3

Torero, Marcel Marceau (1970)
conté and gouache on paper
93 x 62.6 cm.
Gift of Mr. J.H. Moore, London,
through the Ontario Heritage
Foundation, 80.A.132

GRANSOW, Helmut (1921-)
Angler (1951)
woodcut on paper
35.6 x 25.4 cm.
Print Fund, 52.A.4

GRANT, Duncan (British: 1885-1978)
Still Life With Irises and Red Poppy
(1954)
oil on canvas
72.4 x 59.7 cm.
Gift of the Contemporary Art Society
of Great Britain, 57.A.35

GRANT, Gordon (American: 1895-1960)
Conflict (n.d.)
lithograph on paper
25.1 x 27 cm.
Print Fund, 46.A.64

Fog over Gloucester (n.d.)
lithograph on paper
22.5 x 29 cm
Print Fund, 46.A.72

GREENSTONE, Marion (1925-)
Composition #153 (1961)
oil on canvas
121.9 x 162.8 cm.
Art Fund, 61.A.21

Composition in Orange No. 105
(n.d.)
oil on canvas
127 x 75.7 cm.
Gift of Mr. J.H. Moore, London,
through the Ontario Heritage
Foundation, 80.A.133

GRIFFITHS, James (1814-1896)
**Die of Flowers
(after Jean Baptiste Monnoyer)** (n.d.)
sepia on paper
38.1 x 27.9 cm.
The Donald Routledge and John
Burton Bequest, 81.A.9

Exotic Foliage and Blooms (n.d.)
watercolour on paper
40.6 x 32.4 cm.
The Donald Routledge and John
Burton Bequest, 81.A.10

Peaches, Plums and Grapes (n.d.)
watercolour on paper
16.5 x 22.5 cm.
Gift of the Estate of Misses Mary L.
and Margaret E. Scott, London,
71.A.17

Phlox (n.d.)
watercolour on paper
25.4 x 19.7 cm.
The Donald Routledge and John
Burton Bequest, 81.A.6

Pink Roses (n.d.)
watercolour on paper
17.1 x 25 cm.
Gift of the Estate of Misses Mary L.
and Margaret E. Scott, London,
71.A.18

Pink, White and Red Roses (n.d.)
watercolour on paper
16.8 x 23.2 cm.
The Donald Routledge and John
Burton Bequest, 81.A.8

Red Roses (n.d.)
watercolour on paper
22.2 x 16.5 cm.
Gift of Mrs. N.A. Ashman, London,
53.A.147

Still Life with Peacock (n.d.)
sepia on paper
38.7 x 31.1 cm.
Gift of Mrs. N.A. Ashman, London,
54.A.77

Yellow Rose (n.d.)
watercolour on paper
19.4 x 25.4 cm.
The Donald Routledge and John
Burton Bequest, 81.A.7

GRIFFITHS, John H. (1826-1898)
Still Life (n.d.)
oil on canvas
46 x 61.2 cm.
Gift of Mrs. R.W. Pike, Ottawa,
76.A.9

GROENEWEGAN, Adrianus (Dutch:
1874-1963)
Dutch Pastures (n.d.)
watercolour on paper
25.4 x 35.6 cm.
Gift of Mrs. Irene Pashley, London,
81.A.58

GROSZ, George (American:
1898-1959)
Acrobat (1915)
graphite on paper
29.1 x 22.5 cm.
Gift of the Volunteer Committee,
78.A.225

GUARNIERI, Luciano (Italian:
1930-)
Portrait of a Young Woman,
Dolores, The Artist's Wife (1962)
pastel on paper
58.4 x 48.3 cm.
Gift of the Estate of Mrs. Margaret
Porteous, London, 69.A.5

HAGAN, Frederick (1918-)
Landscape (1946)
lithograph on paper
25.7 x 36.9 cm.
Print Fund, 47.A.32

Ladder No. 2 Watch (1955-56)
lithograph 12/24 on paper
41.9 x 20.3 cm.
Print Fund, 57.A.34

HAGARTY, Clara (1871-1958)
Fish Market, Etaples (1912)
oil on canvas
91.4 x 73.1 cm.
Anonymous gift, 68.A.97

Dutch Interior (n.d.)
oil on canvas
35.6 x 30.5 cm.
Gift of Miss Clara Hagarty, Toronto,
49.A.20

Sisters (Brittany Childhood) (n.d.)
oil on canvas
53.3 x 44.5 cm.
Gift of Miss Clara Hagarty, Toronto,
49.A.19

Spring Tulips (n.d.)
oil on canvas
66 x 55.9 cm.
Art Fund, 42.A.14

White and Green (n.d.)
oil on canvas
81.3 x 66 cm.
Gift of Miss Clara Hagarty, Toronto,
52.A.72

HAHN, Sylvia (1911-)
The Cider Press (1948)
woodcut on paper
18.4 x 22.9 cm.
Print Fund, 48.A.5

Basswood (c.1946)
wood engraving on paper
20 x 14.9 c.m
Print Fund, 46.A.12

Cicada (c.1947)
woodcut on paper
15.2 x 10.8 cm.
Print Fund, 47.A.30

HAINES, Fred (1879-1960)
Cloche Mountains (1937)
oil on masonite
91.4 x 91.4 cm.
Gift of Mrs. Dorothy Hoover, Toronto,
63.A.6

HALLAM, J.S. (1898-1953)
London, Ontario (1842)
oil on canvas
55.9 x 81.3 cm.
Gift of the O'Keefe Brewing Co. Ltd.,
Toronto, 46.A.40

Near St. Faustin, Québec (1948)
oil on card
30.8 x 40.6 cm.
Art Fund, 54.A.74

Autumn Woodland, Algonquin Park
(n.d.)
oil on masonite
33 x 43.2 cm.
Art Fund, 50.A.50

R.R. #1 (n.d.)
oil on masonite
61 x 76.2 cm.
Gift of the Canadian National
Exhibition Association, Toronto,
53.A.152

Spring Morning (n.d.)
oil on canvas
50.8 x 66 cm.
Art Fund, 47.A.70

HALLEWELL, Edmund G. (British:
active 1839-1869)
Waterloo Bridge, London, Canada
West (1848)
watercolour on paper
33 x 41.9 cm.
Gift of Mrs. P.N. Stevens, England,
58.A.52

London, Canada West (1849)
crayon and wash on paper
18.4 x 27.9 cm.
Gift of Mrs. P.N. Stevens, England,
58.A.50

London, Canada West (c.1850)
crayon and wash on paper
24.2 x 28.5 cm.
Gift of Mrs. P.N. Stevens, England,
58.A.51

HALLIDAY, Francis Robert
(1884-)
Free Speech (1955)
etching on paper
22.3 x 17.8 cm.
Print Fund, 55.A.51

HAMILTON, James (1810-1896)
Landscape with Mill Wheel (c. 1840)
watercolour on paper
27 x 20.9 cm.
Gift of the Estate of Mrs. Dorothy
Merrill White, London, 77.A.11

Roger Smith's Mill, London
(1848-49)
oil on card
25.1 x 38.1 cm.
Anonymous gift, 64.A.27

The Flats, London, C.W. (1850)
oil on paper
24.2 x 36.8 cm.
Art Fund, 48.A.55

The Clay Banks (c.1860)
oil on paper
24.2 x 35.6 cm.
Art Fund, 48.A.56

Becher's Island (1883)
watercolour on paper
15.2 x 25.4 cm.
Art Fund, 48.A.58

The Courthouse & Mechanics'
Institute, London (n.d.)
oil on wood
40.6 x 53.3 cm.
Gift of Dr. Fred Landon, London,
56.A.62

Forks of the Thames (n.d.)
oil on canvas
61 x 71.1 cm.
Anonymous gift, 68.A.91

HAMILTON, Richard (British:
1922-)
Fashion Plate (1969-70)
mixed media 70/70 on paper
92.7 x 59.7 cm.
Gift of the Volunteer Committee,
78.A.12

HANKEY, Lee (British: 1869-1952)
The Joke (n.d.)
dry point etching on paper
23.5 x 22.9 cm.
Print Fund, 40.A.5

HARDY, Dudley (British: 1865-1922)
A Dead Calm (n.d.)
oil on canvas
50.8 x 40.6 cm.
Gift of Mrs. Ethel McNee, London,
74.A.50

HARMAN, Jack (1927-)
Figure #2 (1960)
bronze
96.5 x 27.9 x 33.0 cm.
Gift of the Volunteer Committee,
62.A.50

HARRIS, Bess (1890-1970)
Ottawa River (n.d.)
oil on canvas
50.8 x 61 cm.
F.B. Housser Memorial Collection,
45.A.52

HARRIS, Lawren S. (1885-1970)
Northern Autumn (1922)
oil on canvas
81.3 x 97.2 cm.
Art Fund, 49.A.49

From the North Shore,
Lake Superior (1923)
oil on canvas
121.9 x 152.4 cm.
Gift of H.S. Southam, Esq., Ottawa,
40.A.12

Rocky Montains #92 (c.1923-30)
graphite on paper
13.1 x 20.6 cm.
Gift of Mrs. Margaret Knox,
Vancouver, B.C., 89.A.12

Rocky Mountains #733 (c.1923-30)
graphite on paper
20.3 x 25.2 cm.
Gift of Mrs. Margaret Knox,
Vancouver, B.C., 89.A.13

Glaciers, Rocky Mountains (1930)
oil on card
30.5 x 38.1 cm.
F.B. Housser Memorial Collection,
45.A.49

Abstract #564 (c.1938-40)
graphite on paper
25.4 x 20 cm.
Gift of Mrs. Margaret Knox,
Vancouver, B.C., 89.A.14

Abstract #576 (c.1938-40)
graphite on paper
27.4 x 21.2 cm.
Gift of Mrs. Margaret Knox,
Vancouver, B.C., 89.A.15

Abstract #577 (c.1938-40)
graphite on paper
25.4 x 20.2 cm.
Gift of Mrs. Margaret Knox,
Vancouver, B.C., 89.A.16

Lake Agnes Above Lake Louise,
Rocky Mountains (1955)
oil on board
29.8 x 37.5 cm.
Gift of Mr. J.H. Moore, London,
through the Ontario Heritage
Foundation, 78.A.193

HARRIS, Peter (1932-)
June (1972)
oil and pastel on paper
50.3 x 55.9 cm.
Gift of Mr. J.H. Moore, London,
through the Ontario Heritage
Foundation, 80.A.134

HARRISON, Mary Kent (British: 1915-1985)
Cambridge Lace (1950)
oil on canvas
50.8 x 61 cm.
Gift of Mrs. Mary Kent Harrison,
England, 71.A.1

HARTMAN, John (1950-)
Scraping and Drying Skins, Roy M.'s House (1985)
drypoint engraving 2/10 on paper
27.4 x 34.7 cm.
Gift of the Volunteer Committee,
89.A.4

Luke taken from his Family (1987)
watercolour on paper
42.3 x 55.4 cm.
Gift of the Volunteer Committee,
89.A.1

The Kwandibens Family (1988)
drypoint engraving 6/10 on paper
27.4 x 34.7 cm.
Gift of the Volunteer Committee,
89.A.2

Pumping Oil (1988)
drypoint engraving 7/10 on paper
27.4 x 34.7 cm.
Gift of the Volunteer Committee,
89.A.3

HASSAN, Jamelie (1948-)
The Fan (1972)
watercolour on paper
44.8 x 33.3 cm.
Art Fund, 73.A.8

The Trial of the Gang of Four (1981)
mixed media installation: watercolour
on paper, wood and fabric dock and
chair, pottery objects
multi-measurements
Purchased with a Canada Council
matching grant and Acquisitions
funds, 81.A.62A-P

Bench from Cordoba (1982)
glazed ceramic, tiles, plywood and
colour photograph book
bench: 132.1 x 88.9 x 63.5 cm.
book: 20.3 x 15.2 x 2.0 cm.
Purchased with matching Acquisitions
funds and a Wintario Grant,
85.A.36A-B

HASSAN, Jamelie (1948-) and Tariq (1973-)
Anti-War Cake (1982)
watercolour and ink on paper
27.2 x 32.8 cm.
Art Fund, 83.A.24

HAWKEN, George (1946-)
Marta (1974)
aquatint and drypoint etching 29/30
on paper
49.6 x 58.4 cm.
Print Fund, 77.A.18

HAWORTH, Bobs Cogill (1904-1988)
Spring Pools (1966)
gouache on masonite
50.8 x 63.5 cm.
Art Fund, 66.A.96

Fog on the Bay of Fundy, N.B. (1976)
acrylic on masonite
57.3 x 79 cm.
Gift of the Estate of Mrs. B. Cogill
Haworth, Toronto, 89.A.33

HAWORTH, Peter (1889-1986)
Harbour (c.1949)
watercolour on paper
50.8 x 63.8 cm.
Art Fund, 50.A.14

Saucy Jane (c.1957)
watercolour on paper
48.9 x 87 cm.
Art Fund, 58.A.128

Boats, Cape Breton (n.d.)
acrylic on canvas
56.3 x 76.5 cm.
Gift of the Estate of Mrs. B. Cogill
Haworth, Toronto, 89.A.34

HAYDEN, Michael (1943-)
Light Sculpture (1967)
plastic, lights, tape and tape recorder
top: 116.8 x 84.4 x 27.8 cm.
bottom: 31.7 x 66.6 x 41.8 cm.
Gift of the Ontario Centennial Art
Exhibition, 69.A.87A-B

HAYES, Claude (British: 1852-1922)
No. 6 in Essex (n.d.)
watercolour on paper
20.3 x 33 cm.
The W. Thomson Smith Memorial
Collection (Bequest of Alfred J.
Mitchell), 48.A.74

HAYNES, Douglas (1936-)
Untitled #1 (1969)
mixed media on masonite
109.2 x 112.4 cm.
Purchased as a "Director's Choice"
with a Canada Council Grant, 69.A.53

HEAD, Bruce (1931-)
Stone Plant (1959)
monoprint on paper
33.6 x 53.9 cm.
Gift of the Western Art League,
60.A.59

Interior Forms (1960)
monoprint on paper
27.4 x 50.3 cm.
Purchased with a Canada Council
matching grant and Acquisitions
funds, 64.A.171

HEALEY, Mary (1885-1923)
Forks of the Thames (c.1920)
watercolour on paper
27.3 x 33.7 cm.
Gift of Mrs. E. Albright, London,
79.A.57

King Street Footbridge (c.1920)
watercolour on paper
22.9 x 34.4 cm.
Gift of Mrs. E. Albright, London,
79.A.56

The Budding Oaks, Springtime near
London, Ontario (c.1920)
watercolour on paper
25.4 x 33 cm.
Gift of W. Baldwin, Esq., London,
56.A.25

Portrait Study (n.d.)
oil on canvas
45.7 x 35 cm.
Gift of W. Baldwin, Esq., London,
56.A.24

Study of a Girl's Head (n.d.)
oil on canvas
57.2 x 50.8 cm.
Gift of the I.O.D.E., Nicholas Wilson
Chapter, 26.A.3

HEASLIP, William (1898-1970)
The Intruder (n.d.)
etching on paper
22.9 x 30.5 cm.
Print Fund, 46.A.69

HEDRICK, Robert (1930-)
Skull (1954)
oil on masonite
64.1 x 50.2 cm.
Gift of Mr. J.H. Moore, London,
through the Ontario Heritage
Foundation, 78.A.75

Morning Green (1959)
oil on canvas
121.9 x 182.9 cm.
Art Fund, 66.A.1

Toronto 20: Untitled (1965)
lithograph 50/100 on paper
66 x 50.8 cm.
Gift of Mr. & Mrs. J.H. Moore,
London, 81.A.23

HELFOND, Riva (American: 1910-)
Children Skating (1946)
serigraph ?/50 on paper
29.2 x 38.1 cm.
Print Fund, 47.A.61

HELIO, Batista de Barros (Brazilian: 1913-)
Damlon and Cosmos (1971)
oil on canvas
52.5 x 45.7 cm.
Gift of Mr. & Mrs. J.H. Moore,
London, 85.A.49

HENDERSON, Alexander (c.1859-1903)
Montreal from the Tower of Notre
Dame (1880)
albumen print on paper
15.2 x 20.5 cm.
Purchased with matching Acquisitions
funds and a Wintario Grant, 82.A.8

HENNESSEY, Frank (1893-1941)
Landscape (1931)
pastel on paper
35.6 x 45.7 cm.
Gift of Mr. Gordon Conn, Newmarket,
52.A.32

HENSHALL, Henry (British: 1856-1928)
Firelight Fancies (n.d.)
watercolour on paper
50.8 x 71.1 cm.
Gift of Mrs. Ethel McNee, London,
74.A.49

Girl with Slate (n.d.)
watercolour on paper
26.7 x 17.8 cm.
The W. Thomson Smith Memorial
Collection (Bequest of Alfred J.
Mitchell), 48.A.63

Sympathy (n.d.)
watercolour on paper
35 x 24 cm.
Gift of Mr. J.H. Moore, London,
through the Ontario Heritage
Foundation, 87.A.101

HEPWORTH, Barbara (British: 1903-1975)
Four Forms - Porthmeer (1965)
wood and slate
16.5 x 35.5 x 27.6 cm.
Gift of Mr. J.H. Moore, London,
through the Ontario Heritage
Foundation, 79.A.50

HERON, Patrick (British: 1920-)
Silhouettes in Ceruleum (1967)
gouache on paper
56.5 x 77.8 cm.
Gift of the Contemporary Art Society
of Great Britain, 72.A.121

HEYWOOD, Carl (1941-)
Twining Blue (1964)
serigraph A/P on paper
55.9 x 74.3 cm.
Gift of Mr. J.H. Moore, London,
through the Ontario Heritage
Foundation, 80.A.68

Spiritual Temporal (1968)
serigraph 20/40 on paper
71.1 x 67.3 cm.
Gift of Mr. J.H. Moore, London,
through the Ontario Heritage
Foundation, 80.A.67

M. Transcending (1969)
serigraph 35/40 on paper
65.5 x 77.5 cm.
Gift of Mr. J.H. Moore, London,
through the Ontario Heritage
Foundation, 80.A.66

Becoming (1971)
serigraph 9/100 on paper
50.3 cm. diameter
Print Fund, 71.A.68

HICKS, R.P.D. (1903-1973)
Fanshawe Dam - March (1958)
watercolour on paper
51.4 x 76.2 cm.
Gift of the Western Art League,
60.A.66

May (1958)
watercolour on paper
37.5 x 56 cm.
Gift of Mr. Carl Schaefer, Toronto,
78.A.3

Church Interior, St. Boniface,
Maryhill, Ontario (1961)
watercolour on paper
39.4 x 56.6 cm.
Gift of Mr. J.H. Moore, London,
through the Ontario Heritage
Foundation, 80.A.20

April Colours (1964)
watercolour on paper
26.6 x 55.4 cm.
Gift of Mrs. Clare Bice, London,
85.A.12

South Thames, Oct. 30, 1968 (1968)
watercolour on paper
36.9 x 54.6 cm.
Gift of Mr. J.H. Moore, London,
through the Ontario Heritage
Foundation, 80.A.135

After the Spring Flood (1972)
watercolour on paper
54.6 x 74.3 cm.
Gift of Mrs. R.P.D. Hicks, London,
73.A.10

HIRSCH, Joseph (American: 1910-)
Clowns and the News (n.d.)
lithograph on paper
22.9 x 34.3 cm.
Print Fund, 46.A.29

HOCKNEY, David (British: 1937-)
Coloured Flowers Made of Paper and Ink (1971)
lithograph 30/50 on paper
101.6 x 96.4 cm.
Gift of the Volunteer Committee,
78.A.13

Flowers Made of Paper and Black Ink (1971)
lithograph 30/50 on paper
101.6 x 96.4 cm.
Gift of the Volunteer Committee,
78.A.14

Billy Wilder (1976)
lithograph 17/43 on paper
97 x 71 cm.
Gift of Mr. & Mrs. J.H. Moore,
London, 78.A.77

HOLDSWORTH, Geoffrey (1952-)
Stallion of Death (1974)
oil on canvas
60.4 x 50.3 cm.
Purchased with funds from the
Mitchell Bequest, 75.A.11

HOLMES, Reginald (1934-)
Red Centre (1967)
acrylic on paper
121.9 x 71.1 cm.
Gift of Mr. J.H. Moore, London,
through the Ontario Heritage
Foundation, 80.A.205

HOOKER, Marion Nelson (1866-1946)
Dog Team in the Woods, Winter (1909)
oil on canvas
71.1. x 50.8 cm.
Gift of Mr. Gordon Conn, Newmarket,
68.A.96

Old Man with Pipe (1932)
oil on card
40.6 x 28.9 cm.
Gift of Mr. Gordon Conn, Newmarket,
68.A.93

HOOTON, Pauline (1931-)
Thistle (n.d.)
oil on canvas
59.7 x 85.1 cm.
Purchased with a Canada Council
matching grant and Acquisitions
funds, 59.A.83

HOPKIN, Robert (American: 1832-1909)
The Fish Auction (n.d.)
oil on canvas
30.5 x 45.7 cm.
The W. Thomson Smith Memorial
Collection (Bequest of Alfred J.
Mitchell), 48.A.76

HORNE, Cleeve (1912-)
Fast Water, Charlton Lake (1947)
oil on masonite
29.2 x 31.4 cm.
Gift of Mr. J.H. Moore, London,
through the Ontario Heritage
Foundation, 78.A.76

HORNYANSKY, Nicholas (1896-1965)
Old Fort York, Toronto (1943)
aquatint on paper
15.2 x 19.1 cm.
Print Fund, 45.A.8

Parliament Hill, Ottawa (c.1940-45)
aquatint on paper
10.2 x 12.7 cm.
Print Fund, 46.A.33E

Canadian Ravine (1940)
etching on paper
21.6 x 14.7 cm.
Print Fund, 42.A.2

Canterbury (1940)
aquatint on paper
10.8 x 9.6 cm.
Print Fund, 46.A.33C

Homeward Trail (1940)
aquatint on paper
9.6 x 10.8 cm.
Print Fund, 46.A.33F

Millstream in Winter (1940)
aquatint on paper
9.6 x 10.8 cm.
Print Fund, 46.A.33B

Misty Dusk, New York (1941)
aquatint 13/250 on paper
25.4 x 20.3 cm.
Print Fund, 42.A.7

Frozen St. Lawrence at Quebec (1945)
aquatint on paper
12.2 x 16.5 cm.
Print Fund, 46.A.33D

Old St. Mark's Church (1945)
aquatint on paper
12.7 x 10.2 cm.
Print Fund, 46.A.33A

Landing on the Nottawasaga River (1947-48)
etching 4/50 on paper
20.3 x 25.4 cm.
Print Fund, 47.A.38

Winter Silence (1951)
aquatint 28/75 on paper
19.8 x 22.9 cm.
Gift of the Society of Canadian
Painter-Etchers and Engravers, 51.A.8

Kingston, Ontario (n.d.)
aquatint 6/100 on paper
19.1 x 15.2 cm.
Print Fund, 42.A.6

Kingston, Ontario (n.d.)
aquatint 3/100 on paper
19.1 x 15.2 cm.
Print Fund, 42.A.5

Light West Wind (n.d.)
etching 3/50 on paper
25.4 x 30.5 cm.
Print Fund, 48.A.10

October Sun (set of six etchings
demonstrating colour aquatint
process)
aquatint on paper
19.8 x 27.9 cm.
Gift of Nicholas Hornyansky, Esq.,
Toronto, 64.A.37-42

Old Briggs At Rest (n.d.)
aquatint 8/100 on paper
30.5 x 40.1 cm.
Print Fund, 46.A.11

Peggy's Cove, Nova Scotia (n.d.)
aquatint on paper
14 x 17.8 cm.
Print Fund, 47.A.31

Peggy's Cove, Nova Scotia (n.d.)
aquatint on paper
14 x 17.8 cm.
Print Fund, 47.A.52

HOUSSER, Yvonne McKague (1898-)
Unloading a Boat, Venice (1922)
oil on wood panel
22 x 26 cm.
Gift of the Estate of Miss Dorothy
Emery, London, 89.A.18

Silver Mine, Cobalt (1930)
oil on canvas
76.2 x 88.9 cm.
F.B. Housser Memorial Collection,
45.A.41

Ross Port, Lake Superior (1930)
oil on canvas
55.9 x 81.3 cm.
F.B. Housser Memorial Collection,
45.A.44

Cap Chat, Quebec (c.1931)
oil on wood
26 x 32 cm.
Gift of the Estate of Miss Dorothy
Emery, London, 89.A.17

Abstraction #1 (1949)
oil on board
47 x 61 cm.
Art Fund, 49.A.6

Jamaica (1949)
watercolour on paper
34.6 x 27.9 cm.
Gift of Mr. J.H. Moore, London,
through the Ontario Heritage
Foundation, 80.A.136

Still Life on Beach, Jamaica (1950)
oil on canvas board
46 x 65 cm.
Gift of the Estate of Miss Dorothy
Emery, London, 89.A.19

HOUSTOUN, D. McKay (1916-)
November Grey (1960)
watercolour on paper
61.6 x 88.9 cm.
Purchased with a Canada Council
matching grant and Acquisitions
funds, 61.A.27

HOUSTON, James (1921-)
Kneeling Man - NIKI (1955)
watercolour on paper
26 x 20.9 cm.
Gift of Mr. J.H. Moore, London,
through the Ontario Heritage
Foundation, 80.A.137

Stranded Whale (1957)
woodcut on paper
20.3 x 34.3 cm.
Print Fund, 59.A.93

Drum Dancer (1957)
woodcut on paper
24.9 x 19.1 cm.
Print Fund, 59.A.90

Eskimo Dancer (1957)
woodcut on paper
25.7 x 19.1 cm.
Print Fund, 59.A.89

Eskimo Family (1957)
woodcut on paper
31.8 x 25.4 cm.
Print Fund, 59.A.98

Eskimo Mother (1957)
woodcut on paper
34.3 x 25.4 cm.
Print Fund, 59.A.92

Eskimo Mother and Child (1957)
woodcut on paper
27.4 x 19.8 cm.
Print Fund, 59.A.91

Eskimo Boat in Ice (1958)
woodcut on paper
23.2 x 30.1 cm.
Print Fund, 59.A.96

Baffin Islander (1958)
woodcut on paper
23.5 x 18.1 cm.
Print Fund, 59.A.95

Eskimo Woman (1958)
woodcut on paper
13.7 x 10.2 cm.
Print Fund, 59.A.97

Kudlalak (1958)
woodcut on paper
25.4 x 19.1 cm.
Print Fund, 59.A.94

HOW, Beatrice (British: 1867-1932)
Mère et Enfant (c.1919)
oil on canvas
76.2 x 63.5 cm.
Gift of Miss Clara Hagarty, Toronto,
48.A.41

Portrait Study of Clara Hagarty (n.d.)
pastel on paper
43.2 x 33 cm.
Gift of Miss Clara Hagarty, Toronto,
50.A.49

HOWARD, Barbara (1926-)
Winter and Sun Descending (1959)
conté on paper
47.7 x 63 cm.
Gift from the Douglas M. Duncan
Collection, 70.A.60

Tree Reflections (1960)
graphite on paper
30.5 x 47 cm.
Gift of Mr. J.H. Moore, London,
through the Ontario Heritage
Foundation, 80.A.21

HUGHES, E.J. (1913-)
Study for Courtenay River
Landscape (1950)
graphite on paper
38.1 x 47 cm.
Gift of Mr. J.H. Moore, London,
through the Ontario Heritage
Foundation, 78.A.77

View of a Freighter at Crofton (1972)
watercolour on paper
49.5 x 59.7 cm.
Gift of Mr. J.H. Moore, London,
through the Ontario Heritage
Foundation, 78.A.78

HUMEN, Gerald (1935-)
Wall (1964)
graphite on paper
30.5 x 22.9 cm.
Gift of Mr. J.H. Moore, London,
through the Ontario Heritage
Foundation, 78.A.79

Untitled (Black and White Oil) (1965)
oil on canvas
93.9 x 93.9 cm.
Gift of Mr. J.H. Moore, London,
through the Ontario Heritage
Foundation, 80.A.138

Trees and Roots (1966)
oil on canvas
61 x 76.2 cm.
Gift from the Douglas M. Duncan
Collection, 70.A.59

Landscape (1967)
graphite on paper
18.3 x 26.7 cm.
Gift from the Douglas M. Duncan
Collection, 70.A.67

HUMPHREY, Jack (1901-1967)
Portrait (1931)
oil on canvas
112 x 81.5 cm.
Gift of the Volunteer Committee,
85.A.7

Improvisations from Ship's Theme
(c.1953)
watercolour on paper
22.9 x 30.5 cm.
Gift of Mr. J.H. Moore, London,
through the Ontario Heritage
Foundation, 80.A.22

Market at Taxco (1958)
watercolour on paper
40.6 x 52.1 cm.
Gift from the Douglas M. Duncan
Collection, 70.A.98

Lamp in the Window (n.d.)
oil on canvas
61.0 x 50.8 cm.
Gift of Dr. & Mrs. K. Gay, London,
86.A.1

Embers by the Sea (n.d.)
gouache on paper
47 x 66.6 cm.
Art Fund, 64.A.3

Woodland, McCormac Lake (n.d.)
watercolour on paper
35.6 x 47.6 cm.
Gift of Mr. J.H. Moore, London,
through the Ontario Heritage
Foundation, 78.A.80

HUNT, John Powell (1854-1932)
Landscape with Cows (1907)
oil on canvas
25.4 x 40.1 cm.
Gift of Mrs. Pennington, London,
53.A.145

Portrait of an Old Man Reading
(n.d.)
oil on canvas
69.3 x 59.5 cm.
Gift of John Powell Hunt through the
I.O.D.E., Nicholas Wilson Chapter,
26.A.5

HUNT, Thomas L. (1882-1938)
Near Turkey Foot Lake, South of
Akron, Ohio (n.d.)
watercolour on paper
11.2 x 16.2 cm.
Gift of Miss D.M.W. Smith, London,
71.A.9

HURLBUT, Spring (1952-)
Fish Box (1980)
mixed media on wood
94.0 x 61.0 x 71.1 cm.
Purchased with a Canada Council
matching grant and Acquisitions
funds, 81.A.55

HURTUBISE, Jacques (1939-)
Philomène (1966)
serigraph 38/100 on paper
64.8 x 50.7 cm.
Gift of Mr. J.H. Moore, London,
through the Ontario Heritage
Foundation, 80.A.69

Griboullle (1969)
acrylic on canvas
127 x 127 cm.
Art Fund, 70.A.116

INGLIS, Clarissa (1936-)
Ismetles (1979-81)
mixed media installation: steel, mylar,
pins, wood, tape and tape recorder
193 x 112 x 112 cm.
Gift of Ms. Clarissa Inglis, Toronto,
87.A.110

INNES, John (1863-1941)
Education of a Bronco (1900)
etching on paper
18.3 x 27.6 cm.
Gift of the Estate of Mrs. Margaret
Porteous, London, 69.A.9

Graduated (1900)
etching on paper
18.4 x 27.9 cm.
Gift of the Estate of Mrs. Margaret
Porteous, London, 69.A.11

Initiated (1900)
etching on paper
18.1 x 27.4 cm.
Gift of the Estate of Mrs. Margaret
Porteous, London, 69.A.10

Roped (1900)
etching on paper
18.4 x 27.9 cm.
Gift of the Estate of Mrs. Margaret
Porteous, London, 69.A.7

Saddled (1900)
etching on paper
18.8 x 27.9 cm.
Gift of the Estate of Mrs. Margaret
Porteous, London, 69.A.8

INUKJURAKJU (1913-)
Bear and Seal (1964)
stonecut 38/50 on paper
25.4 x 48.3 cm.
Print Fund, 72.A.80

Owl Family (1964)
stonecut 6/50 on paper
33 x 43.2 cm.
Print Fund, 72.A.25

Spirit of the Fisherman (1964)
stonecut 38/50 on paper
43.2 x 43.2 cm.
Print Fund, 72.A.35

Spirit of the Hunter (1964)
stonecut 19/50 on paper
50.8 x 35.6 cm.
Print Fund, 72.A.23

IRWIN, Patricia K. (1916-)
Bright Fish (1959-60)
etching 7/12 on paper
25.4 x 40.6 cm.
Gift from the Douglas M. Duncan
Collection, 70.A.80

Dark Kingdom III (1957-59)
crayon on paper
22.3 x 31.1 cm.
Gift of Mr. J.H. Moore, London,
through the Ontario Heritage
Foundation, 80.A.139

ISKOWITZ, Gershon (1921-1988)
Flowers (1959)
watercolour on paper
53.3 x 36.2 cm.
Gift of Mr. J.H. Moore, London,
through the Ontario Heritage
Foundation, 80.A.140

Night (1962-63)
oil on canvas
25.5 x 38 cm.
Gift of Mr. J.H. Moore, London,
through the Ontario Heritage
Foundation, 78.A.81

Variation on Green #4 (1976)
oil on canvas
111.8 x 162.8 cm.
Art Fund, 77.A.16

**IVES, Norman (American:
1923-)**
Quick Step #14 (1973)
collage and gouache on paper
25.4 x 16.5 cm.
Gift of Mr. J.H. Moore, London,
through the Ontario Heritage
Foundation, 78.A.173

IYAKAK, Edward (1928-)
Legend (n.d.)
soapstone
35 x 55.9 x 7.6 cm.
Purchased with funds from the
Mitchell Bequest, 67.A.16

IYOLA Kingwatsiak (1933-)
Arctic Rock Cod (1959)
seal skin stencil 26/30 on paper
36.9 x 55.9 cm.
Print Fund, 60.A.53

Geese Leaving (1964)
seal skin stencil 38/50 on paper
26.7 x 45.7 cm.
Print Fund, 70.A.36

Stalking a Seal (1964)
etching 38/50 on paper
20.3 x 25.4 cm.
Print Fund, 72.A.60

JACKSON, A.Y. (1882-1974)
Cacouna (1921)
oil on wood
20.9 x 26.7 cm.
F.B. Housser Memorial Collection,
45.A.25

Winter, Laurentians (c.1921)
oil on wood
21.6 x 26.7 cm.
F.B. Housser Memorial Collection,
45.A.30

February (c.1923)
oil on wood
20.3 x 26.7 cm.
F.B. Housser Memorial Collection,
45.A.35

Lake Superior at Port Munroe (1923)
oil on wood
20.9 x 26.7 cm.
F.B. Housser Memorial Collection,
45.A.28

North Devon Island (c.1927)
graphite on paper
17.8 x 25.4 cm.
Gift of Mr. J.H. Moore, London,
through the Ontario Heritage
Foundation, 78.A.83

Morning, Baie St. Paul (1928)
oil on wood
21.3 x 26.7 cm.
F.B. Housser Memorial Collection,
45.A.29

St. Urbain, P.Q. (1929)
oil on wood
20.9 x 26.7 cm.
F.B. Housser Memorial Collection,
45.A.32

Sun, Snow, Barn (c.1930)
oil on wood
21.6 x 26.7 cm.
F.B. Housser Memorial Collection,
45.A.27

Winter, Barn with Red Doors (1930)
oil on wood
20.9 x 26.7 cm.
F.B. Housser Memorial Collection,
45.A.31

Winter Landscape with Sleigh
(c.1930)
oil on wood
21.3 x 26.7 cm.
F.B. Housser Memorial Collection,
45.A.36

Melting Snow (c.1930)
oil on wood
21.6 x 26.7 cm.
F.B. Housser Memorial Collection,
45.A.33

Road to Charlevoix (c.1936)
oil on canvas
52.1 x 64.8 cm.
Art Fund, 57.A.77

Flat Rock Lake (1940)
oil on wood
26.7 x 41.9 cm.
F.B. Housser Memorial Collection,
47.A.83

St.-Tite-des-Caps (1941)
graphite on paper
21.6 x 26.7 cm.
Gift of the Volunteer Committee,
63.A.12

Czech Farm, Fernie, B.C. (1947)
oil on wood
26.7 x 34.3 cm.
F.B. Housser Memorial Collection,
48.A.39

Early Spring, Ste. Hyacinthe (n.d.)
oil on wood
21.6 x 26.7 cm.
Gift from the Douglas M. Duncan
Collection, 70.A.84

June, St. Aubert (n.d.)
oil on wood
26 x 34.3 cm.
Art Fund, 45.A.23

St. Fidèle (n.d.)
oil on wood
21.6 x 25.4 cm.
Art Fund, 45.A.22

Untitled (n.d.)
oil on panel
25.4 x 32.4 cm.
Gift of Mr. J.H. Moore, London,
through the Ontario Heritage
Foundation, 78.A.82A-B

JACKSON, Ken (1944-)
Above the Studio (n.d.)
serigraph AP VI/X on paper
46.8 x 60.1 cm.
Gift of Mr. & Mrs. Richard M. Ivey,
London, 87.A.13

JACKSON-PETRIE, Geneva
(c.1911-)
Les Éboulements from the South
Shore (1954)
oil on panel
29 x 34.1 cm.
Gift of Mr. Alfred Petrie, London,
88.A.23

JACOBI, Otto (1812-1901)
Landscape with Lake (1878)
watercolour on paper
37.6 x 20.6 cm.
Art Fund, 76.A.15

JAMASIE Teevee (1910-)
Camp Scene (1964)
etching 38/50 on paper
25.4 x 29.2 cm.
Print Fund, 83.A.27

Hunting Seal (1964)
etching 38/50 on paper
25.4 x 30.5 cm.
Print Fund, 72.A.69

We Used To Fish This Way (1964)
etching 38/50 on paper
30.5 x 25.4 cm.
Print Fund, 72.A.55

JANES, Phyllis (1904-)
Boy and His Cat (n.d.)
wash on paper
89.9 x 57.2 cm.
Gift of Mr. J.H. Moore, London,
through the Ontario Heritage
Foundation, 80.A.141

Children and Towels (n.d.)
pastel on paper
73.7 x 58.4 cm.
Gift of the Douglas M. Duncan
Collection, 70.A.77

JANUARIO, Dores (Brazilian:
1939-)
Armadillo (n.d.)
wood
39.3 x 47.6 x 4.0 cm.
Gift of Mr. & Mrs. J.H. Moore,
London, 85.A.76

Portrait of a Girl With Symbols (n.d.)
casein and graphite on masonite
41.9 x 30.9 cm.
Gift of Mr. & Mrs. J.H. Moore,
London, 85.A.50

JANVIER, Alex (1936-)
True Blue Racists (1973)
acrylic on canvas
50.8 x 61 cm.
Gift of Mr. J.H. Moore, London,
through the Ontario Heritage
Foundation, 78.A.84

JARVIS, Donald (1923-)
Red Landscape (1962)
oil on canvas
127 x 91.4 cm.
Purchased with a Canada Council
matching grant and Acquisitions
funds, 64.A.167

JEFFERESS, Connie (1930-)
Landscape (1964)
ink on paper
23.4 x 33.7 cm.
Gift of Mr. & Mrs. Richard M. Ivey,
London, 87.A.211

Figure at the Edge of the Sea (n.d.)
monoprint on paper
27.9 x 39.4 cm.
Art Fund, 65.A.90

JEFFERIES, Gloria (1923-)
Eskimo Madonna (1947)
walnut
15.2 x 7.3 x 14 cm.
Anonymous gift, 77.A.89

Untitled (Horse and Colt) (n.d.)
fired clay
27.3 x 36.2 x 14 cm.
Anonymous gift, 77.A.88

JENKINS, Paul (American:
1923-)
Anatomy of a Cloud (1981)
colour lithograph 61/150 on paper
87.5 x 69.5 cm.
Gift of Mr. & Mrs. Richard M. Ivey,
London, 87.A.238

Cardinal Prism (1981)
colour lithograph 16/94 on paper
96.5 x 74.3 cm.
Gift of Mr. & Mrs. Richard M. Ivey,
London, 87.A.235

Continental Divide (1981)
colour lithograph HP X on paper
96.5 x 74.3 cm.
Gift of Mr. & Mrs. Richard M. Ivey,
London, 87.A.232

Phenomena Moby Dick (1981)
colour lithograph 46/70 on paper
96.5 x 74.3 cm.
Gift of Mr. & Mrs. Richard M. Ivey,
London, 87.A.236

Sheffield Blue
(1981)
colour lithograph HC IV on paper
96.5 x 74.3 cm.
Gift of Mr. & Mrs. Richard M. Ivey,
London, 87.A.231

Sinclair Red (1981)
colour lithograph 150/150 on paper
96.5 x 74.3 cm.
Gift of Mr. & Mrs. Richard M. Ivey,
London, 87.A.237

Vermillion Enigma (1981)
colour lithograph 32/150 on paper
96.5 x 74.3 cm.
Gift of Mr. & Mrs. Richard M. Ivey,
London, 87.A.233

York Summer Solstice (1981)
colour lithograph 48/150 on paper
96.5 x 74.3 cm.
Gift of Mr. & Mrs. Richard M. Ivey,
London, 87.A.234

JOHN, Augustus (British: 1878-1962)
Sketch For a Family Group (c.1935)
oil and charcoal on canvas
152.4 x 106.6 cm.
Gift of the Contemporary Art Society
of Great Britain, 62.A.40

JOHNS, Jasper (American:
1935-)
Land's End (1978)
etching 18/56 on paper
86.3 x 62.1 cm.
Gift of the Volunteer Committee,
79.A.15

JOHNSON, Nick (1942-)
Landscape from the Cornfield Codex
(1982)
ink, charcoal and graphite on paper
36.8 x 36.7 cm.
General Purchase Fund, 87.A.61

The Hummingbird (1983)
ink, charcoal and graphite on paper
36.8 x 36.7 cm.
General Purchase Fund, 87.A.62

Dragonfly (c.1987)
slate and feathers
8.4 x 6.8 x 8.3 cm.
General Purchase Fund, 87.A.65

JOHNSTON, Frances Anne
(1910-1987)
Studio Corner (n.d.)
oil on board
76.2 x 55.9 cm.
Gift of the Volunteer Committee,
65.A.8

JOHNSTON, Franz (1888-1949)
Gibraltar, Eldorado, Great Bear
Lake, N.W.T. (1939)
oil on masonite
30.5 x 35.6 cm.
Purchased with funds from the
Mitchell Bequest, 60.A.35

Radium Strike, Labine Point (1939)
oil on board
35.6 x 30.5 cm.
Gift of Mr. J.H. Moore, London,
through the Ontario Heritage
Foundation, 80.A.142

JONES, Brian (1950-)
Father and Son (c.1973)
graphite on paper
44.5 x 41.9 cm.
Purchased with funds from the
Mitchell Bequest, 73.A.107

Looking Through (1976)
oil on canvas
116.8 x 91.4 cm.
Queen's Silver Jubilee Collection, on
permanent loan from the Government
of Ontario, 77.A.14

Wringing Trousers (1976)
serigraph 38/40 on paper
48.3 x 48.3 cm.
Purchased with funds from the
Mitchell Bequest, 76.A.18

Yard Scene #1 (1976)
oil on canvas
45.7 x 60.9 cm.
Gift of Mr. & Mrs. Richard M. Ivey,
London, 89.A.39

Still Life (1977)
serigraph A/P on paper
41.6 x 60.5 cm.
Gift of Mr. & Mrs. Richard M. Ivey,
London, 87.A.14

Raking Leaves (1978)
watercolour on paper
50.8 x 73.7 cm.
Acquisitions budget, 78.A.2

Crossing Over (1978)
oil on panel
60.9 x 76.2 cm.
Gift of Mr. & Mrs. Richard M. Ivey,
London, 89.A.38

JONES, William "Bill" (1946-)
A New Kind of Song For a Dime
(1975)
photographic assemblage on plywood
198.1 x 121.9 cm.
Art Fund, 75.A.27

JORGENSON, Flemming (1934-)
Yellow Field Section (1970)
serigraph 7/15 on paper
71.4 x 55.5 cm.
Print Fund, 71.A.67

JOUBERT, Suzanne (1934-)
Liberté (1972)
acrylic on canvas
126 x 101.7 cm.
Gift of Mr. J.H. Moore, London,
through the Ontario Heritage
Foundation, 79.A.47

JUDSON, William (1842-1928)
Snow Journey (1877)
oil on canvas laid on masonite
64.8 x 90.8 cm.
Gift of the Estate of Miss Dorothy
Gunn, London, 82.A.16

Byron Village (1882)
oil on canvas
50.8 x 87 cm.
Bequest of Mrs. Isobel McKone,
London, 70.A.10

Indian Hunter (n.d.)
oil on canvas
65.5 x 39.4 cm.
Gift of Rev. Cecil Dixon, London,
47.A.84

Near Hyde Park (n.d.)
oil on canvas
39.5 x 65.1 cm.
Gift of Mrs. Audre E. Walker, London,
87.A.65

JURY, Amos (1861-1964)
Near Delaware (1905)
oil on board
11.3 x 22.8 cm.
The Director's Discretionary Fund,
90.A.31

KADYULIK, Annie (1928-)
Kneeling Mother and Baby (p.1966)
black stone with incised lines
16.5 x 11.4 x 11.4 cm.
Art Fund, 77.A.75

KAHANE, Anne (1924-)
Figure and Distant Figure (1961)
mahogany
165.1 x 102.9 x 12.2 cm.
Art Fund, 62.A.47

Sleeping Figure III (1962)
mahogany
25.4 x 37.4 x 14 cm.
Gift of Mr. J.H. Moore, London,
through the Ontario Heritage
Foundation, 78.A.205

**KAMBINDA, Raquel
(Brazilian: -)**
Tower of St. Lazare with Child and
Old Man (1970)
oil on canvas
54.6 x 37.1 cm.
Gift of Mr. & Mrs. J.H. Moore,
London, 85.A.51

**KANANGINAK Pootoogook
(1935-)**
Three Narwhal (1959)
seal skin stencil 23/30 on paper
45.7 x 61 cm.
Print Fund, 60.A.45

Caribou Hunt (1964)
engraving 38/50 on paper
15.2 x 30.5 cm.
Print Fund, 72.A.54

Igloo (1964)
engraving 38/50 on paper
16.5 x 27.9 cm.
Print Fund, 72.A.66

Injured Bear (1964)
stonecut 38/50 on paper
45.7 x 43.2 cm.
Print Fund, 72.A.30

King Eider (1964)
engraving 38/50 on paper
19.1 x 24.2 cm.
Print Fund, 72.A.72

Summer Caribou (1964)
engraving 38/50 on paper
15.2 x 26.7 cm.
Print Fund, 72.A.39

Walrus (1977)
stone cut 29/200 on paper
56.3 x 71.5 cm.
Gift of Mr. J.H. Moore, London,
through the Ontario Heritage
Foundation, 87.A.200

Caribou (1977)
stone cut 20/200 on paper
71.3 x 56.3 cm.
Gift of Mr. J.H. Moore, London,
through the Ontario Heritage
Foundation, 87.A.199

Metik (1977)
stone cut and stencil 29/200 on paper
71.3 x 56.3 cm.
Gift of Mr. J.H. Moore, London,
through the Ontario Heritage
Foundation, 87.A.198

Omingmungjuaq (1977)
stone cut 29/200 on paper
71.3 x 56 cm.
Gift of Mr. J.H. Moore, London,
through the Ontario Heritage
Foundation, 87.A.197

**KANANGINAK Pootoogook
(1935-) and POOTOOGOOK
(1887-1959)**
Legend of the Blind Man and the
Bear (1959)
seal skin stencil 27/30 on paper
Print Fund, 60.A.47

**KANDINSKY, Wassily (Russian:
1866-1944)**
Couple in a Row Boat (1904)
woodcut 7/30 on paper
22.5 x 58.8 cm.
The Dr. Robert A.D. Ford Collection,
86.A.42

Horsemen (1909)
photogravure on paper
14.2 x 14.5 cm.
The Dr. Robert A.D. Ford Collection,
87.A.69

Birds (1909)
photogravure on paper
13.7 x 14.6 cm.
The Dr. Robert A.D. Ford Collection,
87.A.70

Church (1909)
photogravure on paper
13.4 x 14.6 cm.
The Dr. Robert A.D. Ford Collection,
87.A.71

Birches (1909)
photogravure on paper
11 x 15.9 cm.
The Dr. Robert A.D. Ford Collection,
87.A.72

Women in the Woods (1909)
photogravure on paper
14.9 x 19.6 cm.
The Dr. Robert A.D. Ford Collection,
87.A.73

Untitled (1913)
gouache on paper
22.4 x 29.6 cm.
The Dr. Robert A.D. Ford Collection,
87.A.74

Bildung (1931)
watercolour and gouache on paper
55 x 24 cm.
Gift of Mr. J.H. Moore, London,
through the Ontario Heritage
Foundation, 78.A.174

KATZ, Mané (French: 1894-1962)
Mère et Enfant (n.d.)
watercolour on paper
43.2 x 30.5 cm.
Gift of Dr. Max Stern, Montreal,
57.A.42

KATZ, Renina (Brazilian: 1924-)
Untitled (1970)
serigraph 1/5 on paper
49.5 x 35 cm.
Gift of Mr. & Mrs. J.H. Moore,
London, 85.A.67

Arcadas com Olhos (1971)
oil on board
52 x 52 cm.
Gift of Mr. & Mrs. J.H. Moore,
London, 85.A.52

Permutacas L. Serie de 100 (1972)
serigraph 3/8 on paper
28 x 20 cm.
Gift of Mr. & Mrs. J.H. Moore,
London, 85.A.65

Untitled (1972)
serigraph 6/15 on paper
51.7 x 43.8 cm.
Gift of Mr. & Mrs. J.H. Moore,
London, 85.A.66

**KELLY, Beverley Lambert
(1943-)**
Collage (3) - Winter (1965)
tissue collage on paper
54.6 x 71.1 cm.
Gift of the Western Art League,
66.A.24

KEMP, James (1914-1983)
Air Raid (1949)
oil on masonite
83 x 70 cm.
Gift of Mrs. Ann Kemp, London,
89.A.9

Untitled (1960)
oil on masonite
63.5 x 43.2 cm.
Gift of Mr. J.H. Moore, London,
through the Ontario Heritage
Foundation, 80.A.23

Reclining Figure (1962)
oil on masonite
121.9 x 121.9 cm.
Purchased with funds from the
Mitchell Bequest, 62.A.37

Untitled (1963)
oil on masonite
19.7 x 25.4 cm.
Gift of Mr. J.H. Moore, London,
through the Ontario Heritage
Foundation, 78.A.85

Untitled (1963)
oil on masonite
17.1 x 17.1 cm.
Gift of Mr. J.H. Moore, London,
through the Ontario Heritage
Foundation, 78.A.86

Figure in Landscape (1965)
oil on canvas
61 x 76.2 cm.
Gift of Mr. J.H. Moore, London,
through the Ontario Heritage
Foundation, 80.A.143

Moth (1974)
oil on masonite
61.5 x 81.8 cm.
Gift of Mrs. Ann Kemp, London,
89.A.10

Untitled Abstract (c.1982)
watercolour on paper
56 x 78.5 cm
Gift of Mrs. Ann Kemp, London,
89.A.11

Seated Girl (n.d.)
acrylic on masonite
60.5 x 81 cm.
Gift of Mr. & Mrs. Richard M. Ivey,
London, 87.A.206

KENNEDY, Dawson, (1906-)
Port of Stranded Pride (c.1948)
watercolour on paper
35.6 x 61 cm.
Art Fund, 49.A.17

KENNEDY, Kathleen (1908-)
Piazza San Marco (c.1961)
watercolour on paper
38.1 x 50.8 cm.
Art Fund, 62.A.23

KENOJUAK (1927-)
Birds I Imagine (1964)
serigraph 38/50 on paper
40.6 x 59.7 cm.
Print Fund, 72.A.44

Wonderful Bird (1964)
copper plate engraving on paper
29.2 x 25.4 cm.
Print Fund, 72.A.26

Owl of the Sea (1977)
stone cut 29/200 on paper
56 x 71.3 cm.
Gift of Mr. J.H. Moore, London,
through the Ontario Heritage
Foundation, 87.A.201

Myself and I (1981)
handcoloured etching 72/275 on paper
20.5 x 25.2 cm.
Gift of Mr. & Mrs. J.H. Moore,
London, 87.A.196

KERGOMMEAUX, Duncan de (1927-)
Cityscape (1959)
serigraph 25/100 on paper
49.6 x 31.8 cm.
Print Fund, 59.A.14

Untitled (1965)
oil on canvas
152.4 x 123.2 cm.
Art Fund, 66.A.15

Red, Green, Grey (1975)
oil on canvas
152.5 x 152.5 cm.
Gift of Mr. & Mrs. Richard M. Ivey,
London, 87.A.34

Untitled (1977)
charcoal and graphite on paper
80 x 80 cm.
Purchased with matching Acquisitions
funds and a Wintario Grant, 80.A.5

Charollais Feed Lot (1981)
oil on linen
213.4 x 213.4 cm.
Purchased with a Canada Council
matching grant and funds donated by
the Volunteer Committee, 85.A.79

New York Maple Leaves #1 (1981)
acrylic on canvas
61 x 61.5 cm.
Gift of Mr. Duncan de Kergommeaux,
London, 89.A.41

New York Maple Leaves #2 (1981)
acrylic on canvas
61 x 61.5 cm.
Gift of Mr. Duncan de Kergommeaux,
London, 89.A.42

New York Maple Leaves #3 (1981)
acrylic on canvas
61 x 61.5 cm.
Gift of Mr. Duncan de Kergommeaux,
London, 89.A.43

New York Maple Leaves #4 (1981)
acrylic on canvas
61 x 61.5 cm.
Gift of Mr. Duncan de Kergommeaux,
London, 89.A.44

New York Maple Leaves #5 (1981)
acrylic on canvas
61 x 61.5 cm.
Gift of Mr. Duncan de Kergommeaux,
London, 89.A.45

New York Maple Leaves #6 (1981)
acrylic on canvas
61 x 61.5 cm.
Gift of Mr. Duncan de Kergommeaux,
London, 89.A.46

New York Maple Leaves #7 (1981)
acrylic on canvas
61 x 61.5 cm.
Gift of Mr. Duncan de Kergommeaux,
London, 89.A.47

New York Maple Leaves #8 (1981)
acrylic on canvas
61 x 61 cm.
Gift of Mr. Duncan de Kergommeaux,
London, 89.A.48

New York Maple Leaves #9 (1981)
acrylic on canvas
61.8 x 61.7 cm.
Gift of Mr. Duncan de Kergommeaux,
London, 89.A.49

New York Maple Leaves #10 (1981)
acrylic on canvas
61.8 x 61.7 cm.
Gift of Mr. Duncan de Kergommeaux,
London, 89.A.50

New York Maple Leaves #11 (1981)
acrylic on canvas
61.5 x 61.5 cm.
Gift of Mr. Duncan de Kergommeaux,
London, 89.A.51

New York Maple Leaves #12 (1981)
acrylic on canvas
61.5 x 61.5 cm.
Gift of Mr. Duncan de Kergommeaux,
London, 89.A.52

New York Maple Leaves #13 (1981)
acrylic on canvas
61 x 61 cm.
Gift of Mr. Duncan de Kergommeaux,
London, 89.A.53

New York Maple Leaves #14 (1981)
acrylic on canvas
61.5 x 61.5 cm.
Gift of Mr. Duncan de Kergommeaux,
London, 89.A.54

New York Maple Leaves #15 (1981)
acrylic on canvas
61.5 x 61.5 cm.
Gift of Mr. Duncan de Kergommeaux,
London, 89.A.55

Distant Pastures #1 (1985-86)
oil on linen
152.4 x 127.0 cm.
Purchased with matching funds from
the Volunteer Committee and a
Wintario Grant, 86.A.2

Distant Pastures #2 (1985-86)
oil on linen
152.4 x 127.0 cm.
Purchased with matching funds from
the Volunteer Committee and a
Wintario Grant, 86.A.3

Distant Pastures #3 (1985-86)
oil on linen
152.4 x 127.0 cm.
Purchased with matching funds from
the Volunteer Committee and a
Wintario Grant, 86.A.4

KHOUBESSERIAN, Hagop (1931-)
Flowers (1965)
ink on paper
28.2 x 42.8 cm.
Gift of Mr. J.H. Moore, London,
through the Ontario Heritage
Foundation, 80.A.24

KIAKSHUK (1888-1966)
Man and Seal (1964)
stonecut 36/50 on paper
12.7 x 20.3 cm.
Print Fund, 72.A.36

Seal Hunt (1964)
stonecut stencil 8/50 on paper
43.2 x 50.8 cm.
Print Fund, 72.A.51

Strange Scene (1964)
stonecut 38/50 on paper
44.5 x 58.4 cm.
Print Fund, 72.A.41

KILBOURN, Rosemary (1931-)
Icarus (1972)
wood engraving 15/15 on paper
35.6 x 27.9 cm.
Print Fund, 67.A.12

KING, Laurence (1913-)
The Badlands (1963)
oil on masonite
91.4 x 116.8 cm.
Gift of the Western Art League,
63.A.35

KINOSHITA, Tomio (Japanese: 1923-)
Clown Couple (n.d.)
woodblock 22/50 on paper
56.3 x 41.7 cm.
Gift of Mr. J.H. Moore, London,
through the Ontario Heritage
Foundation, 79.A.20

KIRKPATRICK, Joseph (British: 1872-1936)
The Clover Harvest, Shotwick near
Chester (1901)
watercolour on paper
38.1 x 62.3 cm.
Hamilton King Meek Memorial
Collection, 40.A.8

KITAJ, Ronald B. (American: 1932-)
The Defect of its Qualities (n.d.)
serigraph 47/70 on paper
89.5 x 60.7 cm.
Gift of Mrs. Mira Godard, Toronto,
87.A.26

KIYOOKA, Roy (1926-)
Untitled (1961)
watercolour and gouache on paper
55.9 x 77.5 cm.
Gift of Mr. J.H. Moore, London,
through the Ontario Heritage
Foundation, 78.A.87

Homage to Bela Bartok (1966)
aquatex on canvas
91.4 x 254 cm.
Art Fund, 68.A.5

KLOEZEMAN, Bert (1921-1987)
Scrapyard (1963)
linocut and woodblock on paper
31.3 x 36.9 cm.
Print Fund, 64.A.5

Opposing Forces (1967)
woodcut 30/75 on paper
20.3 x 25.4 cm.
Gift of the Society of Canadian
Painter-Etchers and Engravers,
67.A.377

Structural and Organic Interplay
(1971)
aquatint A/P on paper
76.2 x 39.6 cm.
Gift of Mrs. Phyllis Cohen, London,
87.A.230

People of the Sun and the Jungles
(1974)
ink and wash on paper
59.0 x 48.0 cm.
Gift of Mrs. Phyllis Cohen, London,
87.A.229

KNOWLES, Dorothy (1927-)
Rolling Fields (1969)
oil and liquitex on canvas
71.1 x 101.6 cm.
Purchased as a ''Director's Choice''
with a Canada Council Grant, 70.A.1

KNOWLES, Elizabeth B. (1866-1928)
Orchard (1909)
oil on board
30.5 x 43.12 cm.
Gift of Mr. Gordon Conn, Newmarket,
53.A.148

KNOWLES, F. McGillivray (1860-1932)
The First Snow (n.d.)
oil on canvas
81.3 x 101.6 cm.
Gift of Mrs. Lila McGillivray Knowles,
St. Thomas, 49.A.44

Head of a Gypsy Woman (n.d.)
oil on canvas
50.8 x 40.6 cm.
Gift of Mr. Gordon Conn, Newmarket,
50.A.57

The Startled Nymph (n.d.)
watercolour on paper
33 x 20.3 cm.
Gift of Mr. Gordon Conn, Newmarket,
52.A.71

KNOWLES, Lila G. (1886-1979)
Fog (n.d.)
oil on canvas
50.8 x 61 cm.
Gift of Mr. Gordon Conn, Newmarket,
53.A.156

KOONING, Willem de (American: 1904-)
Figure at Gerard Beach (1970)
lithograph 10/32 on paper
101.0 x 71.1 cm.
Gift of Dr. & Mrs. Ralph Bull, London,
85.A.90

KORNER, John (1913-)
Coast Glitter #16 (c.1958)
oil on canvas
91.4 x 122.2 cm.
Art Fund, 60.A.118

Coastal Glitter Blue (1959)
oil on canvas
64.1 x 49.6 cm.
Gift of Mr. J.H. Moore, London,
through the Ontario Heritage
Foundation, 80.A.25

Centennial Suite: Flowerstar (1967)
serigraph 19/50 on paper
30.8 x 40.6 cm.
Gift of Simon Fraser University,
Burnaby, B.C., 68.A.74

KOSSOFF, Leon (British: 1926-)
Near St. Paul's, London (n.d.)
charcoal and gouache on paper
101.6 x 116.8 cm.
Gift of Contemporary Art Society of
Great Britain, 69.A.49

KOVACH, Rudi (1929-)
Young Forest #2 (1955)
drypoint etching 6/40 on paper
44.5 x 28.5 cm.
Print Fund, 55.A.25

KOVINATILLAH (1930-)
Building a Snowhouse (1964)
engraving 38/50 on paper
8.9 x 11.5 cm.
Print Fund, 70.A.33

The Fisherman (1964)
engraving 38/50 on paper
25.4 x 22.9 cm.
Print Fund, 72.A.56

Near The Flow Edge (1964)
engraving 38/50 on paper
20.3 x 30.5 cm.
Print Fund, 72.A.89

Woman (1964)
engraving 38/50 on paper
27.9 x 17.8 cm.
Print Fund, 72.A.65

KRAJCBERG, Frans (Brazilian: 1921-)
Untitled (1970)
cast paper print 1/10 on paper
56.5 x 75.2 cm.
Gift of Mr. & Mrs. J.H. Moore,
London, 85.A.68

KRAMOLC, Ted (1922-)
Interior (1954)
linocut on paper
22.9 x 30.5 cm.
Gift from the Douglas M. Duncan
Collection, 70.A.74

KRASNOPEVTSEV, Dmitry (Russian: 1925-)
Still Life with Pipe, Candle and
Papers (1962)
oil on masonite
42 x 52 cm.
The Dr. Robert A.D. Ford Collection,
88.A.16

KRIEGHOFF, Cornelius (1815-1872)
Niagara Falls from the British Side
(1856)
oil on canvas
40.6 x 55.9 cm.
Purchased with funds from the Art
Fund and the Province of Ontario
Council for the Arts, 64.A.128

KUBOTA, Nobuo (1932-)
The Music Gallery Portfolio: Now
and Then (1982)
serigraph 4/40 on paper
43.8 x 61.6 cm.
Purchased with a Canada Council
matching grant and Acquisitions
funds, 82.A.33

KUDJURAKJU (1908-)
Polar Bear and Bird (1964)
stonecut 38/50 on paper
50.8 x 62.3 cm.
Print Fund, 72.A.34

KUEHNER, Martha (1937-)
Kaleidoscope (n.d.)
mixed media
142.7 x 76.2 x 27 cm.
Art Fund, 74.A.20

KULAKOV, Mikhail (Russian: -)
Three Female Figures (1966)
oil on paper mounted on canvas
65 x 89 cm.
The Dr. Robert A.D. Ford Collection,
88.A.18

KUPKA, Frank (French: 1871-1957)
Summer (1932)
graphite on paper
27 x 40.8 cm.
Gift of the Volunteer Committee,
85.A.10

KURELEK, William (1927-1977)
Crime is Disappearing in the Streets
(1964)
gouache on masonite
70.6 x 81.9 cm.
Art Fund, 70.A.54

Unloading Hay into Cowbarn Loft
(1964)
oil on board
49.5 x 64.8 cm.
Gift of Mr. J.H. Moore, London,
through the Ontario Heritage
Foundation, 80.A.144

Toronto 20: The Hound of Heaven
(c.1965)
lithograph 50/100 on paper
45.5 x 34.6 cm.
Gift of Mr. & Mrs. J.H. Moore,
London, 81.A.24

KUTHAN, Georges (1916-1966)
L'Arc de Triomphe, Paris (n.d.)
etching 11/60 on paper
30.5 x 40.3 cm.
Print Fund, 53.A.51

LACROIX, Richard (1939-)
Helienrethée (1961)
serigraph 15/30 on paper
37.6 x 36.2 cm.
Gift of Mr. J.H. Moore, London,
through the Ontario Heritage
Foundation, 80.A.71

Cascades (1962)
etching 23/50 on paper
42.6 x 39.4 cm.
Gift of Mr. J.H. Moore, London,
through the Ontario Heritage
Foundation, 80.A. 70

La Feuillée (1963)
etching A/P on paper
64.5 x 64.8 cm.
Gift of Mr. J.H. Moore, London,
through the Ontario Heritage
Foundation, 80.A.73

Izaran (1963)
serigraph 14/50 on paper
46.3 x 40.6 cm.
Gift of Mr. J.H. Moore, London,
through the Ontario Heritage
Foundation, 80.A.72

Teotihuacan (1963)
serigraph 19/50 on paper
34.6 x 34.6 cm.
Gift of Mr. J.H. Moore, London,
through the Ontario Heritage
Foundation, 80.A.74

Rogues jaunes (1964)
relief etching 11/50 on paper
45.7 x 30.5 cm.
Print Fund, 66.A.98

Variante '66 (1966)
acrylic on canvas
81.3 x 81.3 cm.
Gift of Mr. J.H. Moore, London,
through the Ontario Heritage
Foundation, 78.A.88

Variante VI-A (1966)
serigraph 20/100 on paper
46.4 x 46.4 cm.
Gift of Mr. J.H. Moore, London,
through the Ontario Heritage
Foundation, 80.A.75

Diamond Points 1-3 Reds (1967)
acrylic on canvas
121.9 x 121.9 cm.
Art Fund, 68.A.46

LAFATIE
Untitled (n.d.)
colour etching 4/75 on paper
36.2 x 22.9 cm.
Gift of Mr. J.H. Moore, London,
through the Ontario Heritage
Foundation, 87.A.90

LAKE, Suzy (1947-)
Petrouchka's Dance with Abaddon
(1978-79)
black and white and colour
photographic prints on paper
96.5 x 470.5 cm.
Gift of the Allstate Foundation of
Canada, 81.A.2A-H

LANE, Henry Bowyer (British: 1787-1853)
Quebec, Lower Canada (c.1840)
watercolour on paper
18.7 x 27.3 cm.
Gift of the Advancement Classes of
London 1930-56 in honour of their
teacher, Miss Ruth Hooper, 81.A.47

LANSDOWNE, J. Fenwick (1940-)
Kingfisher (1962)
watercolour and oil pastel on paper
40.9 x 24.9 cm.
Gift of Mr. J.H. Moore, London,
through the Ontario Heritage
Foundation, 80.A.146

Fieldfare (1963)
watercolour on paper
52.1 x 42.6 cm.
Gift of Tom Hayman, Esq., London,
68.A.1

Palm Warbler (1965)
watercolour on paper
28.5 x 23.2 cm.
Art Fund, 68.A.2

Sparrowhawk (1963)
watercolour on paper
38.4 x 47 cm.
Gift of Mr. J.H. Moore, London,
through the Ontario Heritage
Foundation, 80.A.145

LAPINE, André (1866-1952)
Portrait Sketch of Mr. Pierce (1922)
conté and pastel on paper
34.3 x 26.7 cm.
Gift of R. York Wilson, Esq., Toronto,
60.A.4

The Roan Team (n.d.)
watercolour on paper
42.4 x 37.6 cm.
Gift of R. York Wilson, Esq., Toronto,
60.A.5

LE TOUZEL, J. Robert (1871-1951)
Chester Cathedral from the South
Transept (n.d.)
drypoint etching on paper
30.5 x 17.3 cm.
Gift of Dr. J.R. Le Touzel through the
I.O.D.E., Nicholas Wilson Chapter,
26.A.4

LEATHERS, Winston (1932-)
Night Machine (1964)
relief etching 3/15 on paper
67.3 x 48.3 cm.
Print Fund, 65.A.13

LEDUC, Fernand (1916-)
Rouge - Orange (1964)
oil on canvas
Gift of the Ontario Centennial Art
Exhibition, 69.A.81

LEE-NOVA, Gary (1943-)
Radio City (1967)
acrylic on canvas
152.4 x 152.4 cm.
Art Fund, 68.A.115

LÉGER, Fernand (French: 1881-1955)
Femme nue assise (1912)
graphite on paper
64 x 49 cm.
Gift of Mr. J.H. Moore, London,
through the Ontario Heritage
Foundation, 79.A.2

LEGRADY, George (1950-)
Floating Objects: B781150-16 (1980)
silver gelatin photographic print 2/10
on paper
57.2 x 81.9 cm.
Purchased with a Canada Council
matching grant and Acquisitions
funds, 81.A.63A

Floating Objects: B780607-19 (1980)
silver gelatin photographic print 2/10
on paper
57.2 x 81.9 cm.
Purchased with a Canada Council
matching grant and Acquisitions
funds, 81.A.63B

Floating Objects: B780607-11 (1980)
silver gelatin photographic print 2/10
on paper
57.2 x 81.9 cm.
Purchased with a Canada Council
matching grant and Acquisitions
funds, 81.A.63C

Floating Objects: B800601-2 (1980)
silver gelatin photographic print 2/10
on paper
57.2 x 81.9 cm.
Purchased with a Canada Council
matching grant and Acquisitions
funds, 81.A.63D

Floating Objects: B751116-6 (1980)
silver gelatin photographic print 2/10
on paper
57.2 x 81.9 cm.
Purchased with a Canada Council
matching grant and Acquisitions
funds, 81.A.63E

Floating Objects: B780610-6 (1980)
silver gelatin photographic print 2/10
on paper
57.2 x 81.9 cm.
Purchased with a Canada Council
matching grant and Acquisitions
funds, 81.A.63F

Floating Objects: 790508-31 (1980)
silver gelatin photographic print 2/10
on paper
57.2 x 81.9 cm.
Purchased with a Canada Council
matching grant and Acquisitions
funds, 81.A.63G

Floating Objects: 780310-2 (1980)
silver gelatin photographic print 2/10
on paper
57.2 x 81.9 cm.
Purchased with a Canada Council
matching grant and Acquisitions
funds, 81.A.63H

Floating Objects: 760909-36 (1980)
silver gelatin photographic print 2/10
on paper
57.2 x 81.9 cm.
Purchased with a Canada Council
matching grant and Acquisitions
funds, 81.A.63 I

Floating Objects: 800601-6 (1980)
silver gelatin photographic print 2/10
on paper
57.2 x 81.9 cm.
Purchased with a Canada Council
matching grant and Acquisitions
funds, 81.A.63J

Floating Objects: 780317-28 (1980)
silver gelatin photographic print 2/10
on paper
57.2 x 81.9 cm.
Purchased with a Canada Council
matching grant and Acquisitions
funds, 81.A.63K

Floating Objects: 790509-30 (1980)
silver gelatin photographic print 2/10
on paper
57.2 x 81.9 cm.
Purchased with a Canada Council
matching grant and Acquisitions
funds, 81.A.63L

LEIGH, Patricia (1932-)
Matrix (c.1954)
etching 9/10 on paper
45.2 x 34 cm.
Print Fund, 54.A.181

LEMIEUX, Jean-Paul (1904-)
L'Été (1959)
oil on canvas
58.4 x 126.4 cm.
Gift of the Maclean-Hunter Publishing
Co. Ltd., Toronto, 60.A.110

Le petit arlequin (1959)
collotype 19/75 print on paper
35.6 x 18.1 cm.
Gift of Mr. & Mrs. J.H. Moore,
London, 81.A.39D

Portrait de profil (1961)
collotype 19/75 print on paper
35.6 x 21.6 cm.
Gift of Mr. & Mrs. J.H. Moore,
London, 81.A.39A

1910 Remembered (1962)
collotype 19/75 print on paper
25.7 x 34.5 cm.
Gift of Mr. & Mrs. J.H. Moore,
London, 81.A.39B

Julie et l'Univers (1965)
collotype 19/75 print on paper
25.7 x 27.4 cm.
Gift of Mr. & Mrs. J.H. Moore,
London, 81.A.35C

Nuit sans étoiles (1964)
oil on canvas
55.9 x 108.6 cm.
Gift of Mr. J.H. Moore, London,
through the Ontario Heritage
Foundation, 78.A.89

Voyage au bout de la nuit (1965)
oil on canvas
102.9 x 112 cm.
Art Fund, 65.A.93

Frontispiece (1971)
Illustration from Gabrielle Roy's
La Petite Poule d'eau
serigraph 74/200 on paper
30 x 50 cm.
Gift of Mr. & Mrs. J.H. Moore,
London, 78.A.89A

Untitled (1971)
Illustration from Gabrielle Roy's
La Petite Poule d'eau
(horse-drawn sleigh with couple in
winter landscape)
serigraph 74/200 on paper
30 x 50 cm.
Gift of Mr. & Mrs. J.H. Moore,
London, 78.A.89B

Untitled (1971)
Illustration from Gabrielle Roy's
La Petite Poule d'eau
(portrait of Luzina)
serigraph 74/200 on paper
30 x 50 cm.
Gift of Mr. & Mrs. J.H. Moore,
London, 78.A.89C

Untitled (1971)
Illustration from Gabrielle Roy's
La Petite Poule d'eau
(man and horse in winter landscape)
serigraph 74/200 on paper
30 x 50 cm.
Gift of Mr. & Mrs. J.H. Moore,
London, 78.A.89D

Untitled (1971)
Illustration from Gabrielle Roy's
La Petite Poule d'eau
(train in winter landscape)
serigraph 74/200 on paper
30 x 50 cm.
Gift of Mr. & Mrs. J.H. Moore,
London, 78.A.89E

Untitled (1971)
Illustration from Gabrielle Roy's
La Petite Poule d'eau
(couple in car in spring landscape)
serigraph 74/200 on paper
30 x 50 cm.
Gift of Mr. & Mrs. J.H. Moore,
London, 78.A.89F

Untitled (1971)
Illustration from Gabrielle Roy's
La Petite Poule d'eau
(children in landscape)
serigraph 74/200 on paper
30 x 50 cm.
Gift of Mr. & Mrs. J.H. Moore,
London, 78.A.89G

Untitled (1971)
Illustration from Gabrielle Roy's
La Petite Poule d'eau
(winter landscape with telephone
poles)
serigraph 74/200 on paper
30 x 50 cm.
Gift of Mr. & Mrs. J.H. Moore,
London, 78.A.89H

Untitled (1971)
Illustration from Gabrielle Roy's
La Petite Poule d'eau
(young woman in landscape)
serigraph 74/200 on paper
30 x 50 cm.
Gift of Mr. & Mrs. J.H. Moore,
London, 78.A.89 I

Untitled (1971)
Illustration from Gabrielle Roy's
La Petite Poule d'eau
(woman with hat and flag)
serigraph 74/200 on paper
30 x 50 cm.
Gift of Mr. & Mrs. J.H. Moore,
London, 78.A.89J

Untitled (1971)
Illustration from Gabrielle Roy's
La Petite Poule d'eau
(landscape with prairie hen)
serigraph 74/200 on paper
30 x 50 cm.
Gift of Mr. & Mrs. J.H. Moore,
London, 78.A.89K

Untitled (1971)
Illustration from Gabrielle Roy's
La Petite Poule d'eau
(young man with backpack in
landscape)
serigraph 74/200 on paper
30 x 50 cm.
Gift of Mr. & Mrs. J.H. Moore,
London, 78.A.89L

Untitled (1971)
Illustration from Gabrielle Roy's
La Petite Poule d'eau
(family waving good-bye in landscape)
serigraph 74/200 on paper
30 x 50 cm.
Gift of Mr. & Mrs. J.H. Moore,
London, 78.A.89M

Untitled (1971)
Illustration from Gabrielle Roy's
La Petite Poule d'eau
(hunting scene)
serigraph 74/200 on paper
30 x 50 cm.
Gift of Mr. & Mrs. J.H. Moore,
London, 78.A.89N

Untitled (1971)
Illustration from Gabrielle Roy's
La Petite Poule d'eau
(le capucin)
serigraph 74/200 on paper
30 x 50 cm.
Gift of Mr. & Mrs. J.H. Moore,
London, 78.A.89 O

Untitled (1971)
Illustration from Gabrielle Roy's
La Petite Poule d'eau
(man in lamp in night winter
landscape)
serigraph 74/200 on paper
30 x 50 cm.
Gift of Mr. & Mrs. J.H. Moore,
London, 78.A.89P

Untitled (1971)
Illustration from Gabrielle Roy's
La Petite Poule d'eau
(people outside a prairie church)
serigraph 74/200 on paper
30 x 50 cm.
Gift of Mr. & Mrs. J.H. Moore,
London, 78.A.89Q

Untitled (1971)
Illustration from Gabrielle Roy's
La Petite Poule d'eau
(night landscape with houses)
serigraph 74/200 on paper
30 x 50 cm.
Gift of Mr. & Mrs. J.H. Moore,
London, 78.A.89R

Untitled (1971)
Illustration from Gabrielle Roy's
La Petite Poule d'eau
(striding capucin in landscape)
serigraph 74/200 on paper
30 x 50 cm.
Gift of Mr. & Mrs. J.H. Moore,
London, 78.A.89S

Untitled (1971)
Illustration from Gabrielle Roy's
La Petite Poule d'eau
(dancing outside at night)
serigraph 74/200 on paper
30 x 50 cm.
Gift of Mr. & Mrs. J.H. Moore,
London, 78.A.89T

LETENDRE, Rita (1928-)
Silent Echo II (1968)
serigraph 11/100 on paper
50.8 x 66 cm.
Gift of Mr. J.H. Moore, London,
through the Ontario Heritage
Foundation, 80.A.76

Koshak (1977)
serigraph VII/XV on paper
70.8 x 101.1 cm.
Gift of Mr. & Mrs. Richard M. Ivey,
London, 87.A.20

Tecumseth (1977)
serigraph VII/XV on paper
70.8 x 101.3 cm.
Gift of Mr. & Mrs. Richard M. Ivey,
London, 87.A.21

Tawaken (1977)
serigraph VII/XV on paper
70.8 x 101.3 cm.
Gift of Mr. & Mrs. Richard M. Ivey,
London, 87.A.22

Mishnak (1977)
serigraph VI/XV on paper
70.9 x 101.4 cm.
Gift of Mr. & Mrs. Richard M. Ivey,
London, 87.A.23

Mistapeut (1977)
serigraph VI/XV on paper
70.8 x 101.4 cm.
Gift of Mr. & Mrs. Richard M. Ivey,
London, 87.A.24

LEVINE, Les (1936-)
**Toronto 20: Les Levine's Zip Code
is 10006** (1965)
serigraph 50/100 on acetate
66 x 50.8 cm.
Gift of Mr. & Mrs. J.H. Moore,
London, 81.A.25

LEWIS, Glen (1935-)
Constitution Cake (1982)
graphite and watercolour on paper
46.2 x 53.5 cm.
Art Fund, 83.A.26

LEWITT, Sol (American: 1928-)
Composite Series - 1/5 (1970)
serigraph 83/150 on paper
35.9 x 35.9 cm.
Gift of Mr. & Mrs. J.H. Moore,
London, 81.A.40E

Composite Series - 2/5 (1970)
serigraph 83/150 on paper
35.9 x 35.9 cm.
Gift of Mr. & Mrs. J.H. Moore,
London, 81.A.40D

Composite Series - 3/5 (1970)
serigraph 83/150 on paper
35.9 x 35.9 cm.
Gift of Mr. & Mrs. J.H. Moore,
London, 81.A.40C

Composite Series - 4/5 (1970)
serigraph 83/150 on paper
35.9 x 35.9 cm.
Gift of Mr. & Mrs. J.H. Moore,
London, 81.A.40B

Composite Series - 5/5 (1970)
serigraph 83/150 on paper
35.9 x 35.9 cm.
Gift of Mr. & Mrs. J.H. Moore,
London, 81.A.40A

LIGHTBODY, Maya (1933-)
Inscribed from No. 3 (1966)
relief etching A/P on paper
45.7 x 33 cm.
Gift of Mr. J.H. Moore, London,
through the Ontario Heritage
Foundation, 80.A.213

People Box (1968)
acrylic on wood
19.6 x 19.6 x 19.6 cm.
Gift of Mr. J.H. Moore, London,
through the Ontario Heritage
Foundation, 87.A.89

LINDNER, Ernest (1897-1988)
Snow Made Magic (c.1936-40)
linocut on paper
11.2 x 14.7 cm.
Print Fund, 45.A.6

Paper Flowers (c.1944)
linocut on paper
20.3 x 25.4 cm.
Print Fund, 45.A.4

LINDNER, Richard (American: 1901-1978)
Portrait #2 (1969)
lithograph on paper
54.6 x 71.1 cm.
Gift of the Volunteer Committee,
78.A.15

LIPCHITZ, Jacques (French: 1891-1973)
The Embrace (1933)
bronze 4/7
23 x 12 x 16 cm.
Gift of Mr. J.H. Moore, London,
through the Ontario Heritage
Foundation, 70.A.107

LISMER, Arthur (1885-1969)
Pine Tree and Rocks (1921)
oil on canvas
81.3 x 102.2 cm.
F.B. Housser Memorial Collection,
45.A.42

The Glacier (1930)
oil on canvas
81.3 x 101.6 cm.
Art Fund, 56.A.60

Big Tree (1958)
ink on paper
38.7 x 29.8 cm.
Gift of Mr. J.H. Moore, London,
through the Ontario Heritage
Foundation, 78.A.91

Rock Study (1963)
ink on paper
30.5 x 44.4 cm.
Gift of Mr. J.H. Moore, London,
through the Ontario Heritage
Foundation, 78.A.90

LITKE, Lucille (1932-)
Monument (1953)
etching 9/10 on paper
26.7 x 45.7 cm.
Print Fund, 55.A.49

LIVICK, Stephen (1945-)
Middle America, Print #81348 (1981)
gum bichromate 9/10 on paper
76 x 76 cm.
Gift of Charles M. Monk, Sarnia,
89.A.65

Middle America, Print #81349 (1981)
gum bichromate 10/10 on paper
76 x 76 cm.
Gift of Charles M. Monk, Sarnia,
89.A.66

Middle America, Print #81351 (1981)
gum bichromate 9/10 on paper
76 x 76 cm.
Gift of Charles M. Monk, Sarnia,
89.A.67

Middle America, Print #81353 (1981)
gum bichromate 10/10 on paper
76 x 76 cm.
Gift of Charles M. Monk, Sarnia,
89.A.68

Middle America, Print #81357 (1981)
gum bichromate 10/10 on paper
76 x 76 cm.
Gift of Charles M. Monk, Sarnia,
89.A.69

Middle America, Print #81356 (1981)
gum bichromate 9/10 on paper
76 x 76 cm.
Gift of Charles M. Monk, Sarnia,
89.A.70

Middle America, Print #81359 (1981)
gum bichromate 9/10 on paper
76 x 76 cm.
Gift of Charles M. Monk, Sarnia,
89.A.71

Middle America, Print #81360 (1981)
gum bichromate 9/10 on paper
76 x 76 cm.
Gift of Charles M. Monk, Sarnia,
89.A.72

Middle America, Print #81361 (1981)
gum bichromate 10/10 on paper
76 x 76 cm.
Gift of Charles M. Monk, Sarnia,
89.A.73

Kalcutt, Print #88452: Picker in
Striped Red Dress (1987)
gum bichromate 7/12 on paper
102 x 75 cm.
Gift of Charles M. Monk, Sarnia,
89.A.74

Kalcutt, Print #88456: Female in
Yellow Sari (1987)
gum bichromate 7/12 on paper
102 x 75 cm.
Gift of Charles M. Monk, Sarnia,
89.A.75

Kalcutt, Print #88458: Girl Sorting
Charcoal (1987)
gum bichromate 7/12 on paper
102 x 75 cm.
Gift of Charles M. Monk, Sarnia,
89.A.76

Kalcutt, Print #88459: Hijra with
Black Bindi (1987)
gum bichromate 7/12 on paper
102 x 75 cm.
Gift of Charles M. Monk, Sarnia,
89.A.77

Kalcutt, Print #88462: Woman in
Purdah (1987)
gum bichromate 7/12 on paper
102 x 75 cm.
Gift of Charles M. Monk, Sarnia,
89.A.78

Kalcutt, Print #88463: Rickshaw
Wallah (1987)
gum bichromate 7/12 on paper
102 x 75 cm.
Gift of Charles M. Monk, Sarnia,
89.A.79

Kalcutt, Print #88464: Woman
Resting (1987)
gum bichromate 7/12 on paper
102 x 75 cm.
Gift of Charles M. Monk, Sarnia,
89.A.80

Kalcutt, Print #88466: Girl with Blue
Bindi (1987)
gum bichromate 7/12 on paper
102 x 75 cm.
Gift of Charles M. Monk, Sarnia,
89.A.81

Kalcutt, Print #88467: Costumed
Hijra (1987)
gum bichromate 7/12 on paper
102 x 75 cm.
Gift of Charles M. Monk, Sarnia,
89.A.82

LOCHHEAD, Ken (1926-)
Prairie Reception (1953)
oil on canvas
31.1 x 30.8 cm.
Gift of Mr. J.H. Moore, London,
through the Ontario Heritage
Foundation, 78.A.93

Attract Opposite (1965)
watercolour on paper
68.6 x 53.6 cm.
Gift of Mr. J.H. Moore, London,
through the Ontario Heritage
Foundation, 80.A.26

Roll Along Colour (1971)
acrylic on canvas
116.8 x 147.3 cm.
Art Fund, 73.A.18

Blue Rest (1972)
acrylic on paper
50.8 x 66 cm.
Gift of Mr. J.H. Moore, London,
through the Ontario Heritage
Foundation, 78.A.92

LONG, Marion (1882-1970)
Portrait of Evan McDonald (1934)
oil on canvas
109.7 x 91.7 cm.
Gift of Miss Marion Long, Toronto,
50.A.56

Canadian Soldier (c.1940)
oil on canvas
106.7 x 91.4 cm.
Gift of Miss Marion Long, Toronto,
62.A.27

Zilba (n.d.)
oil on canvas
106.7 x 91.4 cm.
Gift of Miss Marion Long, Toronto,
62.A.26

LONG, Sidney (Australian: 1872-1955)
Between Showers (n.d.)
etching on paper
25.1 x 30.5 cm.
Print Fund, 40.A.1

LORCINI, Gino (1923-)
Beta Delta 1 (1966)
chrome and vinyl mounted on wood
53.9 x 91.4 x 10.7 cm.
Art Fund, 67.A.8

Omega - Mixed Doubles (1976)
acrylic on aluminum with gold plated
elements, 2/5
116.8 x 116.8 x 8 cm.
Anonymous gift, 86.A.39

Quadriga (1977)
corten steel 1/3
158.8 x 127 x 38.1 cm.
Gift of Mr. J.H. Moore, London,
through the Ontario Heritage
Foundation, 87.A.186

LORING, Frances (1887-1968)
Lamia (c.1910-13)
bronze
30.7 x 31 x 20.7 cm.
Gift of Dr. Richard Crouch, London,
44.A.27

LOUIS, Donald J. (1937-)
Grasses (1961)
ink on paper
10.5 x 12.4 cm.
Gift from the Douglas M. Duncan
Collection, 70.A.92

LUBOJANSKA, Janina (1934-)
History's Magic (1966)
collage on canvas
30.5 x 40.6 cm.
Purchased with funds from the
Mitchell Bequest, 67.A.10

LUCIONI, Luigi (American: 1900-)
Late Shadows (1944)
etching on paper
22.3 x 34 cm.
Print Fund, 46.A.67

LUCY Qinnuayuak (1915-1982)
Bird and Flower Composition (1964)
stonecut 38/50 on paper
26.7 x 33 cm.
Print Fund, 72.A.88

Bird with a Fish (1964)
stencil 38/50 on paper
30.5 x 33 cm.
Print Fund, 72.A.24

Man Wanting a Seal (1964)
stonecut and seal skin stencil 38/50
on paper
35.6 x 22.9 cm.
Print Fund, 70.A.38

Two Owls (1964)
stonecut 38/50 on paper
38.1 x 43.2 cm.
Print Fund, 72.A.28

We All Have Something To Do
(1964)
stonecut 27/50 on paper
29.2 x 44.5 cm.
Print Fund, 70.A.41

Women and Birds (1964)
stonecut 38/50 on paper
22.9 x 45.7 cm.
Print Fund, 70.A.37

LUKACS, Attila Richard (1962-)
Junge Spartaner Forden Knaben
zum Kampf heraus (1988)
tar, oil, enamel and varnish on canvas
275 x 662.5 cm.
Purchased with matching funds from
a Wintario grant and the Volunteer
Committee, 89.A.37

LUKE, Alexandra (1901-1967)
Sound Vibrations (1963)
oil on masonite
81.3 x 101.6 cm.
Gift of the Volunteer Committee,
64.A.61

LUKTAK Qiatsuk (1928-)
Canada Geese, Nesting Ground
(1959)
seal skin stencil 29/30 on paper
15.2 x 26.7 cm.
Print Fund, 60.A.55

Mother and Child (1959)
stonecut 26/30 on paper
16.5 x 12.7 cm.
Print Fund, 60.A.56

Owl (1959)
stonecut 27/30 on paper
30.5 x 45.7 cm.
Print Fund, 60.A.50

Bear and Narwahl (sic) (1964)
etching 38/50 on paper
19.1 x 25.4 cm.
Print Fund, 72.A.63

LURCAT, Jean (French: 1892-1966)
Illustration pour Domaine: L'Abeille
(n.d.)
handcoloured lithograph on paper
34.2 x 26.7 cm.
Gift of Mr. J.H. Moore, London,
through the Ontario Heritage
Foundation, 87.A.93

LUZ, Virginia (1911-)
Hirsau, Germany (1950)
casein on paper
55.9 x 38.1 cm.
Art Fund, 63.A.78

Woodwards Cove, Night (1961)
watercolour on paper
69 x 77.5 cm.
Art Fund, 62.A.25

MABE, Manabu (Brazilian: 1924-)
Flôr (1973)
oil on canvas
46 x 38 cm.
Gift of Mr. & Mrs. J.H. Moore,
London, 85.A.53

MacDONALD, Evans (1905-1972)
Lynne Valley Creek, B.C. (n.d.)
oil on card
40.6 x 50.8 cm.
Art Fund, 46.A.51

MacDONALD, Grant (1909-1987)
Two Women in Grey (1958)
oil on canvas
50.8 x 40.6 cm.
Gift of Mr. J.H. Moore, London,
through the Ontario Heritage
Foundation, 78.A.94

Family (1970)
acrylic on masonite
38.1 x 50.8 cm.
Gift of Mr. J.H. Moore, London,
through the Ontario Heritage
Foundation, 80.A.147

MacDONALD, J.E.H. (1873-1932)
Corner of Yonge and Centre Streets,
Thornhill (1913)
graphite on paper
24.8 x 24.1 cm.
Gift of Mr. J.H. Moore, London,
through the Ontario Heritage
Foundation, 78.A.95

The Log Pickers, Georgian Bay
(1913)
oil on canvas
40.6 x 51.4 cm.
Art Fund, 55.A.131

View from East Window, Thornhill
(1915-1916)
oil on card
20.3 x 25.4 cm.
Gift of Mr. Thoreau MacDonald,
Thornhill, 70.A.13

Wilfred Ball's Hill, Thornhill (1915)
oil on card
20.3 x 25.4 cm.
Gift of Mr. J.H. Moore, London,
through the Ontario Heritage
Foundation, 78.A.98

Rainy Weather, Algoma (1918)
oil on card
21.6 x 26.7 cm.
Art Fund, 48.A.30

The Little Fall (1919)
oil on canvas
71.1 x 91.4 cm.
F.B. Housser Memorial Collection,
45.A.45

Evening, Mongoose Lake (1920)
oil on card
21.6 x 26.7 cm.
Art Fund, 48.A.31

Mongoose Lake, Algoma (c.1920)
oil on card
21.6 x 26.7 cm.
Art Fund, 48.A.26

Mount Schaefer, near Lake O'Hara
(1929)
oil on card
21.6 x 26.7 cm.
Art Fund, 48.A.27

Near Lake Arthur (1929)
oil on card
21.6 x 26.7 cm.
Art Fund, 55.A.24

Rain, Lake O'Hara (1929)
oil on card
21.6 x 26.7 cm.
Art Fund, 48.A.21

Near Ross Lake (c.1920)
oil on card
21.6 x 26.7 cm.
Art Fund, 55.A.23

**MacDONALD, J.W.G. (Jock)
(1897-1960)**
Still Life with Flowers (1952)
watercolour on paper
36.1 x 43.8 cm.
Gift of Mr. J.H. Moore, London,
through the Ontario Heritage
Foundation, 78.A.97

Desert Rim (1957)
oil on masonite
134.6 x 120 cm.
Purchased with a Canada Council
matching grant and Acquisitions
funds, 60.A.67

MacDONALD, Manly (1889-1971)
Winter Road (c.1942)
oil on canvas
50.8 x 66 cm.
Art Fund, 42.A.13

MacDONALD, Thoreau (1901-1989)
Deer in Swamp (c.1955)
ink on paper
19.8 x 24.2 cm.
Art Fund, 55.A.19

Early Spring (c.1955)
watercolour on paper
22.9 x 43.2 cm.
Art Fund, 55.A.22

Farm Sawmill (c.1955)
ink on paper
19.8 x 24.5 cm.
Art Fund, 55.A.18

Grasshopper Hunt (c.1955)
ink on paper
22.5 x 29.5 cm.
Art Fund, 55.A.20

Horned Owl (c.1955)
ink on paper
22.3 x 16.7 cm.
Art Fund, 55.A.17

Owl in Tree (c.1955)
ink on paper
17.2 x 22.2 cm.
Art Fund, 55.A.16

Snowy Owl in Open Fields (c.1955)
watercolour on paper
31.8 x 41.9 cm.
Art Fund, 55.A.21

Barnyard Play (c.1959)
ink on paper
11.5 x 19.4 cm.
Gift of Dr. Lorne Pierce, Toronto,
59.A.45

Early Fisherman (c.1959)
ink on paper
12.4 x 19.8 cm.
Gift of Dr. Lorne Pierce, Toronto,
59.A.100

Hayfield Jungle (c.1959)
ink on paper
12.3 x 19.8 cm.
Gift of Dr. Lorne Pierce, Toronto,
59.A.102A

March Morning (c.1959)
ink on paper
12.7 x 20.3 cm.
Gift of Dr. Lorne Pierce, Toronto,
59.A.102

Rewards of Freezing (c.1959)
ink on paper
12.2 x 20.3 cm.
Gift of Dr. Lorne Pierce, Toronto,
59.A.44

Tracks in the Snow (c.1959)
ink on paper
14.7 x 19 cm.
Gift of Dr. Lorne Pierce, Toronto,
55.A.99

MacDOUGALL, Nini (1915-)
Crocus (n.d.)
pastel on paper
34 x 51.8 cm.
Gift of Mr. J.H. Moore, London,
through the Ontario Heritage
Foundation, 80.A.27

MacGREGOR, John (1944-)
Prussian Family (1973)
oil on canvas
61 x 61 cm.
Gift of Mr. J.H. Moore, London,
through the Ontario Heritage
Foundation, 78.A.98

MacKAY, Don (1937-)
Big Morgan (1975-)
air brush acrylic on canvas
121.9 x 121.9 cm.
Art Fund, 77.A.5

MacKENZIE, Hugh (1928-)
The Young Warriors (1959)
tempera on masonite
38.1 x 66.6 cm.
Art Fund, 60.A.34

Still Life (1962)
tempera on masonite
20.3 x 22.2 cm.
Gift of Mr. J.H. Moore, London,
through the Ontario Heritage
Foundation, 78.A.103

Mother and Child (1967)
graphite on paper
15.2 cm. diameter
Gift of Mr. J.H. Moore, London,
through the Ontario Heritage
Foundation, 78.A.101

Banana (1972)
watercolour on paper
16.5 x 27.3 cm.
Gift of Mr. J.H. Moore, London,
through the Ontario Heritage
Foundation, 78.A.99

Expressway No. 3 (1973)
watercolour on paper
22 x 37.5 cm.
Gift of Mr. J.H. Moore, London,
through the Ontario Heritage
Foundation, 78.A.100

Sunflower (1973)
watercolour on paper
24 x 28 cm.
Gift of Mr. J.H. Moore, London,
through the Ontario Heritage
Foundation, 78.A.102

Bar Scene #18 (1975)
etching 2/25 on paper
15.2 x 22.4 cm.
Gift of Mr. & Mrs. J.H. Moore,
London, 87.A 79

Bar Scene #11 (1975)
etching 1/2 on paper
18.3 x 22.5 cm.
Gift of Mr. & Mrs. J.H. Moore,
London, 87.A.78

Bar Scene #8 (1975)
etching 2/25 on paper
19.7 x 30.4 cm.
Gift of Mr. & Mrs. J.H. Moore,
London, 87.A.80

Bridge (1982)
etching 12/15 on paper
19.5 x 31 cm.
Gift of Mr. Tony Urquhart, Wellesley,
87.A.216

Tree (1982)
watercolour on paper
16.9 x 21.5 cm.
Gift of Mr. & Mrs. J.H. Moore,
London, 87.A.83

Bridge II (1983)
etching 1/5 on paper
30 x 22.5 cm.
Gift of Mr. Tony Urquhart, Wellesley,
87.A 217

Expressway Ramp and Buildings
(1983)
coloured etching 9/10 on paper
19.7 x 30 cm.
Gift of Mr. Tony Urquhart, Wellesley,
87.A.218

Typewriter (1983)
etching 3/10 on paper
24.5 x 32.3 cm.
Gift of Mr. & Mrs. J.H. Moore,
London, 87.A.82

Overnight Parking II (1983)
etching 3/12 on paper
13.5 x 23.5 cm.
Gift of Mr. & Mrs. J.H. Moore,
London, 87.A.81

Ferry Bumper (1984)
etching 9/10 on paper
18.5 x 29 cm.
Gift of Mr. Tony Urquhart, Wellesley,
87.A.219

White Water (1987)
etching 4/10 on paper
12.7 x 15.1 cm.
Gift of Mr. Tony Urquhart, Wellesley,
87.A.220

MacKENZIE, Robin (1938-)
A Print in Four Parts (1973-74)
lithograph 7/59 on paper
each part 73.7 x 91.4 cm.
Gift of Dr. Robert MacPhedrin, St.
Catharines, 87.A.228A-D

**MacKINNON-PEARSON, Ian
(1896-)**
L'Embarcadère, St. Simeon (1942)
drypoint etching 4/50 on paper
27.9 x 16.5 cm.
Print Fund, 45.A.9

Entrance to Laval Seminary, Québec
(c.1946)
drypoint 14/50 on paper
28.5 x 20.9 cm.
Print Fund, 47.A.34

Road to Slide Road, Gaspé (1948)
drypoint 2/75 etching on paper
23.5 x 19.8 cm.
Gift of the Society of Canadian
Painter-Etchers and Engravers, 48.A.9

MacLENNAN, Toby (1939-)
The Upside Down Cake (1982)
graphite on paper
43.3 x 30.7 cm.
Art Fund, 83.A.29

MacLEOD, Pegi Nicol (1904-1949)
Men on Telephone Poles (c.1935)
watercolour on paper
75 x 54 cm.
Gift of Mr. Richard Alway, Toronto,
84.A.243

Saint John Harbour (c.1940)
oil on canvas
102 x 70 cm.
Gift of the Volunteer Committee,
85.A.30

**Sailors in Training, University of
New Brunswick** (c.1943)
oil on canvas
101.5 x 71.5 cm.
Gift of the Volunteer Committee,
85.A.31

The Two Cent Ride (n.d.)
watercolour on paper
29.2 x 40.6 cm.
Art Fund, 47.A.62

MADAY, Helene (1916-)
Calico Cat (1961)
oil on canvas
102.2 x 54.6 cm.
Gift of Mr. J.H. Moore, London,
through the Ontario Heritage
Foundation, 78.A.104

**MAIA, Antonio (Brazilian:
1928-)**
Untitled (1972)
hand impression on rice paper
32.4 x 47 cm.
Gift of Mr. & Mrs. J.H. Moore,
London, 85.A.69

MAIA, Jorge (Brazilian: -)
Ossanha Oriza Da Medicina Ervas
(1971)
watercolour on paper
41.9 x 29.5 cm.
Gift of Mr. & Mrs. J.H. Moore,
London, 85.A.54

**MAILLOL, Aristide (French:
1861-1944)**
Femme agenouillée (n.d.)
bronze 2/6
20.3 x 8.9 x 12.7 cm.
Gift of Mr. J.H. Moore, London,
through the Ontario Heritage
Foundation, 78.A.188

**MANIGAULT, Edward Middleton
(1887-1922)**
**City Hall, Richmond Street, London,
Ontario** (1905)
ink on paper
23.3 x 24.2 cm.
Gift of Mrs. Caroline S. Hart, Ottawa,
84.A.237

**Dominion Customs and Excise
Building, Richmond Street, London,
Ontario** (1905)
ink on paper
28.7 x 21.2 cm.
Gift of Mrs. Caroline S. Hart, Ottawa,
84.A.236

**Normal School, Elmwood Avenue,
London, Ontario** (1905)
ink on paper
22.4 x 25.1 cm.
Gift of Mrs. Caroline S. Hart, Ottawa,
84.A.238

**Post Office Building, Richmond
Street, London, Ontario** (1905)
ink on paper
24.7 x 21.1 cm.
Gift of Mrs. Caroline S. Hart, Ottawa,
84.A.235

Tenements, New York (1906)
etching on paper
14.5 x 11.6 cm.
Gift of Mrs. Rosemary Chunn,
London, 89.A.21

**Near the North Branch of the
Thames at the Richmond Street
Bridge** (c.1906)
oil on canvas
41 x 51 cm.
Gift of Mrs. Rosemary Chunn,
London, 89.A.22

E.M. Manigault Bookplate (n.d.)
etching on paper
11 x 11.1 cm.
Gift of Mrs. Rosemary Chunn,
London, 89.A.23

MANNING, Jo Rothfels (1923-)
Untitled Image #5 (1965)
wash and graphite on paper
45.7 x 38.1 cm.
Gift of the Western Art League,
65.A.14

**MANOEL, Alexandre Filho
(Brazilian: -)**
Carangueijo e Cajus (1970)
oil on masonite
34.9 x 53.9 cm.
Gift of Mr. & Mrs. J.H. Moore,
London, 85.A.37

MARKELL, Jack (1919-1979)
Landscape (n.d.)
oil on card
30.5 x 39.3 cm.
Gift of Mr. J.H. Moore, London,
through the Ontario Heritage
Foundation, 78.A.105

Red Orchard (n.d.)
oil on canvas
110.5 x 132.1 cm.
Art Fund, 60.A.112

MARKGRAF, Waltraud (1937-)
Toronto 20: Untitled (1965)
serigraph 50/100 on paper
50.8 x 66 cm.
Gift of Mr. & Mrs. J.H. Moore,
London, 81.A.27

MARKLE, Gary
Baroque Dough Wreath (1982)
mixed media on wood
113 cm. diameter
Art Fund, 83.A.30

MARKLE, Robert (1936-1990)
Morning Nude (1963)
charcoal on paper
87.6 x 57.2 cm.
Gift of Mr. J.H. Moore, London,
through the Ontario Heritage
Foundation, 78.A.106

Untitled Toronto 20: (c.1965)
lithograph 50/100 on paper
66 x 50.8 cm.
Gift of Mr. & Mrs. J.H. Moore,
London, 81.A.26

**MARLOW, William (British:
1740-1813)**
St. Paul's From Ludgate Hill (c.1795)
oil on canvas
106.7 x 86.4 cm.
Gift of Mrs. Rachel Johnstone,
England, 53.A.150

MARSH, Anne (1923-)
Detail, Dundas and Maitland Streets
(1969)
ink on paper
31.5 x 42.2 cm.
Gift of Mr. & Mrs. Ken Singleton,
London, 89.A.20

MARTIN, Jack (1904-1965)
Spring (1943)
drypoint etching 6/20 on paper
17.2 x 18.4 cm.
Print Fund, 47.A.37

Ten O'Clock (1945-46)
mezzotint on paper
17.8 x 22.3 cm.
Print Fund, 46.A.17

All's Well (n.d.)
drypoint etching 20/35 on paper
16.8 x 19.1 cm.
Print Fund, 46.A.13

St. George's (n.d.)
wood engraving on paper
13.3. x 10.8 cm.
Print Fund, 49.A.2

MARTIN, Ron (1943-)
Sky (1966)
enamel on wood
106.1 x 106.1 cm.
Gift of the Western Art League,
66.A.23

Conclusion #9 - Homage to Hugo MacPherson (1967)
paper collage on card
53.3 x 53.3 cm.
Art Fund, 69.A.66A

Transfer #9 - Homage to Hugo MacPherson (1967)
enamel on wood
123.9 x 123.9 cm.
Art Fund, 69.A.66B

Conclusion (1967)
paper collage on paper
23 x 22 cm.
Gift of Mr. J.H. Moore, London,
through the Ontario Heritage
Foundation, 78.A.107

February 1970 #12
watercolour on paper
76.2 x 65.9 cm.
Art Fund, 76.A.20

World No. 4 (1970)
graphite and watercolour on paper
107.2 x 72.1 cm.
Gift of Mr. J.H. Moore, London,
through the Ontario Heritage
Foundation, 80.A.148

World No. 5 (1970)
graphite and watercolour on paper
107.9 x 71.8 cm.
Gift of Mr. J.H. Moore, London,
through the Ontario Heritage
Foundation, 80.A.149

World No. 6 (1970)
graphite and watercolour on paper
106.7 x 71.1 cm.
Gift of Mr. J.H. Moore, London,
through the Ontario Heritage
Foundation, 80.A.150

World Number 72 (1970)
graphite and watercolour on paper
74.3 x 53.9 cm.
Gift of Mr. J.H. Moore, London,
through the Ontario Heritage
Foundation, 80.A.30

World Number 82 (1970)
graphite and watercolour on paper
74.3 x 53.9 cm.
Gift of Mr. J.H. Moore, London,
through the Ontario Heritage
Foundation, 80.A.31

World Number 83 (1970)
graphite and watercolour on paper
78.7 x 58.4 cm.
Gift of Mr. J.H. Moore, London,
through the Ontario Heritage
Foundation, 80.A.32

Drawing-Black Magic Marker (1971)
ink on paper
61 x 48.3 cm.
Gift of Mr. J.H. Moore, London,
through the Ontario Heritage
Foundation, 80.A.29

Drawing-Red Magic Marker (1971)
ink on paper
61 x 48.3 cm.
Gift of Mr. J.H. Moore, London,
through the Ontario Heritage
Foundation, 80.A.28

One Human Substance #12 (1976)
acrylic on canvas
213.4 x 167.6 cm.
Art Fund, 76.A.19

The Music Gallery Portfolio: Chip 22 (1982)
serigraph 4/40 on paper
63.5 x 45.7 cm.
Purchased with a Canada Council
matching grant and Acquisitions
funds, 82.A.41

MASSER, Ken (1932-)
Flora No. 2 (1962)
oil on canvas
69.2 x 84.4 cm.
Gift of Mr. J.H. Moore, London,
through the Ontario Heritage
Foundation, 80.A.151

Sea Image No. 2 (1962)
oil on canvas
102.2 x 70.2 cm.
Gift of Mr. J.H. Moore, London,
through the Ontario Heritage
Foundation, 79.A.46

After Rubens #1 (1963)
charcoal on paper
46.3 x 62.2 cm.
Gift of Mr. J.H. Moore, London,
through the Ontario Heritage
Foundation, 78.A.108

MASSEY, John (1950-)
The Music Gallery Portfolio: Blind Faith (1982)
serigraph 4/40 on paper
44.5 x 62.2 cm.
Purchased with a Canada Council
matching grant and Acquisitions
funds, 82.A.34

MASSON, Henri (1907-)
Spring Flood (1937)
oil on canvas
66 x 76.2 cm.
Gift of H.S. Southam, Esq., Ottawa,
47.A.71

La Rue (c.1940)
oil on masonite
30.5 x 40.6 cm.
Gift of Mr. J.H. Moore, London,
through the Ontario Heritage
Foundation, 80.A.152

Backyards (c.1945)
watercolour on paper
26 x 27.3 cm.
Art Fund, 83.A.18

MATHURIN, Maurice (French: 1884-)
Village of the Loire (1937)
oil on canvas
98.4 x 79.3 cm.
Bequest of the Williams family in
memory of Miss M.B. and Dr. Ernie
Williams, 72.A.21

MATISSE, Henri (French: 1869-1954)
Femme au collier... (1934-36)
etching 20/28 on paper
15 x 11 cm.
Gift of Mr. J.H. Moore, London,
through the Ontario Heritage
Foundation, 78.A.181

Head of Odalisque (1942)
crayon on paper
39.9 x 52.1 cm.
Gift of Mr. J.H. Moore, London,
through the Ontario Heritage
Foundation, 79.A.3

MAURICIO, Luciano (Brazilian: 1925-)
Clarisse Tao Longe (1972)
oil on panel
35 x 50 cm.
Gift of Mr. & Mrs. J.H. Moore,
London, 85.A.55

MAYCOCK, Bryan (1944-)
Short Story #2 (1972)
lithograph assemblage 3/25 on paper
63.5 x 63.5 cm.
Purchased with funds from the
Mitchell Bequest, 72.A.122

Drawing from "Captive Rip" (1976)
mixed media on paper
45.7 x 45.7 cm.
Gift of Mr. J.H. Moore, London,
through the Ontario Heritage
Foundation, 80.A.237

Comfit Grid (n.d.)
mixed media
63 x 63 x 7.6 cm.
Art Fund, 73.A.17

MAYCOCK, Jill (1945-)
Bathroom Door (1973)
batik on cotton
193 x 90.9 cm.
Art Fund, 74.A.5

Bathroom Door (1973)
watercolour on paper
55.9 x 20.3 cm.
Art Fund, 74.A.6

MAYHEW, Elza (1916-)
Farewell (1959)
serigraph 25/100 on paper
49.6 x 31.8 cm.
Print Fund, 59.A.11

MAYRS, David (1935-)
Soldier, Soldier, Will You Marry Me? (n.d.)
oil on canvas
151.1 x 135.9 cm.
Purchased with a Canada Council
matching grant and Acquisitions
funds, 64.A.170

McCAFFERY, Steven (1947-)
The Music Gallery Portfolio: Monotony Test (1982)
serigraph 4/40 on paper
64.1 x 43.8 cm.
Purchased with a Canada Council
matching grant and Acquisitions
funds, 82.A.35

McCARTHY, Doris (1910-)
Middle Pier, Brixham (1951)
watercolour on paper
38.1 x 55.9 cm.
Art Fund, 53.A.70

McCLOY, William (1913-)
The Potter (1953)
etching on paper
45.7 x 33 cm.
Print Fund, 55.A.52

McDOUGALL, Clark (1921-1980)
January Drift (1944)
watercolour on paper
40.6 x 50.8 cm.
Gift of Mr. Clare Wood, Toronto,
through the Ontario Heritage
Foundation, 83.A.11

St. James Church (1963)
oil on masonite
61.0 x 81.3 cm.
Gift of Mrs. Marion McDougall,
St. Thomas, 88.A.30

Untitled: Winter Landscape with Side of Barn (1966)
acrylic on masonite
80.0 x 59.7 cm.
Gift of Marion and Alf Murray,
Islington, 88.A.24

Untitled: Farm Lane in Winter (1966)
watercolour mounted on masonite
80.0 x 59.7 cm.
Gift of Marion and Alf Murray,
Islington, 88.A.25

Abandoned Farm, 6th and Victoria Road (1968)
oil on masonite
111.8 x 99.1 cm.
Purchased with funds from the
Mitchell Bequest, 68.A.117

Site (1976)
gouache on paper
90.5 x 121.4 cm.
Gift of the Volunteer Committee,
78.A.5A

Site (1976)
acrylic on board
92 x 122.5 cm.
Gift of the Volunteer Committee,
78.A.5B

Site (1977)
serigraph 1/60 on paper
45.7 x 61 cm.
Gift of the Volunteer Committee,
78.A.16

Bucke's Farm (1978)
serigraph 127/200 on paper
48.2 x 60 cm.
Gift of Mr. & Mrs. Richard M. Ivey,
London, 87.A.1

Near 13th Concession (1978)
serigraph 165/200 on paper
44.8 x 59.5 cm.
Gift of Mr. & Mrs. Richard M. Ivey,
London, 87.A.2

St. James Church (1978)
serigraph 168/200 on paper
46 x 60 cm.
Gift of Mr. & Mrs. Richard M. Ivey,
London, 87.A.3

East Broadway, Buffalo (1978)
serigraph 68/110 on paper
47.3 x 59.5 cm.
Gift of Mr. & Mrs. Richard M. Ivey,
London, 87.A.4

Buffalo News Stand (1978)
serigraph 83/200 on paper
45.4 x 60.1 cm.
Gift of Mr. & Mrs. Richard M. Ivey,
London, 87.A.5

McELCHERAN, William (1927-)
Peripatetics (1968)
bronze
39.4 x 46.3 x 24.2 cm.
Art Fund, 70.A.117

McEVOY, Henry Nesbit (1828-1914)
Landscape (1850)
oil on canvas
39.4 x 48.3 cm.
The W. Thomson Smith Memorial
Collection (Bequest of Alfred J.
Mitchell), 48.A.87

Springbank Park (1880)
oil on canvas
55.9 x 92.7 cm.
Gift of Mrs. Jessie Minhinnick,
London, 82.A.45

McEWEN, Jean (1923-)
Rouge assiégée par des jaunes
(1962)
oil on canvas
152.4 x 193 cm.
Art Fund, 63.A.14

Icône rouge (1967)
oil on canvas
38.1 x 38.1 cm.
Gift of Mr. J.H. Moore, London,
through the Ontario Heritage
Foundation, 78.A.109

La Toile en bleu (1962)
oil on canvas
78.1 x 77.5 cm.
Gift of Mr. J.H. Moore, London,
through the Ontario Heritage
Foundation, 78.A.110

Untitled (1962)
watercolour on paper
38.4 x 28.6 cm.
Gift of Mr. J.H. Moore, London,
through the Ontario Heritage
Foundation, 80.A.33

McEWEN, John (1945-)
Teko - with Broken Base (1980)
corten steel
wolf: 118.1 x 55.3 x 6.4 cm.
short base: 254 x 6.4 x 6.4 cm.
long base: 442 x 6.4 x 6.4 cm.
Purchased with a Canada Council
matching grant and funds from the
Volunteer Committee, 84.A.1A-C

McGILLIVRAY, Florence (1864-1938)
Harvesting Cocoanuts, Jamaica
(n.d.)
watercolour on paper
62.3 x 45.7 cm.
Gift of Miss Kathleen Hillray, Toronto,
54.A.76

Ice Chair, St. Anthony (n.d.)
watercolour on paper
36.9 x 41.9 cm.
Gift of Mr. Gordon Conn, Newmarket,
50.A.45

McINTOSH, Ian (1931-)
Camble Viaduct (1951)
aquatint 7/15 on paper
14.7 x 22.3 cm.
Print Fund, 53.A.68

McINTOSH, Sylvia (1930-)
Moonlight (1952)
aquatint 2/25 on paper
14.7 x 22.3 cm.
Print Fund, 53.A.66

McLAUGHLIN, Isobel (1903-)
House in Moonlight (n.d.)
oil on canvas
38.1 x 40.6 cm.
F.B. Housser Memorial Collection,
45.A.46

MENSES, Jan (1933-)
Study for Kaddish Set #5 (1964)
oil on panel
20.3 x 31.7 cm.
Gift of Mr. J.H. Moore, London,
through the Ontario Heritage
Foundation, 78.A.111

Study for Kaddish Set #25 (1964)
oil on board
24.1 x 38.1 cm.
Gift of Mr. J.H. Moore, London,
through the Ontario Heritage
Foundation, 78.A.112

MERCER, Alexander Cavalie (British: 1783-1868)
Entrance to Halifax Harbour, August 15, 1851
graphite and watercolour on paper
26 x 37 cm.
Gift of Dr. Daniel Lowe, London,
89.A.60

MEREDITH, John (1933-)
Encounter (1965)
oil on canvas
152.4 x 152.4 cm.
Purchased with a Canada Council
matching grant and Acquisitions
funds, 79.A.10

Toronto 20: Untitled (1965)
serigraph 50/100 on paper
55.9 x 40.6 cm.
Gift of Mr. & Mrs. J.H. Moore,
London, 81.A.28

Yume/Dream (1977)
oil on canvas
152.4 x 182.9 cm.
Purchased with a Canada Council
matching grant and Acquisitions
funds, 79.A.11

METHUEN, Paul A. (British: 1886-1974)
Widcomb Manor (1945)
oil on card
23.5 x 35.6 cm.
Gift of the Contemporary Art Society
of Great Britain, 55.A.117

MIAIJI, Uitangi (c.1911-1965)
Standing Mother and Infant (p.1966)
grey stone
26.5 x 14.8 x 8 cm.
Art Fund, 77.A.81

MAIRY (Pudlat, Mary) (1923-)
Bear (1964)
stonecut 38/50 on paper
12.7 x 26.7 cm.
Print Fund, 72.A.57

MICKUNAS, Irene (1930-)
A Happening (1965)
collage and watercolour on paper
36.9 x 42.8 cm.
Gift of Mr. J.H. Moore, London,
through the Ontario Heritage
Foundation, 80.A.153

Celebration I (1967)
collage and acrylic on masonite
92 x 92 cm.
Purchased with funds from the
Mitchell Bequest, 67.A.11

MICKUSKA, Frank (1930-)
The Grail (1962)
ink on paper
69.9 x 36.6 cm.
Gift of the Western Art League,
64.A.77

MILLS, Gray (1929-)
A River, A Hill (1960)
watercolour on paper
50.8 x 69.9 cm.
Art Fund, 60.A.32

MILNE, David (1882-1953)
Cottage Interior, West Sangerties, New York (1914)
watercolour on paper
44.5 x 48.3 cm.
Gift of Mr. J.H. Moore, London,
through the Ontario Heritage
Foundation, 78.A.194

Icebox and Kitchen Shelves (1919)
watercolour and graphite on paper
44.7 x 55.1 cm.
Bequest of Mrs. Frances Barwick,
Ottawa, 85.A.17

Winding Road, Mount Riga, New York (1921)
watercolour on paper
26 x 37.4 cm.
Gift of Mr. J.H. Moore, London,
through the Ontario Heritage
Foundation, 78.A.122

Hillside With Melting Snow, Mount Riga, New York (1923)
watercolour on paper
38.1 x 53.3 cm.
Art Fund, 58.A.101

Islands in the Lake, Big Moose Lake (1925)
watercolour on paper
27.3 x 36.8 cm.
Gift of Mr. J.H. Moore, London,
through the Ontario Heritage
Foundation, 78.A.113

Grey Cloud, Temagami (1929)
oil on canvas
29.2 x 39.3 cm.
Gift of Mr. J.H. Moore, London,
through the Ontario Heritage
Foundation, 78.A.120

Autumn, Palgrave (c.1931-32)
oil on canvas
39.4 x 55.9 cm.
Art Fund, 58.A.126

The Big Maple on a Dark Day, Palgrave (1932)
oil on canvas
49.5 x 54.6 cm.
Gift of Mr. J.H. Moore, London,
through the Ontario Heritage
Foundation, 78.A.114

The Maple Blooms on Hiram's Farm, Palgrave (1933)
oil on canvas
50.8 x 71.1 cm.
Gift from the Douglas M. Duncan
Collection, 70.A.56

One Trillium, Six Mile Lake (1934)
(recto)
(a.k.a. **Still Life with Lamp**)
oil on canvas
44.4 x 59.7 cm.
Trilliums (1934) (verso)
oil on canvas
44.4 x 59.7 cm.
Gift of Mr. J.H. Moore, London,
through the Ontario Heritage
Foundation, 78.A.118A,B

Yard of the Queen's Hotel (1937)
drypoint etching on paper
17.4 x 22.5 cm.
Gift from the Douglas M. Duncan
Collection, 70.A.71

Unloading Coal (1941)
watercolour on paper
36.8 x 50.8 cm.
Gift of Mr. J.H. Moore, London,
through the Ontario Heritage
Foundation, 78.A.118,119

Christmas Tree in October, Uxbridge (1942)
watercolour on paper
36.9 x 50.3 cm.
Gift from the Douglas M. Duncan
Collection, 70.A.99

Misty Harbour (1942)
watercolour and graphite on paper
36 x 53 cm.
Bequest of Mrs. Frances Barwick,
Ottawa, 85.A.18

Signs and Symbols, Uxbridge (1943)
watercolour on paper
36.8 x 44.8 cm.
Gift of Mr. J.H. Moore, London,
through the Ontario Heritage
Foundation, 78.A.117

Ascension #10, Uxbridge (c.1945)
watercolour on paper
53.9 x 36 cm.
Art Fund, 58.A.99

Return from the Journey, number 2, Uxbridge (1944)
watercolour on paper
36.8 x 54.6 cm.
Gift of Mr. J.H. Moore, London, through the Ontario Heritage Foundation, 78.A.115

Radio number 3, Uxbridge, August, 1946
watercolour on paper
36 x 53.9. cm.
Art Fund, 58.A.100

Sweet Peas and Poppies, Uxbridge (1946)
oil on canvas
35.6 x 30.5 cm.
Gift from the Douglas M. Duncan Collection, 70.A.57

The River and the Trees, Baptiste Lake (1951)
watercolour on paper
35.6 x 48.3 cm.
Gift of Mr. J.H. Moore, London, through the Ontario Heritage Foundation, 78.A.116

Road Through the Spruce, Baptiste Lake (1952)
watercolour on paper
36.9 x 47.7 cm.
Gift from the Douglas M. Duncan Collection, 70.A.100

MIRÓ, Joan (Spanish: 1893-1983)
Bougrelas et sa mère (1953)
serigraph 22/75 on paper
54.6 x 75 cm.
Gift of the Volunteer Committee, 78.A.6

MITCHELL, Doug (1950-)
Heartland (1978)
oil on masonite
96.5 x 96 cm.
Gift of Mr. & Mrs. J.H. Moore in memory of Alex Graydon, 87.A.227

MITCHELL, Janet (1915-)
Effect of a Procession XII (1960)
watercolour on paper
52 x 67.3 cm.
Purchased with a Canada Council matching grant and Acquisitions funds, 61.A.26

MOCHIZUKI, Betty (1929-)
Eggplant and Things (1954)
watercolour on paper
39.1 x 54.6 cm.
Gift of Mr. J.H. Moore, London, through the Ontario Heritage Foundation, 80.A.154

Landscape (1960)
watercolour on paper
35 x 44.5 cm.
Gift from the Douglas M. Duncan Collection, 70.A.64

MODIGLIANI, Amedeo (Italian: 1889-1920)
Femme assise (c.1919)
graphite on paper
53.3 x 36 cm.
Gift of Mr. J.H. Moore, London, through the Ontario Heritage Foundation, 79.A.4

MOL, Leo (1915-)
Portrait of A.Y. Jackson (1962)
bronze
32 x 23 x 28 cm.
Purchased with funds from the Mitchell Bequest, 65.A.2

MOLINARI, Guido (1933-)
Untitled (n.d.)
serigraph 56/67 on paper
61 x 76.2 cm.
Gift of Mr. J.H. Moore, London, through the Ontario Heritage Foundation, 80.A.214

MOLL, Gilbert (1940-)
Portrait of a Flyer (1974)
mixed media on paper
39.1 x 59.4 cm.
Gift of the Junior Volunteer Committee, 74.A.62

Flight Formation (1976)
serigraph 3/50 on paper
59.5 x 39.3 cm.
Gift of Mr. & Mrs. Richard M. Ivey, London, 87.A.11

Tell-Tails #4 (1977)
airbrushed acrylic on canvas
124.5 x 188 cm.
Queen's Silver Jubilee Collection, on permanent loan from the Government of Ontario, 77.A.15

The Wingwalker's Apprentice (1977)
serigraph A/P #2 on paper
46.7 x 58 cm.
Gift of Mr. & Mrs. Richard M. Ivey, London, 87.A.12

MOODIE, Kim (1951-)
Houses (1983)
ink on paper
121.9 x 111.8 cm.
Art Fund, 84.A.3

MOORE, Henry (British: 1898-1986)
Six Reclining Figures (1957)
lithograph 46/60 on paper
45.7 x 37.6 cm.
Gift of Mr. J.H. Moore, London, through the Ontario Heritage Foundation, 80.A.53

Reclining Figure Maquette (1960)
bronze 4/9
12.7 x 20.4 x 9.6 cm.
Gift of Mr. J.H. Moore, London, through the Ontario Heritage Foundation, 78.A.189

Garsdale (1973-74)
lithograph LXXIV/CL on paper
24 x 31.6 cm.
Gift of Mrs. Mira Godard, Toronto, 87.A.33A

Cavern (1973-74)
lithograph LXXIV/CL on paper
31.9 x 26.6 cm.
Gift of Mrs. Mira Godard, Toronto, 87.A.33B

Lullaby - Sleeping Head (1973-74)
lithograph LXXIV/CL on paper
27.2 x 29.3 cm.
Gift of Mrs. Mira Godard, Toronto, 87.A.33C

Splitstone (1973-74)
lithograph LXXIV/CL on paper
30.3 x 14.7 cm.
Gift of Mrs. Mira Godard, Toronto, 87.A.33D

Draped Reclining Figure (1974)
lithograph A/P on paper
34.3 x 47.3 cm.
Gift of the Volunteer Committee, 78.A.17

Four Reclining Figures: Caves (1974)
lithograph on paper
45.1 x 56.8 cm.
Gift of Dr. & Mrs. Ralph Bull, London, 85.A.92

Sheep Plate VIII (1974)
etching 29/80 on paper
30.5 x 38.1 cm.
Gift of the Volunteer Committee, 78.A.18

Ideas for Wood Sculpture (1975)
lithograph 22/50 on paper
35.2 x 27 cm.
Gift of the Volunteer Committee, 78.A.19

MOORE, Penny (1950-)
Painting #10 (n.d.)
acrylic on canvas
152.4 x 182.9 cm.
Gift of Mr. & Mrs. J.H. Moore, London, 89.A.24

MORAIS, Ivan (Brazilian: -)
Cena Foclorica (1972-73)
acrylic and oil on canvas
100 x 80 cm.
Gift of Mr. & Mrs. J.H. Moore, London, 85.A.56

MOREY, Charles (1927-)
Archetypal Landscape (1965)
vinyl copolymer and acrylic on paper
55.9 x 76.2 cm.
Gift of Mr. J.H. Moore, London, through the Ontario Heritage Foundation, 80.A.155

MORI, Yoshatoshi (Japanese: 1900-)
Trees (1967)
woodblock 1/50 on paper
33.3 x 53.9 cm.
Gift of Mr. J.H. Moore, London, through the Ontario Heritage Foundation, 79.A.41

MORRICE, J.W. (1865-1924)
Portrait Sketch of Robert Henri (1896)
oil on canvas
60.4 x 45.7 cm.
Art Fund, 60.A.44

Sketch (n.d.)
oil on wood
12.3 x 15.5 cm.
Gift of the Estate of Mr. David R. Morrice, Montreal, 78.A.277

Sketch - St. Malo, France (n.d.)
oil on wood
12.1 x 15.2 cm.
Gift of the Estate of Miss F.E. Morrice, Montreal, 81.A.13

Three Men at the Bar (n.d.)
graphite on paper
10.8 x 16.5 cm.
Gift of Mr. J.H. Moore, London, through the Ontario Heritage Foundation, 78.A.123

Winter Street Scene (n.d.)
oil on canvas
19.7 x 21.7 cm.
Gift of the Estate of Mr. David R. Morrice, Montreal, 78.A.226

Woman and Girl on a Bench (n.d.)
graphite on paper
10.8 x 16.5 cm.
Gift of the Volunteer Committee, 62.A.2

MORRIS, Michael (1942-)
Centennial Suite: Screen Test (1967)
serigraph 19/50 on paper
35.6 x 46.3 cm.
Gift of Simon Fraser University, Burnaby, B.C., 68.A.75

Untitled (1967)
gouache on paper
53.3 x 63.5 cm.
Gift of Mr. J.H. Moore, London, through the Ontario Heritage Foundation, 78.A.124

Untitled (1967)
silkscreen 39/50 on paper
72.7 x 56.5 cm.
Gift of Mr. J.H. Moore, London, through the Ontario Heritage Foundation, 80.A.77

MORRISSEAU, Norval (1932-)
The Dawn (c.1979)
serigraph 45/350 on paper
61.5 x 48 cm.
Gift of Mr. J.H. Moore, London, through the Ontario Heritage Foundation, 88.A.9

Shaman Conjuring Speech (c.1979)
serigraph 45/350 on paper
61.5 x 48 cm.
Gift of Mr. J.H. Moore, London, through the Ontario Heritage Foundation, 88.A.10

Composition with Loons (c.1979)
serigraph 45/350 on paper
61.5 x 48 cm.
Gift of Mr. J.H. Moore, London, through the Ontario Heritage Foundation, 88.A.11

Young Gulls Watching (c.1979)
serigraph 45/350 on paper
61.5 x 48 cm.
Gift of Mr. J.H. Moore, London, through the Ontario Heritage Foundation, 88.A.12

Shaman and Apprentice (c.1979)
serigraph 45/350 on paper
61.5 x 48 cm.
Gift of Mr. J.H. Moore, London, through the Ontario Heritage Foundation, 88.A.13

The Medicine Snake (n.d.)
crayon and ink on paper
60.4 x 77.5 cm.
Gift of Mr. J.H. Moore, London, through the Ontario Heritage Foundation, 80.A.156

Shaking the Tent (n.d.)
watercolour on paper
35.6 x 55.9 cm.
Gift of Mr. J.H. Moore, London,
through the Ontario Heritage
Foundation, 78.A.125

MORTON, Sylvia (active 1964-1967)
Bird (1964)
monoprint on paper
30.5 x 25.4 cm.
Gift from the Douglas M. Duncan
Collection, 70.A.65

MUHLSTOCK, Louis (1904-)
Haunted House (1938)
oil on canvas
61 x 76.2 cm.
Gift of H.S. Southam, Esq., Ottawa,
47.A.72

Goat (1943)
monoprint on paper
36.9 x 26.7 cm.
Gift from the Douglas M. Duncan
Collection, 70.A.82

MUNGITUK (1940-)
Blue Geese on Snow (1959)
seal skin stencil 23/30 on paper
27.9 x 19.1 cm.
Print Fund, 60.A.58

Man Carried to the Moon (1959)
stonecut 26/50 on paper
48.3 x 38.1 cm.
Print Fund, 60.A.46

Capturing a Powerful Bird (1964)
stonecut 38/50 on paper
38.1 x 44.5 cm.
Print Fund, 72.A.31

MUNTZ, Laura Lyall (1860-1930)
Study (Child's Head) (n.d.)
oil on canvas card
36 x 30.5 cm.
Gift of Mr. Gordon Conn, Newmarket,
50.A.20

NAKAMURA, Kazuo (1926-)
Suspended Interior (1958)
oil on canvas
101.6 x 81.3 cm.
Gift of Mr. J.H. Moore, London,
through the Ontario Heritage
Foundation, 78.A.127

Grey Morning (1961)
watercolour on paper
38.7 x 53.8 cm.
Gift of Mr. J.H. Moore, London,
through the Ontario Heritage
Foundation, 80.A.157

Lakeside, Summer Morning (1961)
oil on canvas
60.3 x 77.5 cm.
Gift of Mr. J.H. Moore, London,
through the Ontario Heritage
Foundation, 78.A.126

Toronto 20: Untitled (c.1965)
etching 50/100 on paper
18.7 x 22.8 cm.
Gift of Mr. & Mrs. J.H. Moore,
London, 81.A.29

Reflection 69 (1969)
oil on canvas
119.4 x 125.1 cm.
Gift of the Volunteer Committee,
70.A.107

NAPACHEE (1938-)
Birds Feeding (1964)
stonecut 38/50 on paper
48.3 x 50.8 cm.
Print Fund, 72.A.86

Sea Spirits (1964)
stonecut 36/50 on paper
17.8 x 22.9 cm.
Print Fund, 72.A.67

NAPARTUK, Henry (1930-)
Loon (n.d.)
black stone with grey inclusions
12.5 x 1.5 x 3.5 cm.
Art Fund, 77.A.78

NESBITT, John (1928-)
Sculpture #14 (1965)
bronze and red marble
34 x 20 x 14 cm.
Gift of Mr. J.H. Moore, London,
through the Ontario Heritage
Foundation, 78.A.206

NEUTHOLAN, F.J.
Fishing Fleet on Shore (n.d.)
oil on canvas
33 x 45.7 cm.
The W. Thomson Smith Memorial
Collection (Bequest of Alfred J.
Mitchell), 48.A.79

**NEVELSON, Louise (American:
1900-1988)**
Six Point Star (1980)
cast paper print on paper
101.6 x 87.7 cm.
Gift of the Volunteer Committee,
81.A.3

NICHOLS, Jack (1921-)
Coquette (1952)
pastel on paper
94.6 x 61.6 cm.
Gift from the Douglas M. Duncan
Collection, 70.A.66

Boy's Profile (1955)
oil on canvas
75 x 62.3 cm.
Gift of Mr. J.H. Moore, London,
through the Ontario Heritage
Foundation, 80.A.158

Circus Person (1957)
lithograph 33/33 on paper
49.6 x 38.1 cm.
Purchased with funds from the
Mitchell Bequest, 61.A.23

The Orange Cloak (1957)
pastel on paper
86.4 x 55.9 cm.
Art Fund, 54.A.72

Pierrot With Ball (1957)
lithograph 12/32 on paper
52.1 x 41.2 cm.
Purchased with funds from the
Mitchell Bequest, 61.A.25

Untitled (1958)
lithograph A/P on paper
41 x 53.3 cm.
Gift from the Douglas M. Duncan
Collection, 70.A.96

The King (1958)
lithograph 2/32 on paper
50.8 x 40.1 cm.
Purchased with funds from the
Mitchell Bequest, 61.A.24

Man and Bull (1958)
lithograph A/P on paper
50.8 x 39.4 cm.
Gift from the Douglas M. Duncan
Collection, 70.A.79

The Draw (1959)
watercolour on paper
58.1 x 44.8 cm.
Gift of Mr. J.H. Moore, London,
through the Ontario Heritage
Foundation, 80.A.159

Listeners (n.d.)
graphite and wash on paper
50.5 x 41.9 cm.
Gift from the Douglas M. Duncan
Collection, 70.A.97

**NICHOLSON, Ben (British:
1894-1978)**
November (Moon) (1962)
mixed media on masonite
69.8 x 55.2 cm.
Gift of Mr. J.H. Moore, London,
through the Ontario Heritage
Foundation, 79.A.5

Bird's Eye View (1966)
etching 17/50 on paper
31.8 x 36.9 cm.
Gift of the Volunteer Committee,
78.A.20

nicol, b.p. (1944-)
**The Music Gallery Portfolio: Three
Drafts** (1982)
serigraph 4/40 on paper
64.1 x 45.7 cm.
Purchased with a Canada Council
matching grant and Acquisitions
funds, 82.A.36

NICOLET, Frank (1887-)
Portrait of a Young Girl (c.1907)
oil on wood
25.7 x 20.3 cm.
Anonymous gift, 68.A.94

NICOLL, Marion (1908-1985)
Sundogs (1967)
oil on canvas
137.2 x 114.3 cm.
Purchased with a Canada Council
matching grant and Acquisitions
funds, 69.A.58

**NITSCH, Richard (German:
1866-)**
Portrait of a Thuringian Man (n.d.)
oil on wood
17.2 x 12.7 cm.
The W. Thomson Smith Memorial
Collection (Bequest of Alfred J.
Mitchell), 48.A.80

Portrait of a Silesian Woman (n.d.)
oil on wood
17.2 x 12.7 cm.
The W. Thomson Smith Memorial
Collection (Bequest of Alfred J.
Mitchell), 48.A.81

NIVERVILLE, Louis de (1933-)
Bespectacled and Birdlike (1967)
oil on canvas
61 x 51.4 cm.
Gift of Mr. J.H. Moore, London,
through the Ontario Heritage
Foundation, 78.A.57

Ménage à trois (1972)
acrylic on canvas
213.4 x 152.4 cm.
Art Fund, 74.A.40

NIVIAKSIAK (1908-1959)
Caribou, Winter Light (1959)
seal skin stencil 26/30 on paper
15.2 x 26 cm.
Print Fund, 60.A.57

Eskimo Summer Tent (1959)
seal skin stencil 26/30 on paper
33 x 30.5 cm.
Print Fund, 60.A.52

Hunter with Bear (1959)
seal skin stencil 21/30 on paper
38.1 x 30.5 cm.
Print Fund, 60.A.49

O'BRIEN, Lucius (1832-1899)
Landscape in Muskoka (1894)
oil on canvas laid on board
32.5 x 46.0 cm.
Gift of Dr. David Nock, Thunder Bay,
86.A.5

O'BRIEN, Paddy Gunn (1929-)
Still Life (1956)
oil on canvas panel
76.2 x 55.9 cm.
Art Fund, 57.A.27

Monument to an Ontario Evening
(1970)
oil on canvas
76.2 x 101.6 cm.
Art Fund, 71.A.5

OESTERLE, Leonhard (1915-)
Mother and Child (c.1962)
bronze 1/5
44.5 x 10 x 8.5 cm.
Art Fund, 62.A.146

OGILVIE, Will (1901-1989)
Arctic (1957)
graphite and wash on paper
29.2 x 43.8 cm.
Gift of Mr. J.H. Moore, London,
through the Ontario Heritage
Foundation, 80.A.160

Comogli, Italy (1958)
ink and watercolour on paper
46.3 x 64.8 cm.
Purchased with a Canada Council
matching grant and Acquisitions
funds, 61.A.19

Evening, Georgian Bay (1961-62)
watercolour on paper
37.6 x 54.6 cm.
Gift from the Douglas M. Duncan
Collection, 70.A.68

Georgian Bay (1961-62)
watercolour on paper
37.6 x 54.6 cm.
Gift of Mr. J.H. Moore, London,
through the Ontario Heritage
Foundation, 80.A.34

Dock Scene (1963)
watercolour on paper
36.8 x 48.8 cm.
Gift of the Estate of Miss Dorothy
Gunn, London, 82.A.17

O'HENLY, John (1923-)
Growth of Cactus (1961)
pastel on paper
47.7 x 36.6 cm.
Gift of Mr. J.H. Moore, London,
through the Ontario Heritage
Foundation, 80.A.35

Beyond Galt (1962)
casein tempera on masonite
48.9 x 59 cm.
Gift of the Western Art League,
62.A.38

Snow Fence (1963)
casein tempera on masonite
49.6 x 68 cm.
Gift of the Western Art League,
64.A.76

Yellow Perceived (1970)
etching A/P on paper
39.4 x 35 cm.
Gift of the London Art Gallery
Association, 70.A.115

O'HENLY, Michael (1952-)
Untitled (1980)
photographic print on paper
21.6 x 33 cm.
Gift of Mr. Michael O'Henly, London,
80.A.226

OKUATSIAK, Lukas (1926-)
Snow House and Sled (p.1966)
grey soapstone
12 x 6.5 x 2.5 cm.
Art Fund, 77.A.76

ONDAATJE, Kim (1928-)
Yellow Chair (1964)
oil on canvas
163.8 x 122.6 cm.
Gift of Mr. & Mrs. Richard M. Ivey,
London, 87.A.224

Bedroom (1970)
serigraph 12/50 on paper
76.2 x 60.4 cm.
Purchased with funds from the
Mitchell Bequest, 70.A.110

Chair (c.1970)
serigraph on paper
81.3 x 61 cm.
Print Fund, 70.A.52

Hall (1970)
serigraph on paper
91.4 x 50.8 cm.
Print Fund, 70.A.53

ONLEY, Toni (1928-)
Polar Theme #4 (1962)
acrylic on panel
45.1 x 62.2
Gift of Mr. J.H. Moore, London,
through the Ontario Heritage
Foundation, 78.A.128

Sphere #4 (1963)
watercolour on paper
46.9 x 60.6 cm.
Gift of Professor Geoffrey Rans,
London, 84.A.240

Beach (1965)
aquatint and etching A/P on paper
26.7 x 35 cm.
Print Fund, 66.A.97

Silent Two (1966)
aquatint A/P on paper
24.3 x 30.7 cm.
Gift of Mr. J.H. Moore, London,
through the Ontario Heritage
Foundation, 80.A.78

Centennial Suite: Landscape (1968)
serigraph 19/50 on paper
28.5 x 38.7 cm.
Gift of Simon Fraser University,
Burnaby, B.C., 68.A.82

Portfolio I: Silent Avenue (1968)
serigraph 16/20 on paper
28.8 x 38.7 cm.
Gift of Mr. & Mrs. J.H. Moore,
London, 81.A.37A

Portfolio I: Still Life (1968)
serigraph 16/20 on paper
28.8 x 38.7 cm.
Gift of Mr. & Mrs. J.H. Moore,
London, 81.A.37B

Portfolio I: Still Water (1968)
serigraph 16/20 on paper
28.8 x 38.7 cm.
Gift of Mr. & Mrs. J.H. Moore,
London, 81.A.37C

Portfolio I: Presence in the Garden
(1968)
serigraph 16/20 on paper
28.8 x 38.7 cm.
Gift of Mr. & Mrs. J.H. Moore,
London, 81.A.37D

Portfolio I: Silent Sentinels (1968)
serigraph 16/20 on paper
28.8 x 38.7 cm.
Gift of Mr. & Mrs. J.H. Moore,
London, 81.A.37E

Portfolio I: Still Land (1968)
serigraph 16/20 on paper
28.8 x 38.7 cm.
Gift of Mr. & Mrs. J.H. Moore,
London, 81.A.37F

Jack's Garden (1969)
serigraph A/P on paper
28.5 x 38.1 cm.
Purchased with a Canada Council
matching grant and Acquisitions
funds, 69.A.69

Lost Valley (1969)
serigraph A/P on paper
28.5 x 38.1 cm.
Purchased with a Canada Council
matching grant and Acquisitions
funds, 69.A.70

Vaseaux (n.d.)
acrylic on wood
121.6 x 55.9 cm.
Gift of Mr. J.H. Moore, London,
through the Ontario Heritage
Foundation, 80.A.36

OSHAWEETUK (1923-)
Four Musk-Oxen (1959)
seal skin stencil 27/30 on paper
29.9 x 61 cm.
Print Fund, 60.A.48

PACHTER, Charles (1942-)
Night and Day You Are The One
(1971)
silkscreen 1/1 paper
112 x 77.7 cm.
Gift of Mr. J.H. Moore, London,
through the Ontario Heritage
Foundation, 79.A.39

PADLO (Padluq Pudlat) (1916-)
Spirit Watching Games (1964)
stonecut 38/50 on paper
25.4 x 44.5 cm.
Print Fund, 72.A.90

PALMER, Frank (1921-)
Boat Houses (1955)
watercolour on paper
48.9 x 61.6 cm.
Art Fund, 58.A.123

PALMER, Herbert S. (1881-1970)
Haliburton Hills (n.d.)
oil on card
35.6 x 43.2 cm.
Art Fund, 44.A.17

Silver and Grey Near Shanty Bay
(n.d.)
oil on card
26 x 33.6 cm.
Art Fund, 44.A.1

PANABAKER, Frank (1904-)
Street Scene (1932)
oil on wood
35.6 x 27.9 cm.
Gift of Miss K. Hillary via Mr. Gordon
Conn, Newmarket, 52.A.34

PANNICHEA (1920-)
Animal Spirit (1964)
stonecut 38/50 on paper
30.5 x 47 cm.
Print Fund, 72.A.79

Bird and Young (1964)
stonecut 36/50 on paper
12.7 x 15.2 cm.
Print Fund, 72.A.68

Birds (1964)
stonecut 21/50 on paper
25.4 x 25.4 cm.
Print Fund, 72.A.49

PANTON, L.A.C. (1894-1954)
Rocks and Fog, Nova Scotia (1947)
oil on masonite
33 x 40.6 cm.
Art Fund, 50.A.36

Grandeur Nigh Unto Dusk (1948)
tempera on masonite
120.6 x 58.4 cm.
Art Fund, 51.A.35

Haliburton Road (n.d.)
oil on panel
33 x 40.6 cm.
Art Fund, 56.A.17

Rocky Shore (n.d.)
tempera on panel
50.3 x 59.7 cm.
Gift of the Art Institute of Ontario,
Toronto, 68.A.100

Six Sketches for Rocky Shore (n.d.)
tempera on panel
67.3 x 53.3 cm.
Gift of the Art Institute of Ontario,
Toronto, 68.A.101A-F

PARR, (1883-1969)
Birds and Animals (1964)
stonecut 38/50 on paper
48.3 x 58.4 cm.
Print Fund, 72.A.43

Games (1964)
stonecut 38/50 on paper
22.9 x 15.2 cm.
Print Fund, 72.A.64

Men Pulling a Walrus (1964)
stonecut 38/50 on paper
21.6 x 58.4 cm.
Print Fund, 72.A.38

Walrus Hunt (1964)
stonecut 38/50 on paper
20.3 x 63.5 cm.
Print Fund, 72.A.42

PARTRIDGE, David (1919-)
Small Configuration (1964)
steel and wood
45.2 x 30.2 x 5.7 cm.
Gift of Mr. J.H. Moore, London,
through the Ontario Heritage
Foundation, 87.A.107

PAS, Gerard (1955-)
As I see it - As it is (1984-85)
watercolour on paper, colour
photographic transparency mounted
on light box
watercolour: 22.0 x 52.0 cm.
transparency: 22.0 x 52.0 cm.
Purchased with funds from the
Somerville Bequest, 86.A.38A-B

Memory of the Dream Brace (1977)
polaroid print on paper
44.5 x 38.0 cm.
Purchased with funds from the
Somerville Bequest, 86.A.46

Memory of the Dream Brace (1977)
polaroid print on paper
44.5 x 38.0 cm.
Purchased with funds from the
Somerville Bequest, 86.A.47

Memory of the Dream Brace (1977)
polaroid print on paper
44.5 x 38.0 cm.
Purchased with funds from the
Somerville Bequest, 86.A.48

Memory of the Dream Brace (1977)
polaroid print on paper
44.5 x 38.0 cm.
Purchased with funds from the
Somerville Bequest, 86.A.49

PASMORE, Victor (1908-)
Points of Contact #21 (1974)
serigraph 63/70 on paper
55.5 x 39.4 cm.
Gift of Mrs. Mira Godard, Toronto,
87.A.30

PAUTA Saila (1916-)
Composition (1964)
etching 38/50 on paper
25.4 x 21.6 cm.
Print Fund, 72.A.59

Owl (1964)
stonecut 6/50 on paper
22.9 x 35.6 cm.
Print Fund, 72.A.81

Owl (1964)
etching 38/50 on paper
21.6 x 22.9 cm.
Print Fund, 72.A.82

PEACOCK, Wilbur K. (1898-)
Ganaraska (1944)
etching 8/50 on paper
21.6 x 23.9 cm.
Print Fund, 64.A.47

PEARLSTEIN, Philip (American: 1924-)
Nude on a Silver Bench (1972)
etching 52/75 on paper
75 x 93.9 cm.
Gift of the Volunteer Committee, 78.A.21

PEEL, John Robert (1830-1904)
Studies of a Horse (1857)
graphite on paper
18 x 23.5 cm.
Gift of Miss Patricia Brooks-Hammond, Laguna Beach, California, 83.A.15

PEEL, Paul (1860-1892)
A Canadian Winter Scene (1877)
oil on canvas
54 x 90.5 cm.
Gift of Mrs. Hugh Thompson, Stratford, 88.A.29

Torso (Study from the Elgin Marbles) (1880)
pastel on paper
27.4 x 40.6 cm.
Gift of J.A. Tillman, Esq., London, 54.A.79

Autumn Leaves (1881)
oil on canvas
88.8 x 68.1 cm.
Purchased with funds from the Volunteer Committee and a donation in memory of Mr. & Mrs. Joseph Dixon Isaacs given by their son, Mr. James D. Candler, 86.A.40

A View in a Cemetery, Pont Aven, France (1881)
oil on canvas
52.5 x 44.4 cm.
Purchased with funds from the Somerville Bequest, 83.A.31

The Covent Garden Market, London, Ontario (1883)
oil on canvas
69.6 x 93.9 cm.
Gift to the City of London by Mrs. Marjorie Barlow, London, 69.A.46

Portrait Bust of Amelia Singleton Hall Peel (1883)
plaster
57.2 x 15.9 x 30.5 cm.
Gift of Mr. Kilgour Shives, Vancouver, B.C., 84.A.245

Portrait Bust of John Robert Peel (1883)
plaster
57.2 x 17.2 x 30.5 cm.
Gift of Mr. Kilgour Shives, Vancouver, B.C., 84.A.244

Portrait of Master Lyford P. Edwards (1883)
oil on canvas
50.8 x 61.3 cm.
Courtesy of the American Friends of Canada, Inc. through Mr. Lyford P. Edwards, Bridgeport, Connecticut, 82.A.48

Return of the Flock (1883)
oil on canvas
60 x 90 cm.
Gift of Mr. & Mrs. Richard M. Ivey, London, 89.A.35

Sketchbook (c.1883)
graphite on paper
12.2 x 19.5 cm
Gift of Mr. Kilgour Shives, Vancouver, B.C., 84.A.246

The Wreck (1884)
oil on canvas
143.5 x 93.4 cm.
Gift of Mrs. Richard Bland, London, 33.A.1

Courtyard, Brittany (1885)
oil on canvas
24.2 x 18.1 cm.
Art Fund, 76.A.29

Portrait of Isaure Verdier Peel (1886)
oil on canvas
123.2 x 93.9 cm.
Gift of Miss Marguerite Peel, Laguna Beach, California, 65.A.50

Portrait of Mr. William Y. Brunton (1888)
oil on canvas
62.3 x 51.4 cm.
Gift of Mr. F.H. Ashbough, Windermere, 74.A.51

The Modest Model (1889)
oil on canvas
146.7 x 114.3 cm.
Gift from the estate of Allan J. Wells with assistance from the Canadian Cultural Property Export Review Board

Artist in his Studio (Self Portrait) (1890)
oil on canvas
116.8 x 82.6 cm.
Gift of Miss Marguerite Peel, Laguna Beach, California, 54.A.78

Battery Scene (n.d.)
graphite on paper
17.5 x 25 cm.
Gift of Miss Patricia Brooks-Hammond, Laguna Beach, California, 83.A.16

The Young Botanist (1888-90)
oil on canvas
114.9 x 91.4 cm.
Purchased with the assistance of The Richard and Jean Ivey Fund, London, 87.A.203

Portrait of Hamilton King Meek (1890)
oil on canvas
42.6 x 33 cm.
Hamilton King Meek Memorial Collection, 40.A.13

Portrait of Robert André Peel (c.1892)
oil on canvas
129.5 x 97.8 cm.
Gift of Miss Marguerite Peel, Laguna Beach, California, 65.A.51

Sketch (n.d.)
oil on wood
15.2 x 23.5 cm.
Gift of John MacGillivary, Esq., London, 64.A.26

PEHAP, Eric (1912-)
Lobsters (1959)
linocut 9/9 on paper
30.8 x 51.4 cm.
Print Fund, 64.A.44

PELLAN, Alfred (1906-1988)
Les Sémaphores (1959)
oil on canvas
73.7 x 48.3 cm.
Purchased with funds donated by Mr. Wayne Porter and a Wintario Grant, 77.A.6

Eléments (1968)
serigraph 6/100 on paper
54.9 x 38.4 cm.
Gift of Mr. J.H. Moore, London, through the Ontario Heritage Foundation, 80.A.79

Omiromancie (1972)
serigraph on paper
46.3 x 40.1 cm.
Gift of Mr. & Mrs. Richard M. Ivey, London, 80.A.229

Pop Shop (1972)
serigraph on paper
46.3 x 40.1 cm.
Gift of Mr. & Mrs. Richard M. Ivey, London, 80.A.228

Jeune Fille constellée (n.d.)
mezzotint 2/12 on paper
30.1 x 22.3 cm.
Gift of Mr. J.H. Moore, London, through the Ontario Heritage Foundation, 80.A.80

PEPPER, George (1903-1962)
Terraced Gardens, France (1926)
oil on canvas
45.7 x 54.6 cm.
F.B. Housser Memorial Collection, 45.A.48

Newfoundland Outport (1952)
watercolour on paper
48.9 x 64.8 cm.
Art Fund, 61.A.50

Eskimo Girl, Povungnituk (n.d.)
oil on canvas
38.5 x 30.5 cm.
Gift of Mr. & Mrs. Richard M. Ivey, London, 87.A.205

PEREHUDOFF, William (1919-)
Upward Harmony (1969)
acrylic on canvas
112.4 x 168.3 cm.
Purchased with a Canada Council matching grant and Acquisitions funds, 69.A.54

PERRE, Henri (1828-1890)
Landscape with Passing Shower (n.d.)
oil on canvas
50.3 x 75.7 cm.
Anonymous gift, 68.A.95

PERRY, Frank (1923-)
Two Warriors (1966)
bronze
15 x 10.2 x 12.7 cm.
Gift of Mr. J.H. Moore, London, through the Ontario Heritage Foundation, 78.A.207

PETIT, Gaston (1930-)
L'Eau (1966)
etching on paper
45.2 x 39.1 cm.
Gift of Mr. J.H. Moore, London, through the Ontario Heritage Foundation, 80.A.55

Greniers antiques (1966)
dye-resist print on paper
69.2 x 50.8 cm.
Gift of Mr. J.H. Moore, London, through the Ontario Heritage Foundation, 80.A.54

PFEIFER, Bodo (1936-)
Untitled - D 9 (1967)
acrylic on canvas
190.5 x 103.5 cm.
Purchased with a Canada Council matching grant and Acquisitions funds, 69.A.57

PFLUG, Christiane (1936-1972)
Portrait of Michael Pflug (c.1954)
watercolour on paper
36.5 x 51.5 cm.
Gift of Dr. Michael Pflug, Toronto, 82.A.53

Church at Blaccourt, Normandy (1955)
tempera on paper
60.3 x 46.4 cm.
Gift of Dr. Michael Pflug, Toronto, 82.A.54

PHILIPS, Tom V. (1931-)
Dark Reflections (1960)
watercolour on paper
58.4 x 80 cm.
Gift of Mr. J.H. Moore, London, through the Ontario Heritage Foundation, 80.A.161

PHILIPS, W.J. (1884-1963)
Winter Wood-cuts: Suburban Street (1920)
woodblock 22/100 on paper
8.6 x 14.9 cm.
Print Fund, 40.A.15

Winter Wood-cuts: Winter Sunshine (1920)
woodblock 22/100 on paper
10.7 x 9.8 cm.
Print Fund, 40.A.21

Winter Wood-cuts: Tree Shadows on Snow (1922)
woodblock 22/100 on paper
10.2 x 15.2 cm.
Print Fund, 40.A.23

Winter Wood-cuts: Snow Bank (1923)
woodblock 22/100 on paper
11.2 x 9.2 cm.
Print Fund, 40.A.28

Winter Wood-cuts: The Lily (1925)
woodblock 22/100 on paper
5.1 x 7.3 cm.
Print Fund, 40.A.22

Winter Wood-cuts: Alpine Meadow (1926)
woodcut 22/100 on paper
8.6 x 10.2 cm.
Print Fund, 40.A.26

Winter Wood-cuts: Little Log House (1926)
woodblock 22/100 on paper
8.3 x 8.9 cm.
Print Fund, 40.A.27

Winter Wood-cuts: Winter Woods (1926)
woodblock 22/100 on paper
8.1 x 9.1 cm.
Print Fund, 40.A.25

Canadian Scene: Cineraria (1928)
woodblock on paper
20.9 x 16.8 cm.
Print Fund, 45.A.55

Canadian Scene: John (1928)
woodblock on paper
19.1 x 23.5 cm.
Print Fund, 45.A.54

Canadian Scene: Mount Cathedral and Mount Stephen (1928)
woodblock on paper
16.4 x 22.5 cm.
Print Fund, 45.A.13

Winter Wood-cuts: Pom Poms (1928)
woodblock 22/100 on paper
9.6 x 8 cm.
Print Fund, 40.A.16

Canadian Scene: Siwash House Posts (1928)
woodblock on paper
22.9 x 15.8 cm.
Print Fund, 45.A.53

Winter Wood-cuts: Soft Maple (1930)
woodblock 22/100 on paper
10.2 x 10.7 cm.
Print Fund, 40.A.14

An Essay in Wood-cuts: Thunderbird, Alert Bay (1930)
woodblock 32/120 on paper
11.8 x 16.2 cm.
Print Fund, 42.A.25

An Essay in Wood-cuts: Zunuk Karlukwees (1930)
woodblock 32/120 on paper
15.2 x 10.8 cm.
Print Fund, 42.A.22

An Essay in Wood-cuts: The Clothes Line, Mamalilicoola (1930)
woodblock 32/120 on paper
12.4 x 12.4 cm.
Print Fund, 42.A.26

An Essay in Wood-cuts: Community Houses, Mamalilicoola (1930)
woodblock 32/120 on paper
13.3 x 14.7 cm.
Print Fund, 42.A.27

An Essay in Wood-Cuts: Dug-out (1930)
woodblock 32/120 on paper
7.6 x 11.8 cm.
Print Fund, 42.A.8

An Essay in Wood-cuts: Floating Dock, Mamalilicoola (1930)
woodcut 32/120 on paper
15.2 x 12.7 cm.
Print Fund, 42.A.28

An Essay in Wood-cuts: The Hon Hok House Posts at Karlukwees (1930)
woodblock 32/120 on paper
14.9 x 12.4 cm.
Print Fund, 42.A.20

An Essay in Wood-cuts: House of the Gulls, Karlukwees (1930)
woodblock 32/120 on paper
11.8 x 12.7 cm.
Print Fund, 42.A.21

Winter Wood-cuts: Agamemnon Channel, B. C. (1936)
woodblock 22/100 on paper
10.7 x 21.8 cm.
Print Fund, 40.A.20

Winter Wood-cuts: Our Street (1933)
woodblock 22/100 on paper
8.9 x 15.2 cm.
Print Fund, 40.A.24

Winter Wood-cuts: Rime (1934)
woodblock 22/100 on paper
10.9 x 11.4 cm.
Print Fund, 40.A.17

An Essay in Wood-cuts: Ruin, Tsatsisnukomi (1930)
woodblock 32/120 on paper
20.9 x 12.4 cm.
Print Fund, 42.A.24

An Essay in Wood-cuts: Shacks on the Beach, Karlukwees (1930)
woodblock 32/120 on paper
14.3 x 11.8 cm.
Print Fund, 42.A.23

Winter Wood-cuts: Smoke Haze, Lake of the Woods (1935)
woodblock 22/100 on paper
14.7 x 22.3 cm.
Print Fund, 40.A.19

Winter Wood-cuts: The Stream in Winter (1935)
woodblock 22/100 on paper
11.5 x 10.8 cm.
Print Fund, 40.A.18

PICASSO, Pablo (Spanish: 1881-1976)
Femme nue assise (1944)
graphite on paper
91 x 49 cm.
Gift of Mr. J.H. Moore, London, through the Ontario Heritage Foundation, 79.A.6

Grande tête de femme (1962)
linoleum block print 5/50 on paper
63.4 x 52.7 cm.
Gift of Mr. J.H. Moore, London, through the Ontario Heritage Foundation, 79.A.7

PICHER, Claude (1927-)
Sunset on the Mountain (1961)
oil on canvas board
30.5 x 60.3 cm.
Gift of Mr. J.H. Moore, London, through the Ontario Heritage Foundation, 78.A.129

PIDDINGTON, Helen V. (1934-)
As It Was (n.d.)
etching 29/30 on paper
64.8 x 27.9 cm.
Gift of Mr. J.H. Moore, London, through the Ontario Heritage Foundation, 80.A.81

PIGGOTT, Marjorie (1904-)
Summer Idyll (c.1960)
watercolour on paper
58.4 x 50.8 cm.
Purchased with a Canada Council matching grant and Acquisitions funds, 61.A.74

PILOT, Robert (1898-1967)
Twilight: Quebec From Levis (n.d.)
oil on canvas
54.6 x 69.9 cm.
Gift of the Volunteer Committee, 60.A.65

PIPER, John (British: 1903-)
Fragments At Finghall, Yorkshire (1952)
mixed media and collage on paper
68.6 x 54.6 cm.
Gift of the Contemporary Art Society of Great Britain, 59.A.82

PIRIE, George (British: 1866-1946)
The Duck (n.d.)
oil on canvas
50.3 x 61 cm.
Anonymous gift, 68.A.98

PITALOUISA Saila (1942-)
Kayak Makers (1973)
stonecut 15/50 on paper
43.2 x 63.5 cm.
Print Fund, 73.A.91

PITCHFORTH, Roland V. (British: 1895-1982)
Ross on Wye (n.d.)
watercolour on paper
54.6 x 73.7 cm.
Art Fund, 56.A.32

PITSEOLAK Ashoona (1904-)
Around The Igloo (1964)
serigraph 35/50 on paper
36.9 x 48.3 cm.
Print Fund, 72.A.73

Birds of Summer (1964)
etching 38/50 on paper
22.9 x 24.2 cm.
Print Fund, 72.A.61

Caribou Hunt (1964)
stonecut and seal skin stencil 38/50 on paper
33 x 52.1 cm.
Print Fund, 70.A.39

Composition (1964)
engraving 38/50 on paper
21.6 x 25.4 cm.
Print Fund, 72.A.58

Man Repairing Sledge (1964)
stonecut 38/50 on paper
30.5 x 44.5 cm.
Print Fund, 72.A.76

Man Trying To Catch A Goose (1964)
stonecut 38/50 on paper
40.6 x 43.2 cm.
Print Fund, 72.A.85

Owl Defending Nest (1964)
stonecut 38/50 on paper
44.5 x 53.3 cm.
Print Fund, 70.A.40

People (1964)
engraving 38/50 on paper
17.8 x 25.4 cm.
Print Fund, 72.A.40

Woman With Doll (1964)
stonecut 38/50 on paper
31.8 x 43.2 cm.
Print Fund, 72.A.52

PITSEOLAK, Peter (1904-1973)
Hawk (1977)
stone cut and stencil on paper
56.3 x 71.2 cm.
Gift of Mr. J.H. Moore, London, through the Ontario Heritage Foundation, 87.A.202

PLASKETT, Joe (1918-)
Reflets dans la glace (1955)
oil on canvas
92 x 72.4 cm.
Purchased with funds from the Mitchell Bequest, 57.A.28

Windmill, Greece (1955)
pastel and watercolour on paper
36.9 x 52.1 cm.
Gift of Mr. J.H. Moore, London, through the Ontario Heritage Foundation, 80.A.164

Les Epées en printemps (1958)
oil on canvas
93.9 x 75.7 cm.
Gift of Mr. J.H. Moore, London, through the Ontario Heritage Foundation, 80.A.162

Boulevard St. Germain, Paris (1960)
pastel on paper
60 x 47 cm.
Gift of Mr. J.H. Moore, London, through the Ontario Heritage Foundation, 80.A.37

Diana Standing (1960)
oil on canvas
114.3 x 72.4 cm.
Purchased with a Canada Council matching grant and Acquisitions funds, 61.A.75

Reflections in the Garden, Luxembourg, Paris, France (1960)
pastel on paper
63 x 49.6 cm.
Gift of Mr. J.H. Moore, London, through the Ontario Heritage Foundation, 80.A.163

Mt. Richter and Lake Osoyoos
(1962)
pastel on paper
62.3 x 47.7 cm.
Gift of Mr. J.H. Moore, London,
through the Ontario Heritage
Foundation, 80.A.38

POOTAGOOK (1887-1959)
With The Raven Comes The Fish
(1959)
stonecut 26/50 on paper
39.4 x 25.4 cm.
Print Fund, 60.A.51

POTY LAZZAROTT, Napolean
Potyguara (Brazilian: 1924-)
Untitled (1976)
ink, graphite and watercolour on
paper
34.2 x 52 cm.
Gift of Mr. & Mrs. J.H. Moore,
London, 85.A.70

POUVUNGNITUK, Lydia (1928-)
Man and Walrus (n.d.)
grey stone
9.8 x 7.8 x 6.2 cm.
Art Fund, 77.A.79

PRATT, Christopher (1935-)
Sheds in Winter (1964)
serigraph 2/25 on paper
35 x 71.1 cm.
Purchased with funds from the
Mitchell Bequest, 64.A.122

Shop on an Island (1969)
oil on board
81.3 x 91.4 cm.
Gift of Mr. J.H. Moore, London,
through the Ontario Heritage
Foundation, 79.A.16

A Girl in Shorts (1970)
graphite on paper
55.9 x 30.5 cm.
Purchased with funds from the
Mitchell Bequest, 70.A.111

Cliff Edge (1972)
graphite on paper
30.5 x 45.7 cm.
Gift of Mr. J.H. Moore, London,
through the Ontario Heritage
Foundation, 81.A.52

Crow and Raven (1978)
serigraph 19/45 on paper
40.6 x 59.7 cm.
Gift of Mr. J.H. Moore, London,
through the Ontario Heritage
Foundation, 81.A.53

PRATT, Mary (1935-)
Roast Beef (1977)
oil on canvas
41.9 x 57.2 cm.
Art Fund, 77.A.17

PRAZOFF, Ettie Richler
(c.1920-)
Ivujivik #II (1986)
etching 18/50 on paper
33 x 61.6 cm.
Gift of Mrs. E.R. Prazoff, Montreal,
Quebec, 89.A.31

PRICE, Winchell (1907-)
Autumn Finale (1963)
oil on board
61 x 73.7 cm.
Gift of Winchell Price, Esq.,
Port Credit, 65.A.16

PRIVETT, Molly (1905-1981)
In Harbour (n.d.)
serigraph 25/100 on paper
49.6 x 31.8 cm.
Print Fund, 59.A.10

PUDLAT, Aoudla (1919-)
Alert Owls (1964)
stonecut 38/50 on paper
26.7 x 10.2 cm.
Print Fund, 72.A.71

Eskimo Hunting Geese (1964)
stonecut 38/50 on paper
20.3 x 48.3 cm.
Print Fund, 72.A.45

Large Owl (1964)
stonecut 38/50 on paper
43.2 x 62.3 cm.
Print Fund, 72.A.91

Owl (1964)
serigraph 38/50 on paper
17.8 x 14 cm.
Print Fund, 72.A.62

RABINOWITCH, David (1943-)
Three Rings (1967)
enamel on galvanized steel
diameters: 45.7 cm., 45.7 cm.,
39.4 cm.
Anonymous gift, 82.A.42A-C

RABINOWITCH, Royden (1943-)
Barrel Construction: Double
Curvature at Right Angles (1964)
oak barrel staves and heads
122 x 122 x 26 cm.
Gift of Jennifer Parkin and David
George, Toronto, 87.A.222

Barrel Construction: Double
Curvature at Right Angles (1964)
oak barrel staves and heads
122 x 122 x 26 cm.
Gift of Jennifer Parkin and David
George, Toronto, 87.A.223

Barrel Construction: Double
Curvature at Right Angles (1964/65;
remade 1983)
oak barrel staves and heads
various measurements
Purchased with a Canada Council
matching grant and funds from the
20/20 Gallery, private sources and the
Acquisitions funds, 83.A.10

Barrel Construction: Double
Curvature at Right Angles (1965/66;
remade 1983)
oak barrel staves and heads
122 x 122 x 26 cm.
Gift of Mr. David George, Sarnia,
85.A.78

Grease Cone (c.1969)
grease, galvanized steel
55.9 x 67.0 cm. diameter
Gift of Mr. Greg Curnoe, London,
85.A.77

Sixth Lemma "A" (1981)
ink on paper
121.9 x 151.8 cm.
Purchased with a Canada Council
matching grant and Acquisitions
funds, 81.A.61

RANEY, Suzanne (1918-)
Old Woman (c.1964)
plastic and metal
29 x 13 x 12 cm.
Art Fund, 64.A.75

RAYNER, Gordon (1935-)
Toronto 20: Untitled (1965)
monotype 50/100 on paper
66 x 50.8 cm.
Gift of Mr. & Mrs. J.H. Moore,
London, 80.A.30

Magnetawindow (1972)
acrylic on canvas
213.4 x 152.4 cm.
Art Fund, 73.A.19

Night on the Nile (1977)
acrylic on canvas
154.9 x 121.9 cm.
Purchased with a Canada Council
matching grant and Acquisitions
funds, 79.A.13

Lucky Draw (1982)
serigraph 4/40 on paper
43.2 x 62.9 cm.
Purchased with a Canada Council
matching grant and Acquisitions
funds, 87.A.37

RECHENBERG, Deiter (1936-)
Pupils (n.d.)
ink on paper
30.8 x 49.5 cm.
Gift of Mr. J.H. Moore, London,
through the Ontario Heritage
Foundation, 78.A.130

REDDY, Krishna (American:
1925-)
River (1960)
lithograph A/P on paper
36.2 x 48.3 cm.
Gift of Mr. J.H. Moore, London,
through the Ontario Heritage
Foundation, 80.A.82

REDFERN, Charles (1919-)
Arch Positano, No. 3 (1965)
oil on canvas
53.3 x 40.6 cm.
Gift of Mr. J.H. Moore, London,
through the Ontario Heritage
Foundation, 80.A.165

Study of a Head (1967)
ink, gouache and watercolour on
paper
48.3 x 30.5 cm.
Gift of Mr. J.H. Moore, London,
through the Ontario Heritage
Foundation, 80.A.206

Young Man (n.d.)
watercolour on paper
43.2 x 33.6 cm.
Gift from the Douglas M. Duncan
Collection, 70.A.55

REDINGER, Walter (1940-)
Caucasian Study (1968)
fibreglass and urethane
134.6 x 218.4 x 38.1 cm.
Gift of Mr. A. Isaacs, Toronto,
85.A.11

Wall Relief #2 (1969)
fibreglass
38.1 x 19 x 6.5 cm.
Gift of Mr. J.H. Moore, London,
through the Ontario Heritage
Foundation, 78.A.208

Wall Relief #3 (1969)
fibreglass
38.1 x 19 x 9.5 cm.
Gift of Mr. J.H. Moore, London,
through the Ontario Heritage
Foundation, 78.A.209

Untitled Sphere #1 (1970)
fibreglass
144.8 cm. diameter
Art Fund, 71.A.29

Untitled Sphere #2 (1970)
fibreglass
144.8 cm. diameter
Art Fund, 71.A.30

Study 1 (1976)
serigraph 25/100 on paper
58.4 x 73.7 cm.
Print Fund, 76.A.2

Study 2 (1976)
serigraph 25/100 on paper
58.4 x 73.7 cm.
Print Fund, 76.A.3

Study 3 (1976)
serigraph 25/100 on paper
58.4 x 73.7 cm.
Print Fund, 76.A.4

Study 4 (1976)
serigraph 25/100 on paper
58.4 x 73.7 cm.
Print Fund, 76.A.5

Study 5 (1976)
serigraph 25/100 on paper
58.4 x 73.7 cm.
Print Fund, 76.A.6

REID, George A. (1860-1947)
Portrait of Hattie (1880)
charcoal on paper
34.3 x 22.9 cm.
Gift of Mrs. Mary Wrinch Reid,
Toronto, 55.A.126

Portrait of Adam Reid (1886)
oil on canvas board
61 x 50.8 cm.
Gift of Mrs. Mary Wrinch Reid,
Toronto, 55.A.127

Portrait of Mary Ann Reid (1886)
oil on board
61 x 50.8 cm.
Gift of Mrs. Mary Wrinch Reid,
Toronto, 55.A.128

Study for the Entrance Mural,
Toronto City Hall (1897)
collage and mixed media on board
20 x 162.6 cm.
Gift of Mrs. Mary Wrinch Reid,
Toronto, 50.A.71

Portrait of a Model (c.1888-89)
oil on canvas
61 x 50.8 cm.
Gift of Mrs. Mary Wrinch Reid,
Toronto, 50.A.69

Nude Leaning on a Stool (1889)
oil on canvas board
55.9 x 35.6 cm.
Gift of Mrs. Mary Wrinch Reid,
Toronto, 50.A.63

Nude Study (1896)
oil on canvas
61 x 45.7 cm.
Gift of Mrs. Mary Wrinch Reid,
Toronto, 50.A.68

Study for Mural "Science" (1896-97)
oil on linen
75.7 x 101.6 cm.
Gift of Mr. Gordon Conn, Newmarket,
74.A.67

Studies for Toronto City Hall Murals
(1897)
oil on linen mounted on board
8 panels in 2 cases: 146 x 124 cm.;
131 x 124 cm.
Gift of Mrs. Mary Wrinch Reid,
Toronto, 50.A.72A-B

Study of Head and Torso (1889)
oil on canvas board
50.8 x 35.6 cm.
Gift of Mrs. Mary Wrinch Reid,
Toronto, 50.A.64

**Canada Receiving the Homage of
her Daughters** (1904)
oil on linen
60.9 x 182.5 cm.
Gift of Mrs. Mary Wrinch Reid,
Toronto, 50.A.70

Agawa Canyon (1926)
oil on canvas
167.6 x 91.4 cm.
Gift of the Art Gallery of
Toronto, 56.A.29

**Discoverers Sailed the Uncharted
Seas** (1930)
oil on canvas
76.2 x 54.6 cm.
Gift of Mrs. Mary Wrinch Reid,
Toronto, 50.A.54

Rippled Water, Temagami (1931)
oil on canvas
101.6 x 76.2 cm.
Gift of Mrs. Mary Wrinch Reid,
Toronto, 50.A.42

Twilight on the Agawa (1933)
etching 5/50 on paper
29.9 x 24.9 cm.
Print Fund, 48.A.52

The Bather (1936)
oil on canvas
50.8 x 40.6 cm.
Gift of Mrs. Mary Wrinch Reid,
Toronto, 50.A.58

Northern Lake (1938)
etching 2/10 on paper
30.5 x 25.4 cm.
Print Fund, 48.A.3

The Flute Player, 1886 (1944)
oil on canvas
61 x 45.7 cm.
Gift of Mrs. Mary Wrinch Reid,
Toronto, 50.A.66

Portrait of Mary Hiester Reid
(c.1885)
oil on canvas
61 x 45.7 cm.
Gift of Mrs. Mary Wrinch Reid,
Toronto, 50.A.55

Seated Nude Study (n.d.)
oil on canvas
73.7 x 38.1 cm.
Gift of Mrs. Mary Wrinch Reid,
Toronto, 50.A.59

Self Portrait (c.1936)
oil on masonite
50.3 x 40.6 cm.
Bequest from the Estate of Mrs. Mary
Wrinch Reid, Toronto, 70.A.2

REID, Mary Hiester (1854-1921)
Autumn, Wychwood Park (n.d.)
oil on canvas
76.2 x 63.5 cm.
Gift of Mrs. Mary Wrinch Reid,
Toronto, 50.A.40

Music (n.d.)
oil on board
23.5 x 20.3 cm.
Gift of Mrs. Mary Wrinch Reid,
Toronto, 50.A.23

Night in the Village, England (n.d.)
oil on canvas
30.5 x 45.7 cm.
Gift of Mrs. Mary Wrinch Reid,
Toronto, 50.A.19

Nude Study (n.d.)
oil on board
30.5 x 20.3 cm.
Gift of Mrs. Mary Wrinch Reid,
Toronto, 50.A.44

Sheep Pasture - Early Spring (n.d.)
oil on canvas
40.6 x 50.8 cm.
Gift of Mrs. Mary Wrinch Reid,
Toronto, 50.A.22

REINBLATT, Moe (1917-1979)
Girls Skipping (c.1962)
etching on paper
26.7 x 42.6 cm.
Print Fund, 62.A.32

REPPEN, Jack (1933-1964)
Clos de Vougeot (1962)
oil on masonite
120.6 x 120.6 cm.
Art Fund, 62.A.149

Outside Toluca (1962)
oil on board
68.6 x 82.5 cm.
Gift of Mr. J.H. Moore, London,
through the Ontario Heritage
Foundation, 78.A.131

RHEAUME, Jeanne (1915-)
Les Pins (1954)
watercolour on paper
50.2 x 67.3 cm.
Gift of Mr. J.H. Moore, London,
through the Ontario Heritage
Foundation, 78.A.132

Still Life (1959)
oil on masonite
79.3 x 86.9 cm.
Purchased with funds from the
Mitchell Bequest, 68.A.18

RILEY, Bridget (British: 1931-)
Red Dominance (1977)
serigraph 61/100 on paper
88 x 39 cm.
Gift of Mrs. Mira Godard, Toronto,
87.A.29

Blue (1978)
screenprint 22/75 on paper
67.3 x 94.3 cm.
Gift of Dr. J.T. and Dr. Marta
Hurdalek, Toronto, 90.A.35

RIOPELLE, Jean-Paul (1923-)
Bacchus et Neptune (1956)
oil on canvas
38.1 x 45.7 cm.
Gift of Mr. J.H. Moore, London,
through the Ontario Heritage
Foundation, 78.A.133

Le Trou des fées (1957)
oil on canvas
73.1 x 91.4 cm.
Art Fund, 62.A.145

Untitled (n.d.)
lithograph 16/75 on paper
40.6 x 79.3 cm.
Gift of Mr. J.H. Moore, London,
through the Ontario Heritage
Foundation, 80.A.215

Untitled (1966)
watercolour on paper
31.1 x 38.7 cm.
Gift of Mr. J.H. Moore, London,
through the Ontario Heritage
Foundation, 80.A.167

**RIVERS, Larry (American:
1923-)**
The Boston Massacre: Cover (1970)
collage and embossed serigraph
78/150 on paper
49.5 x 75.5 cm.
Gift of Mrs. Mira Godard, Toronto,
87.A.32A

**The Boston Massacre: Boston
Harbor and Shooting** (1970)
collage and embossed serigraph
78/150 on paper
49 x 70.5 cm.
Gift of Mrs. Mira Godard, Toronto,
87.A.32B

**The Boston Massacre: Some (Visual)
Afterthoughts on the Boston
Massacre** (1970)
collage and embossed serigraph
78/150 on paper
49.2 x 70.8 cm.
Gift of Mrs. Mira Godard, Toronto,
87.A.32C

**The Boston Massacre: Enlisted Man
and Officer** (1970)
collage and embossed serigraph
78/150 on paper
49 x 71.6 cm.
Gift of Mrs. Mira Godard, Toronto,
87.A.32D

**The Boston Massacre: 40th
Regiment** (1970)
collage and embossed serigraph
78/150 on paper
48.8 x 70.8 cm.
Gift of Mrs. Mira Godard, Toronto,
87.A.32E

The Boston Massacre: Ready - Aim
(1970)
collage and embossed serigraph
78/150 on paper
48.5 x 70 cm.
Gift of Mrs. Mira Godard, Toronto,
87.A.32F

**The Boston Massacre: Ready - Aim
and Two Hands** (1970)
collage and embossed serigraph
78/150 on paper
47.8 x 68.9 cm.
Gift of Mrs. Mira Godard, Toronto,
87.A.32G

The Boston Massacre: Black Review
(1970)
collage and embossed serigraph
78/150 on paper
48.2 x 69.5 cm.
Gift of Mrs. Mira Godard, Toronto,
87.A.32H

The Boston Massacre: Victims
(1970)
collage and embossed serigraph
78/150 on paper
48.5 x 70.3 cm.
Gift of Mrs. Mira Godard, Toronto,
87.A.32 I

**The Boston Massacre: Those Who
Fire, Those Who Run** (1970)
collage and embossed serigraph
78/150 on paper
48.2 x 68.6 cm.
Gift of Mrs. Mira Godard, Toronto,
87.A.32J

The Boston Massacre: Observation
(1970)
collage and embossed serigraph
78/150 on paper
48.4 x 70.8 cm.
Gift of Mrs. Mira Godard, Toronto,
87.A.32K

**The Boston Massacre: Redcoats -
Mist** (1970)
collage and embossed serigraph
78/150 on paper
48.2 x 70.8 cm.
Gift of Mrs. Mira Godard, Toronto,
87.A.32L

The Boston Massacre: Redcoats
(1970)
collage and embossed serigraph
78/150 on paper
48.3 x 112.6 cm.
Gift of Mrs. Mira Godard, Toronto,
87.A.32M

Diane Raised II (1970-71)
lithograph 22/36 on paper
51 x 72 cm.
Gift of Mr. J.H. Moore, London,
through the Ontario Heritage
Foundation, 78.A.182

ROBBINS, Hulda (American: 1910-)
Domain (1942)
serigraph on paper
33 x 45.7 cm.
Print Fund, 47.A.54

ROBERTS, Goodridge (1904-1974)
Eastern Township (c.1945)
watercolour on paper
38.1 x 50.8 cm.
Art Fund, 76.A.12

Islands, Georgian Bay (c.1948)
watercolour on paper
38.1 x 53.3 cm.
Anonymous gift, 81.A.12

Wildflower Bouquet (c.1950)
oil on masonite
40.5 x 30.5 cm.
Gift of the Estate of Miss Dorothy
Gunn, London, 82.A.11

Flowers and Easel (1958)
oil on masonite
29.8 x 42.5 cm.
Gift of Mr. J.H. Moore, London,
through the Ontario Heritage
Foundation, 78.A.134

Laurentian Farm #35 (1958)
oil on masonite
79.3 x 111.8 cm.
Art Fund, 59.A.7

ROBERTS, William (1821-)
Cold, Cold, Cold (n.d.)
watercolour and graphite on paper
48.3 x 70.6 cm.
Gift of the London Art Gallery
Association, 70.A.112

A Memory of Fundy (c.1960)
watercolour on paper
54.6 x 82.6 cm.
Purchased with a Canada Council
matching grant and Acquisitions
funds, 61.A.3

Near Home (Milton) (n.d.)
watercolour on paper
34.3 x 50.3 cm.
Gift of Mr. J.H. Moore, London,
through the Ontario Heritage
Foundation, 80.A.39

Gilbert's Cove (n.d.)
serigraph 97/100 on paper
46.5 x 60 cm.
Gift of Mr. & Mrs. Richard M. Ivey,
London, 87.A.8

The Magician's Table (n.d.)
serigraph AP V on paper
50 x 40 cm.
Gift of Mr. & Mrs. Richard M. Ivey,
London, 87.A.29

ROBINSON, Albert H. (1881-1956)
Montreal Near the Harbour (1909)
oil on canvas
30.5 x 43.2 cm.
Gift of Mr. J.H. Moore, London,
through the Ontario Heritage
Foundation, 78.A.135

Old Fort St. Malo (1911)
oil on wood
21.6 x 26.7 cm.
Given by her children, in memory of
their mother, Marjorie Gibbons
Counsell, 76.A.16

Hillside Farm, Bolton Pass (1930)
oil on canvas
106 x 116.2 cm.
Art Fund, 56.A.61

ROBINSON, Ray (1931-)
Jug and Orange (1966)
charcoal on paper
28.7 x 31.3 cm.
Gift of Mr. J.H. Moore, London,
through the Ontario Heritage
Foundation, 87.A.150

Head of Brenda Robinson
(1966)
charcoal on paper
43.4 x 36.6 cm.
Gift of Mr. J.H. Moore, London,
through the Ontario Heritage
Foundation, 87.A.151

Head of Brenda Robinson (1966)
charcoal on paper
38.5 x 28.7 cm.
Gift of Mr. J.H. Moore, London,
through the Ontario Heritage
Foundation, 87.A.152

Head of Brenda (1966)
plaster
38.6 x 20.8 x 21.7 cm.
Gift of Mr. J.H. Moore, London,
through the Ontario Heritage
Foundation, 87.A.182

Jug with Two Oranges (1967)
plaster
30 x 20.8 x 14.7 cm.
Gift of Mr. J.H. Moore, London,
through the Ontario Heritage
Foundation, 87.A.180

Jug with Two Oranges (1967)
ciment fondu
25.9 x 16.7 x 12.2 cm.
Gift of Mr. J.H. Moore, London,
through the Ontario Heritage
Foundation, 87.A.181

Head of Brenda (1966)
plaster
36.3 x 21.7 x 27.2 cm.
Gift of Mr. J.H. Moore, London,
through the Ontario Heritage
Foundation, 87.A.183

Marion Gariepy (1968)
charcoal on paper
33.4 x 25.5 cm.
Gift of Mr. J.H. Moore, London,
through the Ontario Heritage
Foundation, 87.A.149

Two Bottles (1969)
charcoal on paper
37.7 x 27.2 cm.
Gift of Mr. J.H. Moore, London,
through the Ontario Heritage
Foundation, 87.A.146

Head of Brenda in Brown Hat (1969)
charcoal on paper
37.6 x 27.1 cm.
Gift of Mr. J.H. Moore, London,
through the Ontario Heritage
Foundation, 87.A.147

Head of Brenda in Brown Hat (1969)
charcoal on paper
37.4 x 27.3 cm.
Gift of Mr. J.H. Moore, London,
through the Ontario Heritage
Foundation, 87.A.148

Marion Gariepy (1970)
charcoal on paper
37.7 x 27.3 cm.
Gift of Mr. J.H. Moore, London,
through the Ontario Heritage
Foundation, 87.A.144

Marion Gariepy (1970)
charcoal on paper
37.7 x 27.1 cm.
Gift of Mr. J.H. Moore, London,
through the Ontario Heritage
Foundation, 87.A.142

Marion Gariepy (1970)
charcoal on paper
54.4 x 30.3 cm.
Gift of Mr. J.H. Moore, London,
through the Ontario Heritage
Foundation, 87.A.143

Marion Gariepy (1970)
bronze
62.3 x 18.2 x 17 cm.
Gift of Mr. J.H. Moore, London,
through the Ontario Heritage
Foundation, 87.A.179

Marion Gariepy Lying on a Persian
Rug in Garden (1970)
pastel on paper
37.7 x 27.1 cm.
Gift of Mr. J.H. Moore, London,
through the Ontario Heritage
Foundation, 87.A.145

Marion Gariepy (1970-71)
charcoal on paper
98.4 x 52.8 cm.
Gift of Mr. Ray Robinson, London,
72.A.2

Marion Gariepy (1971)
charcoal on paper
45.4 x 34 cm.
Gift of Mr. J.H. Moore, London,
through the Ontario Heritage
Foundation, 87.A.140

Marion Gariepy (1971)
charcoal on paper
45.4 x 37.7 cm.
Gift of Mr. J.H. Moore, London,
through the Ontario Heritage
Foundation, 87.A.141

Female Figure - Study for Chess
Castle (1975)
terracotta
20.1 x 9 x 10.1 cm.
Gift of Mr. J.H. Moore, London,
through the Ontario Heritage
Foundation, 87.A.160

Female Figure - Study for Chess
Castle (1979)
terracotta
20.3 x 11.2 x 9.8 cm.
Gift of Mr. J.H. Moore, London,
through the Ontario Heritage
Foundation, 87.A.161

Anne Fighter (1971)
terracotta
49.3 x 17.8 x 16.4 cm.
Gift of Mr. J.H. Moore, London,
through the Ontario Heritage
Foundation, 87.A.176

Anne Fighter (1971)
terracotta
58.3 x 17.9 x 17.5 cm.
Gift of Mr. J.H. Moore, London,
through the Ontario Heritage
Foundation, 87.A.177

Anne Fighter (1971)
terracotta
61.5 x 15.8 x 22.7 cm.
Gift of Mr. J.H. Moore, London,
through the Ontario Heritage
Foundation, 87.A.178

Brenda Robinson Seated (1972)
charcoal on paper
37.7 x 27.4 cm.
Gift of Mr. J.H. Moore, London,
through the Ontario Heritage
Foundation, 87.A.138

Still Life - Two Jugs on a Wooden
Table (1972)
charcoal on paper
27.1 x 19.5 cm.
Gift of Mr. J.H. Moore, London,
through the Ontario Heritage
Foundation, 87.A.139

Young Woman in Studio Viewing
Sculpture (1973)
charcoal and pastel on paper
37.7 x 26.9 cm.
Gift of Mr. J.H. Moore, London,
through the Ontario Heritage
Foundation, 87.A.126

Young Woman in Studio (1973)
charcoal and pastel on paper
33 x 27.2 cm.
Gift of Mr. J.H. Moore, London,
through the Ontario Heritage
Foundation, 87.A.127

Study for Chess Pawn (1973)
charcoal on paper
37.7 x 27.2 cm.
Gift of Mr. J.H. Moore, London,
through the Ontario Heritage
Foundation, 87.A.128

Study for Chess Pawn (1973)
charcoal on paper
33.3 x 25.5 cm.
Gift of Mr. J.H. Moore, London,
through the Ontario Heritage
Foundation, 87.A.129

Study for Chess Pawn (1973)
charcoal on paper
37.7 x 27.3 cm.
Gift of Mr. J.H. Moore, London,
through the Ontario Heritage
Foundation, 87.A.130

Study for Chess Pawn (1973)
charcoal and chalk on paper
37.8 x 27.2 cm.
Gift of Mr. J.H. Moore, London,
through the Ontario Heritage
Foundation, 87.A.131

Female Figure - Study for Chess Set
Pawn (1973)
pastel and conté on paper
37.7 x 27.2 cm.
Gift of Mr. J.H. Moore, London,
through the Ontario Heritage
Foundation, 87.A.132

Female Figure - Study for Chess Set Pawn (1973)
charcoal on paper
37.6 x 27.1 cm.
Gift of Mr. J.H. Moore, London, through the Ontario Heritage Foundation, 87.A.137

Chair - Study for Chess Set Pawn #28 (1973)
charcoal and pastel on paper
33.2 x 25.4 cm.
Gift of Mr. J.H. Moore, London, through the Ontario Heritage Foundation, 87.A.133

Young Woman Seated in Garden #31 (1973)
charcoal on charcoal
37.7 x 27 cm.
Gift of Mr. J.H. Moore, London, through the Ontario Heritage Foundation, 87.A.134

Female Figure - Ruth Comfort (1973)
charcoal on paper
45.3 x 32.8 cm.
Gift of Mr. J.H. Moore, London, through the Ontario Heritage Foundation, 87.A.135

Female Figure - Brenda Robinson Reading (1973)
charcoal on paper
43.8 x 33.6
Gift of Mr. J.H. Moore, London, through the Ontario Heritage Foundation, 87.A.136

Brenda Seated in Chair (1973)
terracotta
28.4 x 12 x 13 cm.
Gift of Mr. J.H. Moore, London, through the Ontario Heritage Foundation, 87.A.175

Study for Reclining Figure (c.1974)
bronze
29.2 x 43.2 x 24.3 cm.
Art Fund, 74.A.24

Female Figure - Study for Chess Pawn (1974)
charcoal and pastel on paper
37.7 x 27.2 cm.
Gift of Mr. J.H. Moore, London, through the Ontario Heritage Foundation, 87.A.117

Female Figure - Study for Chess Pawn (1974)
charcoal and pastel on paper
35.8 x 27.2 cm.
Gift of Mr. J.H. Moore, London, through the Ontario Heritage Foundation, 87.A.118

Female Figure - Ruth Comfort in Motion (1974)
charcoal on paper
37.8 x 27.2 cm.
Gift of Mr. J.H. Moore, London, through the Ontario Heritage Foundation, 87.A.119

Female Figure - Ruth Comfort in Motion (1974)
charcoal on paper
37.7 x 27.1 cm.
Gift of Mr. J.H. Moore, London, through the Ontario Heritage Foundation, 87.A.120

Female Figure - Ruth Comfort in Motion (1974)
charcoal on paper
42.8 x 31.3 cm.
Gift of Mr. J.H. Moore, London, through the Ontario Heritage Foundation, 87.A.121

Female Figure - Ruth Comfort in Motion (1974)
charcoal on paper
46.6 x 37.7 cm.
Gift of Mr. J.H. Moore, London, through the Ontario Heritage Foundation, 87.A.122

Memory Study after a Rembrandt in the Scottish National Gallery (1974)
charcoal on paper
37.8 x 27.1 cm.
Gift of Mr. J.H. Moore, London, through the Ontario Heritage Foundation, 87.A.123

Memory Study after a Rembrandt in the Scottish National Gallery (1974)
charcoal on paper
37.8 x 27 cm.
Gift of Mr. J.H. Moore, London, through the Ontario Heritage Foundation, 87.A.124

Female Figure - Brenda Robinson Reading in the Studio (1974)
charcoal and pastel on paper
28.3 x 27.2 cm.
Gift of Mr. J.H. Moore, London, through the Ontario Heritage Foundation, 87.A.125

Seated Female Figure (1974)
bronze 1/5
18.6 x 14.7 x 10.1 cm.
Gift of Mr. J.H. Moore, London, through the Ontario Heritage Foundation, 87.A.167

Walking Man (1974)
bronze 1/10
14 x 5.7 x 11.9 cm.
Gift of Mr. J.H. Moore, London, through the Ontario Heritage Foundation, 87.A.168

Standing Female Figure (1974)
terracotta
14.1 x 8.4 x 9 cm.
Gift of Mr. J.H. Moore, London, through the Ontario Heritage Foundation, 87.A.169

Reclining Female Figure - Marion Gariepy (1974)
bronze
20 x 24.8 x 16.2 cm.
Gift of Mr. J.H. Moore, London, through the Ontario Heritage Foundation, 87.A.170

Reclining Female Figure - Marion Gariepy (1974)
bronze 5/5
18.3 x 28.2 x 13.7 cm.
Gift of Mr. J.H. Moore, London, through the Ontario Heritage Foundation, 87.A.171

Reclining Female Figure - Marion Gariepy (1974)
bronze 1/5
20.2 x 23.5 x 11.7 cm.
Gift of Mr. J.H. Moore, London, through the Ontario Heritage Foundation, 87.A.172

Reclining Female Figure - Marion Gariepy (1974)
bronze 1/5
13.5 x 26.8 x 14.6 cm.
Gift of Mr. J.H. Moore, London, through the Ontario Heritage Foundation, 87.A.173

Reclining Female Figure - Marion Gariepy (1974)
bronze 1/5
18.3 x 23.4 x 10.8 cm.
Gift of Mr. J.H. Moore, London, through the Ontario Heritage Foundation, 87.A.174

Head of Brenda Robinson (1975)
charcoal on paper
35 x 26 cm.
Gift of Mr. J.H. Moore, London, through the Ontario Heritage Foundation, 87.A.116

Male Figure - Study for Chess Bishop (1975)
terracotta
19 x 8.7 x 10.2 cm.
Gift of Mr. J.H. Moore, London, through the Ontario Heritage Foundation, 87.A.159

Male Figure - Study for Chess Bishop (1975)
terracotta
20.8 x 9 x 10 cm.
Gift of Mr. J.H. Moore, London, through the Ontario Heritage Foundation, 87.A.162

Male Figure - Study for Chess Bishop (1975)
terracotta
18.9 x 12.3 x 10.7 cm.
Gift of Mr. J.H. Moore, London, through the Ontario Heritage Foundation, 87.A.163

Reclining Female Figure (1975)
bronze
5.8 x 7.7 x 11 cm.
Gift of Mr. J.H. Moore, London, through the Ontario Heritage Foundation, 87.A.164

Head of Brenda Reclining (1975)
bronze
18.2 x 18 x 25 cm.
Gift of Mr. J.H. Moore, London, through the Ontario Heritage Foundation, 87.A.165

Standing Female Figure (1975)
limestone
128 x 41 x 41 cm.
Gift of Mr. J.H. Moore, London, through the Ontario Heritage Foundation, 87.A.166

J.H. Moore Chess Set (1975)
terracotta and wood
various measurements
Gift of Mr. J.H. Moore, London, through the Ontario Heritage Foundation, 87.A.185A-Q

Reclining Figure (1976)
terracotta
12.7 x 25.4 x 13.2 cm.
Gift of Mr. J.H. Moore, London, through the Ontario Heritage Foundation, 87.A.157

Annunciation - Gabriel and Mary (1976)
terracotta
25.2 x 23.3 x 10 cm.
Gift of Mr. J.H. Moore, London, through the Ontario Heritage Foundation, 87.A.158

Landscape (1976)
terracotta
24.3 x 28.5 x 10.2 cm.
Gift of Mr. J.H. Moore, London, through the Ontario Heritage Foundation, 87.A.184

Sans Souci (1977)
bronze 2/5
43.5 x 29 x 23.7 cm.
Gift of Mr. J.H. Moore, London, through the Ontario Heritage Foundation, 87.A.156

Man Looking at Tree (1980)
terracotta
31.5 x 20.5 x 24 cm.
Gift of Mr. J.H. Moore, London, through the Ontario Heritage Foundation, 87.A.155

Reclining Female Figure (1981)
terracotta
8.6 x 21.4 x 10.3 cm.
Gift of Mr. J.H. Moore, London, through the Ontario Heritage Foundation, 87.A.154

Manitoba Maple Tree (1981)
charcoal on paper
39.6 x 34.7 cm.
Gift of Mr. J.H. Moore, London, through the Ontario Heritage Foundation, 87.A.113

Manitoba Maple Tree (1981)
charcoal on paper
37.6 x 27.2 cm.
Gift of Mr. J.H. Moore, London, through the Ontario Heritage Foundation, 87.A.114

Manitoba Maple Tree (1981)
charcoal on paper
37.8 x 27.7 cm.
Gift of Mr. J.H. Moore, London, through the Ontario Heritage Foundation, 87.A.115

ROBINSON, Ross (1930-)
Lumber Camp (n.d.)
acrylic on masonite
42.6 x 53.3 cm.
Gift of Mr. J.H. Moore, London, through the Ontario Heritage Foundation, 80.A.168

ROCK, Geoffrey (1923-)
Branding Study, Douglas Lake Ranch, B.C. (1973)
charcoal and watercolour on paper
47 x 62.3 cm.
Gift of Mr. J.H. Moore, London, through the Ontario Heritage Foundation, 80.A.40

Cowboy Study, Douglas Lake Ranch, B.C. (1973)
charcoal and watercolour on paper
47 x 61 cm.
Gift of Mr. J.H. Moore, London, through the Ontario Heritage Foundation, 80.A.42

Cowboy Study No. 2, Douglas Lake Ranch, B.C. (1973)
charcoal and watercolour on paper
46.7 x 63 cm.
Gift of Mr. J.H. Moore, London, through the Ontario Heritage Foundation, 80.A.43

Cowboys With Dog, Douglas Lake Ranch, B.C. (1973)
charcoal and watercolour on paper
46.3 x 62.3 cm.
Gift of Mr. J.H. Moore, London, through the Ontario Heritage Foundation, 80.A.41

RODRIGUES, Glauco (Brazilian: 1929-)
Dans le Jardin de ma tante (1969)
oil on board
38.1 x 55.2 cm.
Gift of Mr. & Mrs. J.H. Moore, London, 85.A.59

ROGERS, Otto D. (1935-)
Steps Toward a Holy Place (1969)
acrylic on canvas
152.4 x 152.4 cm.
Purchased with a Canada Council matching grant and Acquisitions funds, 70.A.11

RONALD, William (1926-)
Toronto 20: Untitled (1965)
monotype and linocut 50/100 on paper
66 x 50.8 cm.
Gift of Mr. & Mrs. J.H. Moore, London, 81.A.31

ROSENQUIST, James (American: 1933-)
Night Smoke (1969-70)
lithograph 3/18 on paper
63.5 x 83.8 cm.
Gift of the Volunteer Committee, 78.A.22

ROSENTHAL, Joe (1921-)
Escape (1965)
ink on paper
27.9 x 35.6 cm.
Gift of Mr. J.H. Moore, London, through the Ontario Heritage Foundation, 78.A.136

Standing Girl Holding Flowers (n.d.)
oil on masonite
50.8 x 40.6 cm.
Gift of Mr. J.H. Moore, London, through the Ontario Heritage Foundation, 80.A.44

ROSNER, Thelma (1941-)
Plan for a Classycal Cake to Celebrate "All Food's Day" (1982)
graphite, ink and watercolour on paper
79 x 112.5 cm.
Art Fund, 83.A.27

Mandelbrote's Garden (Panel #20) (1988)
oil on canvas
182.9 x 137.2 cm.
Gift of the Volunteer Committee, 89.A.5

Mandelbrote's Garden (Panel #21) (1988)
oil on canvas
182.9 x 137.2 cm.
Gift of the Volunteer Committee, 89.A.6

Mandelbrote's Garden (Panel #22) (1988)
oil on canvas
182.9 x 137.2 cm.
Gift of the Volunteer Committee, 89.A.7

ROSS, Robert (1902-)
Ellen (n.d.)
pastel on paper
35.6 x 27.9 cm.
Gift of the Graphic Arts Fund, the Toronto Telegram, 58.A.88

ROSS, William (1947-)
Subterane (1969)
coloured pencil on paper
52.4 x 35.2 cm.
Gift of Mr. J.H. Moore, London, through the Ontario Heritage Foundation, 80.A.45

ROTHENSTEIN, William (British: 1872-1946)
Portrait of R.B. Cunninghame Graham (1897-98)
lithograph on paper
25.4 x 20.3 cm.
Gift of the Contemporary Art Society of Great Britain, 55.A.125

ROUAULT, Georges (French: 1871-1958)
Mouth That Was Fresh, Bitter as Gall (c.1922)
lithograph on paper
49.9 x 35 cm.
Gift of Mr. J.H. Moore, London, through the Ontario Heritage Foundation, 80.A.56

ROWDEN, Thomas (British: 1842-1926)
Departing Day (1900)
watercolour on paper
18.4 x 30.5 cm.
The W. Thomson Smith Memorial Collection (Bequest of Alfred J. Mitchell), 60.A.10

ROWLANDSON, Thomas (British: 1756-1827)
The Fair Bather (After Boucher) (1799)
etching and mezzotint on paper
17.8 x 25.4 cm.
Anonymous gift, 74.A.71

Repose (After Boucher) (1799)
etching and mezzotint on paper
17.8 x 25.4 cm.
Anonymous gift, 74.A.70

The Serenade (After Titian) (1799)
etching and mezzotint on paper
17.4 x 24.9 cm.
Anonymous gift, 74.A.68

The Surprise (After Albano) (1799)
etching and mezzotint on paper
18.1 x 25.4 cm.
Anonymous gift, 74.A.72

Venus (After Titian) (1799)
etching and mezzotint on paper
17.8 x 25.4 cm.
Anonymous gift, 74.A.73

Wood Nymphs (1799)
etching and mezzotint on paper
17.8 x 25.4 cm.
Anonymous gift, 74.A.69

RUHKIN, Eugeny (Russian: 1943-1976)
Abstract (1973)
mixed media collage on canvas
70 x 66 cm.
The Dr. Robert A.D. Ford Collection, 88.A.19

Abstract (1973)
mixed media collage on canvas
99 x 96 cm.
The Dr. Robert A.D. Ford Collection, 88.A.20

Abstract (1973)
mixed media collage on canvas
100 x 97 cm.
The Dr. Robert A.D. Ford Collection, 88.A.21

RUSSELL, Larry, (1932-)
Pear (1970)
crayon on paper
30.5 x 39.3 cm.
Gift of Mr. J.H. Moore, London, through the Ontario Heritage Foundation, 78.A.137

SABINA, Jose (Brazilian: -)
Lorcida de Futebal (n.d.)
acrylic on canvas
55 x 38 cm.
Gift of Mr. & Mrs. J.H. Moore, London, 85.A.60

SAGER, Peter (1920-)
Monument (n.d.)
linocut 9/25 on paper
31.5 x 23.5 cm.
Gift from the Douglas M. Duncan Collection, 70.A.72

SALICATH, Oernulf (Norwegian: 1888-1962)
Portrait of a Man Smoking (1920)
oil on canvas
85.1 x 75 cm.
Gift of Mr. Gordon Conn, Newmarket, 49.A.15

SALOMONIE, Joanasie (c.1939-)
Mother and Pouting Child (n.d.)
green stone
14 x 13.3 x 12.6 cm.
Art Fund, 77.A.82

SALTMARCHE, Ken (1920-)
Stancezza (1955)
oil on masonite
76.6 x 55.9 cm.
Art Fund, 57.A.26

SAMARAS, Lucas (American: 1936-)
The Hook (1972)
serigraph 56/150 on paper
92 x 64.1 cm.
Gift of Mr. J.H. Moore, London, through the Ontario Heritage Foundation, 80.A.193

SAMILA, David (1941-)
Untitled I (1968)
acrylic on canvas
121.9 x 123.2 cm.
Gift of Mr. J.H. Moore, London, through the Ontario Heritage Foundation, 80.A.207

Mural Sketch II (1972)
serigraph 9/17 on paper
43.2 x 54.6 cm.
Gift of Mr. J.H. Moore, London, through the Ontario Heritage Foundation, 80.A.238

SANDERS, Benita (1935-)
Noona II (1965)
etching 2/10 on paper
52.1 x 66 cm.
Gift of Mr. J.H. Moore, London, through the Ontario Heritage Foundation, 80.A.83

Klunkwoi Rocks (1971)
etching A/P on paper
50.8 x 50.8 cm.
Gift of Mr. J.H. Moore, London, through the Ontario Heritage Foundation, 80.A.216

SARAFINCHAN, Lillian (1935-)
Untitled (1968)
oil on canvas
102.9 x 104.2 cm.
Gift of Mr. J.H. Moore, London, through the Ontario Heritage Foundation, 78.A.138

SASAJINE, Kihei (Japanese: 1906-)
Untitled (Black and White Woods) (1971)
woodblock 11/50 on paper
63.4 x 66 cm.
Gift of Mr. J.H. Moore, London, through the Ontario Heritage Foundation, 79.A.18

SAWAI, Noboru (1931-)
Honourable Curator (1974)
woodcut and copper etching 5/100 on paper
50.8 x 66 cm.
Purchased with funds from the Mitchell Bequest, 74.A.65

SAWARD, Gillian (1934-1983)
Margot (1968)
casein on masonite
122.2 x 76 cm.
Gift of Mr. J.H. Moore, London, through the Ontario Heritage Foundation, 78.A.139

SCHAEFER, Carl (1903-)
Tree Crowned Hill, Haliburton Town (1932)
oil on board
30.5 x 35.4 cm.
Gift of Mr. Richard Alway, Toronto, 84.A.241

Pears (1952)
watercolour on paper
27.9 x 38.1 cm.
Gift from the Douglas M. Duncan
Collection, 70.A.62

**Field to the Pinnacle, Waterloo
County** (1958)
watercolour on paper
33 x 45.7 cm.
Purchased with a Canada Council
matching grant and Acquisitions
funds, 61.A.20

Trilliums, Carnarvon (1963)
watercolour and pen on paper
37.2 x 54.9 cm.
Gift of Mr. J.H. Moore, London,
through the Ontario Heritage
Foundation, 80.A.169

SCHERMAN, Tony (1950-)
In Praise of Flat (1982)
watercolour on paper
66 x 57 cm.
Art Fund, 83.A.28

SCHNEIDER, Herbert
Olympishe Herzen (1972)
serigraph 26/100 on paper
76.8 x 69.9 cm.
Gift of Mr. J.H. Moore, London,
through the Ontario Heritage
Foundation, 80.A.194

SCHNEIDER, Mary (1900-)
**Toronto Scenes: Colborne Lodge,
High Park** (1967)
lithograph 43/100 on paper
24.7 x 33 cm.
Gift of Mr. & Mrs. J.H. Moore,
London, 81.A.41A

Toronto Scenes: St. Lawrence Hall
(1967)
lithograph 43/100 on paper
24.7 x 33 cm.
Gift of Mr. & Mrs. J.H. Moore,
London, 81.A.41B

**Toronto Scenes: Royal Alexandra
Theatre** (1967)
lithograph 43/100 on paper
24.7 x 33 cm.
Gift of Mr. & Mrs. J.H. Moore,
London, 81.A.41C

Toronto Scenes: Casa Loma (1967)
lithograph 43/100 on paper
24.7 x 33 cm.
Gift of Mr. & Mrs. J.H. Moore,
London, 81.A.41D

**Toronto Scenes: St. Lawrence
Market** (1967)
lithograph 43/100 on paper
24 7 x 33 cm.
Gift of Mr. & Mrs. J.H. Moore,
London, 81.A.41E

**Toronto Scenes: Parish Hall of
St. George the Martyr** (1967)
lithograph 43/100 on paper
24.7 x 33 cm.
Gift of Mr. & Mrs. J.H. Moore,
London, 81.A.41G

Toronto Scenes: Osgoode Hall
(1967)
lithograph 43/100 on paper
24.7 x 33 cm.
Gift of Mr. & Mrs. J.H. Moore,
London, 81.A.41F

**Toronto Scenes: New and Old City
Halls** (1967)
lithograph 43/100 on paper
24.7 x 33 cm.
Gift of Mr. & Mrs. J.H. Moore,
London, 81.A.41H

Toronto Scenes: Mackenzie House
(1967)
lithograph 43/100 on paper
24.7 x 33 cm.
Gift of Mr. & Mrs. J.H. Moore,
London, 81.A.41 I

**Toronto Scenes: Old School House,
Trinity Street** (1967)
lithograph 43/100 on paper
24.7 x 33 cm.
Gift of Mr. & Mrs. J.H. Moore,
London, 81.A.41J

**Toronto Scenes: Queen's Wharf,
Lighthouse** (1967)
lithograph 43/100 on paper
24.7 x 33 cm.
Gift of Mr. & Mrs. J.H. Moore,
London, 81.A.41K

**Toronto Scenes: St. Michael's
Cathedral** (1967)
lithograph 43/100 on paper
24.7 x 33 cm.
Gift of Mr. & Mrs. J.H. Moore,
London, 81.A.41L

SCHOFIELD, Stephen (1952-)
Yellow Jackets (1977)
walnut, basalt stoneware
55.8 x 25.4 x 22.8 cm.
Gift of Mr. J.H. Moore, London,
through the Ontario Heritage
Foundation, 85.A.3

**SCHOLDER, Fritz (American:
1937-)**
Buffalo (1974)
watercolour on paper
28 x 38 cm.
Gift of Mr. J.H. Moore, London,
through the Ontario Heritage
Foundation, 78.A.175

SCHOOL OF ADRIAN VAN OSTADE
The Itinerant Vendor (n.d.)
oil on wood
68.2 x 53 cm.
Gift of the Estate of Miss Dorothy
Gunn, London, 82.A.18

SCHOOL OF TOM THOMSON
Untitled Sketch (1917)
oil on wood
20.9 x 26.7 cm.
Purchased with funds from the
Mitchell Bequest, 55.A.66

**SCHREIBER, George (American:
1904-1977)**
Going Home (n.d.)
lithograph on paper
23.5 x 33.6 cm.
Print Fund, 46.A.71

**SCLIAR, Carlos (Brazilian:
1920-)**
Garrafa, Castical e Tangerinas
(1971)
collage and oil on panel
56 x 37 cm.
Gift of Mr. & Mrs. J.H. Moore,
London, 85.A.61

SCOTT, Adam Sherriff (1887-1980)
**Sketch: Cardinal Richelieu and the
100 Associates** (c.1920)
oil on canvas panel
27.5 x 36.5 cm.
Gift of Mr. & Mrs. D.J. Heron,
London, 89.A.58

SCOTT, Campbell (1930-)
Seeds in the Wind (1961)
woodcut 4/30 on paper
45.2 x 67.3 cm.
Print Fund, 62.A.34

SCOTT, Gerald (1926-)
Joyce (1963)
oil on canvas
50.8 x 40.6 cm.
Gift of Mr. J.H. Moore, London,
through the Ontario Heritage
Foundation, 80.A.170

SCOTT, John (1950-)
Set Dasein (1981)
acrylic, oil stick and graphite on paper
188.0 x 218.4 cm.
Purchased with a Canada Council
matching grant and Acquisitions
funds, 81.A.64

SCOTT, Marion (1906-)
Stone and Protoplasm #2 (1948)
oil on masonite
61 x 50.8 cm.
Gift of the Volunteer Committee,
84.A.231

SCOTT, William (1913-1989)
Cup and Pan Blues (1970)
serigraph 54/100 on paper
61 x 90.5 cm.
Gift of Mr. J.H. Moore, London,
through the Ontario Heritage
Foundation, 80.A.57

Blue and White (1973)
oil on canvas
61 x 61 cm.
Gift of Mr. J.H. Moore, London,
through the Ontario Heritage
Foundation, 78.A.214

SEATH, Ethel (1879-1963)
Down Our Street (1943)
oil on wood
40.6 x 30.5 cm.
Gift of George Hulme, Esq., Toronto,
68.A.86

SEAVEY, J.R. (1857-1940)
In the Doctor's Study (1890)
oil on canvas
49.1 x 59.8 cm.
Gift of the Estate of Dr. Fred Luney,
London, 87.A.52

SEELY-SMITH, Dorothy (1890-1961)
Portrait of a Woman (c.1926)
oil on canvas
71.1 x 53.3 cm.
Gift of Mrs. Dorothy Seely Smith
through the I.O.D.E., Nicholas Wilson
Chapter, 65.A.52

**SEIDLER, Doris (American:
1912-)**
Archaios X (1963)
etching 2/10 on paper
30.5 x 25.4 cm.
Print Fund, 65.A.5

SENIW, Thomas (1940-)
Drawing /67-1 (1967)
gouache on cut mounting board
46.3 x 61.6 cm.
Gift of the Ontario Centennial Art
Exhibition, 69.A.82

SEXTON, Ezekiel (c.1820-1859)
Self Portrait with Wife and Daughter
(c.1852)
oil on canvas
98.1 cm. diameter
Gift of Ed McKone, Esq., London,
64.A.132

SHADBOLT, Jack (1909-)
Cut Melons on a Table (1957)
watercolour and ink on paper
49 x 62.5 cm.
Gift of Mr. J.H. Moore, London,
through the Ontario Heritage
Foundation, 79.A.34

Farms on the Steppes (1957)
oil on canvas
71.7 x 90.2 cm.
Art Fund, 58.A.97

Dark Garden #2 (1960)
oil on masonite
81.3 x 121.9 cm.
Gift of the Volunteer Committee,
65.A.9

Theme in Yellow and Red (1960)
ink and acrylic on paper
57.2 x 36.1 cm.
Gift of Mr. J.H. Moore, London,
through the Ontario Heritage
Foundation, 78.A.140

Centennial Suite: Begetting Green
(c.1967)
serigraph 19/59 on paper
47 x 35 cm.
Gift of Simon Fraser University,
Burnaby, B.C., 68.A.79

The Hornby Suite #1 (1969)
lithograph 39/150 on paper
57.7 x 37.2 cm.
Gift of Mr. & Mrs. J.H. Moore,
London, 81.A.14A

The Hornby Suite #2 (1969)
lithograph 39/150 on paper
57.7 x 37.2 cm.
Gift of Mr. & Mrs. J.H. Moore,
London, 81.A.14B

The Hornby Suite #3 (1969)
lithograph 39/150 on paper
57.7 x 37.2 cm.
Gift of Mr. & Mrs. J.H. Moore,
London, 81.A.14C

The Hornby Suite #4 (1969)
lithograph 39/150 on paper
57.7 x 37.2 cm.
Gift of Mr. & Mrs. J.H. Moore,
London, 81.A.14D

The Hornby Suite #5 (1969)
lithograph 39/150 on paper
57.7 x 37.2 cm.
Gift of Mr. & Mrs. J.H. Moore,
London, 81.A.14E

The Hornby Suite #6 (1969)
lithograph 39/150 on paper
57.7 x 37.2 cm.
Gift of Mr. & Mrs. J.H. Moore,
London, 81.A.14F

The Hornby Suite #7 (1969)
lithograph 39/150 on paper
57.7 x 37.2 cm.
Gift of Mr. & Mrs. J.H. Moore,
London, 81.A.14G

The Hornby Suite #8 (1969)
lithograph 39/150 on paper
57.7 x 37.2 cm.
Gift of Mr. & Mrs. J.H. Moore,
London, 81.A.14H

The Hornby Suite #9 (1969)
lithograph 39/150 on paper
57.7 x 37.2 cm.
Gift of Mr. & Mrs. J.H. Moore,
London, 81.A.14 I

The Hornby Suite #10 (1969)
lithograph 39/150 on paper
57.7 x 37.2 cm.
Gift of Mr. & Mrs. J.H. Moore,
London, 81.A.14J

The Hornby Suite #11 (1969)
lithograph 39/150 on paper
57.7 x 37.2 cm.
Gift of Mr. & Mrs. J.H. Moore,
London, 81.A.14K

The Hornby Suite #12 (1969)
lithograph 39/150 on paper
57.7 x 37.2 cm.
Gift of Mr. & Mrs. J.H. Moore,
London, 81.A.14L

The Hornby Suite #13 (1969)
lithograph 39/150 on paper
57.7 x 37.2 cm.
Gift of Mr. & Mrs. J.H. Moore,
London, 81.A.14M

The Hornby Suite #14 (1969)
lithograph 39/150 on paper
57.7 x 37.2 cm.
Gift of Mr. & Mrs. J.H. Moore,
London, 81.A.14N

The Hornby Suite #15 (1969)
lithograph 39/150 on paper
57.7 x 37.2 cm.
Gift of Mr. & Mrs. J.H. Moore,
London, 81.A.14 O

SHARNI (1922-)
Birds Walking (1964)
stonecut 38/50 on paper
30.5 x 48.3 cm.
Print Fund, 72.A.27

Buntings (1964)
stonecut 38/50 on paper
35.6 x 39.4 cm.
Print Fund, 72.A.46

Ducks and Young (1964)
stonecut 38/50 on paper
30.5 x 38.1 cm.
Print Fund, 72.A.75

Fantasy (1964)
stonecut 38/50 on paper
40.6 x 55.9 cm.
Print Fund, 72 A 47

Two Polar Bears (1964)
etching 38/50 on paper
14 x 22.9 cm.
Print Fund, 70.A.34

SHELTON, Margaret (1915-1984)
Mt. Louis, Banff (1943)
linocut 40/100 on paper
10.8 x 14 cm.
Print Fund, 45.A.17

Windblown Fir (1947)
linocut 7/50 on paper
20.3 x 26.7 cm.
Print Fund, 48.A.2

SHEPHERD, Reginald (1924-)
Arctic Ice (1968)
monoscreen on paper
42.6 x 56.5 cm.
Gift of Reginald Shepherd, Esq.,
St. John's, Nfld., 70.A.104

The Sea #5 (1968)
monoscreen on paper
41.6 x 56.5 cm.
Gift of Reginald Shepherd, Esq.,
St. John's, Nfld., 70.A.105

SHONIKER, Claire (1931-)
Laudes Evangelii Annunciation
(1964)
woodcut 4/50 on paper
50.8 x 40.6 cm.
Print Fund, 65.A.4

SHOROSHILUTO (1941-)
Woman Juggling (1964)
stonecut 38/50 on paper
30.5 x 40.6 cm.
Print Fund, 72.A.84

SHOUYU Pootoogook (1938-)
Ducks Feeding (1964)
stonecut 22/50 on paper
41.9 x 43.2 cm.
Print Fund, 72.A.83

SICKERT, Walter R. (British: 1860-1942)
The New Bedford (c.1908)
graphite on paper
25.4 x 11.5 cm.
Gift of the Contemporary Art Society
of Great Britain, 55.A.120

SIEBNER, Herbert (1925-)
Canal (1953)
serigraph on paper
44.5 x 33 cm.
Print Fund, 57.A.13

Figure Group (1959)
serigraph 25/100 on paper
49.6 x 31.8 cm.
Print Fund, 59.A.12

SILVERBERG, David (1936-)
Jidoi Matsuri (1968)
engraving A/P on paper
44.5 x 33 cm.
Gift of Mr. J.H. Moore, London,
through the Ontario Heritage
Foundation, 80.A.84

Nureyev in Modern Garb (1968-69)
ink and wash on paper
34.6 x 29.5 cm.
Gift of Mr. J.H. Moore, London,
through the Ontario Heritage
Foundation, 80.A.85

SINCLAIR, Robert (1939-)
Canadian Classic: Tall Mountain
Space (1975)
aquatic stain on raw cotton
impregnated in magna varnish
289.6 x 86.4 cm.
Gift of Dr. J.T. and Dr. Marta
Hurdalek, Toronto, 90.A.36

SINGLETON, Becky (1952-)
Four Dials (1984)
ink on paper
1st circle - 15 cm. diameter
2nd circle - 12.3 cm. diameter
Purchased with a Canada Council
matching grant and the Art Fund,
85.A.1A-E

SISLEY, Edgar B. (1900-)
Chippie (1948)
etching on paper
19.8 x 15.2 cm.
Print Fund, 48.A.11

Evening, Hart House (c.1948)
drypoint and aquatint on paper
17.8 x 22.3 cm.
Print Fund, 48.A.1

Old Mill At Blair (c.1953)
aquatint on paper
24.9 x 20.3 cm.
Print Fund, 52.A.3

SLIPPER, Gary (1934-)
Where the Winds Meet (1964)
oil on masonite
36 x 46 cm.
Gift of Mr. J.H. Moore, London,
through the Ontario Heritage
Foundation, 78.A.141

SLOGGETT, Paul (1950-)
Oquassac (1980)
acrylic, sand and plywood on canvas
207.7 x 121.9 cm.
Gift of the Allstate Foundation of
Canada, 81.A.1

SMITH, Gordon (1919-)
Cormorants (1952)
lithograph 7/15 on paper
26.7 x 21.6 cm.
Print Fund, 53.A.67

Still Life With Fruit (1952)
screen print 3/35 on paper
36.9 x 50.8 cm.
Print Fund, 57.A.65

Street Musicians (1952)
serigraph on paper
35.6 x 47.7 cm.
Print Fund, 56.A.13

Caledonian Square (1953)
serigraph 4/35 on paper
48.3 x 55.9 cm.
Print Fund, 68.A.42

Water Lilies (1957)
oil on masonite
82.6 x 55.9 cm.
Purchased with funds from the
Mitchell Bequest, 57.A.29

Cornwall (1960)
oil on canvas
64.8 x 83.8 cm.
Gift of Mr. J.H. Moore, London,
through the Ontario Heritage
Foundation, 80.A.95

Rising Forms (1960)
serigraph A/P on paper
43.5 x 30.5 cm.
Gift of Mr. Gordon Smith, Esq.,
Vancouver, B.C., 64.A.160

Through the Window No. 2 (1966)
oil on canvas
58.4 x 66 cm.
Gift of Mr. J.H. Moore, London,
through the Ontario Heritage
Foundation, 78.A.142

Variations (1966)
oil on canvas
71.1 x 88.9 cm.
Gift of Mr. J.H. Moore, London,
through the Ontario Heritage
Foundation, 80.A.171

Centennial Suite: Special Green
(1968)
serigraph 19/50 on paper
37.6 x 50.8 cm.
Gift of Simon Fraser University,
Burnaby, B.C., 68.A.77

Cube (1968)
serigraph on plexiglass, metal
20.3 x 20.3 x 20.3 cm.
Gift of Mr. J.H. Moore, London,
through the Ontario Heritage
Foundation, 78.A.210

Portfolio A: I (1968)
serigraph 15/65 on paper
47 x 47 cm.
Gift of Mr. & Mrs. J.H. Moore,
London, 81.A.44A

Portfolio A: II (1968)
serigraph 15/65 on paper
47 x 47 cm.
Gift of Mr. & Mrs. J.H. Moore,
London, 81.A.44B

Portfolio A: III (1968)
serigraph 15/65 on paper
47 x 47 cm.
Gift of Mr. & Mrs. J.H. Moore,
London, 81.A.44C

Portfolio A: IV (1968)
serigraph 15/65 on paper
47 x 47 cm.
Gift of Mr. & Mrs. J.H. Moore,
London, 81.A.44D

Portfolio A: V (1968)
serigraph 15/65 on paper
47 x 47 cm.
Gift of Mr. & Mrs. J.H. Moore,
London, 81.A.44E

Portfolio A: VI (1968)
lithograph 15/65 on paper
46.1 x 46.1 cm.
Gift of Mr. & Mrs. J.H. Moore,
London, 81.A.38F

Portfolio B: I (1968)
lithograph 15/65 on paper
46.1 x 46.1 cm.
Gift of Mr. & Mrs. J.H. Moore,
London, 81.A.38A

Portfolio B: II (1968)
lithograph 15/65 on paper
46.1 x 46.1 cm.
Gift of Mr. & Mrs. J.H. Moore,
London, 81.A.38B

Portfolio B: III (1968)
lithograph 15/65 on paper
46.1 x 46.1 cm.
Gift of Mr. & Mrs. J.H. Moore,
London, 81.A.38C

Portfolio B: IV (1968)
lithograph 15/65 on paper
46.1 x 46.1 cm.
Gift of Mr. & Mrs. J.H. Moore,
London, 81.A.38D

Portfolio B: V (1968)
lithograph 15/65 on paper
46.1 x 46.1 cm.
Gift of Mr. & Mrs. J.H. Moore,
London, 81.A.38E

Portfolio B: VI (1968)
lithograph 15/65 on paper
46.1 x 46.1 cm.
Gift of Mr. & Mrs. J.H. Moore,
London, 81.A.38F

Capilano Point (1970)
watercolour on paper
38.4 x 58.4 cm.
Gift of Mr. J.H. Moore, London,
through the Ontario Heritage
Foundation, 80.A.86

Sea Wall, Ambleside (1970)
serigraph 24/50 on paper
43.2 x 67.3 cm.
Gift of Mr. J.H. Moore, London,
through the Ontario Heritage
Foundation, 79.A.23

Folded Orange (1972)
serigraph 6/50 on paper
48.3 x 71.1 cm.
Gift of Mr. J.H. Moore, London,
through the Ontario Heritage
Foundation, 80.A.87

Project for Arthur Erickson (1972)
serigraph 24/25 on paper
52.1 x 67.6 cm.
Gift of Mr. J.H. Moore, London,
through the Ontario Heritage
Foundation, 80.A.88

Tidal Place (1974)
silkscreen 47/175 on paper
43.2 x 58.4 cm.
Gift of Mr. J.H. Moore, London,
through the Ontario Heritage
Foundation, 80.A.217

Khafre (1979)
serigraph A/P on paper
41.6 x 51.4 cm.
Gift of Mr. Marshall Webb, Toronto,
82.A.47

Night Landscape (n.d.)
oil on canvas
85.8 x 120.6 cm.
Art Fund, 59.A.3

November Image (n.d.)
serigraph A/P on paper
44.8 x 40 cm.
Gift of Mr. Gordon Smith, Vancouver,
B.C., 64.A.161

SMITH, Jeremy (1946-)
Playground (1972-73)
tempera on wood
73.7 x 116.8 cm.
Gift of Mr. J.H. Moore, London,
through the Ontario Heritage
Foundation, 80.A.172

Window: Cat and Birds (1976)
ink on paper
152.4 x 61.0 cm.
Gift of Mr. J.H. Moore, London,
through the Ontario Heritage
Foundation, 81.A.54

Study for "Mirror" (1978)
graphite on paper
33.6 x 26.7 cm.
Gift of Mr. & Mrs. J.H. Moore,
London, 87.A.85

Study: Male Nude (1978)
graphite on paper
35.6 x 27.3 cm.
Gift of Mr. J.H. Moore, London,
through the Ontario Heritage
Foundation, 87.A.108

A Young Woman (1983)
graphite and ink on paper
46 x 31 cm.
Gift of Mr. & Mrs. J.H. Moore,
London, 87.A.84

SMITH, Joel (1929-)
Centennial Suite: The Red Queen
(c.1967)
serigraph 19/50 on paper
48.9 x 35.6 cm.
Gift of Simon Fraser University,
Burnaby, B.C., 68.A.72

SMITH, John (British: 1652-1742)
after MONNOYER, Jean Baptiste
(French: 1636-1699)
Die of Flowers (n.d.)
lithograph on paper
24.8 x 17.8 cm.
The Donald Routledge and John
Burton Bequest, 81.A.11

SMITH, John Ivor (1927-)
Smiling Head No. 2 (1960)
cast stone
28.9 x 17.5 x 34.3 cm.
Purchased with funds from the
Mitchell Bequest, 62.A.148

Sleeping Head (1965)
bronze, 5/8
25.5 x 14.9 x 21.5 cm.
Gift of Mr. J.H. Moore, London,
through the Ontario Heritage
Foundation, 78.A.211

SMITH, Lawrence Beall (American:
1909-)
Seaside Nomads (n.d.)
lithograph on paper
24.2 x 33.6 cm.
Print Fund, 46.A.68

SMITH, William "St. Thomas"
(1862-1947)
House by the River (n.d.)
watercolour on paper
35.6 x 50.8 cm.
Gift of Mrs. Fred Phelps, London,
51.A.16

Landscape with Ducks (n.d.)
watercolour on paper
26.7 x 36.9 cm.
Gift of Mary Rowell Jackman in
memory of Mary Coyne Rowell,
77.A.12

Misty Weather (n.d.)
watercolour on paper
64.1 x 96.5 cm.
Gift of Mrs. E.S. Heighway, London,
60.A.37

Restless Sea (n.d.)
watercolour on paper
29.2 x 43.2 cm.
Gift of Donald Routledge, Esq.,
London, 60.A.117

River Barges (n.d.)
watercolour on paper
29.2 x 45.4 cm.
Purchased with funds from the
Somerville Bequest, 78.A.221

SNOW, John (1911-)
Summer (1964)
lithograph 5/25 on paper
42.8 x 67.3 cm.
Gift of Mr. J.H. Moore, London,
through the Ontario Heritage
Foundation, 80.A.218

SNOW, Michael (1929-)
Red Head (1963)
oil on canvas
26.5 x 30.5 cm.
Gift of Mr. J.H. Moore, London,
through the Ontario Heritage
Foundation, 78.A.143

Walking Woman Corner Bracket
(1963)
oil on wood
99.2 x 44.4 x 30.3 cm.
Purchased with a Canada Council
matching grant and funds from Union
Gas to commemorate the retirement
of Mr. John B. Cronyn from its Board
of Directors, 82.A.5

Toronto 20: Clara Bley (1965)
photographic offset print 50/100
on paper
66 x 50.8 cm.
Gift of Mr. & Mrs. J.H. Moore,
London, 81.A.32

Waiting Room (1979)
mixed media installation: colour
photographic print on paper,
cardboard, plywood
photo: 173.2 x 124.5 cm.
projector and base: 22.6 x 31.3 x
21.0 cm.
plywood base: 121.9 x 59.1 x
36.8 cm.
Purchased with matching Acquisitions
funds and a Wintario Grant,
79.A.52A-C

The Music Gallery Portfolio: Score
of Sopranos (1982)
serigraph 4/40 on paper
62.9 x 42.6 cm.
Purchased with a Canada Council
matching grant and Acquisitions
funds, 82.A.38

SOTO, Jesus (Venezuelan:
1923-)
Tige sur transparence (1968)
acrylic plastic 28/100
69.9 x 20 x 14 cm.
Gift of Mr. J.H. Moore, London,
through the Ontario Heritage
Foundation, 80.A.199

SPENCE, Jean (1946-)
Los Compadres Codex (1988)
mixed media installation: ink and
watercolour on paper, feathers,
leather, fired clay, mother of pearl,
turquoise, coloured pebbles, sea
shells and black fired slip
various measurements
Gift of the Volunteer Committee,
89.A.8A-H

SPENCELEY, Marjorie (1897-)
Breaking Surf, Atlantic Coast (n.d.)
oil on board
40.6 x 50.8 cm.
Gift of Mrs. Chester Rowntree,
London, 57.A.41

SPENCER, Stanley (British:
1891-1959)
Breaking Firewood, Elsie
graphite on paper
38.5 x 24.7 cm.
Gift of Mr. J.H. Moore, London,
through the Ontario Heritage
Foundation, 85.A.28

Leah & Rachel (n.d.)
graphite on paper
37.5 x 26.2 cm.
Gift of Mr. J.H. Moore, London,
through the Ontario Heritage
Foundation, 85.A.29

SPICKETT, Ron (1926-)
Pietà Theme (1963)
oil on canvas
177.8 x 172.7 cm.
Purchased with a Canada Council
matching grant and Acquisitions
funds, 64.A.169

SPIEGEL, Stacey (1955-)
This cake is to celebrate history's
obscure inventors whose inspiration
and vision continued to change our
universe (1982)
mixed media collage on paper
56.3 x 76.2 cm.
Art Fund, 83.A.25

SPIERS, Raymond (1934-)
Chrome and White No. 5 (n.d.)
chrome, steel and enamel
63.5 x 81.6 x 22.9 cm.
Gift of the Ontario Centennial Art
Exhibition, 69.A.86

STAPLES, Owen (1866-1949)
Main Entrance Doorway, University
College, University of Toronto (n.d.)
etching on paper
25.0 x 17.5 cm.
Gift of Mr. D.B.G. Fair, in memory of
Mr. Lloyd McLarty, London, 85.A.89

STEINBACHER, Guerite (1904-)
Seaweed (1969)
wool and other media
184 x 47.5 cm.
Gift of Mr. J.H. Moore, London,
through the Ontario Heritage
Foundation, 87.A.189

STEINHOUSE, Tobie (1925-)
Subterranean Summer (c.1966)
etching on paper
31.8 x 39.1 cm.
Print Fund, 67.A.4

**STELLA, Frank (American:
1936-)**
Avicenna (1970)
lithograph 65/75 on paper
40.6 x 56.8 cm.
Gift of Mr. J.H. Moore, London,
through the Ontario Heritage
Foundation, 78.A.183

STEVENS, Dorothy (1888-1966)
Segovia, Spain (c.1922)
etching on paper
29.9 x 29.9 cm.
Print Fund, 44.A.18

STEWART, Vaughan (1945-)
Pottery Bowl (n.d.)
glazed earthen-ware
12.4 x 31.2 x 31.2 cm.
Gift of Mr. J.H. Moore, London,
through the Ontario Heritage
Foundation, 87.A.190

Pottery Jug (n.d.)
glazed earthen-ware
58.7 x 31.6 x 32 cm.
Gift of Mr. J.H. Moore, London,
through the Ontario Heritage
Foundation, 87.A.191

Covered Pottery Dish (n.d.)
glazed earthen-ware
15.2 x 21.7 x 18 cm.
Gift of Mr. J.H. Moore, London,
through the Ontario Heritage
Foundation, 87.A.192

Small Pottery Jug (n.d.)
glazed earthen-ware
26.8 x 12.3 x 16.2 cm.
Gift of Mr. J.H. Moore, London,
through the Ontario Heritage
Foundation, 87.A.193

Covered Pottery Dish (n.d.)
glazed earthen-ware
20.1 x 25.7 x 25.7 cm.
Gift of Mr. J.H. Moore, London,
through the Ontario Heritage
Foundation, 87.A.194

STOHN, John (1922-)
Teardrop (1971)
string and plastic
31 x 16.4 x 16.4 cm.
Gift of Mr. J.H. Moore, London,
through the Ontario Heritage
Foundation, 87.A.100

**STRASSER, Maria
(Austrian: -)**
Madonna and Child (copy after
Holbein) (1936)
oil on wood
22.9 x 15.2 cm.
Gift of Mr. Gordon Conn, Newmarket,
49.A.18

Rembrandt's Mother (copy after
Rembrandt) (n.d.)
oil on wood
81.3 x 59.7 cm.
Gift of Mr. Gordon Conn, Newmarket,
49.A.41

Self Portrait (copy after Rembrandt)
(n.d.)
oil on canvas
113.7 x 81.3 cm.
Gift of Mr. Gordon Conn, Newmarket,
49.A.42

Titus Reading (copy after Rembrandt)
(n.d.)
oil on canvas
69.9 x 61 cm.
Gift of Mr. Gordon Conn, Newmarket,
49.A.45

**STRUTT, William (British:
1826-1915)**
Calf (n.d.)
graphite on paper
19.1 x 27.9 cm.
Gift of Mrs. M. Strutt Davies,
Breakeyville, P.Q., 55.A.4

Kid With Bound Feet (n.d.)
graphite on paper
20.6 x 22.3 cm.
Gift of Mrs. M. Strutt Davies,
Breakeyville, P.Q., 55.A.1

Two Kids With Bound Feet (n.d.)
graphite on paper
17.8 x 23.5 cm.
Gift of Mrs. M. Strutt Davies,
Breakeyville, P.Q., 55.A.2

Kneeling Girl (n.d.)
graphite on paper
25.1 x 20.3 cm.
Gift of Mrs. M. Strutt Davies,
Breakeyville, P.Q., 55.A.3

STUBBS, Maurice (1924-)
Untitled (1962)
pastel and charcoal on paper
39.5 x 21.5 cm.
Gift of Mr. & Mrs. Richard M. Ivey,
London, 87.A.209

White Door (1964)
oil on masonite
121.9 x 91.4 cm.
Gift of the Volunteer Committee,
64.A.166

Horse and Rider Still Life (1965)
oil and acrylic on masonite
91.4 x 121.9 cm.
Gift of the Western Art League,
65.A.11

Untitled (1965)
acrylic and gold leaf on masonite
61 x 61 cm.
Gift of Mr. J.H. Moore, London,
through the Ontario Heritage
Foundation, 80.A.173

Winter Still Life #2 (1965)
acrylic on masonite
61 x 61 cm.
Gift of Mr. & Mrs. Richard M. Ivey,
London, 87.A.208

STURDEE, Vivian (1937-1986)
Here's How I Did It (1974)
photo-lithograph 2/3 on paper
53.3 x 78.7 cm.
Gift of the Junior Volunteer
Committee, 74.A.56

Journeying #1 (1980)
charcoal on paper
57.1 x 76.7 cm.
Gift of Anne C. Bolgan, London,
87.A.53

Journeying #2 (1980)
charcoal on paper
57.1 x 76.7 cm.
Gift of Anne C. Bolgan, London,
87.A.54

Journeying #3 (1980)
charcoal on paper
57.1 x 76.7 cm.
Gift of Anne C. Bolgan, London,
87.A.55

Journeying #4 (1980)
charcoal on paper
57.1 x 76.7 cm.
Gift of Anne C. Bolgan, London,
87.A.56

Journeying #5 (1980)
charcoal on paper
57.1 x 76.7 cm.
Gift of Anne C. Bolgan, London,
87.A.57

Journeying #6 (1980)
charcoal on paper
57.1 x 76.7 cm.
Gift of Anne C. Bolgan, London,
87.A.58

SUNOL, Alvar (Spanish: 1935-)
No. 1 (n.d.)
lithograph A/P on paper
45.7 x 71.1 cm.
Gift of Mr. J.H. Moore, London,
through the Ontario Heritage
Foundation, 80.A.195

SURREY, Philip (1910-)
O Boy! Oh Boy! (1954)
wash and ink on paper
24.2 x 33 cm.
Gift of the Graphic Arts Fund, the
Toronto Telegram, 58.A.87

Summer Night (c.1958)
oil on canvas
50.8 x 76.2 cm.
Purchased with funds from the
Mitchell Bequest, 61.A.71

Place Ville Marie (1963)
watercolour and pastel on paper
45.2 x 58.4 cm.
Gift of Mr. J.H. Moore, London,
through the Ontario Heritage
Foundation, 80.A.174

**SUTHERLAND, Graham (British:
1884-1980)**
Untitled (1957)
serigraph 19/25 on paper
50.8 x 66 cm.
Gift of Mr. J.H. Moore, London,
through the Ontario Heritage
Foundation, 80.A.58

**SUZOR-COTÉ, Marc-Aurèle de Foy
(1869-1937)**
Landscape on a Summer's Day
(n.d.)
pastel on paper
39.5 x 24.5 cm.
Gift of Mr. & Mrs. Hugh Pryce-Jones
in memory of Miss Lenore Crawford,
8A.A.233

SWARTZ, Burrell (1925-)
Audrey With Aaron (c.1960)
oil on board
121.9 x 81.3 cm.
Purchased with a Canada Council
matching grant and Acquisitions
funds, 61.A.76

SWINTON, George (1917-)
Arctic Night (1966)
gouache on paper
40.6 x 61 cm.
Gift of Mr. J.H. Moore, London,
through the Ontario Heritage
Foundation, 80.A.94

SYMONS, Bessie Fry (1884-1976)
Coast Range, Spring (1947)
linocut 11/30 on paper
24.9 x 16.5 cm.
Print Fund, 47.A.36

Evening Star, Tonquin Valley (1944)
linocut 41/50 on paper
25.8 x 20.9 cm.
Print Fund, 47.A.60

TAHEDL, Ernestine (1940-)
Composition XV (1963)
oil and enamel on paper mounted on
wood
92.7 x 69.9 cm.
Purchased with a Canada Council
matching grant and Acquisitions
funds, 64.A.164

TANABE, Takao (1926-)
Spring Sun (1958)
oil on canvas
119.4 x 64.8 cm.
Gift of Mr. J.H. Moore, London,
through the Ontario Heritage
Foundation, 78.A.146

**Landscape From an Interior
Country, Tokyo** (1960)
oil on canvas
64.8 x 119.4 cm.
Gift of Mr. J.H. Moore, London,
through the Ontario Heritage
Foundation, 80.A.176

Flag (1962)
collage and rhoplex on masonite
26.5 x 49.5 cm.
Gift of Mr. J.H. Moore, London,
through the Ontario Heritage
Foundation, 78.A.144

Boy's Head (1967)
watercolour on paper
59 x 53.9 cm.
Gift of Mr. J.H. Moore, London,
through the Ontario Heritage
Foundation, 80.A.175

Centennial Suite: Envelope Sketch
(1967)
serigraph 19/50 on paper
33 x 43.2 cm.
Gift of Simon Fraser University,
Burnaby, B.C., 68.A.76

The Land, Sketch A (1972)
acrylic on canvas
27.9 x 35.6 cm.
Gift of Mr. J.H. Moore, London,
through the Ontario Heritage
Foundation, 78.A.145

Interior (1973)
lithograph 4/75 on paper
54.1 x 49.6 cm.
Purchased with funds from the
Mitchell Bequest, 73.A.14

TÀPIES, Antoni (Spanish: 1923-)
No. 1008 (n.d.)
etching 45/75 on paper
58.4 x 76.2 cm.
Gift of Mr. J.H. Moore, London, through the Ontario Heritage Foundation, 80.A.196

Untitled (n.d.)
etching 15/75 on paper
67 x 49 cm.
Gift of Mrs. Mira Godard, Toronto, 87.A.27

TASCONA, Tony (1926-)
Challenge in Red (1961)
ink print on paper
48.9 x 67.3 cm.
Purchased with a Canada Council matching grant and Acquisitions funds, 64.A.173

Pendulum (1965)
lacquer on masonite
100.3 x 75 cm.
Art Fund, 66.A.21

Structure #3 (1965)
enamel on masonite
121.9 x 76.2 cm.
Art Fund, 65.A.12

TAUSZ, Bruno (Brazilian: 1939-)
Untitled (1972)
serigraph 13/30 on paper
24.8 x 24.8 cm.
Gift of Mr. & Mrs. J.H. Moore, London, 85.A.71

Untitled (1972)
serigraph 22/30 on paper
24.8 x 24.8 cm.
Gift of Mr. & Mrs. J.H. Moore, London, 85.A.72

Three Cylinders (n.d.)
serigraph 72/80 on paper
28.3 x 28.3 cm.
Gift of Mr. & Mrs. J.H. Moore, London, 85.A.73

TAYLOR, Frederick (1966-1987)
Early Winter, St. Urbain Street, Montreal (1947)
aquatint 6/8 on paper
19.1 x 16.5 cm.
Print Fund, 48.A.4

Looking up St. Cecile Street, Montreal (1954)
serigraph ?/150 on paper
38.4 x 18.8 cm.
Print Fund, 56.A.14

TAYLOR, John B. (1917-1970)
McArthur #11 (1968)
acrylic on masonite
66 x 81.3 cm.
Purchased with a Canada Council matching grant and Acquisitions funds, 69.A.80

TEITELBAUM, Mashel (1921-1985)
Toronto 20: Untitled (c.1965)
embossed print 50/100 on paper
36.8 x 28 cm.
Gift of Mr. & Mrs. J.H. Moore, London, 81.A.33

TEMPLAR, Albert (1897-)
Old Buildings, London (1926)
oil on canvas
68.6 x 91.4 cm.
Gift of Mr. Albert Templar through the I.O.D.E., Nicholas Wilson Chapter, 26.A.1

Olinesky Clan (1926)
watercolour on paper
10.2 x 18.4 cm.
The Donald Routledge and John Burton Bequest, 81.A.5

Self Portrait with Orange Tie (1927)
oil on canvas
61 x 58.8 cm.
Gift of Mr. Albert Templar, London, 89.A.56

Abbott Block, Dundas St., London, Ontario (1928)
oil on canvas
50.8 x 61 cm.
Anonymous, 73.A.5

Comfort Place (1944)
oil on canvas
71.1 x 91.4 cm.
Gift of Mr. Albert Templar, London, 89.A.57

THAUBERGER, David (1948-)
Front Yard (1981)
acrylic and glitter on canvas
114.3 x 172.7 cm.
Purchased with a Canada Council matching grant and Acquisitions funds, 82.A.22

THIBERT, Pat (1943-)
Study for Lambeth Field (1979)
ink on mylar
61 x 76.2 cm.
Purchased with a Canada Council matching grant and Acquisitions funds, 82.A.29

THOMSON, Tom (1877-1917)
Wild Geese (1917)
oil on wood
20.6 x 26.7 cm.
F.B. Housser Memorial Collection, 45.A.24

THOMSON, William (1926-1988)
Bending Nude Seen From Above (1958)
oil on canvas
50.8 x 102.2 cm.
Purchased with funds from the Mitchell Bequest, 60.A.33

TIKITO (1935-)
I Recall How We Used To Hunt (1964)
stonecut 22/50 on paper
30.5 x 63.5 cm.
Print Fund, 72.A.37

TILEY, James (1933-)
Rock Column (1962)
oil and emulsion on board
107.9 x 81.3 cm.
Gift of the Volunteer Committee, 64.A.73

TILSON, Joe (British: 1928-)
Mother Earth (1972)
serigraph and collage 31/70 on paper
65 x 91 cm.
Gift of Mrs. Mira Godard, Toronto, 87.A.31

TIMANGIA (1940-)
Walrus (1964)
stonecut 38/50 on paper
33 x 36.9 cm.
Print Fund, 72.A.40

TIMMAS, Osvald (1919-)
Sea Denizen (1966)
watercolour on paper
76.2 x 56.5 cm.
Art Fund, 66.A.22

TINGLEY, Merle (1921-)
Lenore Crawford (1974)
mixed media on paper
35.3 x 25.9 cm.
Gift of the Estate of Miss Lenore Crawford, London, 87.A.38

So that explains the wrinkled roof (1982)
ink, marker and letraset on paper
29.5 x 24.0 cm.
Gift of Mr. Merle Tingley, London, 86.A.36

Hey!....what say....we pool our pennies...and...? (1984)
ink, marker and letraset on paper
28.0 x 26.3 cm.
Gift of Mr. Merle Tingley, London, 86.A.37

TOMASSI, Shima (Japanese: 1937-)
Cranes (1962)
woodblock 25/100 on paper
55.8 x 71 cm.
Gift of Mr. J.H. Moore, London, through the Ontario Heritage Foundation, 79.A.21

TONNANCOUR, Jacques de (1917-)
Girl With Black Cat (1958)
oil on masonite
121.9 x 90.2 cm.
Gift of the Volunteer Committee, 59.A.80

Open Field (1959)
oil on board
61 x 80.6 cm.
Gift of Mr. J.H. Moore, London, through the Ontario Heritage Foundation, 78.A.58

Tree Tops (1959)
oil on masonite
121.9 x 165.1 cm.
Purchased with funds from the Mitchell Bequest, 67.A.7

Poisson des profondeurs (1975)
oil and collage on wood
30.5 x 30.5 cm.
Gift of Mr. J.H. Moore, London, through the Ontario Heritage Foundation, 87.A.111

TOOKLOOKTOOK, Paul (1947-)
Eskimo Man (n.d.)
grey stone
15 x 6.5 x 3.4 cm.
Art Fund, 77.A.77

TOPOLSKI, Feliks (British: 1907-)
Coronation (1953)
watercolour and crayon on paper
54.6 x 76.2 cm.
Art Fund, 56.A.30

TOULOUSE-LAUTREC, Henri de (French: 1864-1901)
Désiré Dihau (n.d.)
graphite on paper
18.4 x 10.8 cm.
Gift of Mr. J.H. Moore, London, through the Ontario Heritage Foundation, 78.A.176

TOUPIN, Fernand (1930-)
Le Temple interdit (1962)
oil on canvas
63.5 x 52.8 cm.
Gift of Mr. J.H. Moore, London, through the Ontario Heritage Foundation, 80.A.46

TOUSIGNANT, Claude (1932-)
5-79-102 (1979)
acrylic on canvas
two circles each 243.8 cm. diameter
Purchased with a Canada Council matching grant and funds from the Donald Routledge and John Burton Bequest, 81.A.4A-B

TOWN, Harold (1924-)
Captain Nemo's Cave (1956)
autographic print on paper
53.3 x 41.9 cm.
Gift of Mr. J.H. Moore, London, through the Ontario Heritage Foundation, 80.A.220

Memory of High Park (1957-1958)
single autographic print on paper
48.3 x 63.5 cm.
Art Fund, 58.A.98

Burning Barn (1959)
ink on paper
55.9 x 76.2 cm.
Gift of Mr. J.H. Moore, London, through the Ontario Heritage Foundation, 80.A.177

Untitled (1960)
single autographic print on paper
50.8 x 64.8 cm.
Gift of Mr. J.H. Moore, London, through the Ontario Heritage Foundation, 80.A.219

Spring Caper (1961)
mixed media on paper
14.6 x 22.2 cm.
Gift of Mr. J.H. Moore, London, through the Ontario Heritage Foundation, 78.A.147

Death of Mondrian No. 1 (1961)
collage on card
121.3 x 118.7 cm.
Gift of Mr. J.H. Moore, London, through the Ontario Heritage Foundation, 78.A.148

Sunday Painter's Set (1962)
oil and lucite on canvas
205.7 x 153.7 cm.
Gift of the Volunteer Committee, 66.A.19

Centrebiz (1965)
oil and lucite on canvas
132.1 x 133.4 cm.
Art Fund, 66.A.20

Popster in Flowered Pith Helmet
(1970)
lithograph 3/16 on paper
50.8 x 35.6 cm.
Gift of Mr. J.H. Moore, London,
through the Ontario Heritage
Foundation, 80.A.221

The Candy Juggler (1976)
serigraph 1/200 on paper
66.6 x 55.9 cm.
Gift of Mr. J.H. Moore, London,
through the Ontario Heritage
Foundation, 80.A.89

TOYOKUNI III (Gototei Kunisada)
(Japanese: 1786-1864)
Panel from Theatre Triptych (1858)
woodblock on paper
35.6 x 25.2 cm.
Anonymous gift, 67.A.17

TRAINOR, Floyd (1946-)
Laurie (n.d.)
lithograph 5/14 on paper
55.9 x 81.3 cm.
Gift of Mr. J.H. Moore, London,
through the Ontario Heritage
Foundation, 80.A.222

Untitled (n.d.)
lithograph 5/11 on paper
43.2 x 38.7 cm.
Gift of Mr. J.H. Moore, London,
through the Ontario Heritage
Foundation, 80.A.223

TRAVERS, Cyril (1887-1954)
The Lighthouse, Port Dover (c.1945)
drypoint etching on paper
27.8 x 21.9 cm.
Print Fund, 45.A.10

Ontario Farm (1945)
drypoint etching on paper
17.8 x 22.9 cm.
Print Fund, 46.A.16

TROTTIER, Gerald (1925-)
Portrait of Ronnie Martin (1966)
oil on canvas
152.4 x 121.9 cm.
Art Fund, 70.A.108

TROY, Cecil (1935-)
Frozen Flash (1962)
oil and spray paint on paper
61.6 x 46.3 cm.
Gift of Mr. J.H. Moore, London,
through the Ontario Heritage
Foundation, 80.A.179

Untitled (1963)
collage and oil on paper
58.4 x 44.5 cm.
Gift of Mr. J.H. Moore, London,
through the Ontario Heritage
Foundation, 80.A.178

TUDLIK (1890-1962)
Division of Meat (1959)
stonecut 27/50 on paper
30.5 x 23.5 cm.
Print Fund, 60.A.54

TULLY, Sidney Strickland
(1860-1911)
Washing (n.d.)
oil on canvas board
35.6 x 32.5 cm.
Gift of Mr. Gordon Conn, Newmarket,
50.A.21

TUMIRA (1943-)
Inukshoo (1964)
stonecut 38/50 on paper
38.1 x 24.2 cm.
Print Fund, 72.A.50

Walrus (1964)
stonecut 38/50 on paper
30.5 x 40.6 cm.
Print Fund, 72.A.78

TURNER, George (active: 1930-1950)
Tree Trunks (1942)
linocut on paper
30.5 x 25.4 cm.
Print Fund, 46.A.18

TURNER, J.W.M. (British:
1775-1851)
Dunstanborough Castle (1808)
etching on paper
20.8 x 29.2 cm.
Gift of Mr. & Mrs. J.H. Moore,
London, 89.A.27

London from Greenwich (1811)
etching on paper
21 x 29.2 cm.
Gift of Mr. & Mrs. J.H. Moore,
London, 89.A.25

Temple of Minerva Medica (a.k.a.
Hindoo Worshipper) (1811)
etching on paper
21 x 29.2 cm.
Gift of Mr. & Mrs. J.H. Moore,
London, 89.A.28

Entrance of Calais Harbour (1816)
etching on paper
21.5 x 30.5 cm.
Gift of Mr. & Mrs. J.H. Moore,
London, 89.A.26

ULAYU Pingwartuk (1904-1978)
Hunter (1964)
stonecut 38/50 on paper
12.7 x 10.2 cm.
Print Fund, 72.A.53

I saw a Strange Bird (1964)
stonecut 38/59 on paper
50.8 x 33 cm.
Print Fund, 70.A.35

Shore Birds (1964)
stonecut 38/50 on paper
29.2 x 25.4 cm.
Print Fund, 72.A.77

Woman Tending Fire (1964)
serigraph 38/50 on paper
33 x 50.8 cm.
Print Fund, 70.A.42

UNIDENTIFIED ARTIST
Lago Maggiore (1875)
watercolour on paper
19.1 x 30.5 cm.
Gift of Mr. Gordon Conn, Newmarket,
50.A.62

UNIDENTIFIED ARTIST
Napoleon and Princess Hatzfeld
(n.d.)
oil on canvas
76.2 x 104.1 cm.
Gift of E.R. Deeks, Esq., Toronto,
60.A.36

UNIDENTIFIED ARTIST
Portrait of a Lady (n.d.)
oil on board
78.7 x 66 cm.
Gift of Mrs. A.M. Cleghorn, London,
60.A.116

UNIDENTIFIED ARTIST
Portrait of a Young Man (n.d.)
oil on canvas
71.8 x 64.1 cm.
Gift of the Estate of Mrs. A.M.
Cleghorn, London, 67.A.394

UNIDENTIFIED ARTIST
Landscape with Hunters (n.d.)
oil on canvas
60.6 x 152.7 cm.
Gift of the Glass Family, London,
68.A.102

UNIDENTIFIED ARTIST
Portrait of a Lady (n.d.)
oil on canvas
63.2 x 50.5 cm.
Anonymous gift, 68.A.103

UNIDENTIFIED ARTIST
Phoebe Lee (n.d.)
oil on linen
68.6 x 61 cm.
Gift of the Misses Pennington,
London, 76.A.30

UNIDENTIFIED ARTIST
Still Life with Wild Game (n.d)
oil on canvas
19.5 x 15 cm.
Gift of the Estate of Miss Dorothy
Gunn, London, 82.A.9

UNIDENTIFIED ARTIST
Still Life with Wild Game, Flounder
and Lobster (n.d.)
oil on canvas
20 x 15 cm.
Gift of the Estate of Miss Dorothy
Gunn, London, 82.A.10

UNIDENTIFIED ARTIST - Brazilian
Untitled (n.d.)
gouache on blue-grey paper
68.5 x 48.7 cm.
Gift of Mr. & Mrs. J.H. Moore,
London, 85.A.63

UNIDENTIFIED ARTIST - Canadian
Kirkcubright, St. Mary's Isle, New
Brunswick (1847)
watercolour on paper
22 x 34.5 cm.
Gift of Dr. Daniel Lowe, London,
89.A.59

UNIDENTIFIED ARTIST - Inuit
Bear With Seal in Its Mouth (n.d.)
stone
27 x 27.5 cm.
Gift of Mr. & Mrs. J.H. Moore,
London, 81.A.46

UNIDENTIFIED ARTIST - Inuit
Hunter In Kayak (p.1966)
stone, ivory and string
31.8 x 5.1 x 7.6 cm.
Art Fund, 77.A.51

UNIDENTIFIED ARTIST - Inuit
Otter (or Weasel) (p.1966)
black stone with soap inlay
13.3 x 4.5 x 3.8 cm.
Art Fund, 77.A.52

UNIDENTIFIED ARTIST - Inuit
Seal (p.1966)
green serpentine
6.1 x 8.7 x 3.0 cm.
Art Fund, 77.A.54

UNIDENTIFIED ARTIST - Inuit
Bear with Incised and Polychromed
Legends on Sides (p.1966)
green stone and dark pigment
11.8 x 15 x 1.9 cm.
Art Fund, 77.A.55

UNIDENTIFIED ARTIST - Inuit
Small Bear (p.1966)
grey stone
8.2 x 14.5 x 8.3 cm.
Art Fund, 77.A.56

UNIDENTIFIED ARTIST - Inuit
Caribou (p.1966)
grey stone with soap inlay
10 x 17.8 x 5 cm.
Art Fund, 77.A.57

UNIDENTIFIED ARTIST - Inuit
Kneeling Mother Holding Infant
(p.1966)
grey stone
12.9 x 8.5 x 9.8 cm.
Art Fund, 77.A.58

UNIDENTIFIED ARTIST - Inuit
Hunter with Gun (p.1966)
green stone and whalebone
27.5 x 9.7 x 5.4 cm.
Art Fund, 77.A.59

UNIDENTIFIED ARTIST - Inuit
Igloo (p.1966)
grey stone
7.6 x 24.7 x 7.7 cm.
Art Fund, 77.A.60

UNIDENTIFIED ARTIST - Inuit
Bear (p.1966)
grey stone
21.5 x 6.3 x 5.7 cm.
Art Fund, 77.A.61

UNIDENTIFIED ARTIST - Inuit
Owl (p.1966)
grey stone and ivory
15.2 x 10.7 x 7.7 cm.
Art Fund, 77.A.62

UNIDENTIFIED ARTIST - Inuit
Small Kayak and Hunter (p.1966)
green and grey stone
24.9 x 3.5 x 7.6 cm.
Art Fund, 77.A.63

UNIDENTIFIED ARTIST - Inuit
Gull (c.1956)
grey stone with soap inlay
20.3 x 10.1 x 4.7 cm.
Art Fund, 77.A.64

UNIDENTIFIED ARTIST - Inuit
Standing Hunter and Igloo (n.d.)
green serpentine
hunter: 11.8 x 5.0 x 4.0 cm.
igloo: 6.0 x 8.4 x 1.5 cm.
Art Fund, 77.A.65A-B

UNIDENTIFIED ARTIST - Inuit
Arctic Hare (p.1966)
soapstone
10.3 x 6.1 x 4.3 cm.
Art Fund, 77.A.67

UNIDENTIFIED ARTIST - Inuit
Tiny Bird (p.1966)
grey stone
6.3 x 3.5 x 2.7 cm.
Art Fund, 77.A.68

UNIDENTIFIED ARTIST - Inuit
Loon (p.1966)
grey-black stone with soap inlay
20 x 12.3 x 5 cm.
Art Fund, 77.A.69

UNIDENTIFIED ARTIST - Inuit
Hunter with Seal (p.1966)
black stone
17 x 15.7 x 5.0 cm.
Art Fund, 77.A.70

UNIDENTIFIED ARTIST - Inuit
Wounded Polar Bear (n.d.)
stone
25 x 40.7 x 4.1 cm.
Gift of Mr. J.H. Moore, London,
through the Ontario Heritage
Foundation, 87.A.109

UNIDENTIFIED ARTIST - Inuit
Mother and Daughter (c.1956)
grey stone
18.4 x 11.5 x 10.1 cm.
Art Fund, 77.A.71

UNIDENTIFIED ARTIST - Inuit
Mother and Child (p.1966)
green stone
14.5 x 9 x 7.6 cm.
Art Fund, 77.A.72

UNIDENTIFIED ARTIST - Inuit
Fish (p.1966)
black soapstone
27.9 x 7.6 x 8 cm.
Art Fund, 77.A.66

UNIDENTIFIED ARTIST - Inuit
Owl with Three Young (p.1966)
black soapstone and ivory
16.5 x 14 x 10.2 cm.
Art Fund, 77.A.84

UNIDENTIFIED ARTIST - Inuit
Large Bear (p.1966)
black soapstone
24.2 x 10.2 x 13.3 cm.
Art Fund, 77.A.85

UNIDENTIFIED ARTIST - Inuit
Standing Bear (p.1966)
black soapstone
17.8 x 7.1 x 3.8 cm.
Art Fund, 77.A.86

UNIDENTIFIED ARTIST - Inuit
Seal (p.1966)
grey soapstone
18.4 x 6.4 x 56.2 cm.
Art Fund, 77.A.87

UNIDENTIFIED ARTIST - Inuit
Young Hunter (p.1966)
green stone
14.7 x 8 x 5.1 cm.
Art Fund, 77.A.53

UNIDENTIFIED ARTIST - Russian
**Russian Soldiers Attacking a
German Cavalry Regiment** (c.1918)
coloured lithograph on paper
33.0 x 50.8 cm.
The Dr. Robert A.D. Ford Collection,
86.A.45

URQUHART, Tony (1934-)
Instrument of Torture (1959)
oil on cardboard
27 x 40.9 cm.
Gift of Mr. J.H. Moore, London,
through the Ontario Heritage
Foundation, 80.A.47

Spanish Commentary (1959)
oil on canvas
137.8 x 121.9 cm.
Purchased with a Canada Council
matching grant and Acquisitions
funds, 60.A.68

Predatory Form (1959)
woodcut 7/15 on paper
20.3 cm. diameter
Gift of Mr. J.H. Moore, London,
through the Ontario Heritage
Foundation, 80.A.224

Hero! (1961)
linocut 8/50 on paper
19.8 cm. diameter
Gift of Mr. J.H. Moore, London,
through the Ontario Heritage
Foundation, 80.A.90

Forgotten Man No. 1: Politician
(1961)
watercolour, graphite and collage on
paper
13 cm. diameter
Gift of Mr. J.H. Moore, London,
through the Ontario Heritage
Foundation, 78.A.150

Forgotten Man. No. 2: Hero (1961)
watercolour, graphite and collage on
paper
13 cm. diameter
Gift of Mr. J.H. Moore, London,
through the Ontario Heritage
Foundation, 78.A.151

Forgotten Man No. 3: Artist (1961)
watercolour, graphite and collage on
paper
13 cm. diameter
Gift of Mr. J.H. Moore, London,
through the Ontario Heritage
Foundation, 78.A.152

Forgotten Man No. 5: Statesman
(1961)
watercolour, graphite and collage on
paper
13 cm. diameter
Gift of Mr. J.H. Moore, London,
through the Ontario Heritage
Foundation, 78.A.153

Forgotten Man No. 6: Explorer
(1961)
watercolour, graphite and collage on
paper
13 cm. diameter
Gift of Mr. J.H. Moore, London,
through the Ontario Heritage
Foundation, 78.A.154

Dead Pine Forest III (1962)
ink and watercolour on paper
40.3 x 34.9 cm.
Art Fund, 83.A.19

Cathedral Series No. 3 (1964)
conté on paper
101.6 x 22.9 cm.
Gift of the Ontario Centennial Art
Exhibition, 69.A.84A

Cathedral Series No. 4 (1964)
conté on paper
101.6 x 119.9 cm.
Gift of the Ontario Centennial Art
Exhibition, 69.A.84B

Cathedral Series No. 5 (1964)
conté on paper
101.6 x 22.9 cm.
Gift of the Ontario Centennial Art
Exhibition, 69.A.84C

Toronto 20: Unknown Landscape
(1965)
woodblock and collage 50/100 on
paper
66 x 50.8 cm.
Gift of Mr. & Mrs. J.H. Moore,
London, 81.A.34

**Frightened by the Trees - Orange
Version** (1965-66)
mixed media on wood
185 x 40.5 x 24.75 cm.
Gift of Mr. Greg Curnoe, London,
82.A.27

Sea Like (1966)
mixed media on wood
137.2 x 91.4 x 91.4 cm.
Gift of City of London, 88.A.3

Opening Box-Black (1968)
mixed media on wood
50.8 x 27.9 x 25.4 cm.
Art Fund, 69.A.65

Opening Box-Rococo (1968)
mixed media on wood
38.7 x 22.9 x 16.7 cm.
Gift of Mr. J.H. Moore, London,
through the Ontario Heritage
Foundation, 78.A.212

The Roman Line (1969)
ink on paper
29.2 x 22.9 cm.
Gift of Mr. J.H. Moore, London,
through the Ontario Heritage
Foundation, 78.A.155

Box with Six Landscape Shards
(1970)
ink on paper
29.2 x 22.9 cm.
Gift of Mr. J.H. Moore, London,
through the Ontario Heritage
Foundation, 78.A.149

Les Nasses (1974)
pen, ink, oil and collage on paper
40.6 x 59.7 cm.
Art Fund, 74.A.21

Black Floor Piece (1978)
mixed media on wood
243.8 x 99.1 x 91.4 cm.
Gift of Mr. David Urquhart, Toronto,
87.A.226

UTSAL, Salme (active circa 1950)
Church Entrance (c.1950)
watercolour on paper
47 x 38.1 cm.
Art Fund, 51.A.28

Sunny Morning (c.1950)
watercolour on paper
45.7 x 35.6 cm.
Art Fund, 52.A.67

VAILLANCOURT, Armand (1932-)
Un Bois (1963)
wood
124.5 x 21.6 x 5.4 cm.
Gift of Mr. J.H. Moore, London,
through the Ontario Heritage
Foundation, 78.A.213

VALIUS, Telesforas (1914-1977)
**Tragedy on the Shore of the Baltic
Sea III** (1942)
woodcut 5/25 on paper
15.2 x 15.2 cm.
Print Fund, 52.A.5

Fire in the Village (1945)
woodcut 28/38 on paper
15.2 x 15.2 cm.
Print Fund, 52.A.39

VAN HALM, Renée (1949-)
Curtains (1981)
mixed media on paper
51 x 56 cm.
Purchased with a Canada Council
matching grant and Acquisitions
funds, 82.A.21

**VAN MASTENBROEK, Johann (Dutch:
1875-1945)**
Lon en Wolken (1905)
watercolour on paper
51.4 x 72.4 cm.
Gift of Mrs. Irene Pashley, London,
81.A.57

VARLEY, F.H. (1881-1969)
Mimulus, Mist and Snow (c.1927-28)
oil on canvas
69.6 x 69.6 cm.
Gift of Volunteer Committee, 72.A.117

Mountain Peak (1929)
oil on wood
30.1 x 38.1 cm.
F.B. Housser Memorial Collection,
77.A.8

Mountains (1929)
oil on wood
30.1 x 38.1 cm.
F.B. Housser Memorial Collection,
77.A.7

Lynn Peak (c.1934)
mixed media on paper
26.7 x 31.8 cm.
Art Fund, 76.A.11

Mountain Forms (n.d.)
graphite on paper
27.9 x 37.4 cm.
Gift of Mr. J.H. Moore, London,
through the Ontario Heritage
Foundation, 78.A.158

Untitled (n.d.)
watercolour on paper
20 x 13 cm.
Gift of Mr. J.H. Moore, London,
through the Ontario Heritage
Foundation, 78.A.157

**VASARELY, Victor (French:
1908-)**
CTA-102 Gold (1965-66)
serigraph 19/125 on paper
70.6 x 70.6 cm.
Print Fund, 68.A.40

Goya S2 (1966)
tempera on board
76 x 76 cm.
Gift of Mr. J.H. Moore, London,
through the Ontario Heritage
Foundation, 78.A.178

Untitled (1967)
Illustration from Jean-Claude
Lambert's *Code*
serigraph and embossed print 95/150
on paper
38.1 x 27.8 cm.
Gift of Mr. & Mrs. J.H. Moore,
London, 81.A.43A

Untitled (1967)
Illustration from Jean-Claude
Lambert's *Code*
serigraph and embossed print 95/150
on paper
38.1 x 27.8 cm.
Gift of Mr. & Mrs. J.H. Moore,
London, 81.A.43B

Untitled (1967)
Illustration from Jean-Claude
Lambert's *Code*
serigraph 95/150 on paper
38.1 x 27.8 cm.
Gift of Mr. & Mrs. J.H. Moore,
London, 81.A.43C

Untitled (1967)
Illustration from Jean-Claude
Lambert's *Code*
serigraph and embossed print 95/150
on paper
38.1 x 27.8 cm.
Gift of Mr. & Mrs. J.H. Moore,
London, 81.A.43D

Untitled (1967)
Illustration from Jean-Claude
Lambert's *Code*
serigraph and embossed print 95/150
on paper
38.1 x 27.8 cm.
Gift of Mr. & Mrs. J.H. Moore,
London, 81.A.43E

Untitled (1967)
Illustration from Jean-Claude
Lambert's *Code*
etching 95/150 on paper
38.1 x 27.8 cm.
Gift of Mr. & Mrs. J.H. Moore,
London, 81.A.43F

Untitled (1967)
Illustration from Jean-Claude
Lambert's *Code*
serigraph and embossed print 95/150
on paper
38.1 x 27.8 cm.
Gift of Mr. & Mrs. J.H. Moore,
London, 81.A.43G

Untitled (1967)
Illustration from Jean-Claude
Lambert's *Code*
serigraph and embossed print 95/150
on paper
38.1 x 27.8 cm.
Gift of Mr. & Mrs. J.H. Moore,
London, 81.A.43H

Axor (1969)
collage on card
38 x 28 cm.
Gift of Mr. J.H. Moore, London,
through the Ontario Heritage
Foundation, 78.A.177

Kanta EG-1-2 (1973)
serigraph 3/4 on aluminum
100 x 100 cm.
Gift of Mr. & Mrs. Richard M. Ivey,
London, 87.A.50

Sin-hat-A (n.d.)
serigraph 70/340 on paper
46.4 x 40.2 cm.
Gift of Mr. & Mrs. Richard M. Ivey,
London, 87.A.40

Hat (n.d.)
serigraph 70/340 on paper
46.2 x 40 cm.
Gift of Mr. & Mrs. Richard M. Ivey,
London, 87.A.41

Cheyt-Rond (n.d.)
serigraph 70/340 on paper
37.9 x 40.2 cm.
Gift of Mr. & Mrs. Richard M. Ivey,
London, 87.A.42

Bicubes (n.d.)
serigraph 70/340 on paper
48 x 22 cm.
Gift of Mr. & Mrs. Richard M. Ivey,
London, 87.A.43

Okta-Pos (n.d.)
serigraph 70/340 on paper
40.1 x 40.1 cm.
Gift of Mr. & Mrs. Richard M. Ivey,
London, 87.A.44

Descartes (n.d.)
serigraph 59/138 on paper
40.4 x 39.8 cm.
Gift of Mr. & Mrs. Richard M. Ivey,
London, 87.A.45

Folkokta (n.d.)
serigraph 70/340 on paper
40.1 x 40 cm.
Gift of Mr. & Mrs. Richard M. Ivey,
London, 87.A.46

Koskavall (n.d.)
serigraph 70/340 on paper
40.3 x 40.4 cm.
Gift of Mr. & Mrs. Richard M. Ivey,
London, 87.A.47

Kapolna (n.d.)
serigraph 70/340 on paper
40.1 x 30.1 cm.
Gift of Mr. & Mrs. Richard M. Ivey,
London, 87.A.48

Untitled (n.d.)
serigraph 70/340 on paper
39.8 x 39.9 cm.
Gift of Mr. & Mrs. Richard M. Ivey,
London, 87.A.49

Permutations (n.d.)
serigraph 30/150 on paper
60 x 60 cm.
Gift of Mr. & Mrs. Richard M. Ivey,
London, 87.A.51

Torony (n.d.)
serigraph 70/340 on paper
59 x 49.5 cm.
Gift of Mr. & Mrs. Richard M. Ivey,
London, 87.A.213

Untitled (n.d.)
serigraph 70/340 on paper
59 x 49.5 cm.
Gift of Mr. & Mrs. Richard M. Ivey,
London, 87.A.214

Tuz (n.d.)
serigraph 70/340 on paper
59 x 49.5 cm.
Gift of Mr. & Mrs. Richard M. Ivey,
London, 87.A.215

VASILIEV, Anatoli (Russian: 1940-)
Mon (1956)
oil on card
70 x 50 cm.
The Dr. Robert A.D. Ford Collection,
88.A.22

VERBOOM, Klaas (1948-)
Snowing (1972)
oil and acrylic on wood
101.6 x 152.4 cm.
Gift of the London Art Gallery
Association, 72.A.13

VERNER, Frederick (1836-1928)
Cows Resting (1891)
watercolour on paper
29.2 x 62 cm.
Gift of Mr. Brian Ayer, Guelph,
87.A.59

Elk Resting (1891)
watercolour on paper
29.2 x 62 cm.
Gift of Mr. Brian Ayer, Guelph,
87.A.60

VICKERS, Henry H. (1851-1918)
Landscape With Cows (1908)
oil on canvas
27.9 x 38.1 cm.
The W. Thomson Smith Memorial
Collection (Bequest of Alfred J.
Mitchell), 48.A.89

VILLELA, Cesar G. (Brazilian: -)
Arlequim (1973)
oil on canvas
60 x 50 cm.
Gift of Mr. & Mrs. J.H. Moore,
London, 85.A.62

VILLENEUVE, Arthur (1910-)
Ste. Rose du nord (1964)
oil on canvas
50.8 x 61 cm.
Gift of Mr. J.H. Moore, London,
through the Ontario Heritage
Foundation, 78.A.159

VINCENT, Bernice (1934-)
Backyards (1979)
acrylic on paper mounted on wood
panel
64.1 x 77.5 cm.
Gift of the City of London 125th
Anniversary, 80.A.236

Suburban Afternoons (1980)
acrylic on board
four panels each: 112 x 29.3 cm.
Purchased with matching Acquisitions
funds and a Wintario Grant,
80.A.227A-D

VON DER OHE, Katie (1937-)
Composition in Wood #5 (1960)
mahogany
58.4 x 20.3 x 20.9 cm.
Purchased with a Canada Council
matching grant and Acquisitions
funds, 64.A.165

VOZNESENSKY, Andrei (Russian: c.1934-)
Russian Village in Winter (c.1974)
oil on card
48.0 x 69.0 cm.
The Dr. Robert A.D. Ford Collection,
86.A.44

WAGSCHAL, Marion (1943-)
Blotting Lipstick (1975)
crayon on paper
74.9 x 54 cm.
Gift of Mr. J.H. Moore, London,
through the Ontario Heritage
Foundation, 78.A.195

Self Portrait #2 (1975)
watercolour on paper
34.3 x 26 cm.
Gift of Mr. J.H. Moore, London,
through the Ontario Heritage
Foundation, 78.A.196

WALKER, Horatio (1858-1938)
Outside Bake Oven and Leg Study
(1886)
graphite on paper
24.2 x 17.8 cm.
Purchased with funds from the
Mitchell Bequest, 58.A.29

Deserted Seaside Village Street
(n.d.)
graphite on paper
25.4 x 17.8 cm.
Purchased with funds from the
Mitchell Bequest, 58.A.25

Fishing Nets (n.d.)
charcoal on paper
54.6 x 43.2 cm.
Gift of Mr. J.H. Moore, London,
through the Ontario Heritage
Foundation, 85.A.5

Horse (n.d.)
graphite on paper
14.3 x 15.2 cm.
Purchased with funds from the
Mitchell Bequest, 58.A.35

House and Trees (n.d.)
graphite on paper
15.2 x 17.2 cm.
Purchased with funds from the
Mitchell Bequest, 58.A.26

Houses on Street (n.d.)
graphite on paper
24.9 x 17.8 cm.
Purchased with funds from the
Mitchell Bequest, 58.A.41

Houses (n.d.)
pastel and graphite on paper
12.7 x 17.8 cm.
Purchased with funds from the
Mitchell Bequest, 58.A.43

Landscape (n.d.)
graphite on paper
20.6 x 25.1 cm.
Purchased with funds from the
Mitchell Bequest, 58.A.20

Landscape With Church (n.d.)
graphite and pastel on paper
12.7 x 17.4 cm.
Purchased with funds from the
Mitchell Bequest, 58.A.13

Landscape With Houses (n.d.)
graphite and pastel on paper
8.6 x 17.8 cm.
Purchased with funds from the
Mitchell Bequest, 58.A.16

Landscape With Houses (n.d.)
pastel and graphite on paper
8.6 x 17.8 cm.
Purchased with funds from the
Mitchell Bequest, 58.A.48

Landscape With Houses (n.d.)
graphite on paper
20.9 x 29.9 cm.
Purchased with funds from the
Mitchell Bequest, 58.A.49

Landscape With Rooftops (n.d.)
graphite on paper
18.4 x 25.4 cm.
Purchased with funds from the
Mitchell Bequest, 58.A.23

Lock (n.d.)
wash and graphite on paper
19.8 x 24.5 cm.
Purchased with funds from the
Mitchell Bequest, 58.A.42

Man on a Horse (n.d.)
graphite on paper
21.6 x 17.4 cm.
Purchased with funds from the
Mitchell Bequest, 58.A.31

Milk Carrier (n.d.)
watercolour on paper
45.7 x 36.9 cm.
Purchased with funds from the
Mitchell Bequest, 58.A.12

Boat: Study for Unloading Hay (n.d.)
graphite on paper
24.2 x 21.6 cm.
Purchased with funds from the
Mitchell Bequest, 58.A.38

Study: Pigs Sleeping (n.d.)
graphite on paper
17.5 x 25.1 cm.
Purchased with funds from the
Mitchell Bequest, 58.A.33

Ploughing, Île d'Orléans (p.1912)
oil on wood
54.6 x 75 cm.
Art Fund, 59.A.4

Return of the Sheep (n.d.)
watercolour on paper
24.2 x 33.6 cm.
Purchased with funds from the
Mitchell Bequest, 58.A.10

Rue à Ste. Petronille, Île d'Orléans
(n.d.)
charcoal on paper
54.6 x 40 cm.
Gift of Mr. J.H. Moore, London,
through the Ontario Heritage
Foundation, 85.A.6

Sheep Dipping/Clipping (n.d.)
graphite and pastel on paper
24.9 x 20.3 cm.
Purchased with funds from the
Mitchell Bequest, 58.A.32

Sheep Resting (n.d.)
watercolour on paper
40.1 x 53.3 cm.
Purchased with funds from the
Mitchell Bequest, 58.A.11

Study of Boats (n.d.)
graphite on paper
25.4 x 17.8 cm.
Purchased with funds from the
Mitchell Bequest, 58.A.40

Study of Cows (n.d.)
graphite on paper
22.3 x 17.8 cm.
Purchased with funds from the
Mitchell Bequest, 58.A.15

Study of Goats (n.d.)
graphite on paper
22.5 x 14.9 cm.
Purchased with funds from the
Mitchell Bequest, 58.A.21

Study of Goats (n.d.)
graphite on paper
19.1 x 14.9 cm.
Purchased with funds from the
Mitchell Bequest, 58.A.22

Study of Man and a Horse (n.d.)
graphite on paper
24.9 x 17.4 cm.
Purchased with funds from the
Mitchell Bequest, 58.A.36

Study of Oxen and Cart (n.d.)
graphite on paper
13.7 x 22.3 cm.
Purchased with funds from the
Mitchell Bequest, 58.A.14

Study of Oxen in Yoke (n.d.)
graphite on paper
22.3 x 14.7 cm.
Purchased with funds from the
Mitchell Bequest, 58.A.39

Study of Sheep (n.d.)
graphite on paper
25.4 x 17.8 cm.
Purchased with funds from the
Mitchell Bequest, 58.A.19

Study of a Donkey (n.d.)
graphite on paper
22.9 x 29.1 cm.
Purchased with funds from the
Mitchell Bequest, 58.A.30

Tree and House Study (n.d.)
graphite on paper
24.9 x 17.8 cm.
Purchased with funds from the
Mitchell Bequest, 58.A.24

Trees (n.d.)
graphite and chalk on paper
15.8 x 17.2 cm.
Purchased with funds from the
Mitchell Bequest, 58.A.27

Trees (n.d.)
graphite on paper
20.3 x 24.2 cm.
Purchased with funds from the
Mitchell Bequest, 58.A.17

Turkey Study (n.d.)
graphite and pastel on paper
15.8 x 27.6 cm.
Purchased with funds from the
Mitchell Bequest, 58.A.37

Village Scene (n.d.)
graphite and pastel on paper
16.8 x 24.9 cm.
Purchased with funds from the
Mitchell Bequest, 58.A.28

Village Sketch (n.d.)
graphite on paper
18.1 x 11.5 cm.
Purchased with funds from the
Mitchell Bequest, 58.A.34

Wooded Scene (n.d.)
pastel and graphite on paper
17.8 x 23.2 cm.
Purchased with funds from the
Mitchell Bequest, 58.A.49A

WALLACE, George (1920-)
Abstract (1955)
linocut on paper
20 x 45.2 cm.
Gift from the Douglas M. Duncan
Collection, 70.A.81

WALLACE, Harry (1892-1977)
**Fort Mississauga,
Niagara-on-the-Lake** (1947)
etching 2/52 on paper
17.2 x 20.3 cm.
Gift of the Society of Canadian
Painter-Etchers and Engravers,
47.A.35

Wind and Rain (n.d.)
etching on paper
28.9 x 26.4 cm.
Print Fund, 46.A.15

**WARHOL, Andy (American:
1927-1987)**
Marilyn Monroe (1967)
serigraph 2/250 on paper
90.2 x 90.2 cm.
Gift of Mr. J.H. Moore, London,
through the Ontario Heritage
Foundation, 80.A.197

Flowers (1970)
serigraph ?/250 on paper
91.4 x 91.4 cm.
Gift of the Volunteer Committee,
78.A.24

Flowers #8 (1970)
serigraph 56/250 on paper
91.4 x 91.4 cm.
Gift of the Volunteer Committee,
78.A.23

Wayne Gretzky 99 (1983)
serigraph 97/300 on paper
102 x 81.6 cm.
Gift of Mr. Robert Daniel Scarabelli,
Vancouver, B.C., 87.A.225

WARKOV, Esther (1941-)
A Procession (c.1964)
oil on canvas
141 x 117.5 cm.
Purchased with a Canada Council
matching grant and Acquisitions
funds, 64.A.168

Lost Soul Cabinet No. 5 (n.d.)
graphite on paper
24.8 x 36.8 cm.
Gift of Mr. J.H. Moore, London,
through the Ontario Heritage
Foundation, 78.A.160

**WATANBE, Sadao (Japanese:
1913-)**
Untitled (Two Figures) (1969)
lithograph 33/50 on paper
67.6 x 57.1 cm.
Gift of Mr. J.H. Moore, London,
through the Ontario Heritage
Foundation, 79.A.22

WATERREUS, Valentine
My True Love (n.d.)
oil on board
42.5 x 49.5 cm.
Gift of Mr. J.H. Moore, London,
through the Ontario Heritage
Foundation, 78.A.156

**WATKINS, Benjamin (British:
1853-1913)**
View of Port Stanley (1898)
watercolour on paper
25.1 x 34.7 cm.
Gift of Mr. & Mrs. C.H. Bastla,
London, 79.A.58

WATSON, Homer (1855-1936)
The Lone Cattle Shed (1894)
oil on canvas
45.7 x 61 cm.
Presented by Mr. & Mrs. H.R.
Jackman, Toronto, in memory of the
Honourable Newton W. & Mrs. Nellie
(Langford) Rowell, 77.A.10

Landscape With Figures (1906)
oil on board
16.5 x 24.2 cm.
Gift of Mrs. B.H. Porteous, London,
63.A.96

Two Figures Under Beech Trees
(n.d.)
oil on card
22.9 x 27.9 cm.
Art Fund, 76.A.14

**WAUGH, Samuel Bell (American:
1814-1885)**
Portrait of Louisa Lawrason
(1844)
oil on linen
76.2 x 63.5 cm.
Gift of the Misses Pennington,
London, 76.A.24

WAUTERS, Jef (Belgian: 1927-)
Trois Enfants (1960)
oil on canvas
43.7 x 36.1 cm.
Gift of Mr. J.H. Moore, London,
through the Ontario Heritage
Foundation, 78.A.179

WEBER, George (1907-)
Inakeep Reserve, Osoyoos, B.C.
(1957)
serigraph 26/75 on paper
20.3 x 25 4 cm.
Print Fund, 59.A.99

WEINSTEIN, Alan (1939-)
Night Watch (1968)
intaglio 16/30 on paper
60.4 x 45.2 cm.
Print Fund, 70.A.109

WEISMAN, Gustav (1926-)
Landscape (1961)
ink and oil on paper
42.5 x 64.6 cm.
Gift of Mr. J.H. Moore, London,
through the Ontario Heritage
Foundation, 78.A.161

Landscape (1963)
pastel on paper
41.9 x 54.6 cm.
Gift from the Douglas M. Duncan
Collection, 70.A.61

Dark Head (n.d.)
charcoal on paper
57 x 46 cm.
Gift of Mr. J.H. Moore, London,
through the Ontario Heritage
Foundation, 78.A.162

WELLINGTON, Hubert (British: 1879-1969)
Stables Behind the Lawyer's House (1915)
oil on canvas
40.6 x 50.8 cm.
Gift of the Contemporary Art Society
of Great Britain, 69.A.47

WELKS, Edward (British: active 1850)
In Scene At Windsor Castle (1850)
lithograph on paper
21.2 x 12.5 cm.
Gift of the Estate of Miss Dorothy
Gunn, London, 82.A.19

WELLS, John (British: 1907-)
Rock Forms (1961)
oil on board
76.2 x 61 cm.
Gift of the Contemporary Art Society
of Great Britain, 65.A.78

WEST, William (1921-)
Passing Ships (1959)
serigraph 25/100 on paper
31.8 x 49.6 cm.
Print Fund, 59.A.9

WHALE, Robert R. (1805-1887)
Portrait of Catherine Gartshore (c.1870)
oil on board
90.8 x 69.9 cm.
Gift of the Estate of Mrs. A.M.
Cleghorn, London, 67.A.395

Portrait of Theresa McClary (c.1870)
oil on canvas
83.6 x 63 cm.
Gift of the Estate of Miss Dorothy
Gunn, London, 82.A.20

WHALE, Robert Heard (1857-1906)
Old Mill, Paris, Ontario (1893)
oil on canvas
58.3 x 37.6 cm.
Hamilton King Meek Memorial
Collection, 40.A.9

Landscape, Paris, Ontario (n.d.)
oil on canvas
45.7 x 33 cm.
Hamilton King Meek Memorial
Collection, 40.A.10

WHEELER, John (1928-)
Edge of Spring (1971)
woodcut A/P on paper
47 x 59.7 cm.
Purchased with funds from the
Mitchell Bequest, 72.A.11

WHISTLER, James (American: 1834-1903)
La rue Furstenburg, Paris (1894)
lithograph on paper
37.8 x 25.7 cm.
Gift of the Contemporary Art Society
of Great Britain, 72.A.93

WHITFIELD, Edwin (British: 1816-1892)
London, Canada West (1855)
engraving on paper
10.2 x 18.4 cm.
Gift of Arthur Mould, Esq., London,
55.A.129

WHYDALE, E. Herbert (British: 1886-)
The Chalk Pit (n.d.)
etching on paper
24.9 x 29.9 cm.
Print Fund, 40.A.2

WHYTE, D. MacGregor (British: 1866-1953)
Digging (n.d.)
oil on canvas
27.9 x 35.6 cm.
The W. Thomson Smith Memorial
Collection (Bequest of Alfred J.
Mitchell), 48.A.84

Reapers on Island (n.d.)
oil on canvas
33 x 41.2 cm.
The W. Thomson Smith Memorial
Collection (Bequest of Alfred J.
Mitchell), 48.A.70

WIELAND, Joyce (1931-)
The Lovers (1957-58)
graphite on paper
21.9 x 27.6 cm.
Gift of Mr. J.H. Moore, London,
through the Ontario Heritage
Foundation, 86.A.35

Toronto 20: Untitled (1965)
ozalid print 50/100 on paper
61 x 45.8 cm.
Gift of Mr. & Mrs. J.H. Moore,
London, 81.A.35

True Patriot Love - Landscape Sequence of Quebec (1971)
graphite on paper
22.5 x 30.3 cm.
Gift of Mr. J.H. Moore, London,
through the Ontario Heritage
Foundation, 86.A.31

Eulalie and Tom Run Away (1971)
graphite on paper
22.5 x 30.3 cm.
Gift of Mr. J.H. Moore, London,
through the Ontario Heritage
Foundation, 86.A.33

Eulalie's House as Seen from Claude's Plane (1971)
graphite on paper
22.5 x 30.3 cm.
Gift of Mr. J.H. Moore, London,
through the Ontario Heritage
Foundation, 86.A.32

Eulalie's House on the Saguenay (1971)
graphite on paper
22.5 x 30.3 cm.
Gift of Mr. J.H. Moore, London,
through the Ontario Heritage
Foundation, 86.A.34

Spring, Summerhill Ave. (1972-73)
stitched quilt
196.8 x 196.8 x 8.9 cm.
Gift of the Volunteer Committee,
76.A.6

Squid Jiggin' Grounds (1973)
lithograph 10/50 on paper
52.4 x 74.9 cm.
Gift of Mr. J.H. Moore, London,
through the Ontario Heritage
Foundation, 78.A.199C

Facing North-Self Impression (1973)
lithograph 10/50 on paper
33 x 43.2 cm.
Gift of Mr. J.H. Moore, London,
through the Ontario Heritage
Foundation, 78.A.199B

The Arctic Belongs to Itself (1973)
lithograph 10/50 on paper
33 x 43.2 cm.
Gift of Mr. J.H. Moore, London,
through the Ontario Heritage
Foundation, 78.A.199A

Drawing for "The Far Shore" Poster (1976)
coloured pencil on paper
73.7 x 53.7 cm.
Gift of Dr. & Mrs. Ralph Bull, London,
85.A.91

WILDMAN, Sally (1939-)
Grandparents (1969)
ink and acrylic on board
109.2 x 152.4 cm.
Gift of the London Art Gallery
Association, 71.A.33

WILLIAMS, Christopher (1947-)
I Want To Live (1972)
graphite on paper
76.2 x 54.6 cm.
Purchased with funds from the
Mitchell Bequest, 72.A.8

Cow's Back (1974)
engraving A/P on paper
54.6 x 39.4 cm.
Gift of the London Art Gallery
Association, 74.A.16

WILLIAMS, John Spurr (active circa 1900)
Annapolis River (1902)
watercolour on paper
21 x 41.5 cm.
Gift of Dr. Daniel Lowe, London,
89.A.61

WILLMORE, Jeff (1954-)
Black Hounds Hunting (1979)
watercolour, coloured pen and
graphite on paper
57.5 x 72.5 cm.
Art Fund, 84.A.5

Legend (1981)
coloured pencil, graphite, ink,
paper collage and tape on paper
50 x 65 cm.
Art Fund, 84.A.4

WILSON, Percy (Roy) (1900-)
The Mirror (1963)
lithograph 4/6 on paper
32.1 x 24.2 cm.
Print Fund, 65.A.35

WILSON, R. York (1907-1984)
Port Credit Spring (1944)
oil on card
30.5 x 40.6 cm.
Art Fund, 45.A.39

Acambam, Querretaro State (1950)
oil on board
29.9 x 40.1 cm.
Gift of the Estate of Miss Florence
Wyle, Toronto, 74.A.37

White Houses, Acambay (1951)
oil on canvas paper
72.1 x 93 cm.
Gift of Mr. Clare Wood, Toronto,
through the Ontario Heritage
Foundation, 83.A.14

Ballerina (1951)
oil on card
30.5 x 40.6 cm.
Gift of Mr. J.H. Moore, London,
through the Ontario Heritage
Foundation, 78.A.163

El Paseo, Canary Islands (1952)
oil on board
45.7 x 61 cm.
Gift of Mr. J.H. Moore, London,
through the Ontario Heritage
Foundation, 80.A.180

Lanzarotte (1957)
oil on masonite
61 x 91.4 cm.
Gift of Mr. J.H. Moore, London,
through the Ontario Heritage
Foundation, 80.A.181

Winter, Ontario (1958)
oil on masonite
30.5 x 40.6 cm.
Gift of Mr. J.H. Moore, London,
through the Ontario Heritage
Foundation, 78.A.164

Tlacolula (c.1962)
acrylic on canvas
81 x 112 cm.
Gift of Mr. & Mrs. Richard M. Ivey,
London, 88.A.2

Corner of Greece (1962)
oil on masonite
30.5 x 40.6 cm.
Gift of Jack Wildridge, Esq., Toronto,
64.A.60

Midsummer, Paris (1962)
gouache on paper
17.8 x 23.9 cm.
Gift of Mr. J.H. Moore, London,
through the Ontario Heritage
Foundation, 80.A.182

Orage (1962)
gouache on paper
48.3 x 63.5 cm.
Gift of Mr. J.H. Moore, London,
through the Ontario Heritage
Foundation, 80.A.183

Lepanto (1963)
oil on canvas
162.6 x 129.5 cm.
Art Fund, 64.A.59

Whirling Dervish (1976)
acrylic on canvas
61 x 61 cm.
Gift of Mrs. Yvonne McKague
Housser, Toronto, 76.A.21

WILSON, Scottie (British: 1890-1972)
Untitled (1942-43)
crayon and ink on paper
31.8 x 21.6 cm.
Gift from the Douglas M. Duncan
Collection, 70.A.73

Garden of Eden (n.d.)
graphite and pen on paper
35.2 x 46 cm.
Gift of Mr. J.H. Moore, London,
through the Ontario Heritage
Foundation, 80.A.49

Untitled (n.d.)
crayon and ink on paper
38.1 x 28.2 cm.
Gift from the Douglas M. Duncan
Collection, 70.A.83

WINTER, William (1909-)
Boys On Bicycles (n.d.)
ink on paper
24.5 x 18.8 cm.
Gift of Mr. J.H. Moore, London,
through the Ontario Heritage
Foundation, 80.A.184

The Carver (n.d.)
oil on card
24.1 x 21.6 cm.
Gift of Mr. J.H. Moore, London,
through the Ontario Heritage
Foundation, 78.A.165

Child No. 2 (n.d.)
oil on card
24.1 x 19 cm.
Gift of Mr. J.H. Moore, London,
through the Ontario Heritage
Foundation, 78.A.166

Mother and Child (n.d.)
ink and wash on paper
24.5 x 17.8 cm.
Gift of Mr. J.H. Moore, London,
through the Ontario Heritage
Foundation, 80.A.185

Music and the Dance (n.d.)
oil on masonite
71.1 x 91.4 cm.
Art Fund, 53.A.155

WISE, Jack (1928-1987)
Midway (c.1967-69)
gouache on paper
22.9 x 32.5 cm.
Gift of Mr. J.H. Moore, London,
through the Ontario Heritage
Foundation, 80.A.48

WOOD, George (1932-)
Kitchen Corner (1967)
co-polymer on fibreboard
182.9 x 121.9 cm.
Purchased with funds from the
Mitchell Bequest, 68.A.19

WOOD, Peter Valentine (British: 1810-1855)
London, Canada West (1842)
watercolour and graphite on paper
24.1 x 36.2 cm.
Gift of the Women's Canadian Club of
London, 75.A.25

WOODS, Christopher (1949-)
Crossed Feet (1973)
etching and aquatint 4/30 on paper
77.5 x 58.4 cm.
Purchased with funds from the
Mitchell Bequest, 75.A.25

WORSLEY, John (British: 1919-)
Conway Estuary, North Wales (1947)
watercolour on paper
33 x 50.8 cm.
Art Fund, 56.A.33

WRINCH, Mary (1877-1969)
Sawmill in Action (1926)
oil on canvas
83.8 x 86.4 cm.
Gift of Mrs. Mary Wrinch Reid,
Toronto, 49.A.21

Snowdrops in the Rain (c.1928-29)
linocut on paper
9.8 x 9.6 cm.
Gift of Mr. Gordon Conn, Newmarket,
70.A.29

The Chicken House (c.1928-29)
linocut on paper
15.2 x 19.8 cm.
Gift of Mr. Gordon Conn, Newmarket,
70.A.32

Breaking Clouds (1930)
block print on paper
23.5 x 26 cm.
Gift of Mr. Gordon Conn, Newmarket,
70.A.27

Poppies in the Garden (1930)
block print on paper
23.5 x 20.6 cm.
Gift of Mr. Gordon Conn, Newmarket,
70.A.26

Ducks on the Wychwood Pond (1932)
linocut on paper
12.7 x 12.7 cm.
Gift of Mr. Gordon Conn, Newmarket,
70.A.30

Limestone Shore, Bruce Peninsula (c.1932)
oil on canvas
76.2 x 92.7 cm.
Gift of Mrs. Mary Wrinch Reid,
Toronto, 50.A.47

Crescent Moon (1935)
linocut on paper
19.4 x 14.9 cm.
Gift of Mr. Gordon Conn, Newmarket,
70.A.31

Wind Clouds (1935)
linocut 7/100 on paper
25.4 x 30.5 cm.
Print Fund, 44.A.20

Chez Nous (1936)
linocut 2/100 on paper
24.9 x 29.9 cm.
Print Fund, 44.A.21

The Leaves Are Falling (1939)
block print on paper
25.4 x 30.5 cm.
Gift of Mr. Gordon Conn, Newmarket,
70.A.28

Spruce Tree on a Grey Day (1939)
linocut 17/100 on paper
25.4 x 30.5 cm.
Print Fund, 44.A.19

Sparkling Water (1941)
linocut 10/120 on paper
25.1 x 30.5 cm.
Print Fund, 46.A.14

Northern Bloodroot (1954)
block print on paper
21.9 x 20.9 cm.
Gift of the Society of Canadian
Painter Etchers and Engravers,
55.A.47

Abitibi Canyon (c.1930)
oil on canvas
86.4 x 96.5 cm.
Gift of Mrs. Mary Wrinch Reid,
Toronto, 62.A.55

WUNDERLICH, Paul (German: 1929-)
Song of Songs, Portfolio VII, 3(2) (1969)
lithograph on paper
81.3 x 67.3 cm.
Gift of the Volunteer Committee,
78.A.25

Song of Songs, Portfolio VII, 3(7) (1969)
lithograph on paper
81.3 x 67.3 cm.
Gift of the Volunteer Committee,
78.A.26

WYERS, Jan (1888-1973)
Watering Horses (n.d.)
oil on canvas
45.7 x 61 cm.
Gift of Mr. J.H. Moore, London,
through the Ontario Heritage
Foundation, 78.A.167

WYLE, Florence (1881-1968)
Susannah (c.1940)
limestone bas-relief
162.6 x 57.2 x 33 cm.
Gift of friends of Frances Loring and
Florence Wyle, 66.A.14

Torso (c.1949)
walnut
42.3 x 21 x 11.4 cm.
Purchased with a Canada Council
matching grant and Acquisitions
funds, 59.A.88

XANTHOS, Irene (1951-)
Number 15 (1980)
paper, paint, enamel and glue
55.9 x 40.6 x 27.9 cm.
Purchased with a Canada Council
matching grant and Acquisitions
funds, 81.A.65

YARWOOD, Walter (1917-)
Relief No. 1 (n.d.)
acrylic on cast aluminium
15.8 x 26.6 x 19.0 cm.
Gift of Mr. J.H. Moore, London,
through the Ontario Heritage
Foundation, 87.A.112

YEEND-KING, Henry John (British: 1855-1924)
Aldermaston Gates (n.d.)
watercolour on paper
27.9 x 39.4 cm.
The W. Thomson Smith Memorial
Collection (Bequest of Alfred J.
Mitchell), 48.A.69

YUNKERS, Adja (American: 1900-)
"A" (1972)
serigraph 23/50 on paper
101.6 x 86.4 cm.
Gift of Mr. J.H. Moore, London,
through the Ontario Heritage
Foundation, 80.A.198

YVARAL, Jean-Pierre (French: 1934-)
Interferences avec le cercle B (1967)
cotton and wood 14/50
59.7 x 59.7 x 30.5 cm.
Gift of Mr. J.H. Moore, London,
through the Ontario Heritage
Foundation, 80.A.200

ZARSKI, Robert (1949-)
Untitled (c.1974)
acrylic on canvas
162.6 x 214.6 cm.
Gift of the London Art Gallery
Association, 74.A.15

ZELENAK, Ed (1940-)
Convolutions (1969)
fibreglas
82.6 x 177.8 x 107.9 cm.
Art Fund, 70.A.48

Untitled No. 7 (1976-79)
plate steel, lead and tin
91.4 x 91.4 x 7.6 cm.
Purchased with matching Acquisitions
funds and a Wintario Grant, 80.A.2

Six by Six, Fifth Site (1979)
tin, lead, graphite, wood and paper
182.9 x 182.9 x 5.5 cm.
Purchased with a Canada Council
matching grant and funds from the
Volunteer Committee, 85.A.80

ZIMMER, Morand (1925-)
Carnival No. 2 (n.d.)
watercolour on paper
35.6 x 43.2 cm.
Gift of Mr. J.H. Moore, London,
through the Ontario Heritage
Foundation, 80.A.186

ZVEREV, Anatoly (Russian: 1931-)
The Church at Peredelkino (1958)
oil on card
74.5 x 99.0 cm.
The Dr. Robert A.D. Ford Collection,
86.A.43

Untitled (1959)
oil and pastel on paper
59.7 x 42.2 cm.
Gift of Mr. J.H. Moore, London,
through the Ontario Heritage
Foundation, 80.A.50

Fish (1968)
oil on canvas board
50 x 35 cm.
The Dr. Robert A.D. Ford Collection,
88.A.17

The London Regional Art and Historical Museums gratefully acknowledges the people listed below who have made this 50th anniversary publication possible.

COLLECTION SPONSOR
Barbara & John Cronyn
Mr. & Mrs. Norman A. Hills
Mr. & Mrs. Richard M. Ivey
Jean & Angus McKenzie
Mrs. John A. McNee
Mr. & Mrs. John H. Moore

COLLECTION DONOR
Marjorie L. Blackburn
Mr. & Mrs. Eric Jarmain
Mr. & Mrs. Ron J. Logan
Mr. & Mrs. W.R. Poole
Robert & Joan Seabrook
Mrs. Lorraine Shuttleworth
Ms. Diane Y. Stewart
van der Westen & Rutherford

COLLECTION COUPLE
Peter & Mary-Helen Adams
Lorna & Ian Anderson
Lynn & Brock Armstrong
Mr. & Mrs. T.V. Avey
Mr. & Mrs. R. Paul Bailey
Gerald & Beverly Baines
Dr. & Mrs. James Ballantyne
Mr. & Mrs. Walter A. Barker
Dr. & Mrs. David Bell
Mr. & Mrs. L.R. Benvenuto
Dr. & Mrs. Warren Blume
Bernard & Jayne Borschke
Mr. & Mrs. Philip W. Bowman
Ellen & David Bratton
Professor & Mrs. Kenneth I. Bray
Dr. & Mrs. Tom Brown
Mr. & Mrs. K. Wayne Brownlee
Jack Burghardt
Mr. & Mrs. Vincent Calzonetti
Lt. Col. Peter Campbell
Dr. & Mrs. S. Edwin Carroll
James & Janet Caskey
Drs. A.B. & Beryl Chernick
Peter & Kate Cuddy
Dr. & Mrs. William S.A. Dale
Mr. & Mrs. William Daly
Mr. & Mrs. P.H. Davies
Major & Mrs. S.C. Davies

Mr. & Mrs. Norman R. Davis
Mr. & Mrs. Ron Dawson
Dr. R.F. Del Maestro
Dr. Paul Dickie &
 Dr. Lauren McCurdy
Dr. & Mrs. Alan Dinniwell
Stephen & Averil Eakins
Mrs. John K. Elliott
Mr. & Mrs. John Hill Ervasti
Mr. Edward Escaf
Mr. & Mrs. Peter Evans
Dr. & Mrs. W.H. Feasby
Peter & Gail Fendrich
Mrs. Alexandra J. Fennell
Marny & Jeffrey Flinn
Chris & Charlotte Forberg
Mrs. Winnifred L. Franks
Mr. & Mrs. Linden Frelick
Trish Fulton
Ian & Jan Gibson
Dr. & Mrs. David Girvan
Ms. Mira Godard
Eva & Jim Good
Dr. & Mrs. Robert A. Goyer
Col. & Mrs. Ian M. Haldane
Dorothy & Peter Hardy
William R. Harper &
 Susan Pepper
Joe & Bonnie Hawlik
Helen & George Hayman
Mr. & Mrs. William C. Heine
Dr. & Mrs. George G. Hinton
Mr. Elwood I. Hodgins
Richard & Jacquelyn Hodgson
Dr. & Mrs. Ronald Holliday
Mr. & Mrs. Grant Hopcroft
A.M.J. & Barbara Hyatt
Mr. Monteith C. Illingworth
Mr. & Mrs. Edwin R. Jarmain
Mr. & Mrs. Peter Johnson
Mr. & Mrs. Allen H. Jones
Mrs. Catharina Jongsma
Mr. George Kapelos &
 Mrs. Thomas Kapelos
Dr. & Mrs. H. Keidan
Mr. & Mrs. E.R. Kelly
Mr. & Mrs. J. Brent Kelman

John & Marion Kestle
Mr. & Mrs. T.F. Kingsmill
Dr. & Mrs. Jonathan B. Kronick
Dr. Peter Lane &
 Ms. Marcia George
Mrs. Ann McColl Lindsay
Betsy & Tony Little
Hewett & Catherine Littlejohn
Mr. & Mrs. B.H. Lowry
Dr. & Mrs. Mario Malizia
Judge & Mrs. D.R. McDermid
Dr. J.G. McMurray
Rev. & Mrs. Orlo Miller
Dr. & Mrs. Thomas Munro
Mr. John R. Murphy
Mr. & Mrs. Lynn J. Murray
Dr. & Mrs. A.H. Neufeld
Mr. & Mrs. John Newbegin
Mr. & Mrs. Richard Newman
Mr. & Mrs. James F. Nicholas
Drs. Blake & Sandra Nicolucci
Dr. & Mrs. Harry Norry
Mr. & Mrs. George Obokata
Mr. Dennis J. O'Connor
Mr. & Mrs. Gordon F.
 Osbaldeston
Shelagh & Ed Parg
Paul & Lesley Pergau
Professor & Mrs. Allen K.
 Philbrick
George & Toni Plaxton
Mr. & Mrs. R.W. Rangeley
Rick & Carol Richardson
Mr. & Mrs. Ronald O.B.
 Richardson
Mr. & Mrs. Robert A. Riseling
Wilson & Judith Rodger
Mr. & Mrs. John R. Roy
Dean Russell Ltd.
Mr. L.A. Russell
Bob & Debbie Schram
Mrs. Elsie Sheldrick
Mr. & Mrs. Lyle B. Sherwin
Shelly & Bob Siskind
Mr. & Mrs. Andrew Spriet
Nancy & Keith Sumner
Jim & Joanne Swan

COLLECTION COUPLE
cont'd.

Mr. & Mrs. J. Allyn Taylor
Mr. & Mrs. Harold Vaisler
Dr. & Mrs. O. Harold Warwick
Mary Ellen Whaley
Mr. & Mrs. John White
Dr. & Mrs. L.D. Wilcox
Dr. & Mrs. W.W. Wilkins
Dr. K.H. Wojakowski
Reva E. Yates &
 Raymond G. Yates
Dr. & Mrs. Y.I. Yeh
Dr. & Mrs. A.A. Yuzpe

COLLECTION SUPPORTER

Militcha Alexander
Ms. Margaret Allan
Mrs. Joyce Allen
Dr. Helen M.B. Allison
Mrs. Morley Almost
Mrs. Claire Anderson
Mrs. Beth Bailey
Dr. Halina Kieraszewicz-Bain
Mr. H.M. Ballantyne
Lillian R. Benson
Mr. Graeme Bieman
Dr. Olga B. Bishop
Mrs. Victor J. Blackwell
Dr. James E. Boone
Mrs. W.G. Boughner
Mrs. J.J. Bowden
Netta Brandon
Ms. Beverly Fay Bray

Frances Bright
Jean Brook
Mrs. Kay Carruthers
Miss Silvia Clarke
Maureen A. Coleman
Ms. Dorothy A. Coutts
Miss Joyce L. De Vecchi
Jo Anne De Wilde
Dorothy Dewhurst
Dorothy L. Dowler
Mrs. Betty Duffield
Wally Duffield
Andrew Durnford
Gerald Fridman
Miss Elsie R.M. Gordon
Miss Mary Patricia Gray
Mrs. Barbara Jackson
Donald F. Johnston
 Holdings Ltd.
Councillor Martha E. Joyce
Ms. Nancy I. Kelly
Mrs. June E. Klassen
Ms. Helen M. Lansing
Mrs. Shirley Leeming
Mr. Harold A. Leonard
Mrs. B. Libby
Ms. Gail Lindsay
Ruth Aileen Loft
Miss Eunice MacDonald
Ms. Florence MacInnes
Mildred E. Maclean
Ms. Claudia V. Main

Mr. Douglas J. McDonald
Miss Donna McIntosh
Mrs. T. Marie McLachlan
Catherine Melito
Martha E. Murray
Dr. Leola E. Neal
M.A. Nisbet
Mrs. Elaine Osborne
Ms. Lilian Turner Parkinson
Florence (Nan) Paterson
Ann Richards
Mrs. Emily Rush
Mr. Mitchell Saddy
Fred Schaeffer
Tom Siess
Bob Simpson
Donna L. Smith
Mrs. Sandy Snelgrove
Dr. James E. Stakiw
W.F. Stanley
Mrs. John Bland Stratton
Leah G. Sutherland
Mrs. Beverly A. Thompson
Dr. Jane Upfold
Mr. Frederick F. Waddell
Miss Joan M. Watt
Fran Whitney
Dr. Jean Zarfas

ANONYMOUS DONORS
Thanks go out to our six
 anonymous donors.

INDEX

CREDITS

Publisher
London Regional Art & Historical Museums
under the direction of Nancy Poole

Editor
Barry Fair

Editorial Assistant
Judith Rodger

Project Manager
Ruth Anne Murray

Cover Design
Robert Ballantine

Design
Denise Ward

Photographers
Artcraft Engravers Ltd., Victor Aziz, Beta Photos,
Randy Dunlop for the Awes Studio, William Kuryluk,
George Marchell, D.G. McLeod, T.E. Moore,
Ron Nelson Photography, Jeff Nolte, Alan Noon,
Gary Pettigrew, Phillip Ross, Superior Engravers,
John Tamblyn, Don Vincent

Word Processor
Rebecca Boughner

Typography
The Aylmer Express Ltd.

Type
Bem

Colour Separation and Film
Newport Graphics Inc.

Printing
The Aylmer Express Ltd.

Binding
Bookshelf Bindery Limited